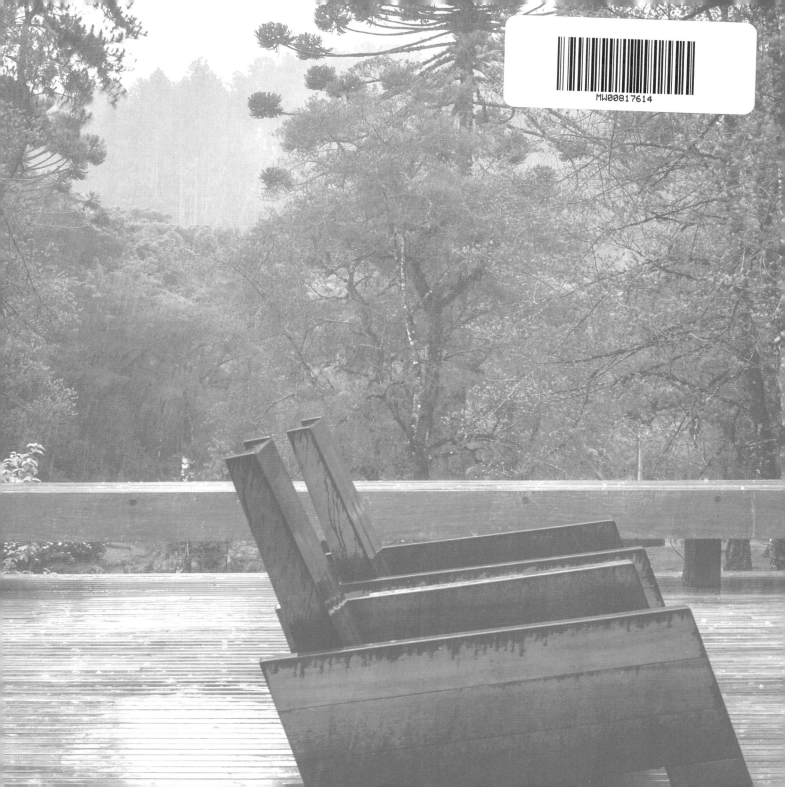

PHILIP JODIDIO

INTO THE WOODS

RETREATS AND
DREAM HOUSES

RIZZOLI NEW YORK

New York · Paris · London · Milan

6 Looking for Arcadia / **Philip Jodidio**

14 Valley Villa / Raguva, Lithuania / **Arches**
20 KGET House / Ensuès-la-Redonne, France / **Bonte & Migozzi Architectes**
24 Casa Myhrer Hauge / Sørbråten, Maridalen, Oslo, Norway / **Gudmundur Jonsson Arkitektkontor**
30 Mylla Cabin / Jevnaker County, Norway / **Mork-Ulnes Architects**
36 Friluftssykehuset Outdoor Care Retreats / Oslo and Kristiansand, Norway / **Snøhetta**
40 Cabin K / Lake Saimaa, Varkaus, Finland / **Studio Kamppari**
44 Wooden House / Kanji Dol, Slovenia / **Studio Pikaplus**
50 Forest Pond House / Sway, Hampshire, UK / **TDO**
54 Forest Retreat / Central Bohemia, Czech Republic / **Uhlik architekti**

58 Cabin on Flathead Lake / Polson, Montana / **Andersson-Wise Architects**
64 Klein A45/ Lanesville, New York / **BIG NYC**
68 Board + Batten / Green Mountains, Vermont / **Birdseye**
74 Lightbox / Point Roberts, Washington / **Bohlin Cywinski Jackson**
80 Charlevoix Domes / Petite-Rivière-Saint-François, Quebec, Canada / **Bourgeois/Lechasseur Architectes**
84 Riverbend Residence / Jackson, Wyoming / **Carney Logan Burke**
90 Connecticut Residence / Connecticut / **Cutler Anderson Architects**
96 Inhabit / Near Woodstock, New York / **Antony Gibbon Designs**
100 Lakeside Retreat / Adirondack Mountains, New York / **GLUCK+**
106 Half-Tree House / Sullivan County, New York / **Jacobschang Architecture**
110 High Horse Ranch / Willits, California / **Kieran Timberlake**
116 Glass/Wood House / New Canaan, Connecticut / **Kengo Kuma & Associates**
120 Week'nder / Madeline Island, Wisconsin / **Lazor/Office**
126 Lundberg Breuer Cabin / Sonoma County, California / **Lundberg Design**
132 Lake Manitouwabing Residence / McKellar, Parry Sound, Ontario, Canada / **MJMA**
138 Gambier House / Gambier Island, British Columbia, Canada / **Office of McFarlane Biggar Architects + Designers**
144 Chechaquo Lot 6 Cabin / Methow Valley, Washington / **Prentiss + Balance + Wickline Architects**
150 Hayes Residence / Berkeley Springs, West Virginia / **Travis Price Architects**
156 Oak Pass Main House / Beverly Hills, California / **Walker Workshop**
162 La Colombière / Sutton, Quebec, Canada / **YH2 Architecture**

168 Villa in the Palms / Sangolda, Goa, India / **Abraham John Architects**

174 Forest Quintet / Yanggu-Eup, South Korea / **Chiasmus Partners**

180 Deck House / Janda Baik, Pahang, Malaysia / **Choo Gim Wah Architect**

186 Forest House 02 / Sóc So'n, Hanoi, Vietnam / **D12 Design**

190 Leaves Villa / Karuizawa, Nagano, Japan / **KIAS**

194 Mount Daisen Cottage / Hoki-cho, Saihaku, Tottori, Japan / **Keisuke Kawaguchi, K2-Design**

198 K-Lagoon / Sasavne, Alibaug, India / **Malik Architecture**

204 Guava House / Hemmathagama, Kegalle District, Sri Lanka / **RA Designs**

208 Brick Kiln House / Munavali, Alibaug, Maharashtra, India / **SPASM Design**

212 Forest Pavilion / Titirangi, Auckland, New Zealand / **Chris Tate Architecture**

216 Spread House / Nagano, Japan / Makoto Takei + Chie Nabeshima/**TNA**

220 Chameleon Villa / Buwit, Bali, Indonesia / **Word of Mouth**

226 Woodhouse / Zunyi, Guizhou, China / **ZJJZ**

E

230 No Footprint House / Ojochal, Puntarenas, Costa Rica / **A-01**

236 Bridge Pavilion / Calamuchita Valley, Córdoba, Argentina / **Alarcia Ferrer Arquitectos**

238 Casa La Roja / San José de Maipo, Chile / **Felipe Assadi Arquitectos**

242 Forest House / Costa Esmeralda, Buenos Aires, Argentina / **Besonias Almeida Arquitectos**

248 Cocobolo House / Montezuma, Puntarenas, Costa Rica / **Cañas Architects**

254 H3 House / Mar Azul, Buenos Aires, Argentina / **Luciano Kruk**

258 Tree House Constantia / Constantia, Cape Town, South Africa / **Malan Vorster**

264 Mororó House / Campos de Jordão, São Paulo, Brazil / **Studio MK27**

270 Chipicas Town Houses / Valle de Bravo, Mexico / **Alejandro Sánchez García, Taller 6A**

274 Yellow House / Pucon, Chile / **Alejandro Soffia Arquitecto**

280 LLU House / Carran, Maihue Lake, XIV Region, Chile / **Cazú Zegers Arquitectura**

288 Photograph Credits

RETREATS AND
DREAM HOUSES

WOODS

LOOKING FOR ARCADIA

Philip Jodidio

> To all delight of human sense exposed,
> In narrow room Nature's whole wealth, yea, more,
> A Heaven on Earth; for blissful Paradise
> Of God the garden was, by him in the east
> Of Eden planted.
>
> —John Milton, *Paradise Lost* (1667)[1]

The forest exerts an irresistible attraction on many persons, either as a source of relaxation from the stress of urban life or as a real way to escape to another world, one where the rules of nature must be obeyed. The houses chosen for this book are intentionally of very different types, ranging from small off-grid shelters to luxurious houses for the lucky few. In fact, this last category is something of an enigma. The will to be surrounded by nature clearly exists but is somewhat obviated by the concomitant desire for the comforts of modern life—a case of wanting to have the best of both worlds, as it were. These forest houses are modern, all twenty-first century and mostly from the past few years. Their different styles and approaches to the forest are underlined by a selection that privileges geographic dispersion, from Latin America to New Zealand.

Forest houses have existed for thousands of years and in some regions are one of the oldest forms of human habitation: living in the wild, creating a shelter from the elements in the preindustrial world. The tree-like forms of Gothic cathedrals bear witness to the early and persistent connection between the forest and deeper beliefs and feelings—such as religion, of course, but also with the spirit of the earth, the spirit that existed before human time began.

A Subtle Chain of Countless Rings

A more modern relation to the forest might be found in American transcendentalism, which found good in nature (and people). In 1836 Ralph Waldo Emerson put forth the keystone of the philosophy in his essay "Nature":

> Within these plantations of God, a decorum and sanctity reign, a perennial festival is dressed, and the guest sees not how he should tire of them in a thousand years. In the woods, we return to reason and faith. There I feel that nothing can befall me

in life,—no disgrace, no calamity (leaving me my eyes), which nature cannot repair. Standing on the bare ground,—my head bathed by the blithe air and uplifted into infinite space,—all mean egotism vanishes. I become a transparent eyeball; I am nothing; I see all; the currents of the Universal Being circulate through me; I am part or particle of God. The name of the nearest friend sounds then foreign and accidental: to be brothers, to be acquaintances,—master or servant, is then a trifle and a disturbance. I am the lover of uncontained and immortal beauty. In the wilderness, I find something more dear and connate than in streets or villages. In the tranquil landscape, and especially in the distant line of the horizon, man beholds somewhat as beautiful as his own nature.[2]

And the essay's epigraph reads:

A subtle chain of countless rings
The next unto the farthest brings;
The eye reads omens where it goes,
And speaks all languages the rose;
And, striving to be man, the worm
Mounts through all the spires of form.[3]

This intimate connection to nature, which also manifested itself in the rejection of some parts of society, took the form of a modest cabin in the woods for Henry David Thoreau. In *Walden; or, Life in the Woods* (1854), he wrote: "For what reason have I this vast range and circuit, some square miles of unfrequented forest, for my privacy, abandoned to me by men? My nearest neighbor is a mile distant, and no house is visible from any place but the hill-tops within half a mile of my own. I have my horizon bounded by woods all to myself."[4] Some might smile at the often luxurious homes

in this volume when thinking of Thoreau's other words from *Walden*: "Most of the luxuries, and many of the so-called comforts of life, are not only not indispensable, but positive hindrances to the elevation of mankind. With respect to luxuries and comforts, the wisest have ever lived a more simple and meagre life than the poor."[5]

And so, many currents underlie the desire to build in the woods, to return to nature, and these run deeper than America's nineteenth-century authors and painters. Whether in Emerson's writing or in James Hilton's story of Shangri-la, there is a view of nature that can be traced, in some sense, back to the founding myths of civilization. It is the story of time before time, when nature and man coexisted in peace, when harmony was the rule. This Arcadian myth, relayed by great artists such as Nicolas Poussin in *Et in Arcadia ego* (1637–38), can be traced to Rome (Virgil's *Eclogues* V) or to Jacopo Sannazaro's poem "Arcadia" (1502), the work that cemented the perception of Arcadia as a lost world of idyllic bliss. Arcadia, yes, but also Paradise Lost.

Cosmic and Physical Laws

Modern architecture has had a varied relation with nature, sometimes embracing it and sometimes razing forests for the sake of concrete and asphalt expanses. One of the most influential builders and thinkers of an "organic" approach to architecture, and thus one that was close to nature, was Frank Lloyd Wright, who wrote in *The Future of Architecture* in 1953:

Change is the one immutable circumstance found in landscape. But the changes all speak or sing in unison of cosmic law, itself a nobler form of change. These cosmic laws are the physical laws of all man-built structures as well as the laws of the landscape. Man takes a positive hand in creation whenever he puts a building upon the earth beneath

the sun. If he has a birthright at all, it must consist in this: that he, too, is no less a feature of the landscape than the rocks, trees, bears, or bees that nature to which he owes his being. Continuously nature shows him the science of her remarkable economy of structure in mineral and vegetable constructions to go with the unspoiled character everywhere apparent in her forms.[6]

The emergence of modernism might seem to be antithetical to this respect for nature, or the desire to be "in" nature; but perhaps the idea of houses with views of the natural world came about first in California with figures such as Richard Neutra, who wrote that his belief in such an integrated architectural landscape "engendered my lifelong inclination to interweave structure and terrain, to bring human habitation into an intimate, stimulating rapport with the expressive processes and cycles of natural growth, and to vivify our everyday awareness of man's inextricable bond with the natural environment. In developing my 'relativity theory,' I resolved that the structural and technical dimensions of design must never be divorced from nature."[7]

Indeed, many of the houses published here participate in what might be called a modern or even a cinematographic vision of nature. Though these houses sometimes have to be reached along forest paths, they are generally viewing platforms, often with outdoor decks, where the rigors of nature often call for great expanses of glass for comfort in the depths of winter or to keep the winds of storm at bay—as though one could see the great movie of what nature used to be from the calm of a fully glazed living room. And this taste for nature or, perhaps, this almost desperate escape to the forest becomes more pronounced and more meaningful as the world devolves with mass extinctions of species and rampant pollution. Here, too, the poet saw the future more distinctly than most:

What are the roots that clutch, what branches grow
Out of this stony rubbish? Son of man,
You cannot say, or guess, for you know only
A heap of broken images, where the sun beats,
And the dead tree gives no shelter, the cricket no relief,
And the dry stone no sound of water.

—T. S. Eliot, *The Waste Land* (1922)[8]

No Footprint, No Waste

It should not be suggested that forest houses considered habitable by the standards of modern comfort must therefore be ecologically unsound. The No Footprint House (pages 230–35, Ojochal, Puntarenas, Costa Rica, 2017), for example, sits very lightly on the ground—as its name implies—in terms of both not disturbing the earth and an efficient system of prefabrication. The architect Oliver Schütte of the A-01 organization insists that this forest house seeks "integral sustainability in terms of its environmental, economic, social and spatial performance."[9] This project is a prototype not necessarily limited to forest construction; it is also capable of functioning in an "off-grid" setting. The Klein A45 house (pages 64–67, Lanesville, New York, 2018), designed by "it" architect Bjarke Ingels of BIG is another prototype that provides minimal floor space (180 square feet or 17 square meters). A riff on the very familiar A-frame house design, A45 is modular in its construction concept and is made with 100 percent recyclable materials. BIG being what it is, this project is also enhanced by a contemporary Nordic feeling through the presence of numerous Danish designers.

The Charlevoix Domes (pages 80–83, Petite-Rivière-Saint-François, Quebec, 2018) by Bourgeois/Lechasseur Architectes confront the issues of sustainability from a different perspective by covering geodesic domes with a gray PVC membrane to better weather the Canadian winter, as well as

to allow relatively easy movement from their location and to permit replication in a rapid, almost industrial manner. With a floor area of just 540 square feet (50 square meters), the Charlevoix Domes cannot be accused of irresponsible expense or use of materials.

Half a world away, the Forest House 02 (pages 186–89, Sóc Sơn, Hanoi, Vietnam, 2018) is somewhat more permanent in its aspect, but for reasons of both ecological impact and cost, it also rests its small 430-square-foot (40-square-meter) area on lightweight columns and minimal concrete anchors. The architect Chu Van Dong emphasizes the openness of the house and its connection to the natural environment, elements that are closer to local building tradition than elsewhere in the world. This is not a house for well-heeled thrill seekers, but a practical and efficient design.

Reclaimed Materials, Limited Budgets

Back in North America, the Inhabit house (pages 96–99, near Woodstock, New York, 2015) by Antony Gibbon has a "chic" appearance that belies the careful attention paid to ecological matters in its construction. FSC-certified wood was used to build the 500-square-foot (46-square-meter) house, which is lifted off the ground and supported at only three points. Not far away in Sullivan County, New York, the Half-Tree House (pages 106–109, 2017) by Jacobschang Architecture measures an even smaller 360 square feet (33 square meters). Entirely off grid, this structure is partially supported by surrounding trees and also by Sonotube concrete footings. The eastern pines used for the house were felled on the property and finished for the exterior cladding with a traditional Scandinavian pine-tar coating.

On the opposite coast, in California, the Lundberg Breuer Cabin (pages 126–31, Sonoma County) is an ongoing project of Olle Lundberg, the owner of the San Francisco firm Lundberg Design. Making extensive use of reclaimed materials or slightly flawed prototypes, the house is a case study in participative construction and design. Continual changes in the structure have been made over the years, and Lundberg's ambition is to make the house a "net-zero energy consumer." Although the escape of an urban dweller to the forest for weekends is not the most significant example of respect for the natural world, there is clearly an intent in this case to destroy the forest as little as possible while living in its protective shade.

The Mylla Cabin (pages 30–35, Jevnaker County, Norway, 2017) is a relatively modest 904-square-foot (84-square-meter) house located near the Nordmarka wilderness. The goal of the architects was to start with the traditional and generally "small and primitive" *hytte* or cabin favored by Norwegians and to make it modern through an unusual pinwheel plan that focuses on certain views. Its extensive use of plywood is in keeping with the limited budget. Small and minimally invasive, given also that the landscape around it has been left undisturbed, the Mylla Cabin is an example of a design that is respectful of both local tradition and the environment to the greatest extent possible. A realistic approach and an awareness of the surroundings serve to make examples such as these acceptable.

The smallest structure in this book is the 64.5-square-foot (6-square-meter) Forest Pond House (pages 50–53, Sway, Hampshire, UK, 2012), which is intended as something of a cross between a pondside place of meditation for adults and a children's playhouse. Built with a timber frame and plywood cladding with one large glass window, the Forest Pond House is not meant to be a residence and thus could not be compared to a certain earlier example on Walden Pond. Yet in its modesty and function, this project by London firm TDO does bring to mind the potential for abnegation that Thoreau sought long ago. It is a place to think or play that is surrounded by nature and does not severely impact the environment.

Making Way for the Cocobolo

Some houses in this book are built close to other residences in environments that do not strictly involve a site in a real forest. These cases can be of interest for their degree of integration, use of material, and respect for the environment. The KGET House (pages 20–23, Ensuès-la-Redonne, France, 2016) by the Marseille architects Bonte & Migozzi is indeed near other houses but on an environmentally sensitive and steeply sloped site. The architects' solution was to use minimally invasive stilts to support the house and replant local vegetation to replace trees that had to be cut down to allow for construction. Using vertical strips of larch for the exterior cladding, a laminated Douglas fir structure and veneered Shinoki ash panels inside, they come as close as possible to giving a natural and discreet presence to a modern house near the sea.

On another seaside site, this time on a cliff overlooking the Pacific, the Cocobolo House (pages 248–53, Montezuma, Puntarenas, Costa Rica, 2016) provides for an existing Cocobolo tree to remain where it was, thanks to an opening in the roof. Passive cooling and a generous use of wood and stone connect the house to this particular site, with the natural presence of the tree further anchoring it on its cliff top. The point here is clearly the view and the dense forest that surrounds the tree on three sides. Although it is decidedly modern in its conception and layout, the house appears to be well integrated into its spectacular site with undue scarification of the natural setting.

Intimate Transparency

Noted Japanese architect Kengo Kuma, who has not built a great deal in the United States, built his Glass/Wood House (pages 116–19, 2010) in New Canaan, Connecticut. It takes on both the natural setting and a rich local architectural history, commenting for example on Philip Johnson's iconic Glass House (1949), which is also in New Canaan. Like Johnson's earlier residence, Kuma's "glass box" is orthogonal, but here it is lifted off a sloping site in the forest, offering what he calls a kind of "intimate transparency." The quasi-cantilever of the house allows it to be entirely glazed while still preserving privacy, something that both Johnson and his sometime partner Ludwig Mies Van der Rohe sought by isolating houses on their sites (like, for example, with the Farnsworth House, Plano, Illinois, 1951). The intimacy here is with the forest—not a distant virgin forest, but a more residential one in a well-known American town.

The Forest Pavilion (pages 212–15, Titirangi, Auckland, New Zealand, 2016) by Chris Tate offers a similar kind of forest intimacy that also makes reference to modernism—specifically that of Richard Neutra in California. Inserted into dense vegetation, the pavilion is slightly cantilevered between the two planes that form the deck and roof. It is almost entirely open to nature, almost fully glazed, and yet also apparently quite private. No houses are in the immediate vicinity, which facilitates the matter of privacy for both Kuma's Glass/Wood House and Tate's Pavilion.

Big but Not Bad

There are also a number of large houses in this book. One interesting and somewhat unusual example is the K-Lagoon (pages 198–203, K-Lagoon, Sasavne, Alibaug, India, 2014), which weighs in at a hefty 22,380 square feet (2,079 square meters). This residence is not so much geared to views as it is to integration into the natural setting. Great care was taken to not disturb the heavily wooded terrain as much as possible, and essentially local materials (stone, wood, and clay tile) were used for construction along with fly-ash blocks that were produced in the region. Care was again taken to respect the traditions of Indian architecture and spaces while still striving for a distinct modernity. Given the location, the

K-Lagoon is clearly meant for frequent outdoor living, in a kind of privileged communion with nature.

The Oak Pass Main House (pages 156–61, Beverly Hills, California, 2015) by the Walker Workshop is another case of a luxurious and large house (8,000 square feet or 743 square meters). No fewer than 130 trees on the property were carefully protected during construction, and stepped terraces and a green roof further integrate the construction into its sloped, forested site in a quasi-urban area above Los Angeles. The lines and materials of the house are not excessive in any respect; they are relatively discreet and harmonious.

Protecting What Is Left

In recent years, more and more attention has been paid to the protection of the natural environment when houses are built in forested environments, which is all well and good considering the high demand for this kind of residence. Though some houses like the Cocobolo or KGET simultaneously offer views of the sea in a wooded environment, most of the forest houses in this book are not focused on distant views but rather on closer, more intimate ones, as Kuma might say. There is a real desire on the part of clients and surely also for some architects to become immersed in what is left of the fast disappearing natural world. Relying on the good motives of builders and clients, though, may not be sufficient to protect forests from undue construction. No matter its design, a house tends to create pollution, both during construction and when it is used. Net-zero energy use is often more a stated goal than a reality, and clients who want air conditioning and winter heating risk further contaminating nature.

Forests are of course not the only natural settings that are popular for private house construction—beaches and mountains are also much sought after. Almost every country or region has regulations of variable efficiency and enforcement that regulate construction in natural environments. It might be of use for the architectural profession itself to set down some rules or regulations that permit construction in forests, for example, but only under strict environment regulation. Fortunately—or intentionally—most of the houses here do engage in dialogue with their sites and exhibit respect for the living world. An interesting way to view these houses is to try to understand which are the most (or the least) respectful of the forest. Few heed the still-radical words of Thoreau regarding luxury, but one day his injunction that "the wisest have ever lived a more simple and meagre life than the poor" may ring true. A house in the forest should seek to reconcile its residents with the natural world without damaging it. It is urgent to be careful and to act responsibly before what little is left of Paradise is truly lost.

Notes
1. John Milton, *Paradise Lost* (1667).
2. Ralph Waldo Emerson, "Nature" (1836).
3. Ibid.
4. Henry David Thoreau, *Walden; or, Life in the Woods* (Boston: Ticknor & Fields, 1854).
5. Ibid.
6. Frank Lloyd Wright, *The Future of Architecture* (New York: Horizon Press, 1953).
7. Richard Neutra, in *Nature Near, Late Essays of Richard Neutra,* ed. William Marlin (Santa Barbara, CA: Capra Press, 1989).
8. T. S. Eliot, *The Waste Land* (1922).
9. Oliver Schütte, email to author.

VALLEY VILLA
RAGUVA, LITHUANIA

Arches / 2016

The Valley Villa is essentially finished with pine prepared using the Kebony system developed in Norway, "an environmentally friendly, patented process that enhances the properties of sustainable softwood." The wood panels were attached using stainless steel profiles and plastic holders. Black shale was employed for the lower parts of the volume. Built in a regional park on the site of a former wooden farm building, the house seeks to echo characteristics of traditional Lithuanian houses in contemporary ways—such as the wood finish, a double pitched roof, and a stone foundation. All existing trees on the site and the original slope of the land were preserved, meaning that the ground floor is partly inserted into the slope. All the main interior spaces open into courtyards or the exterior. The overhanging wood-clad upper level creates a covered terrace. The ground-floor windows are partially covered with vertical wooden slats that serve to protect the house from direct solar gain. The floor area of the house is 4,467 square feet (415 square meters). It is surrounded by green lawns and the forest. The firm Arches, whose co-owners are Rolandas Liola, Arūnas Liola, and Edgaras Neniškis, was created in Vilnius, Lithuania, in 1993.

Opposite: Set in a forest clearing, the house blends into the site all the more because of its wood cladding. Its presence is both modest and appropriate. **Following spread, left:** The interior of the house is suited to the exterior, with a marked presence of wood and a willful expression of the desire to fit into the location to the greatest extent possible. **Following spread, right:** Floor plans for the house show that all main spaces open directly to the exterior. The overhanging upper volume creates protected spaces below.

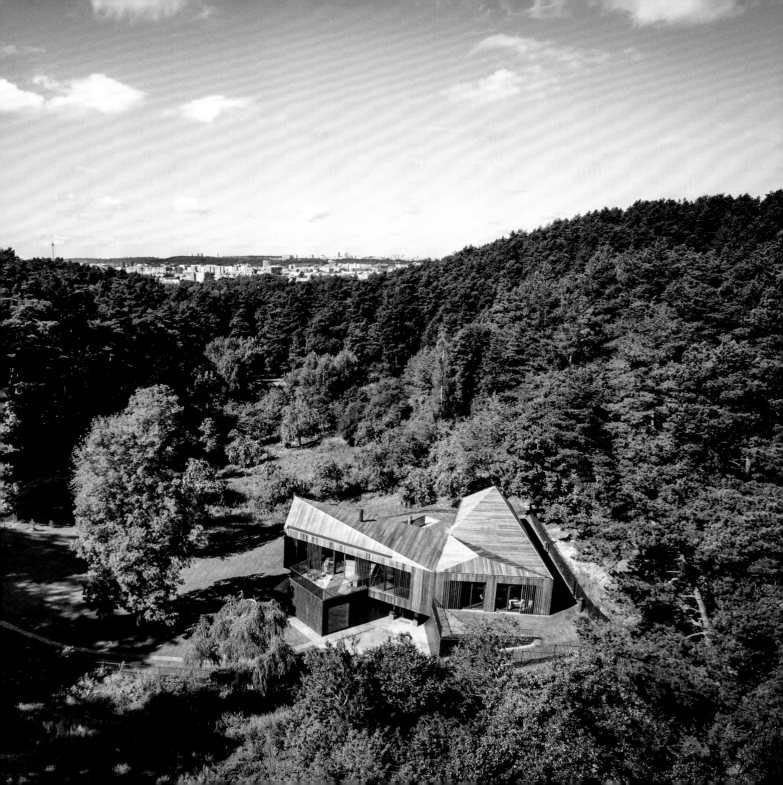

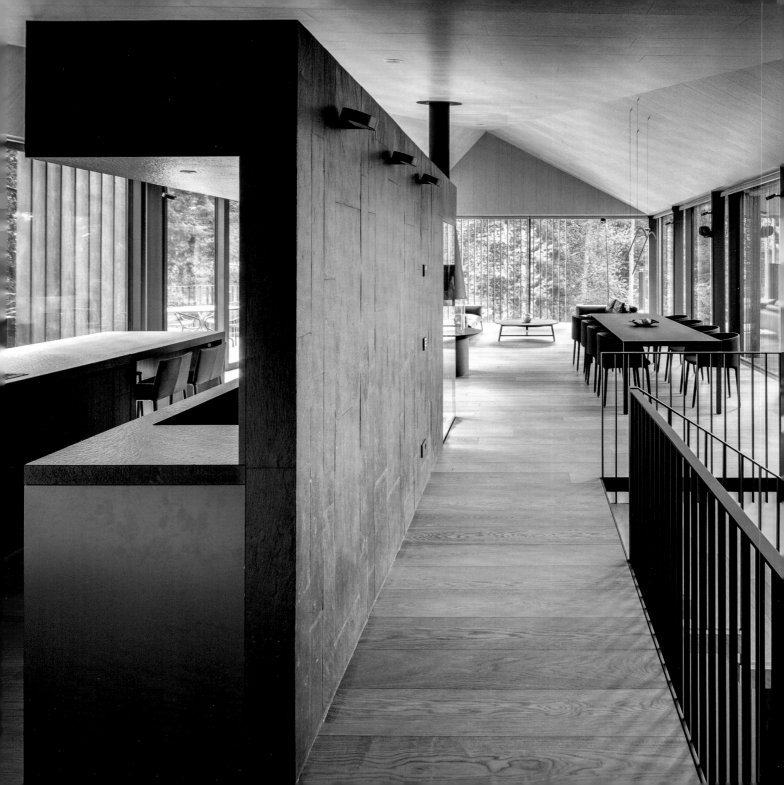

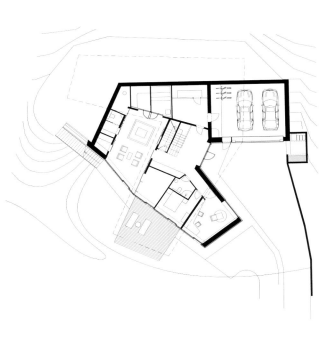

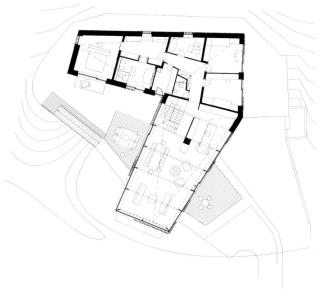

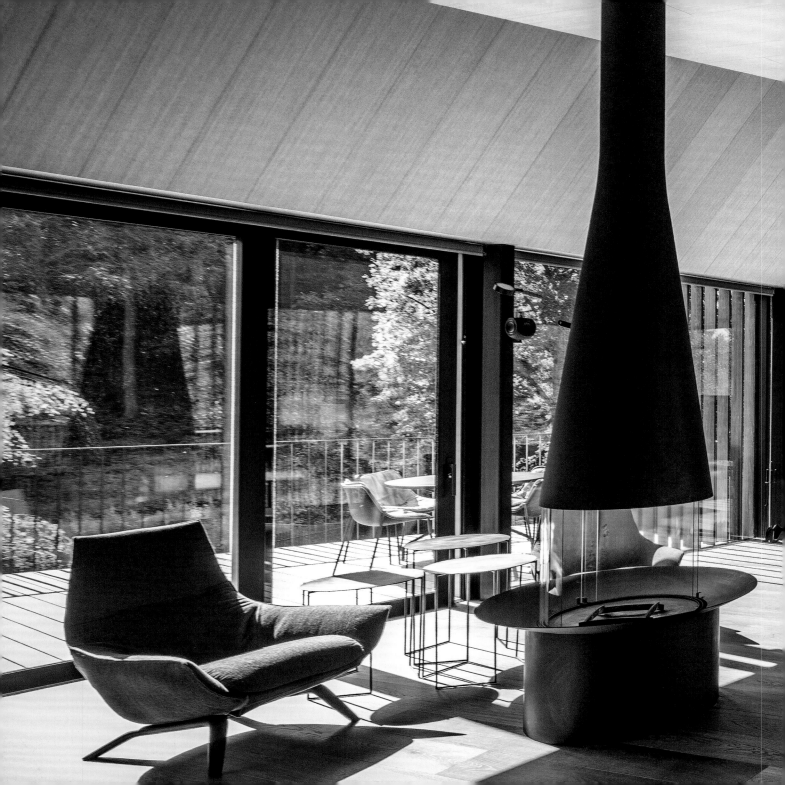

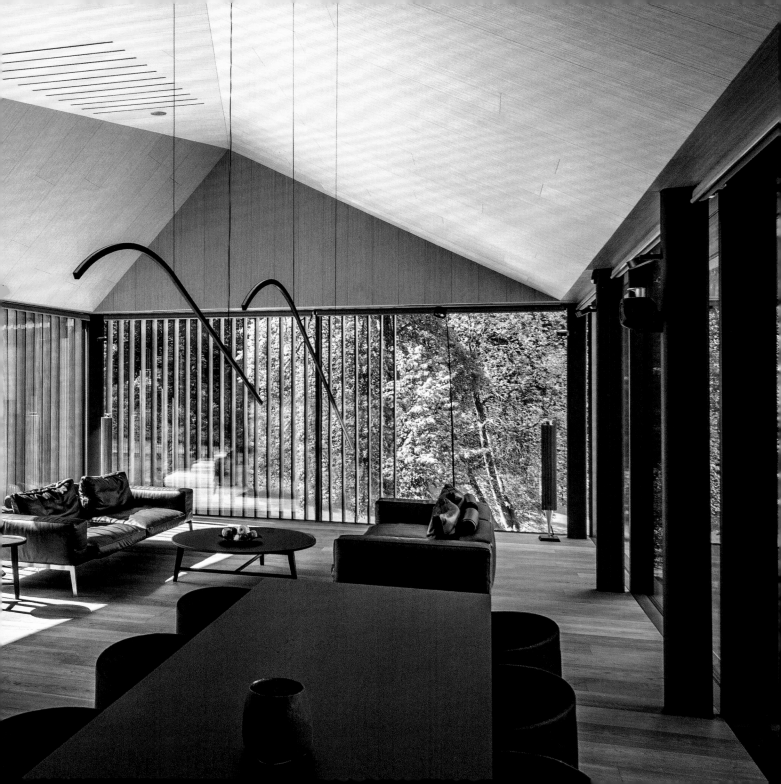

KGET HOUSE
ENSUÈS-LA-REDONNE, FRANCE

Bonte & Migozzi Architectes / 2016

Ensuès-la-Redonne is in the Bouches du Rhone area of France, about nine miles from Marseille. This house was built on a restricted 8,500-square-foot (785-square-meter) sloped and triangular site. The architect Christophe Migozzi compares the design to a contemporary version of "Ulysses's vessel that surfs on a slope like a crab trawler." The only solution to build on the site was to set the house on minimally invasive stilts and to reduce any leveling to a minimum. The trees that had to be cut down during construction were replaced with fig and eucalyptus, along with Vibrunum shrubs, opuntia cacti, and phormium evergreens. The architects worked with local landscape firm MM on the replanting with the intention of making the new house blend into the landscape as much as possible. The structure of the house is in laminated Douglas fir and the exterior cladding is in vertical strips of larch that were painted white. The house has two stories, with the living room and kitchen on the ground level and two bedrooms above. The interiors are finished with veneered Shinoki ash panels.

Above and opposite: The house sits lightly on the protected and sloped site that looks down on the Mediterranean Sea and the rugged shoreline near Marseille. **Following spread, left:** The protected upper-level deck is partially shaded by the wooden slat frame. Interior and exterior flow into each other without visible interruption. **Following spread, right:** The front facade of the house as seen from the seaside gives a hint of the delicate balance on stilts to which it owes its presence on this site. Plans show the projecting upper level above the smaller ground volume.

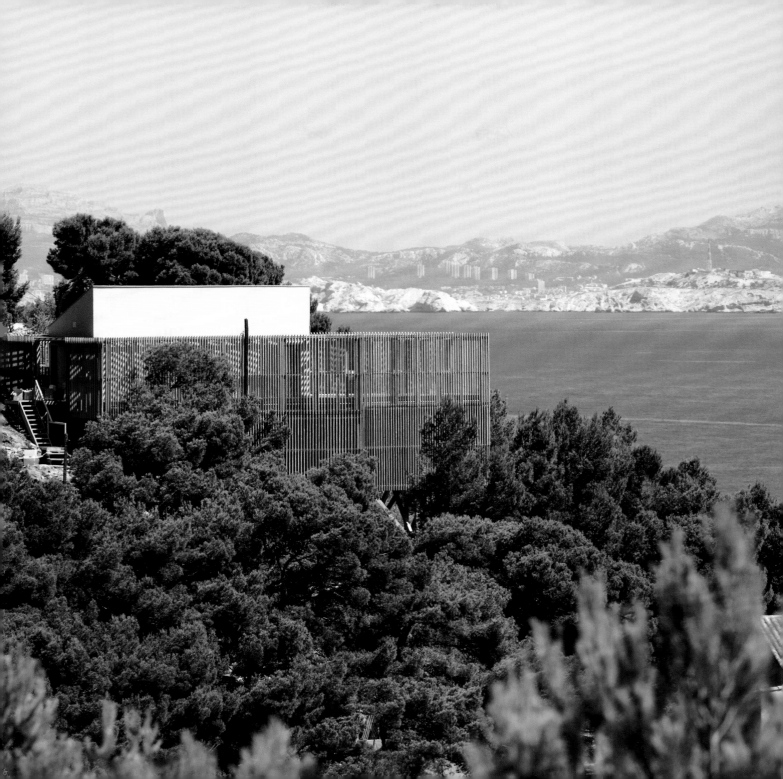

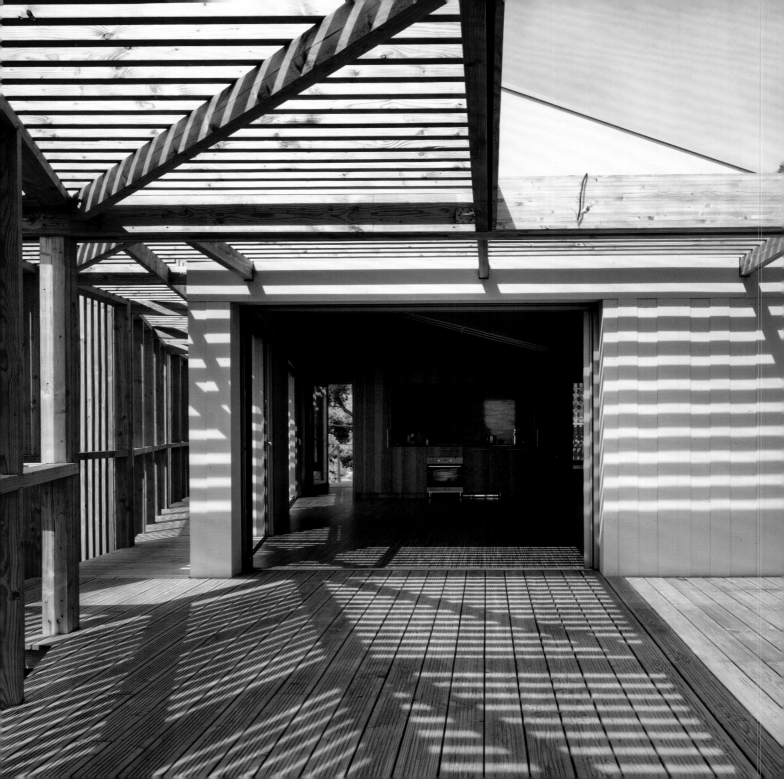

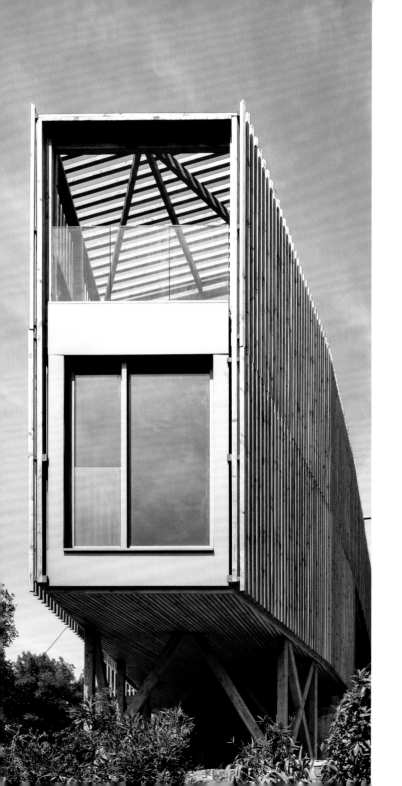

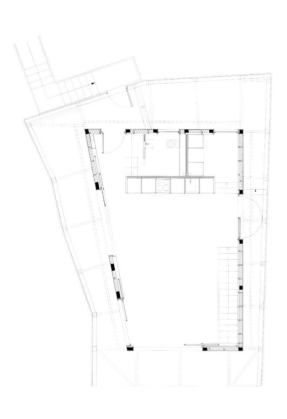

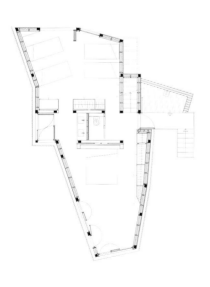

CASA MYHRER HAUGE
SØRBRÅTEN, MARIDALEN, OSLO, NORWAY

Gudmundur Jonsson Arkitektkontor / 2018

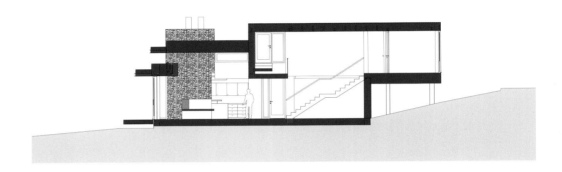

Regulations prohibited construction within 328 feet of a stream near the site for this house, but the architect decided that the stream should be part of the design. He states that because of the "wish to enhance the importance between the stream and the project, the garage and the house are connected with a bridge floating over the landscape." The idea of a bridge is used inside the house as well, in the division of the private and public areas of the structure, generating a roof terrace that offers views of the Maridalen forest. The rear part of the house is lifted off the ground on stilts "in dialogue with the tree trunks." Built on a 34,423-square-foot (3,198-square-meter) site, the house has a floor area of 3,498 square feet (325 square meters) including a garage. Steel, concrete, and wood were the main materials for the ground floor, with wooden construction and plaster surfaces for the upper level and garage. The design is essentially rectilinear with the exception of a rounded wall to the rear of the residence where technical elements are housed.

Opposite: The glazed living space looks out to the snowy site. A band of clerestory windows brings more light inside, where white surfaces are contrasted with dark wood paneling. **Following spread, left:** A rough stone chimney recalls the rugged nature outside in the midst of an otherwise smooth, modern environment. **Following spread, right:** Spare furnishings allow the surfaces of the walls, floors, and ceilings to play off one another, somehow participating in the forest landscape visible in the distance.

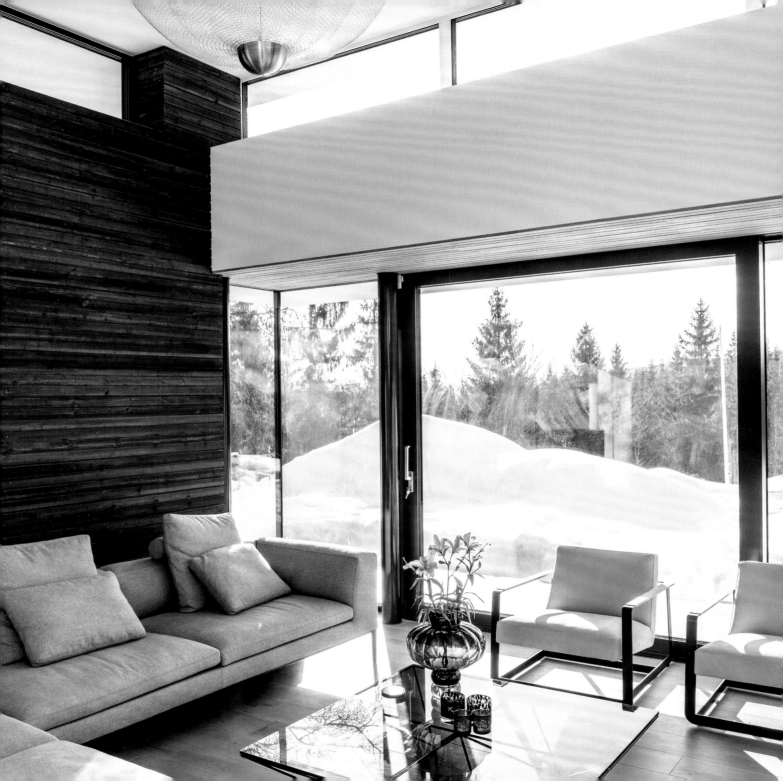

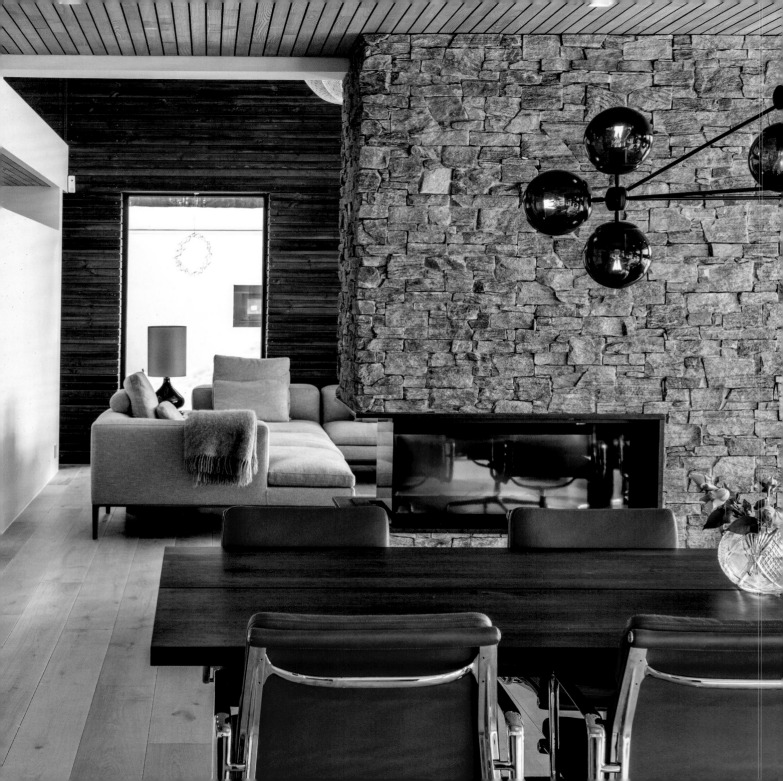

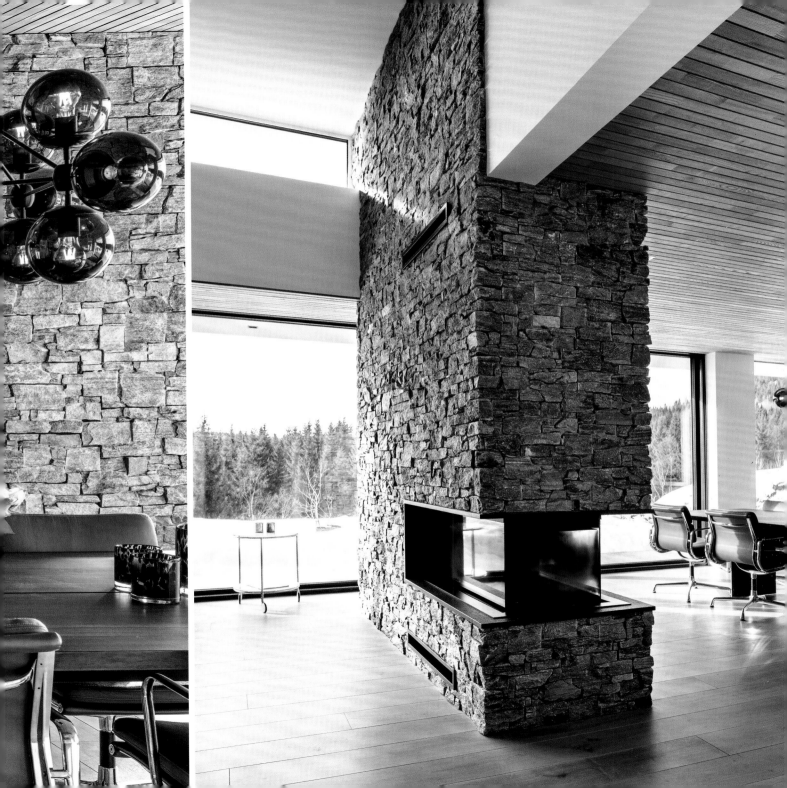

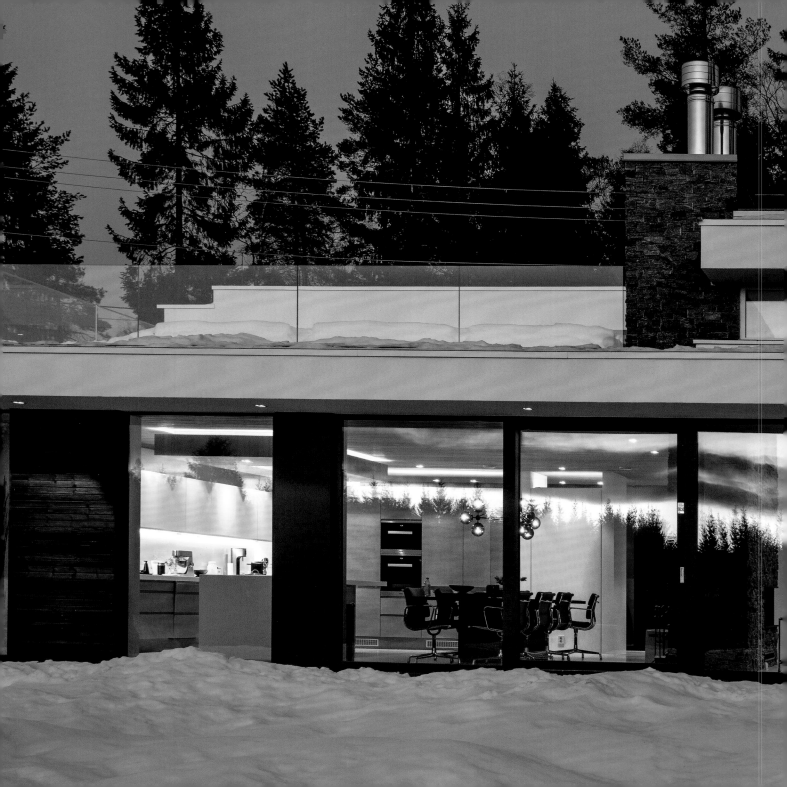

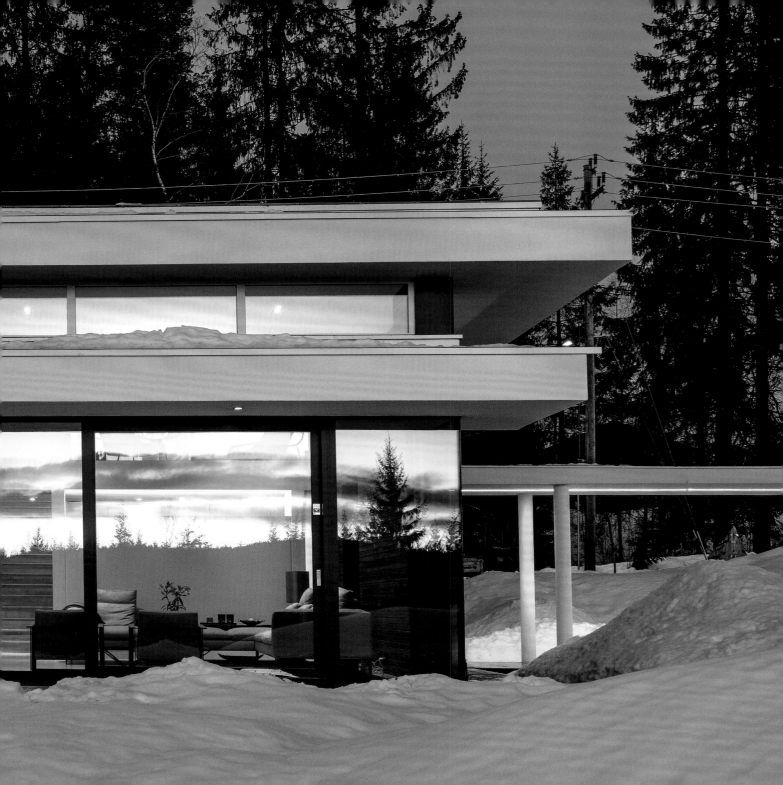

MYLLA CABIN
JEVNAKER COUNTY, NORWAY

Mork-Ulnes Architects / 2017

Located an hour drive north of Oslo, where its American owners live, the 904-square-foot (84-square-meter) Mylla Cabin is situated on a hilltop at the northern edge of the Nordmarka wilderness area. Clad in untreated pine siding, the house has a "pinwheel" plan, "which radiates into the landscape to both frame four distinct views—Mylla Lake, the rolling hillside, the sky, and a towering forest—and to form wind- and snow-sheltered outdoor patios." The architects sought to rework the traditional Norwegian hytte (cabin) design. As they explain, these structures tend to be "small and primitive" with limited amenities. The goal was to make the structure more expansive and generous, with three bedrooms and two small bathrooms, while connecting closely to the landscape and yet maintaining a functional and compact structure. The expansive nature of the interior is emphasized by ceilings that are between eight and fourteen feet high. Working with a local building code that requires a gable roof, the architects "were able to split the gable in half to create four shed roofs." Interiors are covered in pine plywood treated with lye and white oil. Most of the furnishings are custom plywood designs. The project budget was a modest $320,000.

Opposite: The simple cabin design offers some unexpected variety in the angles of its roof. Vertical wood cladding echoes the presence of the surrounding trees. **Following spread, left:** The light wood cladding of the exterior is in harmony with the interior, where the ceilings echo the variety in the exterior form of the roof. **Following spread, right:** The plan is a cross with bedrooms diagonally placed and the central volume devoted to the compact social spaces.

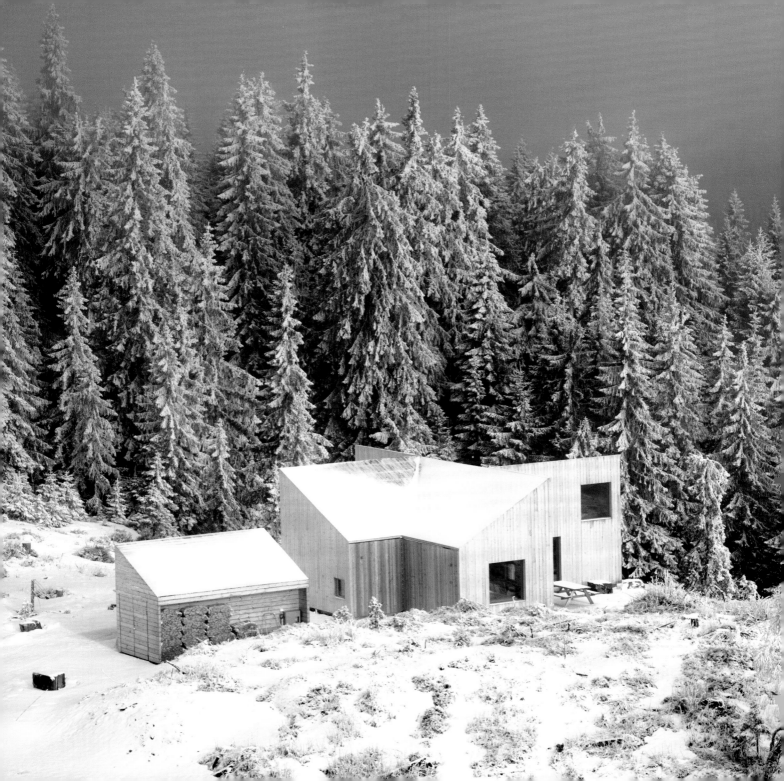

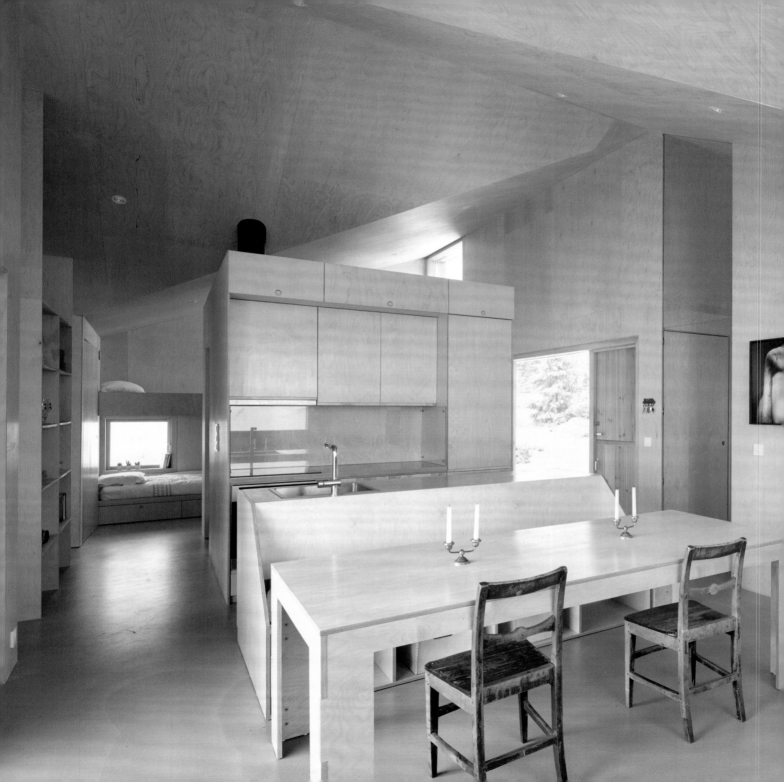

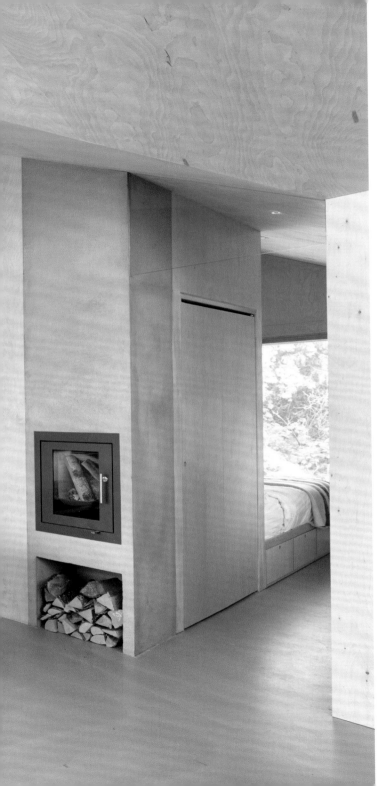
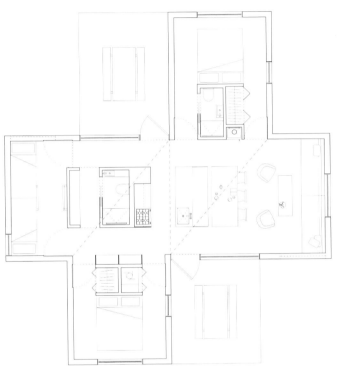

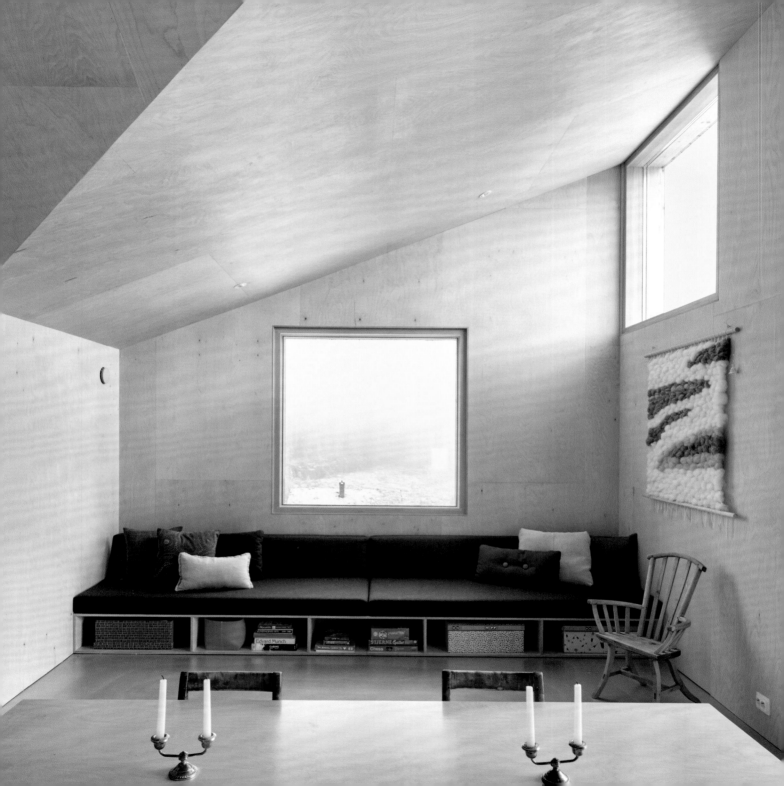

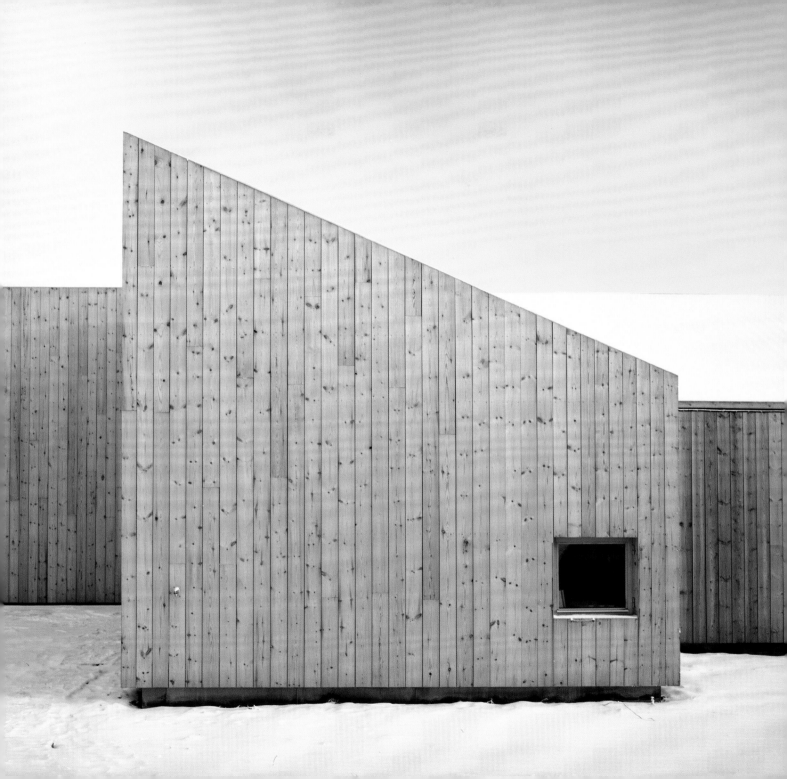

FRILUFTSSYKEHUSET OUTDOOR CARE RETREATS OSLO AND KRISTIANSAND, NORWAY

Snøhetta / 2018

Designed for the Friluftssykehuset Foundation, these wood shelters located near major hospitals in Oslo and Kristiansand "offer visitors a physical and psychological respite from stringent treatment regiments and the isolation that often follows long-term hospitalization." The Oslo facility is close to Oslo University Hospital, Rikshospitalet, the largest hospital in Norway. The second location, close to the Sørlandet Hospital Kristiansand is in the south of Norway. These projects began their development with the Department of Psychosomatics and CL-Child Psychiatry at Oslo University Hospital. One of the initiators of the project, child psychologist Maren Østvold Lindheim, explains: "Nature provides spontaneous joy and helps patients relax. Being in natural surroundings brings them a renewed calm that they can bring back with them into the hospital. In this sense, the Outdoor Care Retreat helps motivate patients to get through treatment and contribute to better disease management." The subdued 377-square-foot (35-square-meter) shelters are open to all patients in the hospitals through a booking system. The wooden structures are intended to become gray with time. They are designed in the form of "asymmetrical branches" and take their inspiration in part from children's tree houses.

Opposite: The modest, slanting structures in some sense reflect the surrounding forest land, giving residents a generous view of their environment. **Following spread, left:** Wooden floors, walls, and ceilings give way to large windows that emphasize the forest setting. **Following spread, right:** Built-in furniture adds a touch of colorful cushions, but the real variety is to be found by looking out the windows.

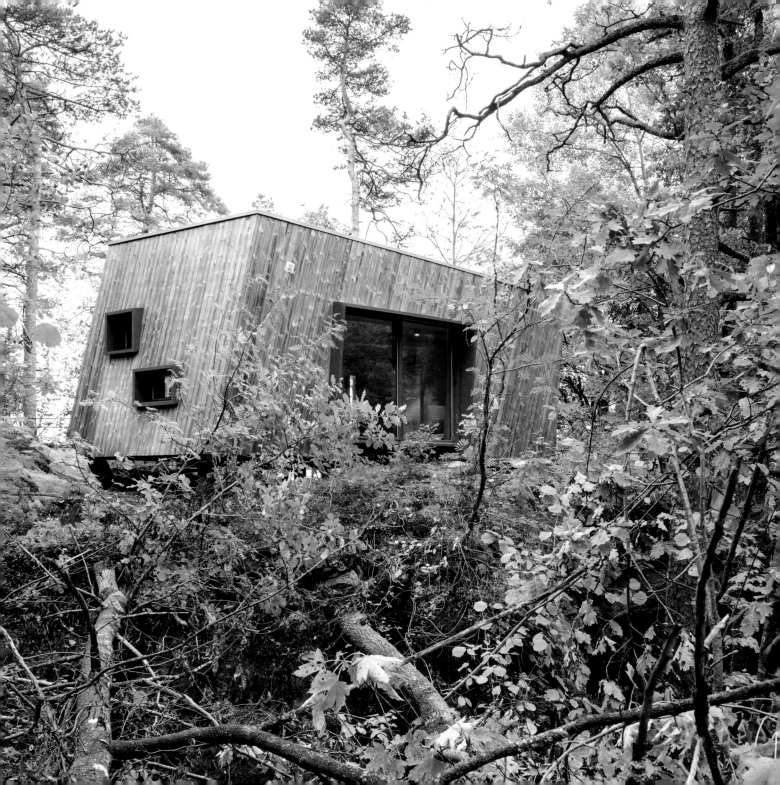

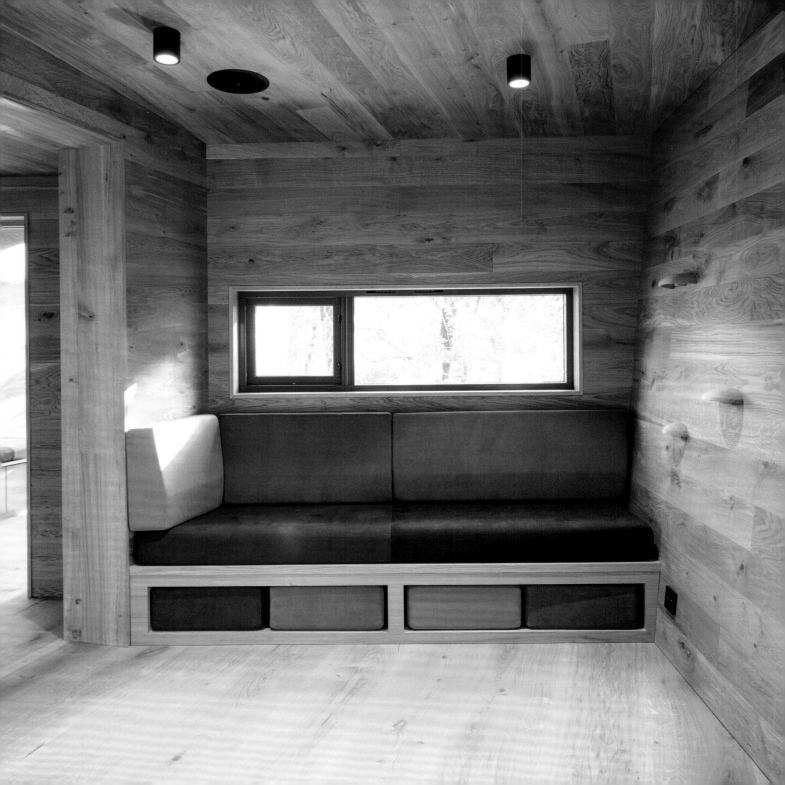

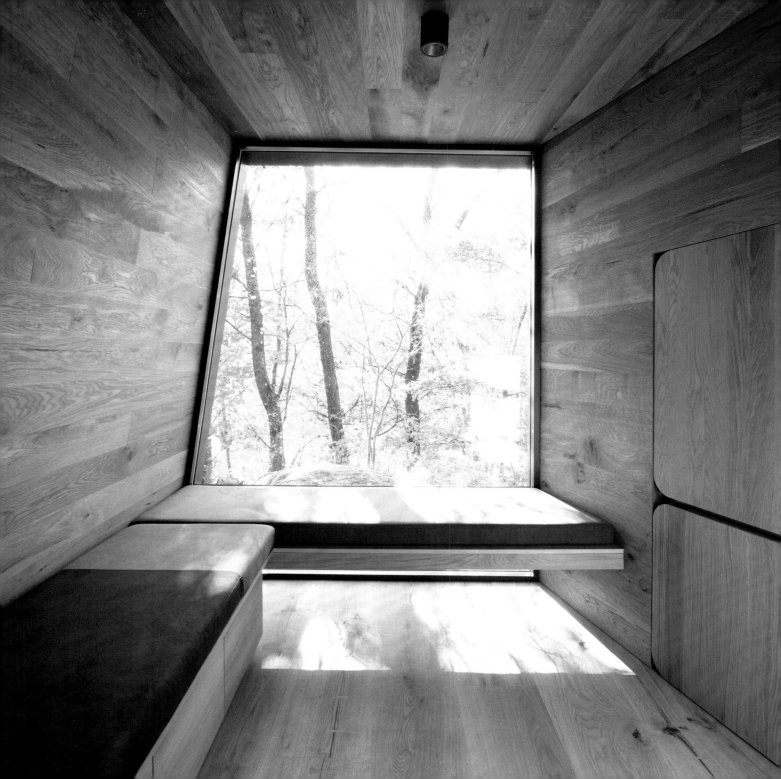

CABIN K
LAKE SAIMAA, VARKAUS, FINLAND

Studio Kamppari / 2016

Cabin K was built on a granite ridge overlooking the forest near Finland's Lake Saimaa. One of the priorities of the construction was to disturb the site as little as possible. Measuring just 600 square feet (56 square meters), the cabin was built for a budget of $135,000. No less than 15 percent of this budget was dedicated to the windows and doors, which are made with Finnish pine at the request of the client. Glue-laminated pine logs were prepared off-site and put on minimal post foundations with a crane. Wood inside the house was left untreated, and the exterior walls were treated with traditional rautavihtrilli (iron oxide), which accelerates graying of the wood. A double-height living room has oversized operable windows on the north and south sides, creating a real connection between interior and exterior during the warm months. Large bedrooms are located at either end of the rectangular house, and a small loft space can be reached through a slotted floor in the living area. Educated in the United States, the Finnish architect of the project, Sini Kamppari, previously worked with Olson Kundig, Miller Hull, and Cary Bernstein Architect in the States. She is currently based in Seattle.

Opposite: The strictly rectangular cabin with its double-sloped roof immediately evokes simplicity, and vertically placed wooden cladding creates a link with the surrounding forest. **Following spread, left:** A modest wooden deck offers an opportunity to view the natural environment, including the nearby lake. **Following spread, right:** Inside and outside are linked by the continual presence of wood and trees, and also by the generous glazing that allows residents to see nature without experiencing its rigors.

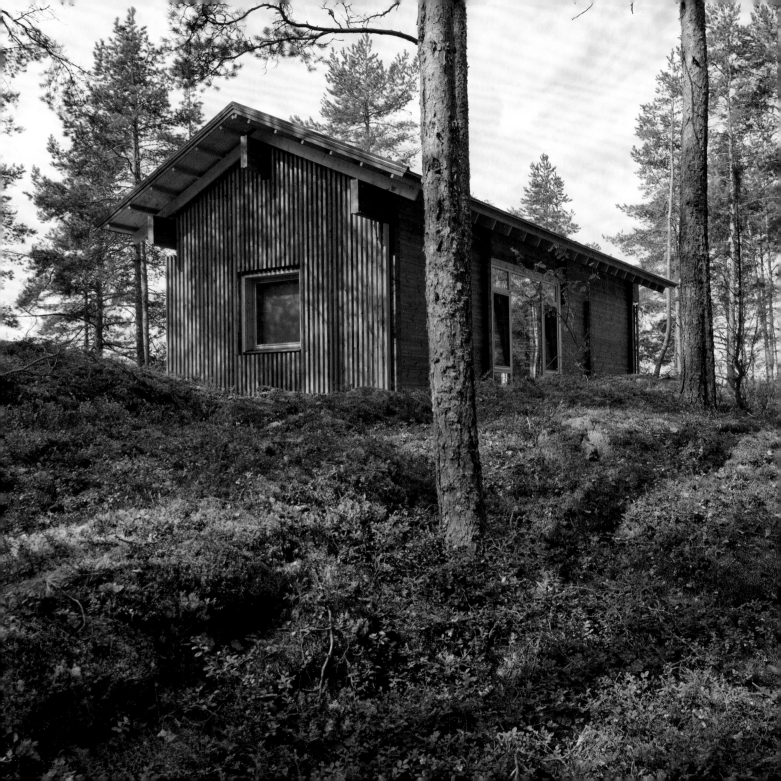

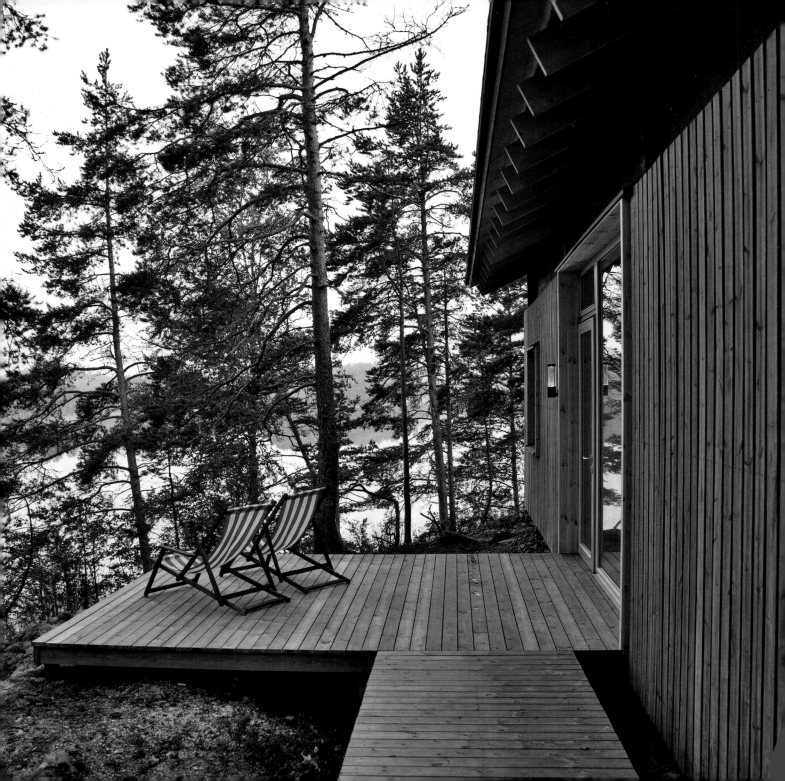

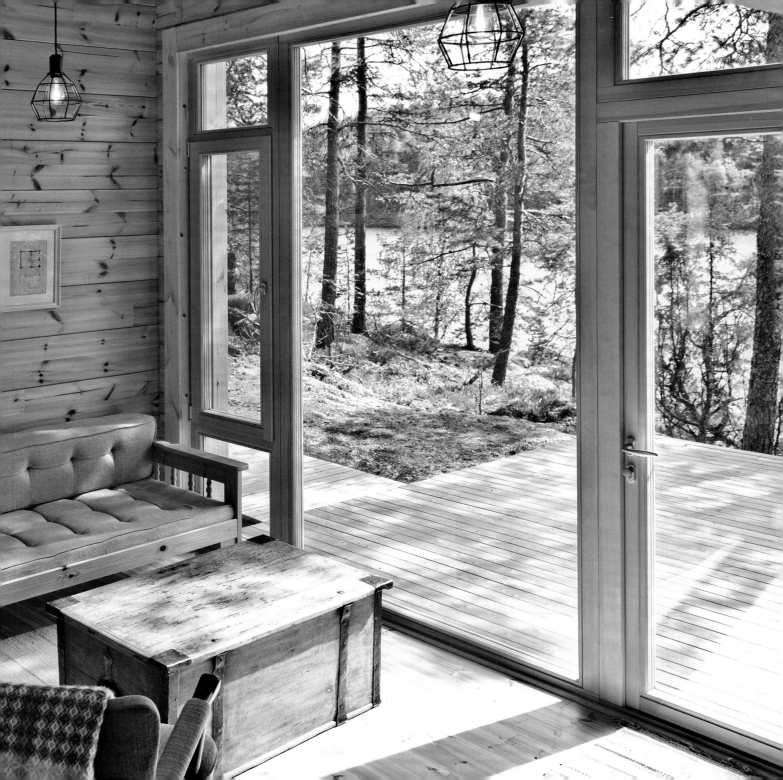

WOODEN HOUSE
KANJI DOL, SLOVENIA

Studio Pikaplus / 2015

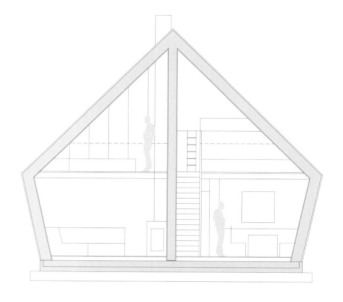

The 883-square-foot (82-square-meter) Wooden House was selected as the Best Wooden Structure in Slovenia in 2016. Although designed to resist inclement weather, the interiors of the house are meant to create an "internal environment replicating the sensation of being outdoors." Located at the edge of the forest, the house was positioned to avoid unduly disturbing the site. All of the spaces in the house with the exception of the bathroom face the generously glazed front. The living and dining space, the kitchen, and the bathroom with sauna are on the ground floor, with two bedrooms upstairs, overlooking the rooms on the ground floor via glass railing. The smaller of the two bedrooms has custom-built bunk beds. The light-colored wood interior finishes contrast with the protective wrapping black metal exterior shell. Some interior details like the black steel sink, stove, refrigerator, and stairway recall the external roof and lateral wall cladding.

Opposite: A dark overarching exterior yields to the much more open wooden heart of the house that allows residents to fully take in the setting. **Following spread, left:** Light wood interior cladding and spaces that interpenetrate each other, such as the balcony with a glass barrier, give an impression of generous space. **Following spread, right:** The plan of the house is square and rigorous, with the bedroom upstairs and the living and dining spaces below.

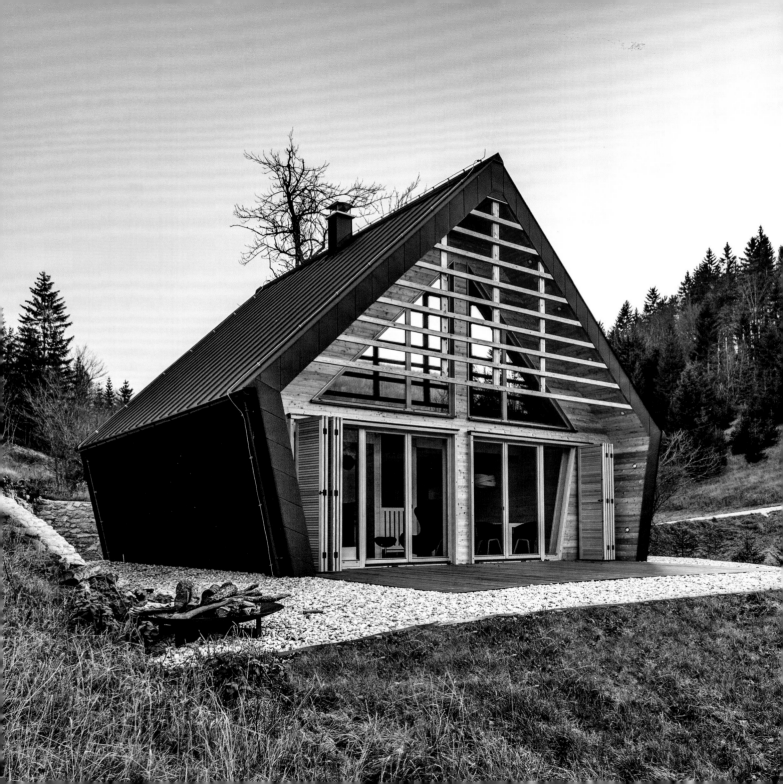

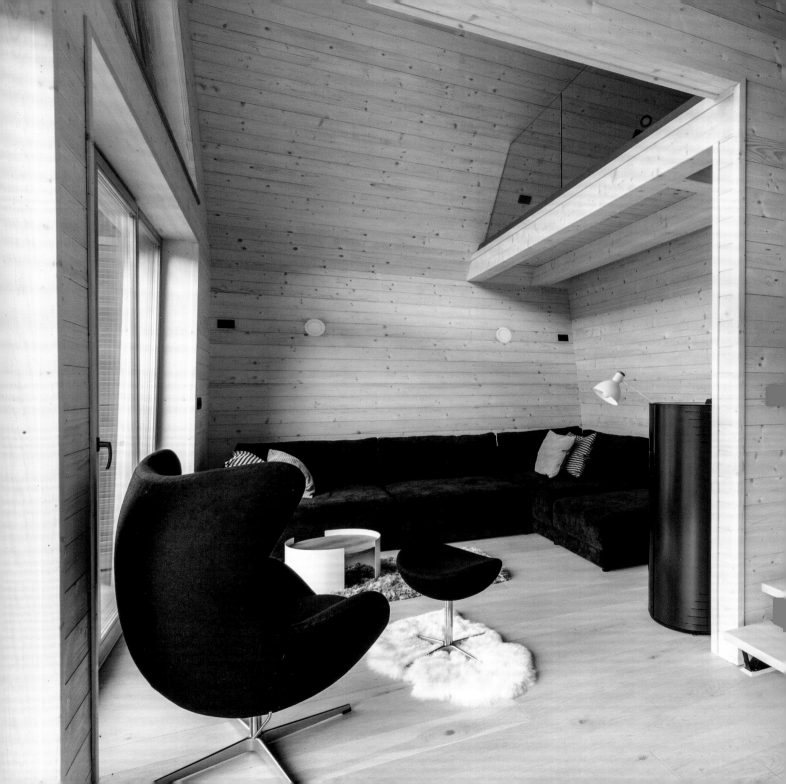

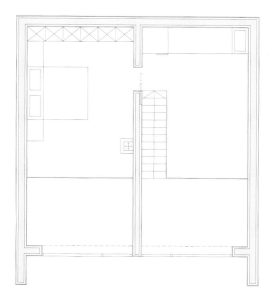

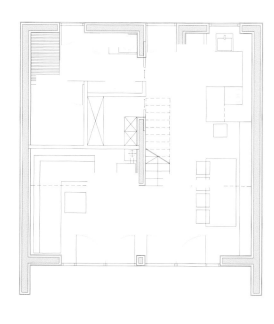

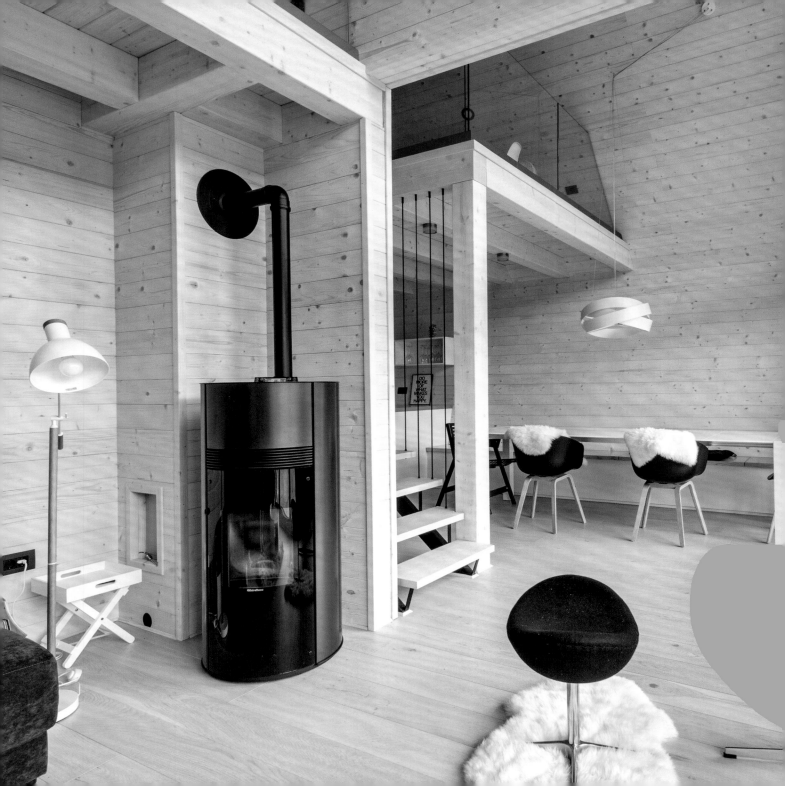

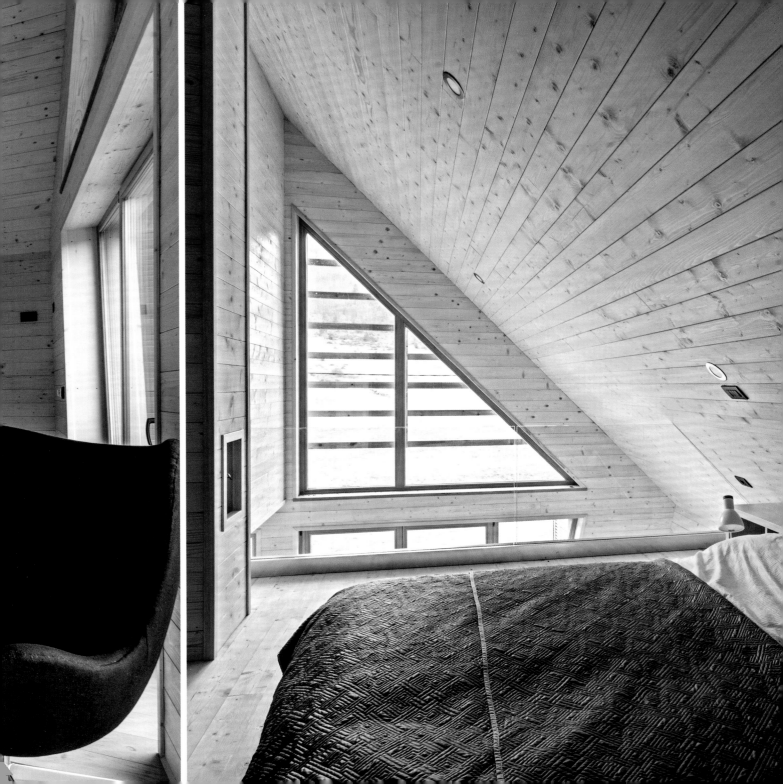

FOREST POND HOUSE
SWAY, HAMPSHIRE, UK

TDO / 2012

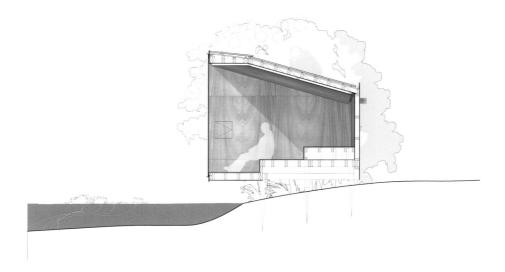

This tiny 64.5-square-foot (6-square-meter) house or pavilion was built by the founding partners of TDO (Tom Lewith, Doug Hodgson, and Owen Jones). The "experimental structure to test ideas of form and materiality" was erected over a twelve-month period because the partners could only work on it during weekends and holidays; at the time they were setting up their architectural practice in London. They estimate the actual construction period at twenty days. Used as a space for meditation and a children's den, the small timber frame structure is finished in plywood and painted black on the exterior. It is cantilevered over a pond in a 9,418-square-foot private family garden. The architects state, "The Forest Pond House combines contrasting surroundings and contrasting uses to striking effect. It nestles between the dark drama of the forest and the bright calm of the water." Aside from the wood used in this unusual configuration, a large sheet of glass closes the surface at the side of the pond. The structure combines a rising floor with a falling ceiling, to accommodate the size of a child at one end, and an opening toward the pond, creating "a place for reflection."

Opposite: The structure surely resembles a woodland pavilion more than a house. It is meant to allow for the contemplation of nature. **Following spread:** The structure can be seen as a tunnel, with openings at the entrance and on the pond side, where a view of the natural setting appears. The irregular geometry and the contrast between the black door frame and the lighter wooden surfaces are seen in these images.

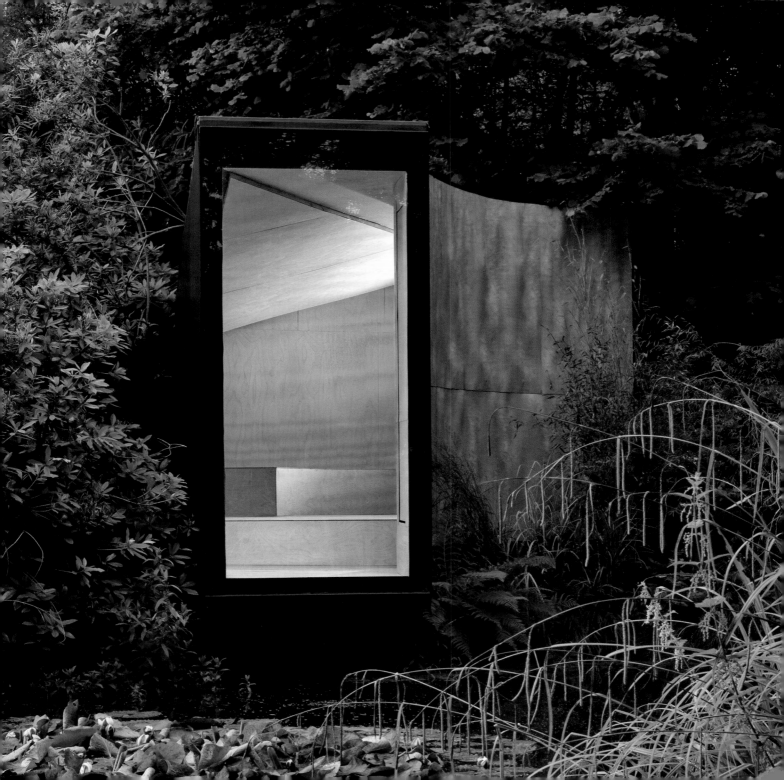

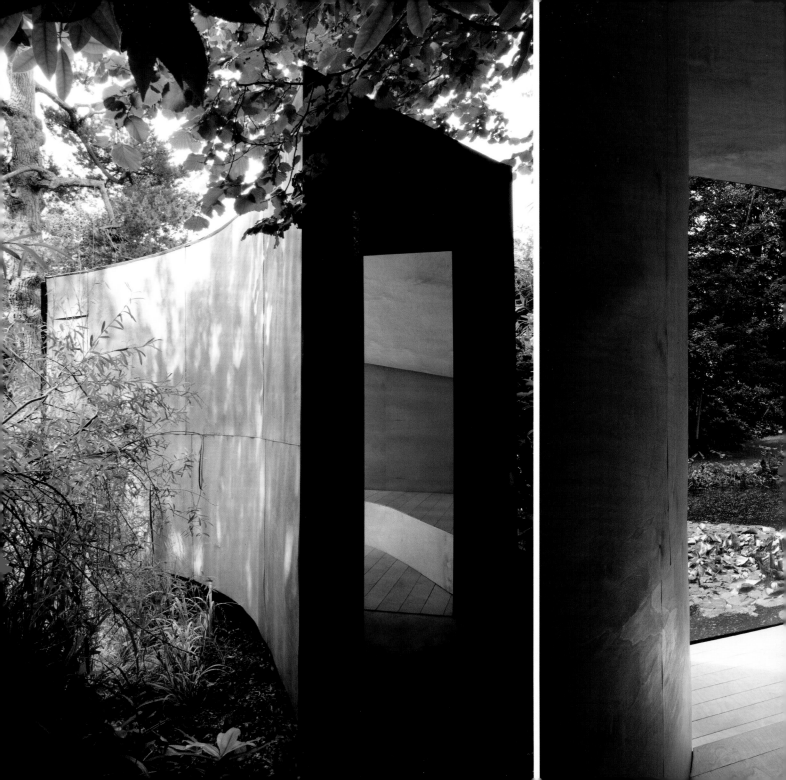

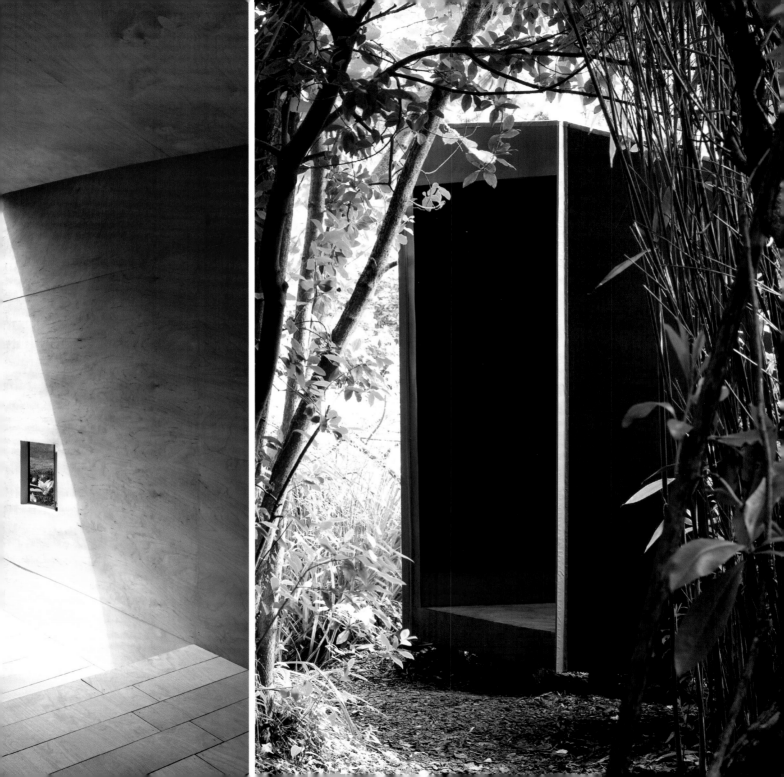

FOREST RETREAT
CENTRAL BOHEMIA, CZECH REPUBLIC

Uhlik architekti / 2013

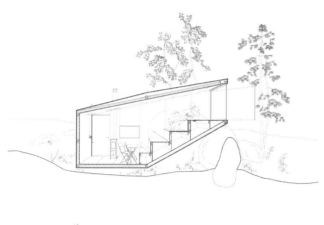

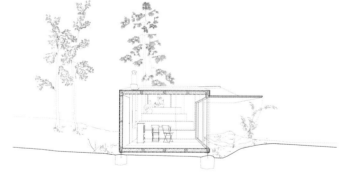

Another very small pavilion, the 172-square-foot (16-square-meter) Forest Retreat was designed as a "hideaway" for a Prague-based client with a demanding job. The client brought the architects to a place near where he spent his childhood, "in the midst of fields, woods, and meadows, full of strange boulders, to a remote and somewhat forgotten place," explains Petr Uhlik, and the architects decided that they could not refuse the commission. Calling on local craftsmen and using wood from a nearby forest, they designed an "object" that rests on a large boulder, with a charred wood exterior. The interior consists in a single ten-by-nineteen-foot space. A glazed surface provides a generous view, and steps can be used to rest or sleep. A storage space opens to reveal a double bed. Oriented strand boards were used inside the building to reinforce it in a cost-efficient manner. An asphalt roof and some steel elements made by a local blacksmith complete the simple structure, which was built by the architects between fall 2012 and spring 2013.

Opposite: The way the Forest Retreat leans on a boulder emphasizes both its incongruity and its connection to an unusual forest location. **Following spread, left:** A propped-up panel of the structure itself is opened to allow the owner to contemplate the forest. **Following spread, right:** Inexpensive materials and a wood-burning stove allow for a conjunction of economy and proximity to nature.

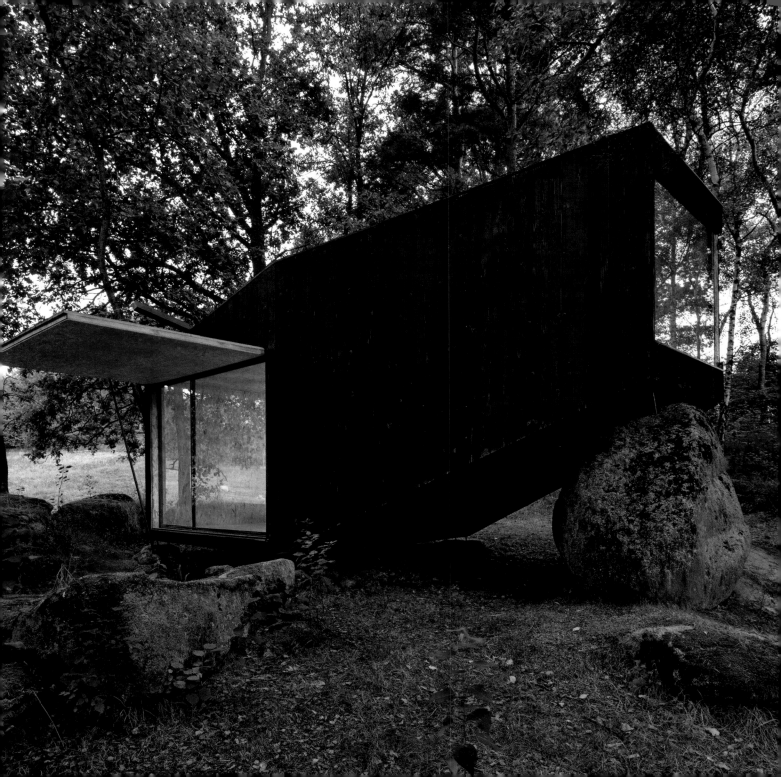

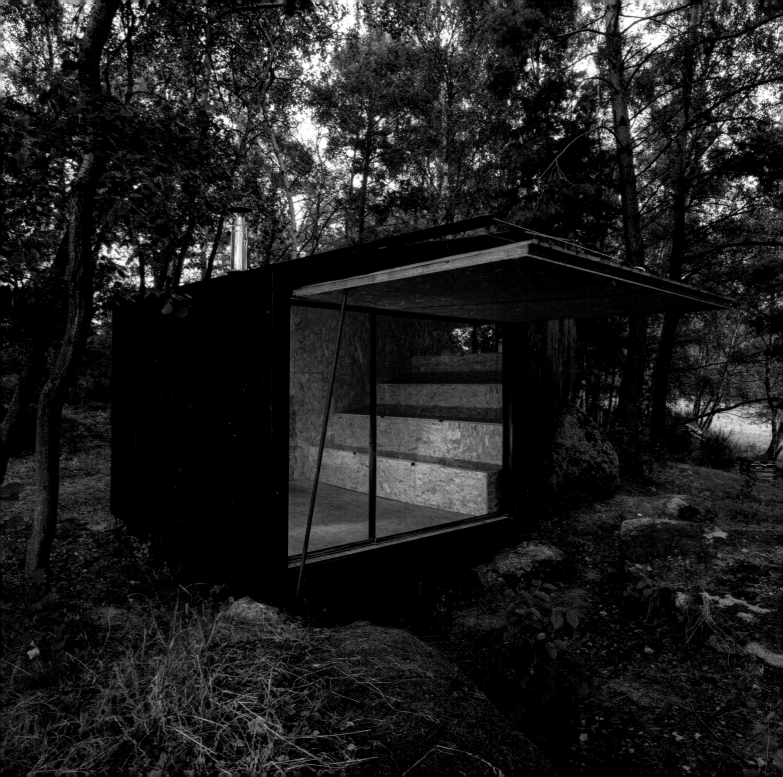

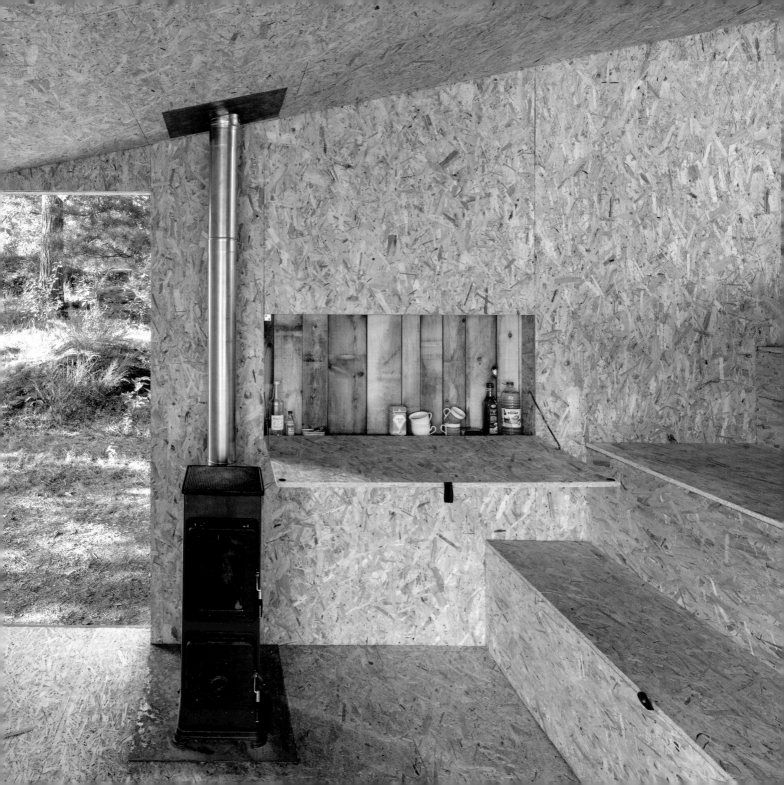

CABIN ON FLATHEAD LAKE
POLSON, MONTANA

Andersson-Wise Architects / 2007

Polson is located in northwestern Montana on the southern shore of Flathead Lake. This small 600-square-foot (58-square-meter) cabin is set on a granite and shale cliff overlooking the lake. Its site is known to be an excellent place to observe eagles, ospreys, and tall ponderosa pines. The open-plan ground floor includes the kitchen, the living room, a bedroom, and a bathroom, with an outdoor shower and deck as well. The visible surfaces of the house are in wood paneling and slats. Set off the ground on six steel piers, the building seeks to have the least possible impact on the natural setting. The cabin has no heating or cooling system and running water is pumped from the lake below. Although the finishing appears to be spartan, the house is a comfortable refuge that allows for a spectacular site to be viewed from behind the generous glazing or from the deck of the house.

Opposite: Were it suspended from trees, this cabin might better be called tree house, but despite its small size it does assume the conventions of an architectural object that sits lightly on the forest floor. **Following spread, left:** With its broad glazing, the interior of the house opens almost entirely to the forest setting. **Following spread, right:** A plan shows the rectangular simplicity of the design, with the enclosed space at the center in continuity with the external deck.

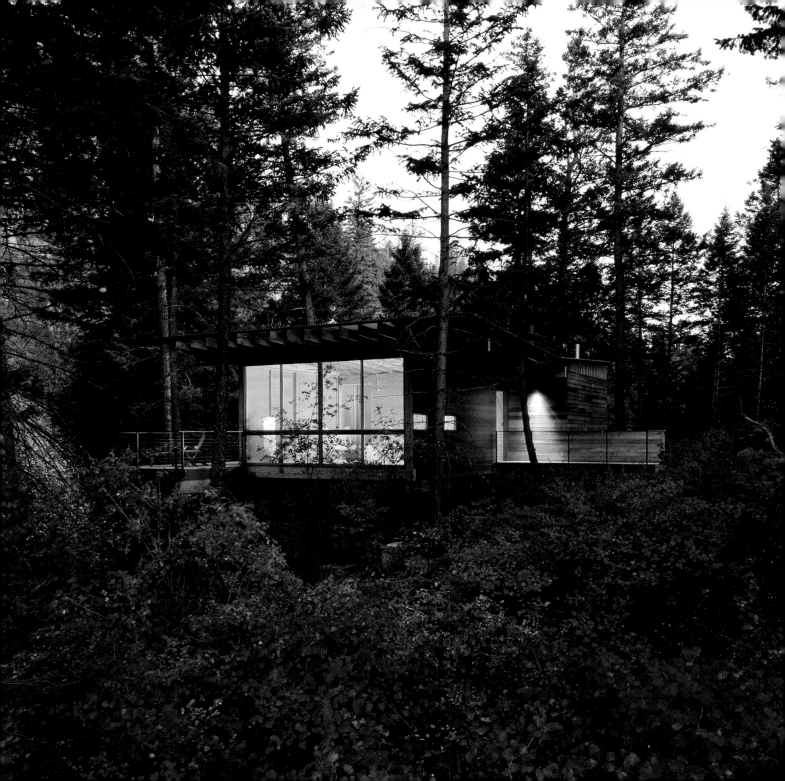

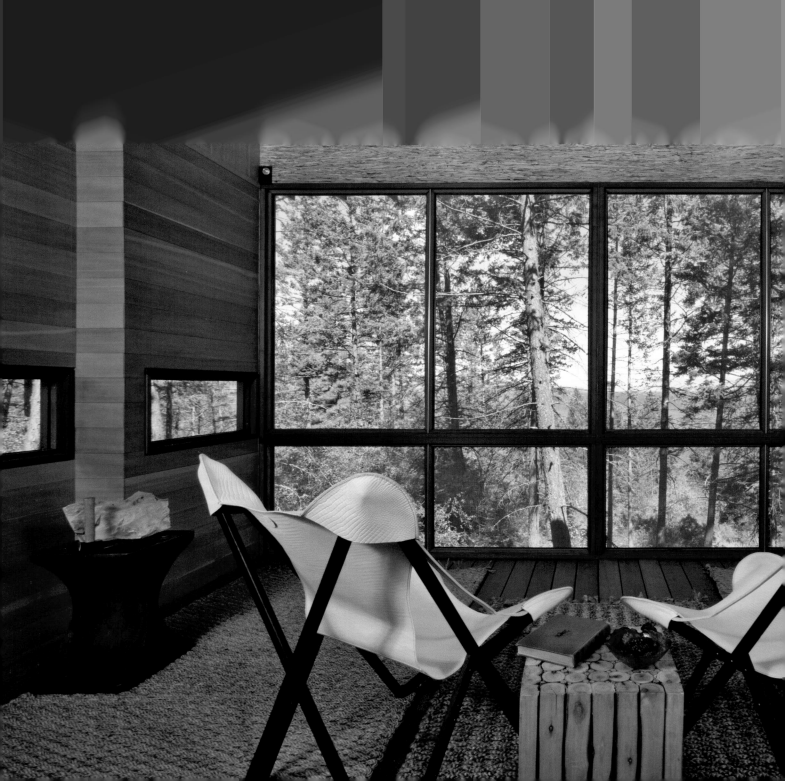

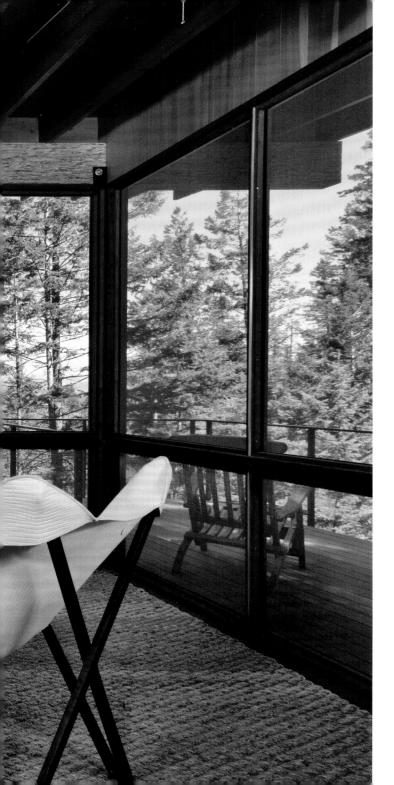

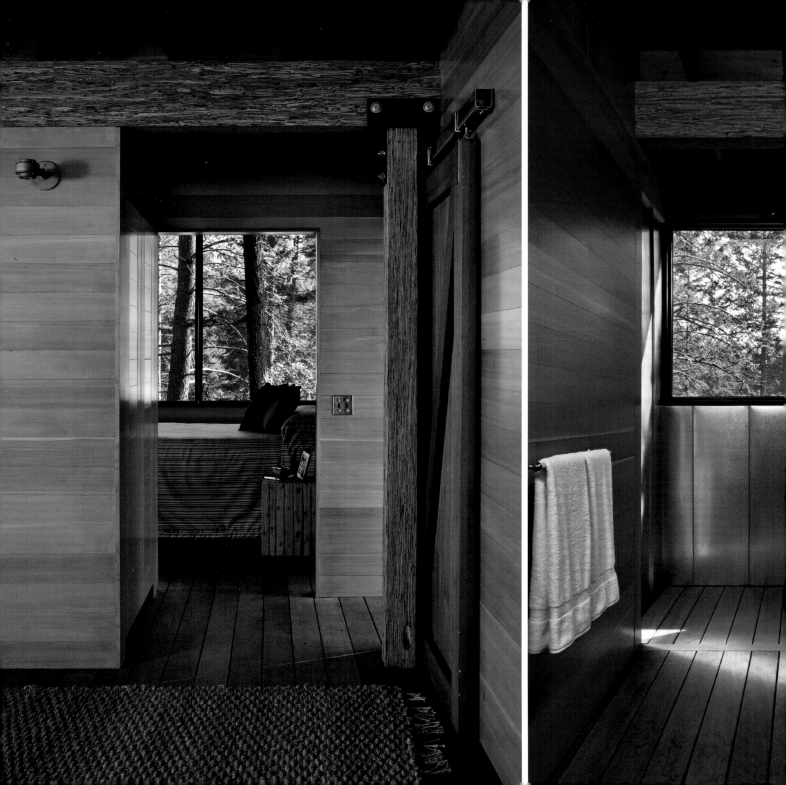

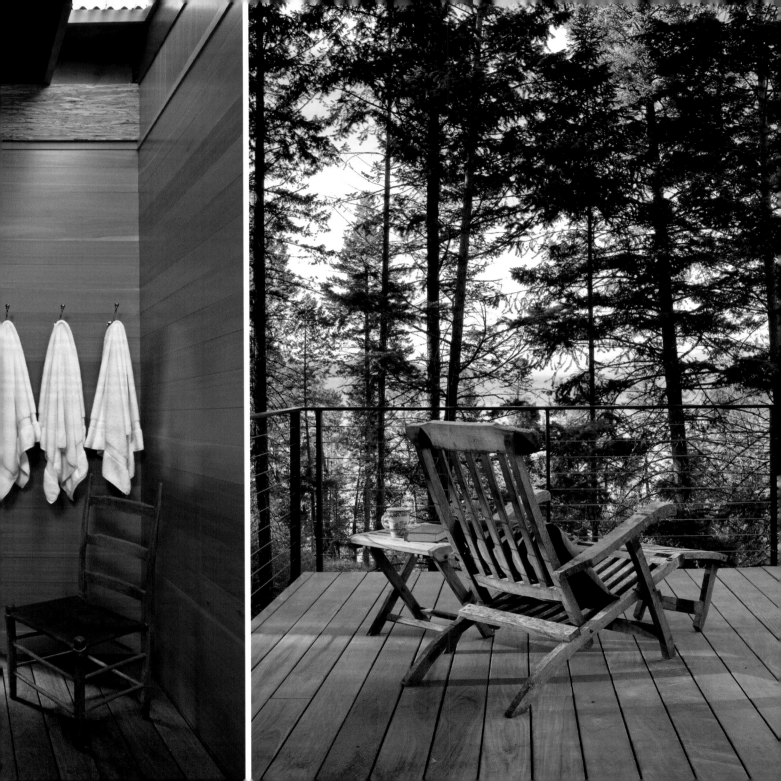

KLEIN A45
LANESVILLE, NEW YORK

BIG NYC / 2018

With a floor area of just 180 square feet (17 square meters), the Klein A45 house (A45) is certainly not one of the larger projects by BIG (Bjarke Ingels Group), which is better known for such large buildings as VIA 57 West, with its 709 residential units on West 57th Street in Manhattan. A45 is, on the contrary, a "tiny house" prototype that can be "built within four to six months in any location, for any purpose." Basically an A-frame structure set up on four concrete piers, this design has a twisted roof that allows for a thirteen-foot height in one corner and a triangular, floor-to-ceiling, seven-pane window. The building has an exposed timber frame in solid pine, a Douglas fir floor, and natural cork interior walls. The architects installed a Morsø wood-burning stove in one corner, a kitchen designed by Københavns Møbelsnedkeri, handcrafted furniture from Carl Hansen, and a bed with Kvadrat

fabric designed by the Søren Rose Studio to complete a decidedly Nordic feeling within this structure. Søren Rose is the founder of Klein, which, like BIG, is a firm based in both New York and Copenhagen. Designed to be assembled in a modular system, the A45 cabin is made with 100 percent recyclable materials and is the first of what Klein says will be a series of tiny homes designed by the world's leading architects.

Above and opposite: Section drawings and the photo show the radical simplicity of the design, with a glazed main facade that reaches a maximum height of nearly 13 feet (4 meters). **Following spread, left:** The use of wood creates a natural feeling inside the house that makes it blend in almost seamlessly with the forest setting. **Following spread, center and right:** Even the bathroom and kitchen take on the all-wood appearance of the house, despite bringing a modicum of modern comfort to an otherwise fairly spartan design.

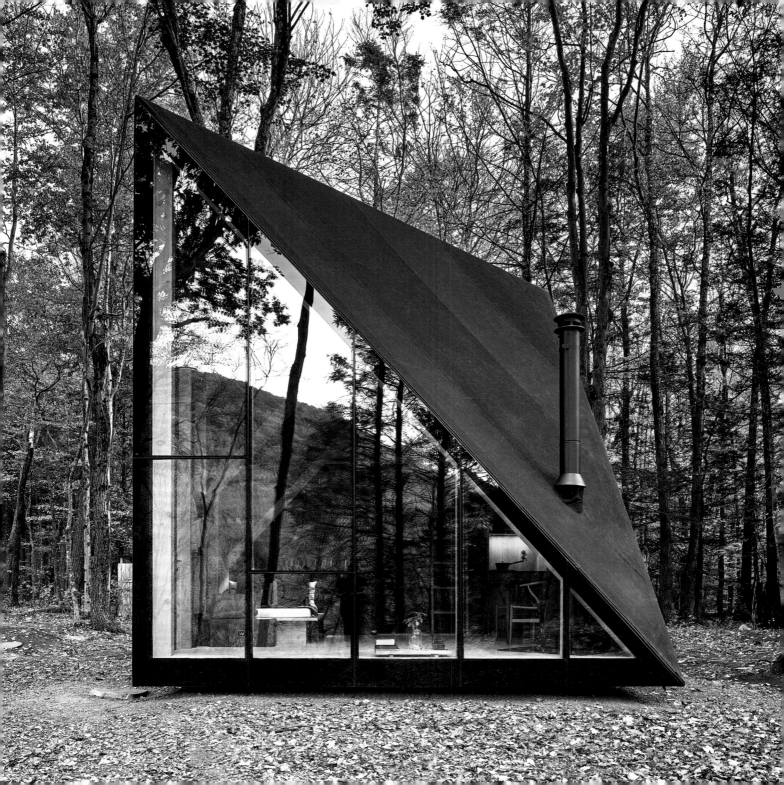

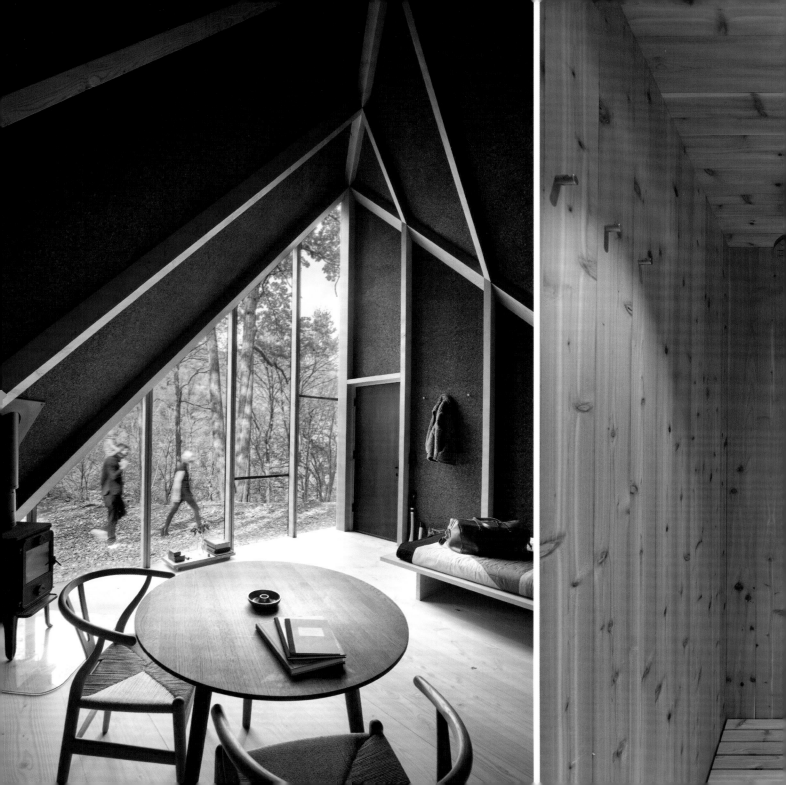

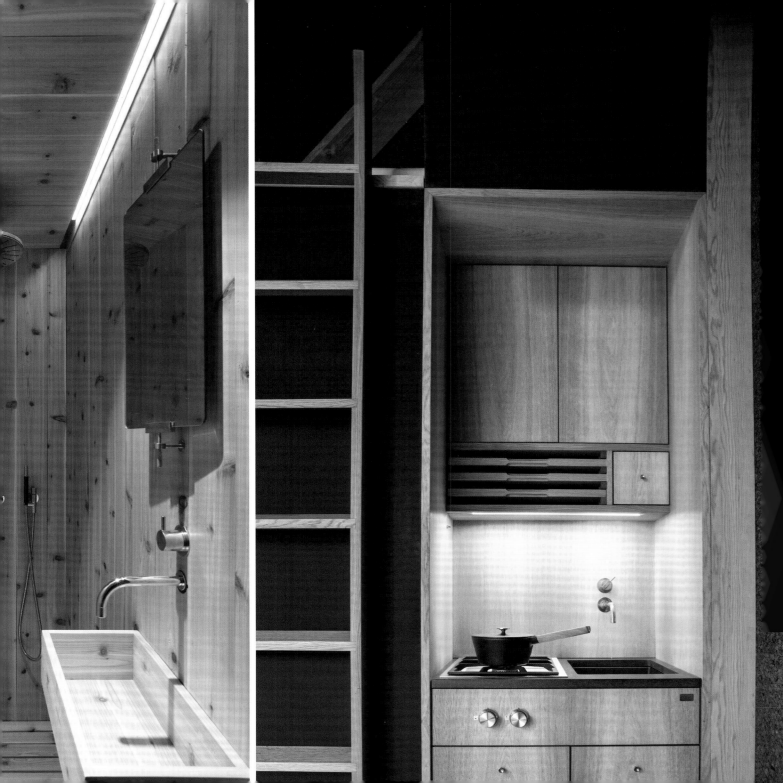

BOARD + BATTEN
GREEN MOUNTAINS, VERMONT

Birdseye / 2017

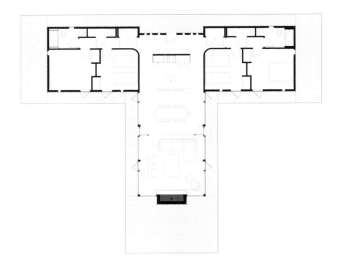

Board + Batten is a 1,984-square-foot (184-square-meter) private guesthouse set between a forest and a private meadow. The living areas in the house, which has a T-shaped plan, face the meadow, and the private part of the residence is opposite the forest. The four bedrooms are arranged in two symmetrical wings and are designed to accommodate up to eight people. An open kitchen, dining, and living room with large windows has a western cedar wall with a built-in fireplace and a cantilevered granite hearth. The name of the house comes from the use of board and batten siding, which is frequently used in the region. Polished stainless-steel surfaces and glass are the other visible materials for the exterior. A cedar deck forms a transition area between exterior and interior. Concrete floors, painted walls, western red cedar details, and custom beds and cabinetry were used for the interiors. Birdseye, founded in 1997, is based in Richmond, Vermont, and specializes in the design of individual houses.

Opposite: A roof with an overhang provides shelter for the outdoor wooden terrace, while nearly full-height glazing permits a symbiosis between interior and exterior. **Following spread, left:** A broad fireplace and generous views inside the house create a protected haven in the midst of a natural environment. **Following spread, right:** The modern kitchen would be as much at home in a city, but here it contrasts with the natural roughness of the forest.

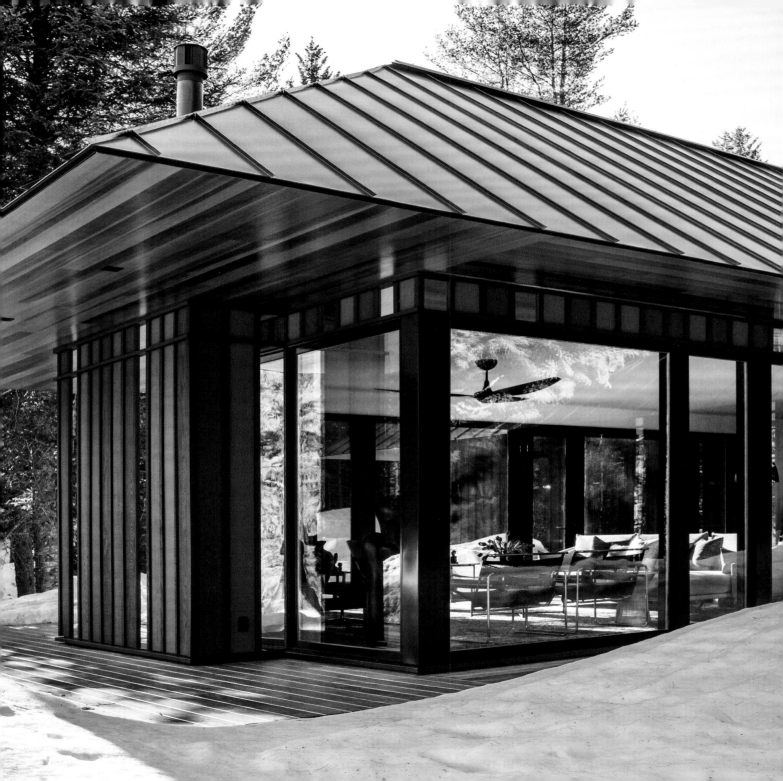

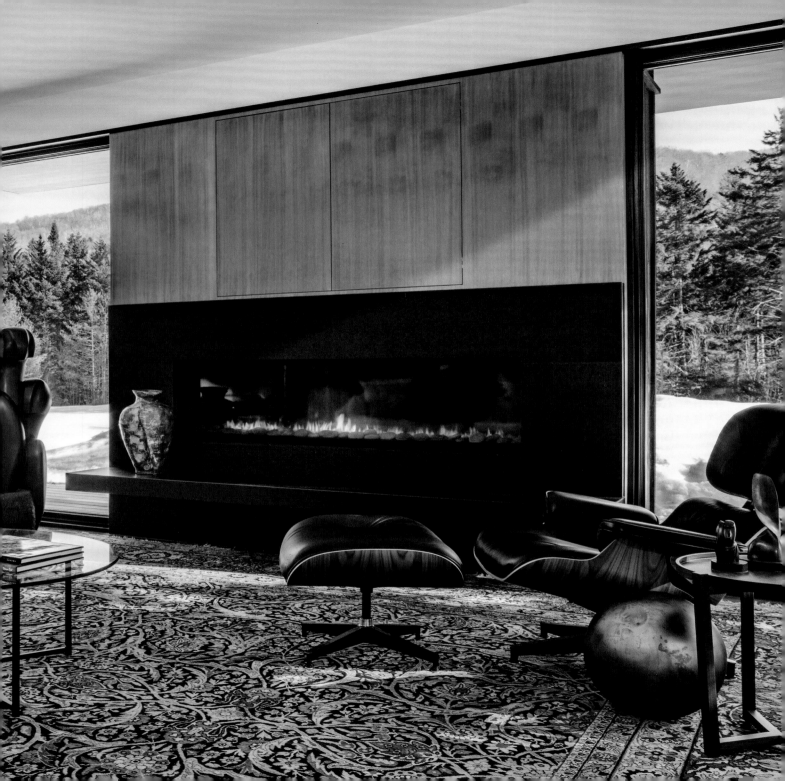

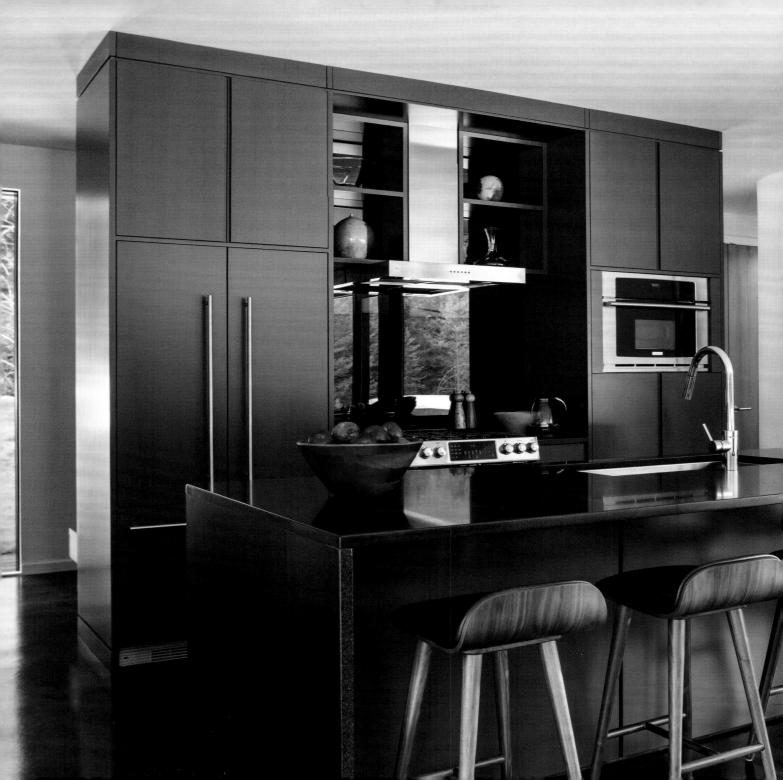

LIGHTBOX
POINT ROBERTS, WASHINGTON

Bohlin Cywinski Jackson / 2015

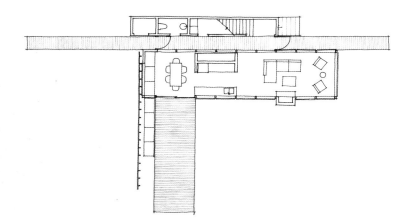
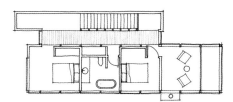

Built on a small 7,800-square-foot (725-square-meter) site in a park overlooking the Strait of Georgia, the San Juan Islands, and Puget Sound for a cost of $346,000, the Lightbox has a floor area of 1,650 square feet (153 square meters). Intended for a photographer and his family, the house was designed with "affordable and common materials" and made of an exposed wood structure and prefabricated aluminum window frames. The two-story glass living area faces south and a long black wooden "box" to the north with narrow openings contains a stairway that is finished in traditional Finnish pine tar coating. The two bedrooms are located on the upper floor. Generous views of the forest and a long rectangular outdoor deck emphasize the intimate connection between this home and its natural environment. The architects, who are very experienced in the design of individual houses, state that "Lightbox is an uncomplicated yet powerful gesture that enables one to view the subtlety and beauty of the site while providing comfort and pleasure in the constantly changing light of the forest."

Opposite: The two-story living space and its glazed surface are entirely open to the exterior, allowing residents to experience a real proximity to nature. **Following spread, left:** Wooden ceilings, floors, and furnishing emphasize the forest environment that lies just beyond the windows. **Following spread, right:** A simple and elegant composition of wooden elements together with a narrow band window that allows views to the outside characterize the stairway volume of the house.

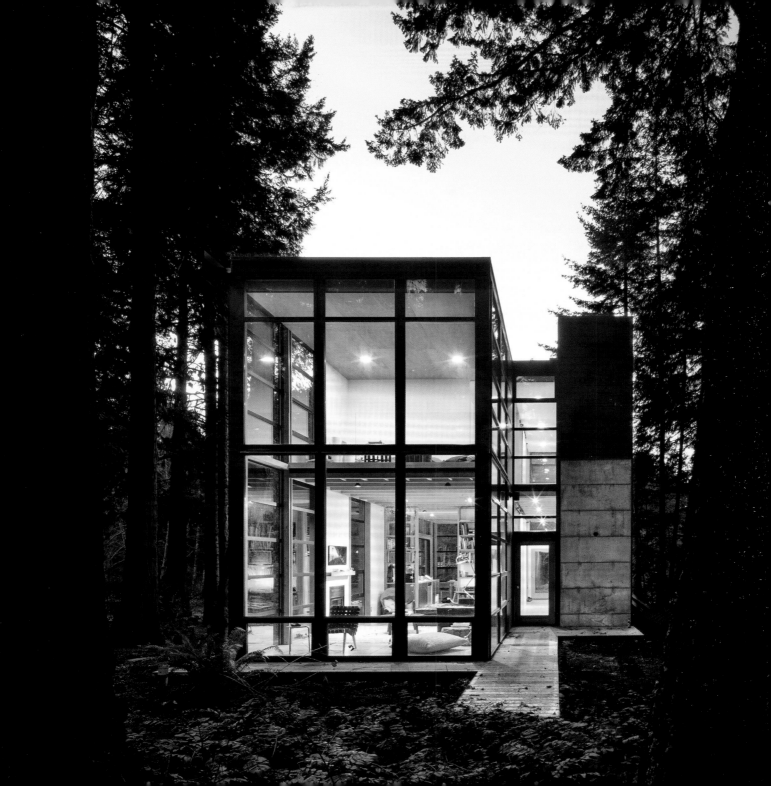

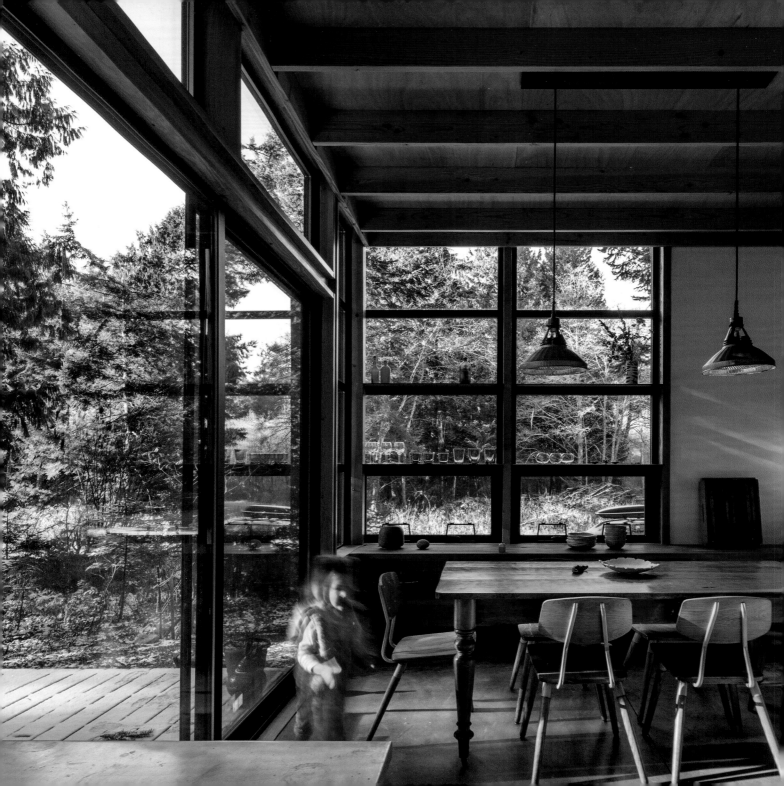

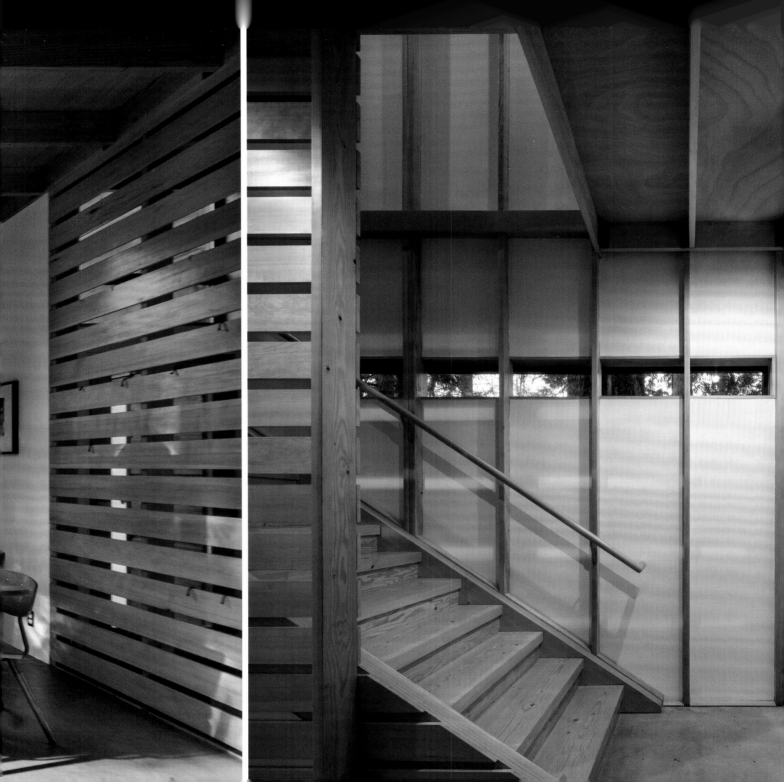

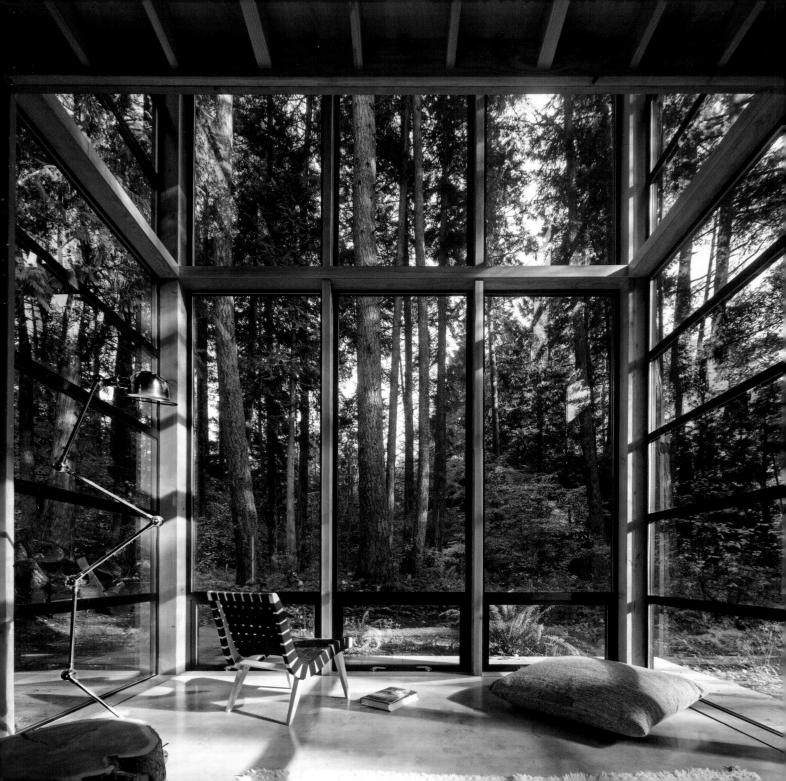

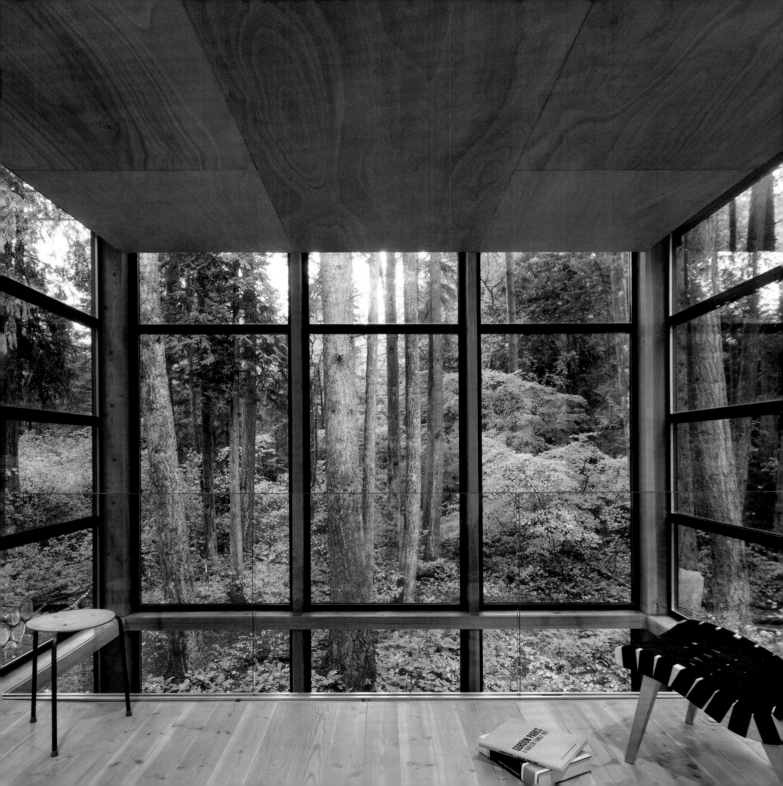

CHARLEVOIX DOMES
PETITE-RIVIÈRE-SAINT-FRANÇOIS, QUEBEC, CANADA

Bourgeois/Lechasseur Architectes / 2018

The architects Bourgeois/Lechasseur designed three domes intended as part of a larger "four-season eco-luxury" resort located near Le Massif de Charlevoix and Quebec City. In their mountainside sites, the geodesic domes are erected on wooden patios with spas and are meant to blend in with the landscape. They have south-facing windows overlooking the St. Lawrence River and concrete floors with radiant heating. A gray PVC membrane mounted on triangular steel panels forms the exterior, which is matched by gray canvas inside, and the domes are fitted with wood-burning stoves. The combination of the chosen materials and the heating systems allows the domes to remain usable even during the harsh winter conditions in Quebec. The structures contain a kitchen, bedroom, and bathroom on the main floor and a second bed that is located above the service area. A nautical-type stair is used to reach the upper bed. The domes have a floor area of 540 square feet (50 square meters), and the developer intends to create ten more in the future. Olivier Bourgeois and Régis Lechasseur created their firm in 2011.

Opposite: Working with the idea of Buckminster Fuller's geodesic dome, the architects created a light structure capable of resisting the rigors of Canadian winters. **Following spread, left:** The triangulated structure is either filled and insulated or glazed, providing both comfort and a real sense of being amid nature. **Following spread, right:** The curving walls of the bedroom and its generous views give a clear impression of privileged comfort despite the small size of the structure.

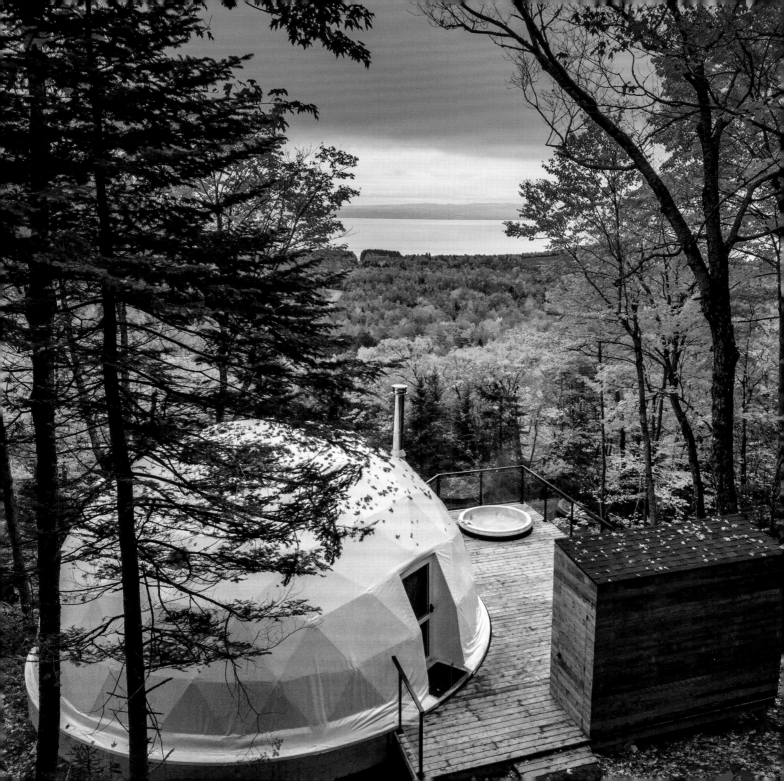

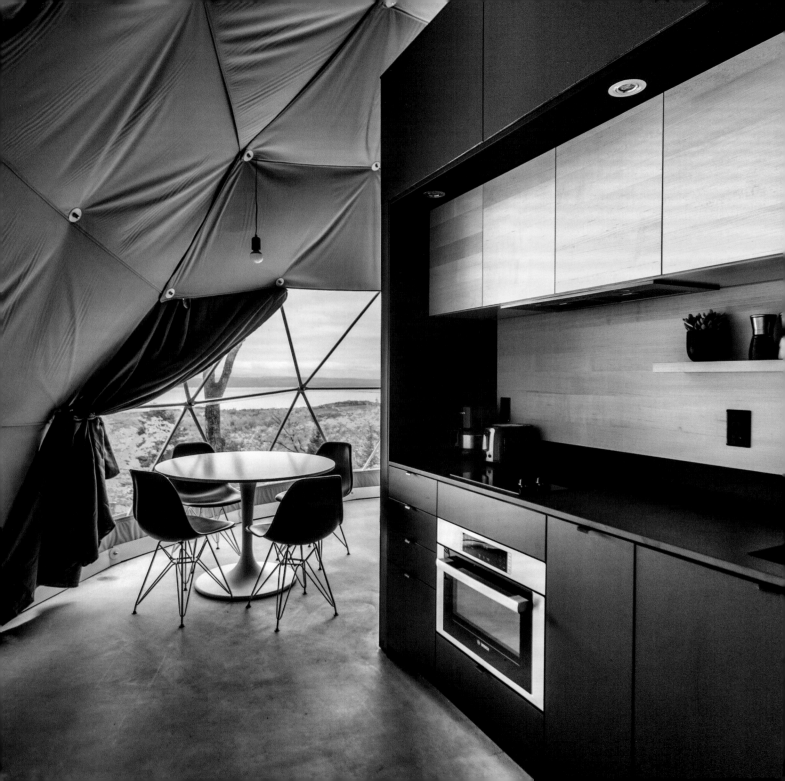

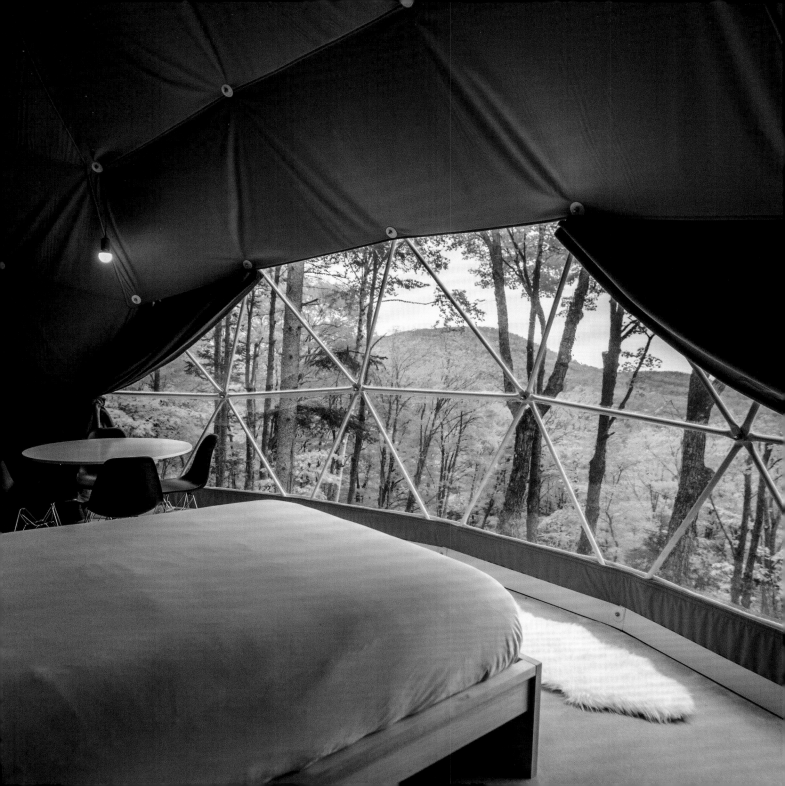

RIVERBEND RESIDENCE JACKSON, WYOMING

Carney Logan Burke / 2018

Located on the Snake River, the Riverbend Residence was built on a twenty-acre site. Although spectacular, the site posed challenges for the views in the form of an artificial berm and a grove of cottonwood, which the architects overcame by lifting the house five feet off the ground. The plan comprises a main house with an east–west orientation and a perpendicular guesthouse with a shared outdoor area. Ten-foot overhangs, lined with cedar, on the north side of the main house extend the living space out toward the terraces, contrasting with the weathering steel used for many outdoor wall surfaces. The covered space includes an outdoor kitchen and dining area with a grill and pizza oven. White plaster walls, cedar ceilings, and architectural concrete floors with embedded pieces of green glass mark the interior spaces on the ground floor; beech flooring was used on the upper level. The main house

has a double-height living, dining, and kitchen area with full-height glazing. The architects collaborated with the clients for the choice of furnishings, emphasizing a casual and warm atmosphere. Carney Logan Burke was founded in 1992 in Jackson Hole. They have a staff of forty and a new design studio that opened in Bozeman, Montana, in 2017.

Opposite: A twenty-acre site is ample space to create the reality of a luxurious house isolated in a forest setting. Extensive glazing connects the interior to the exterior views. **Following spread, left and center:** Full-height windows and wooden surfaces make for a direct relationship between the architecture and the forest. **Following spread, right:** Seating near a large window allows residents to be just a few inches from the outdoor world.

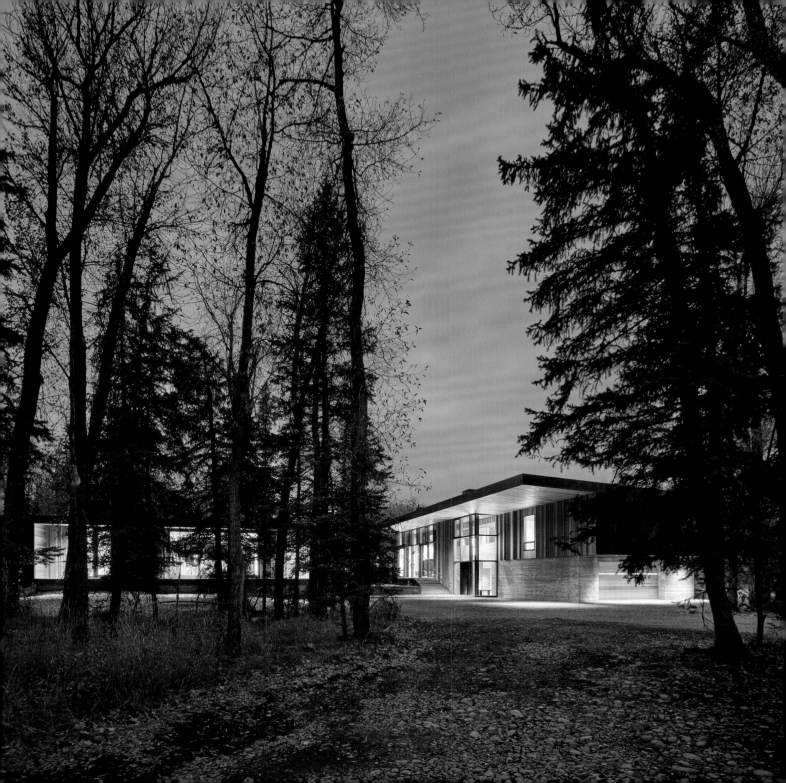

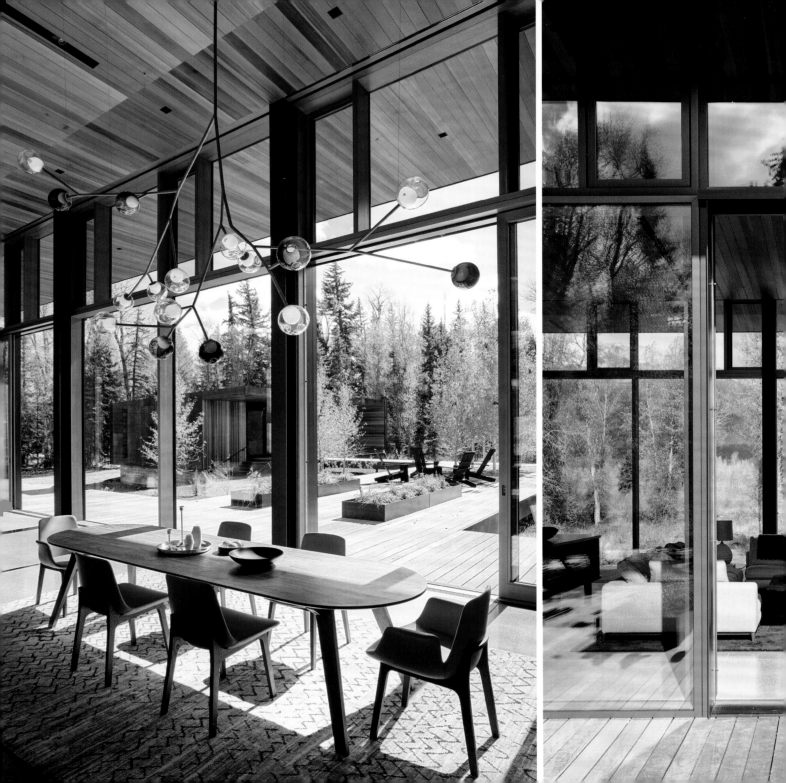

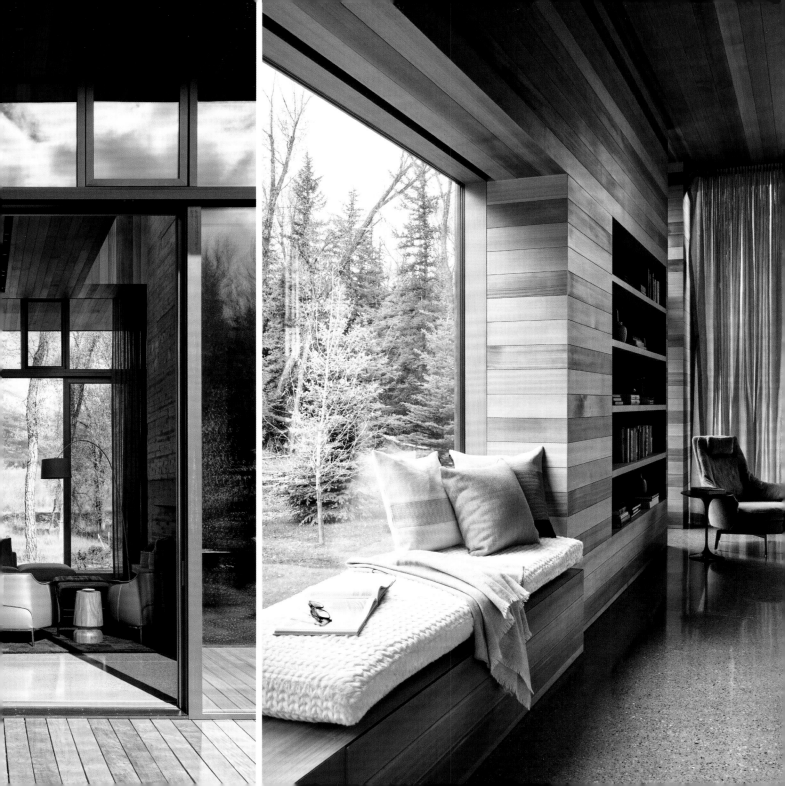

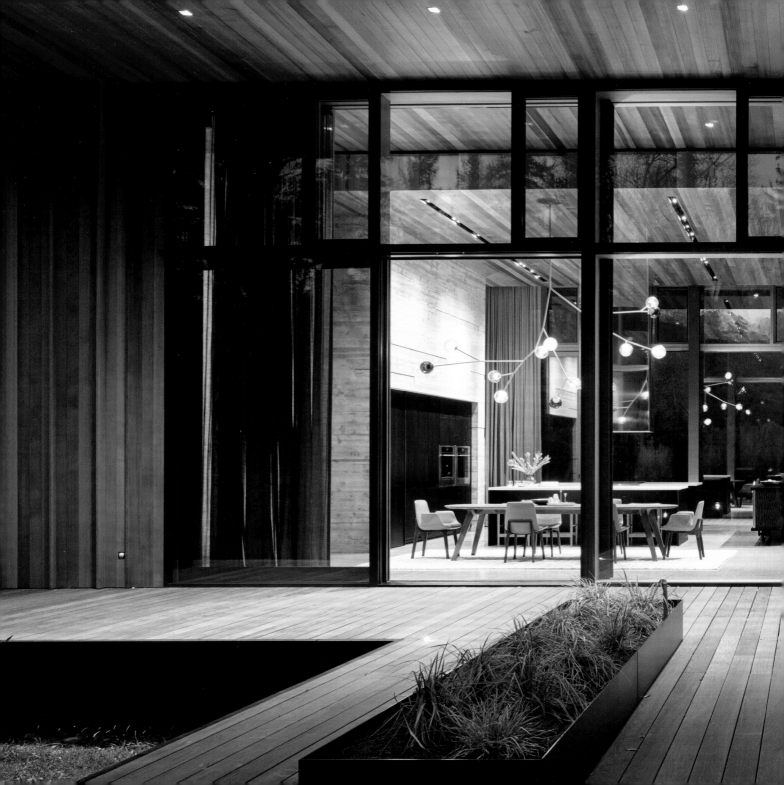

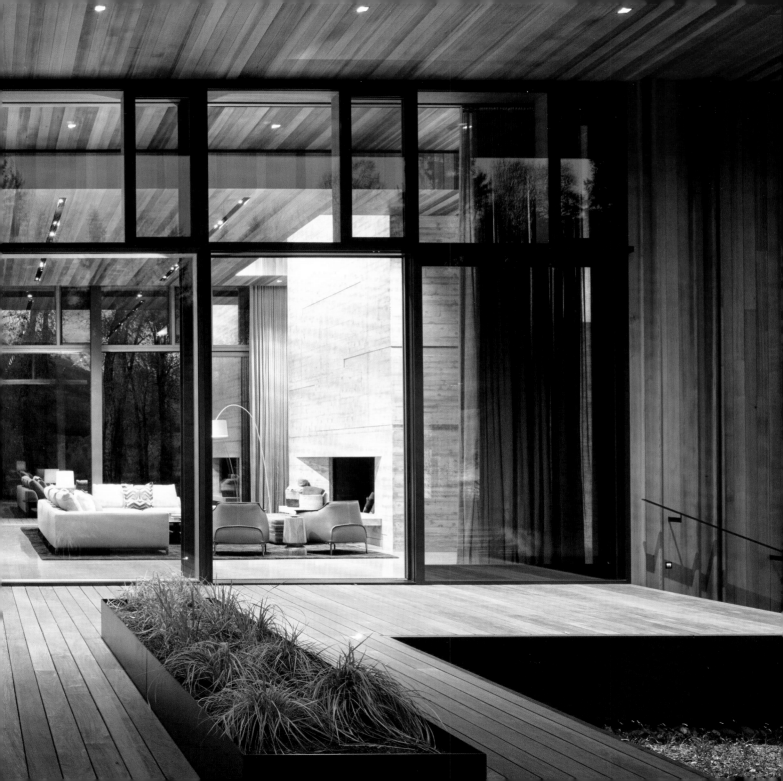

CONNECTICUT RESIDENCE CONNECTICUT

Cutler Anderson Architects / 2016

The five-bedroom Connecticut Residence was built on a 4.3-acre site within a 720-acre nature preserve by dedicated environmentalists. The design seeks to fit into the existing topography to the greatest extent possible. Water running down from hills to the north of the site was used to provide a source for a pond on the property. Low-emissivity glazing, cypress exterior siding, Douglas fir interior surfaces, and rift-sawn red oak floors confirm the overall intent to fully respect the natural setting. The clients sought "net-zero energy use." The house is insulated with plant-based foam and makes use of a geothermal heating system with fourteen wells dug on the site. A heat pump and household use are powered by a 2,800-square-foot solar photovoltaic installation on the rooftop, which together with six-panel radiant solar array meets 100 percent of the current electrical requirements. Six rooftop solar flat-plate collectors are also employed for domestic hot water use. The owners have carefully monitored the movement of wildlife around the site since the completion of the house. Seventy-four new species of birds have been seen on the property since 2016. Wildlife observed in the first year included a black bear, coyotes, possums, skunks, Kingfishers, great blue herons, egrets, three species of frogs, and fish in the pond that may have arrived as eggs on the feet of birds.

Opposite: High windows and a beamed wooden ceiling give warmth to the interiors, even in colder months. The idea of an ecological rapport between the building and the forest is evident. **Following spread, left:** The dining area has very high windows and a large door that can be opened to the garden. **Following spread, right:** Resting lightly on the ground, a corner bedroom looks out to the forest in two directions, almost completely surrounded by nature.

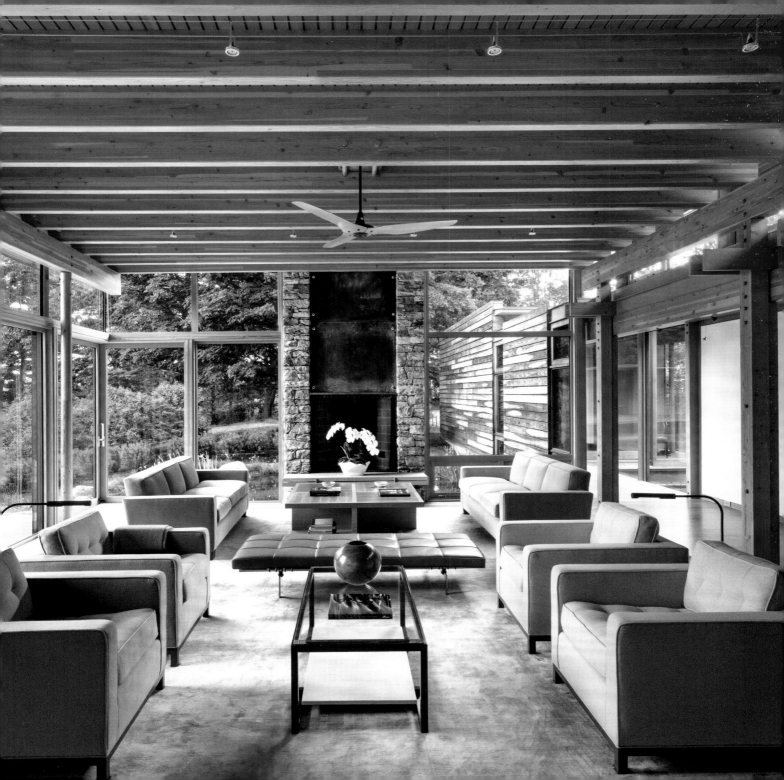

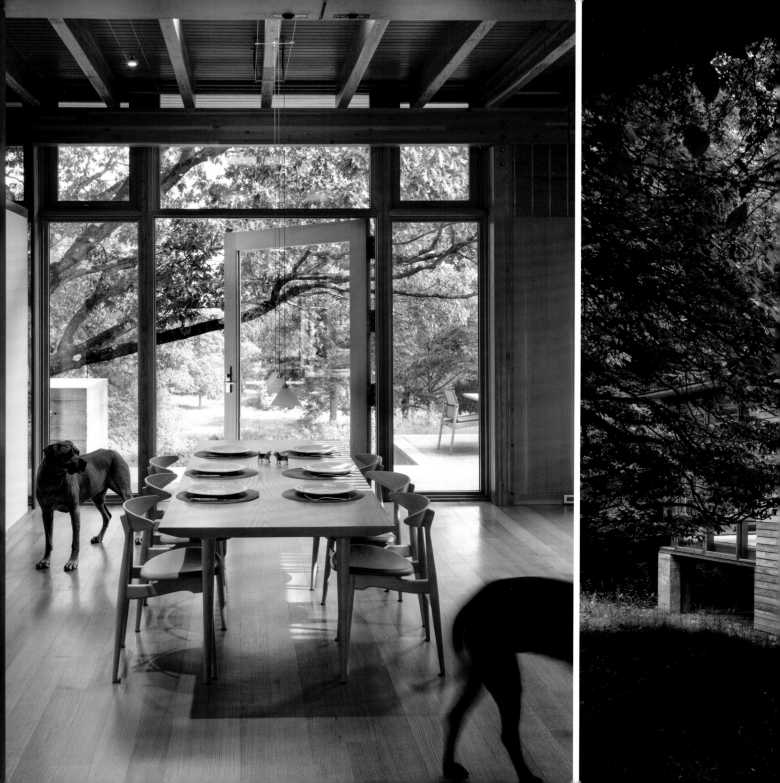

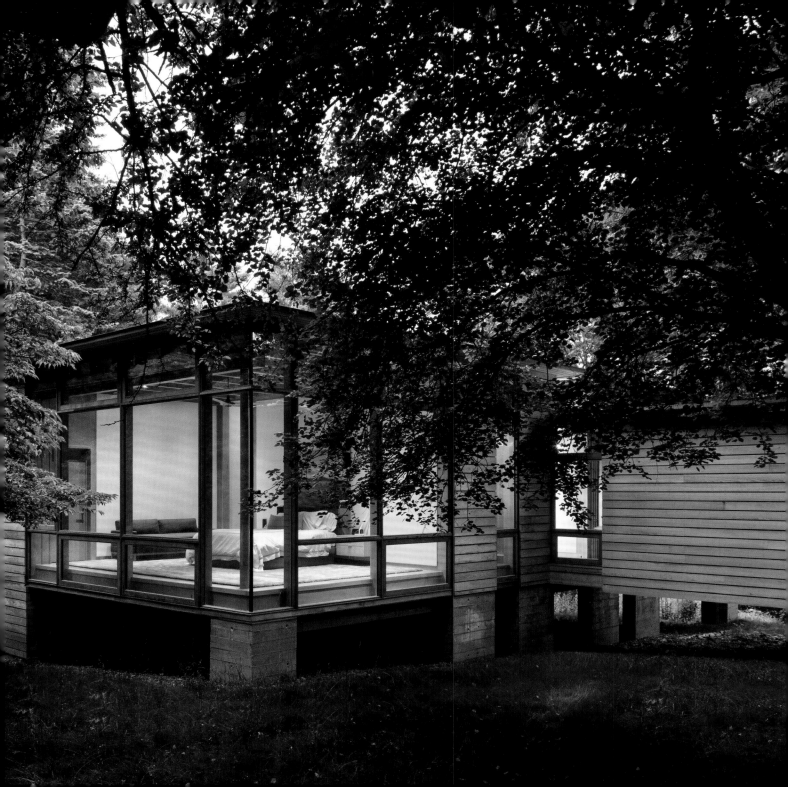

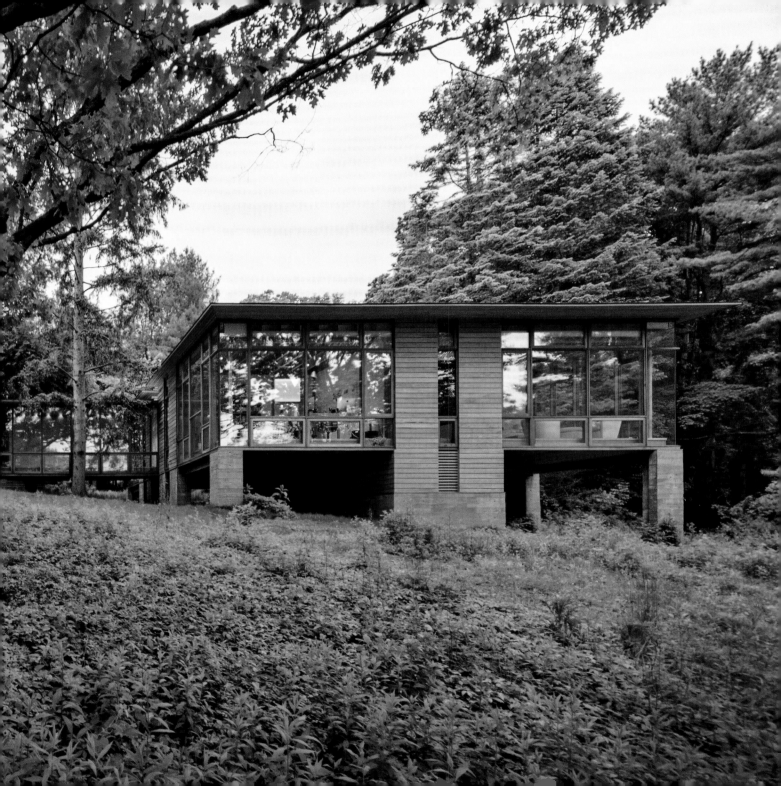

INHABIT
NEAR WOODSTOCK, NEW YORK

Antony Gibbon Designs / 2015

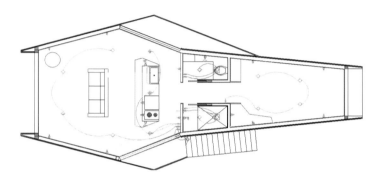

Built with locally sourced reclaimed FSC-certified cedar, this 500-square-foot (46-square-meter) house is set in dense woodland near Woodstock and the Catskill Mountains. The design has an open plan lounge with a wood-burning stove and a kitchen with a trapezoidal eating and working surface. The interiors are finished in reclaimed pine wood that is also FSC certified. Interior forms generated by the plan and sloping roof for the most part avoid ninety-degree angles. A loft bedroom is located on the upper level. A second bedroom or office is at the rear of the house, as is a shower and a bathroom. The house has large windows as well as two balconies on either side of the kitchen and lounge, with a large terrace beneath that leads down to a hot tub and a lake. The trapezoidal house is lifted off the ground and supported at only three points. The UK-based architect and designer Antony

Gibbon has stated that the house "contrasts geometric forms against the organic forms of the forest but still blends into the surroundings with its timber materials." Trees were planted close to the structure to help "strengthen the idea that the building cuts through the forest and is semi-camouflaged into its surroundings."

Opposite: A glass wall allows residents to view a pond from their living room. A wood-burning stove provides heat in the colder months. **Following spread, left:** Set up on angled stilts on the lower side of the site, the house touches the ground as little as possible. **Following spread, right:** The living room space and its broad windows are in front of the kitchen, which is beneath the mezzanine-level sleeping area.

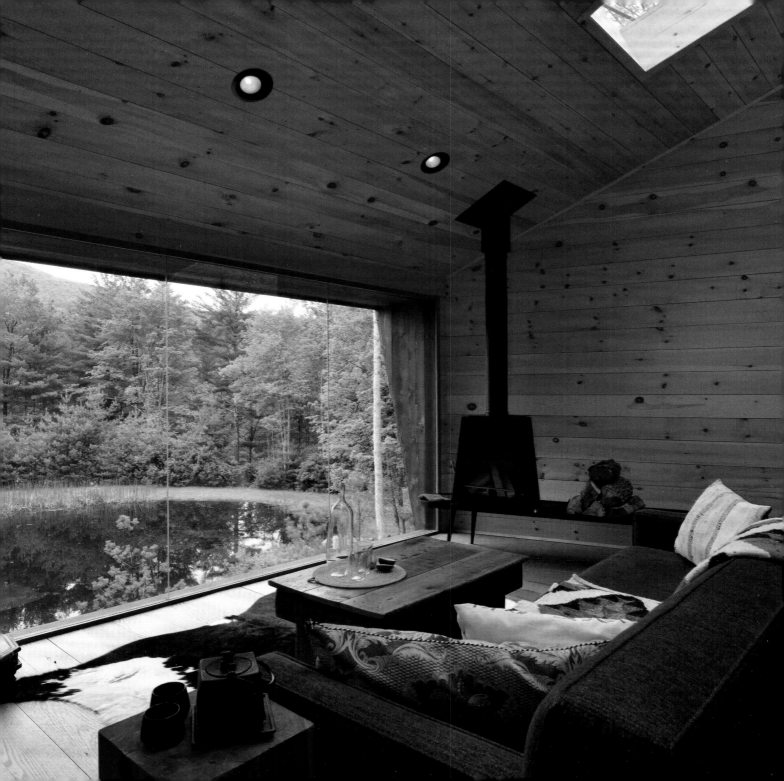

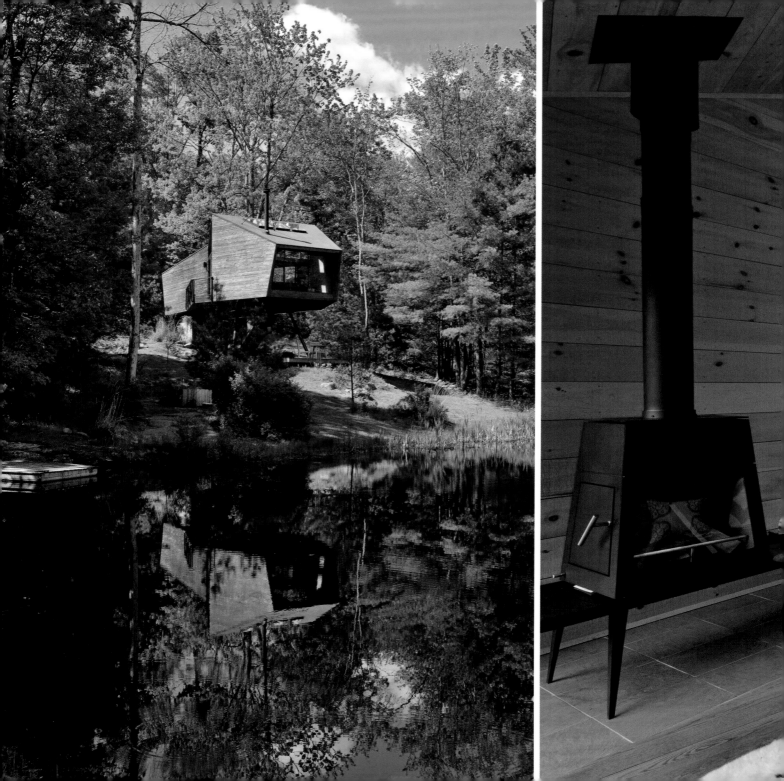

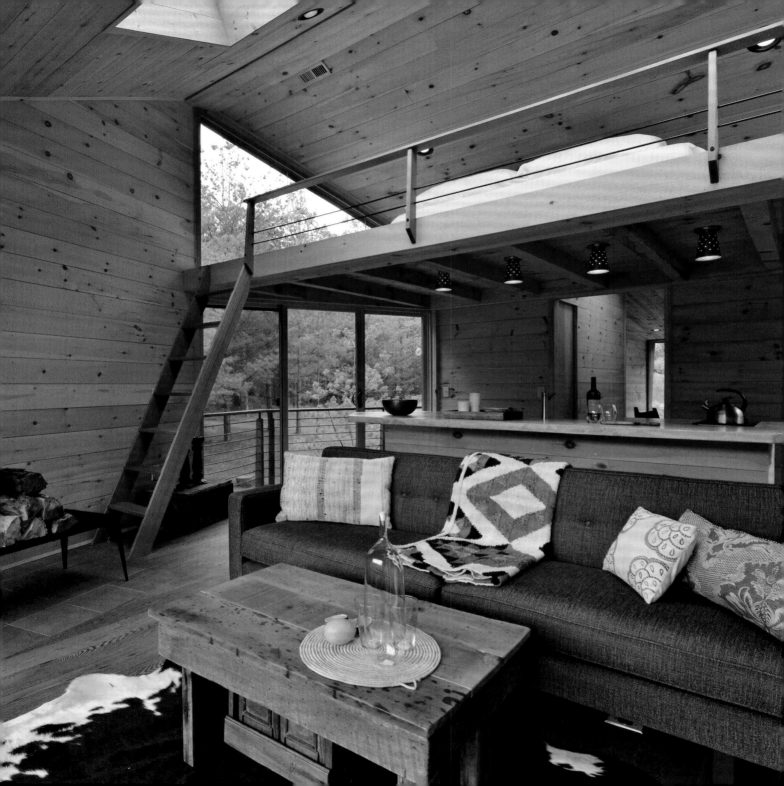

LAKESIDE RETREAT
ADIRONDACK MOUNTAINS, NEW YORK

GLUCK+ / 2010

The Lakeside Retreat was conceived as a "series of buildings located across the site to promote engagement with the landscape." A gatehouse garage, guesthouses, family house, recreation building, and boathouse are all part of the project, which is inserted into a sloping site. A clear effort was made to allow the architecture to blend into the landscape as much as possible, creating a series of "non-buildings." Placing structures partially below grade makes them less visible and at the same time makes them energy efficient. From the nearby lakeside, the buildings are hardly visible, thanks in part to wooden screens. Full-height glass doors in the bedrooms turn the spaces into "sleeping porches," and sunken courtyards that can be used in the summer as outdoor living rooms are part of the concept. In this instance, the entire family house constitutes private quarters, and includes a master suite, guest bedrooms, a kitchen, living, and dining area,

and an art gallery. The recreational building has a lap pool, spa, gym, steam room, changing rooms, kitchens, open living spaces, and a formal dining room that opens up to become a screened porch. The architects state, "What was inhospitable and uninhabitable becomes new playing fields, outdoor dining terraces, and recreational lookouts to more fully experience the exceptional characteristics of the geography of that particular place." The Lakeside Retreat was the Architectural Record House of the Month in November 2011.

Above and opposite: Plans (above) and photo (right) show how the angular forms of the house are inserted into the sloped site, almost becoming part of the topography, with a green roof and an unobtrusive profile. **Following spread, left:** Steps lead down to a sunken patio and the lower level dining area and swimming pool. **Following spread, right:** A boat dock extends toward the water.

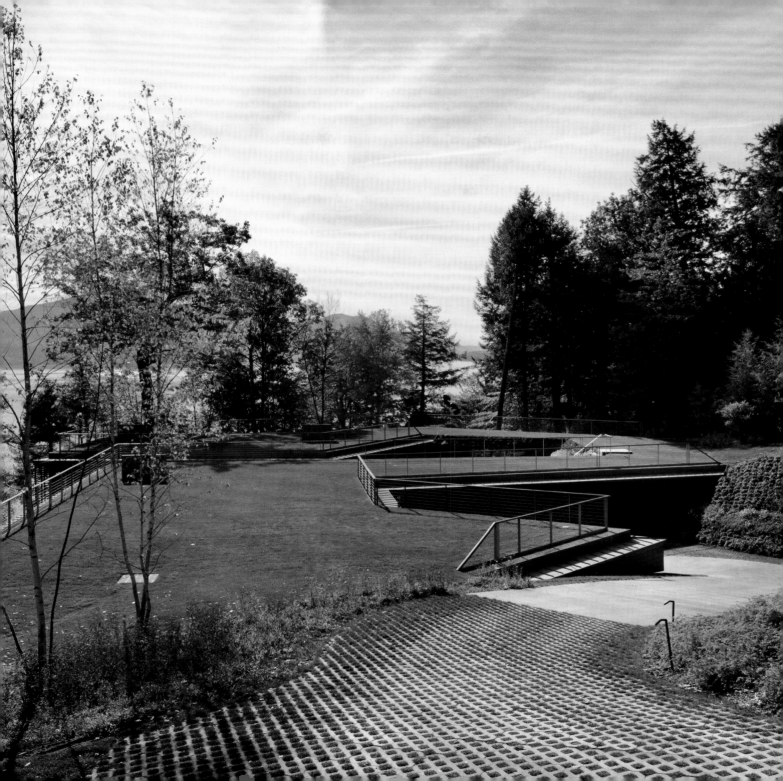

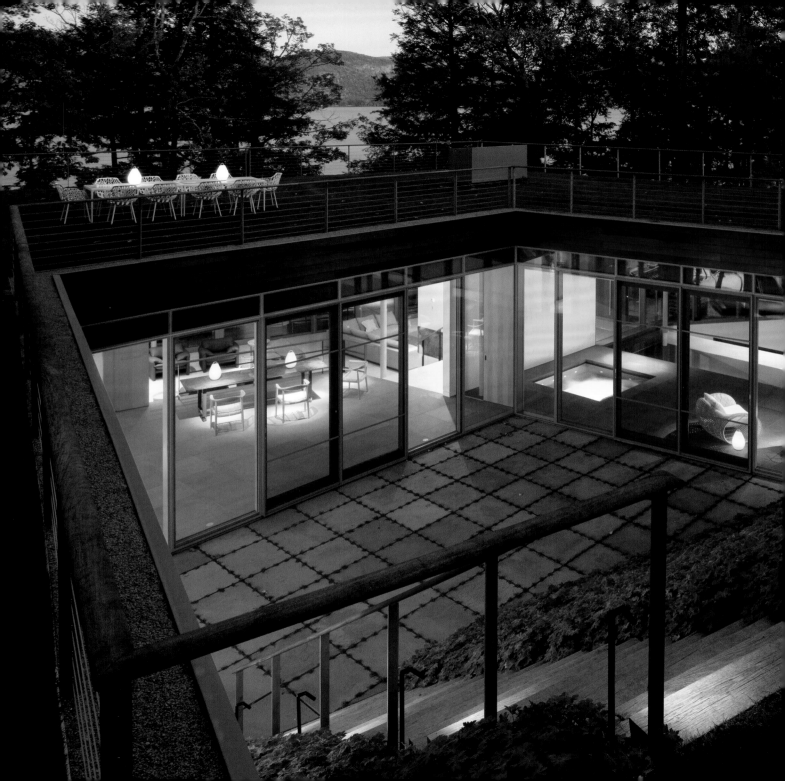

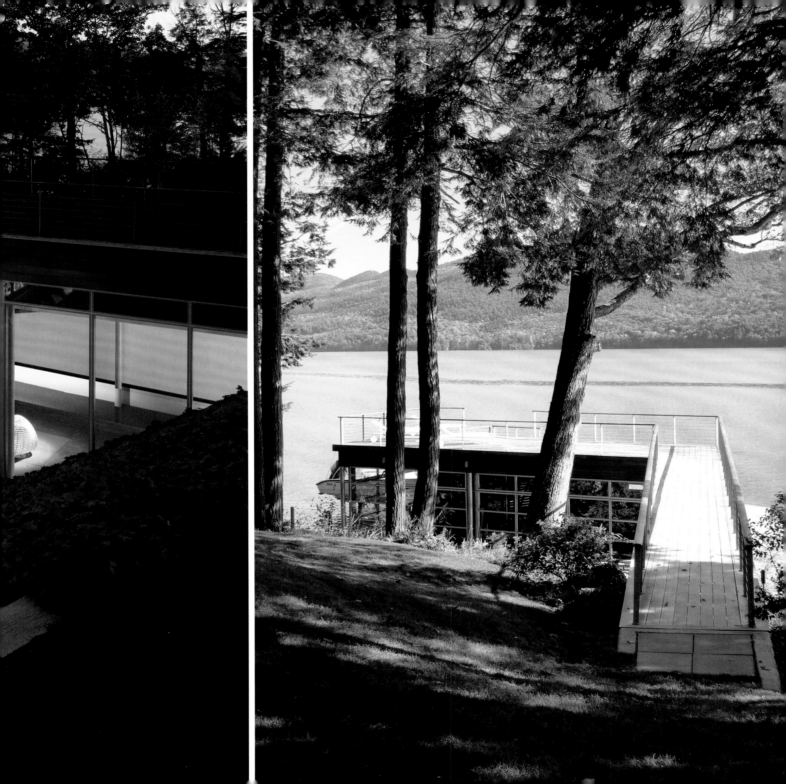

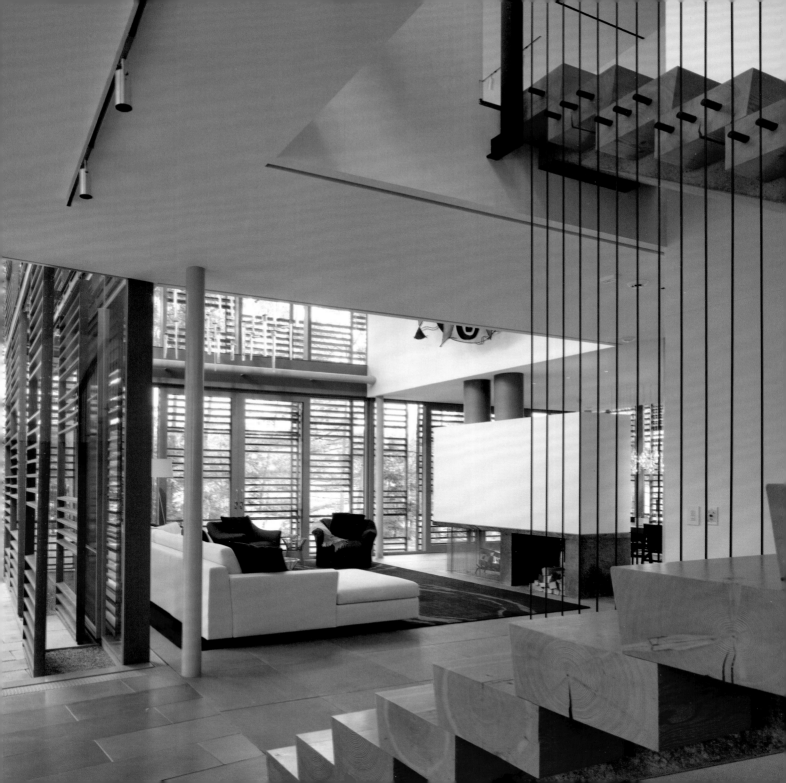

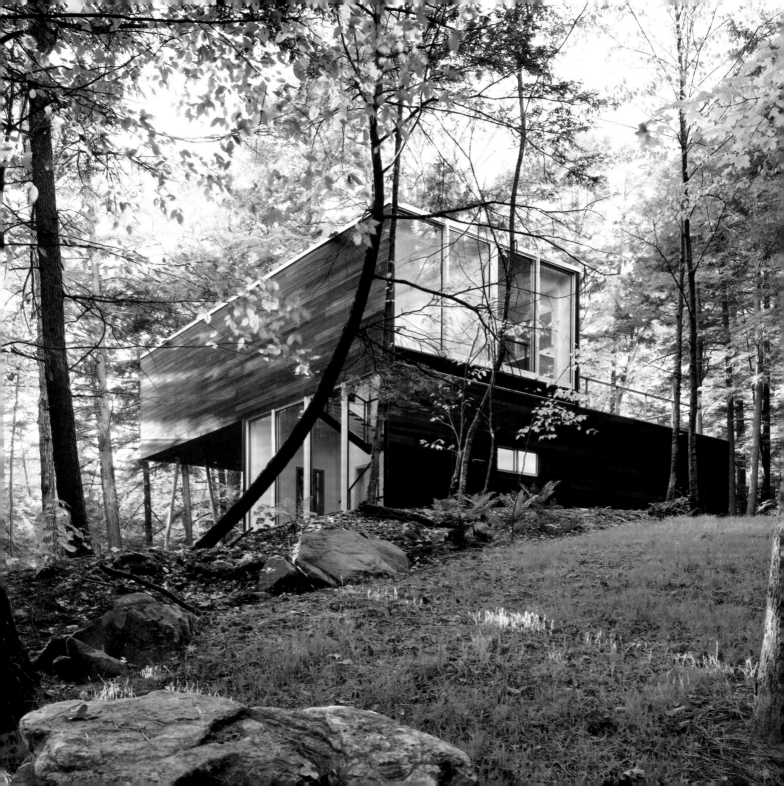

HALF-TREE HOUSE
SULLIVAN COUNTY, NEW YORK

Jacobschang Architecture / 2017

Designed to be erected by amateur builders with a small budget, this tiny 360-square-foot (33-square-meter) house is located in a sixty-acre private forest area in Sullivan County, to the east of Poughkeepsie. The steep site has no vehicular access, no water, and no electricity. Since concrete foundations were ruled out by the location and the budget, the weight of the structure is partially supported by neighboring trees and Sonotube concrete footings. The name of the house is derived from the partial support of the trees. Engineered wood beams and large glazed steel-tube pivot doors manufactured off site were used; the interior and exterior boards were made with Eastern pines felled on the property; and the outdoor surfaces were treated with traditional Scandinavian

pine tar. The house appears as a cantilevered black wedge among the trees because of this coating. A portable generator can be used to provide electricity, and heating comes from an efficient Jotul wood stove.

Opposite: The house seems to hold up on its own on the forested slope, but it is in fact partially supported by surrounding trees. **Following spread, left:** Full-height pivoting windows in the living area allow inside and outside to become indistinguishable. **Following spread, right:** A plan shows the layout of the interior, including the large pivoting windows.

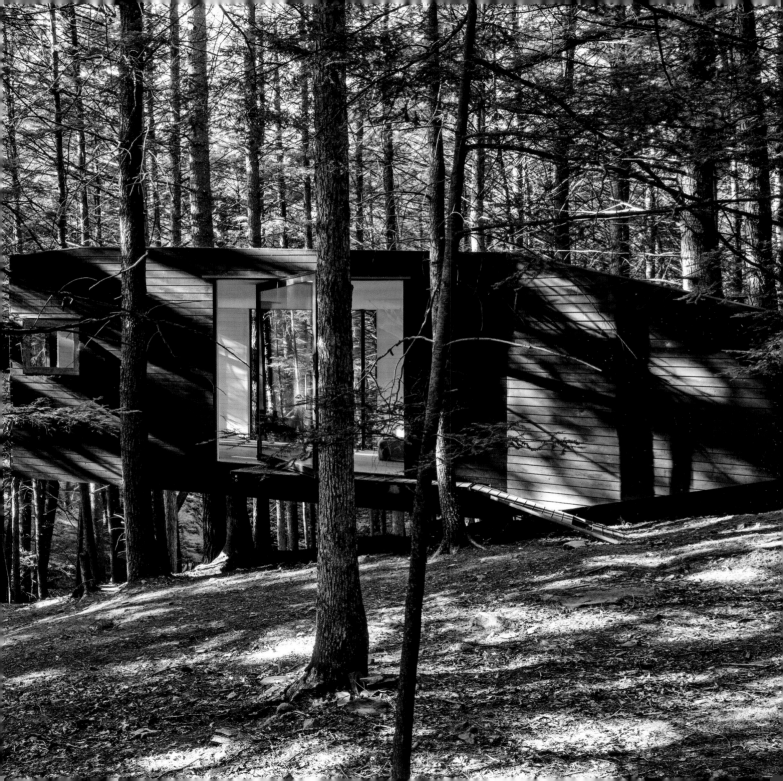

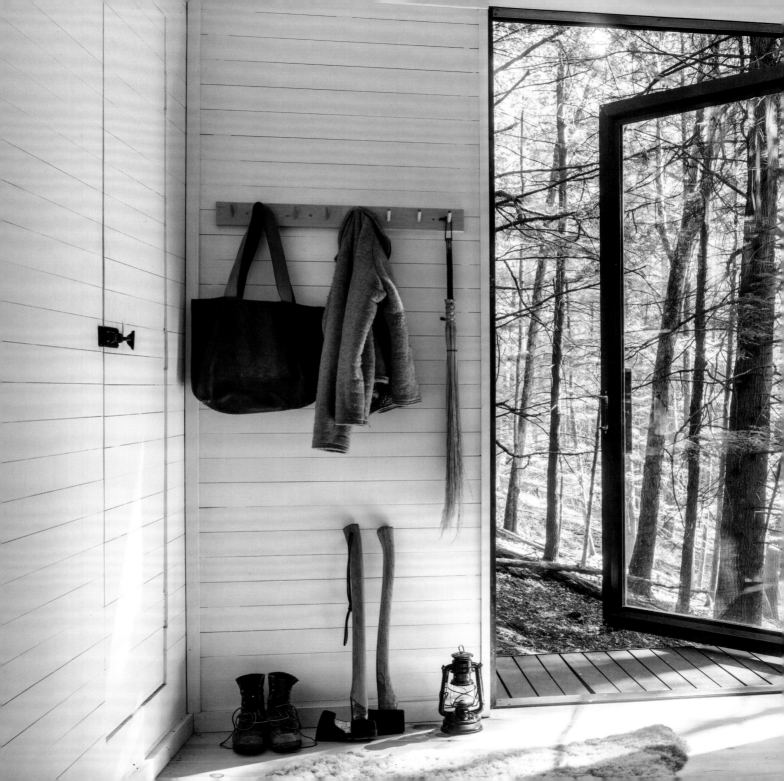

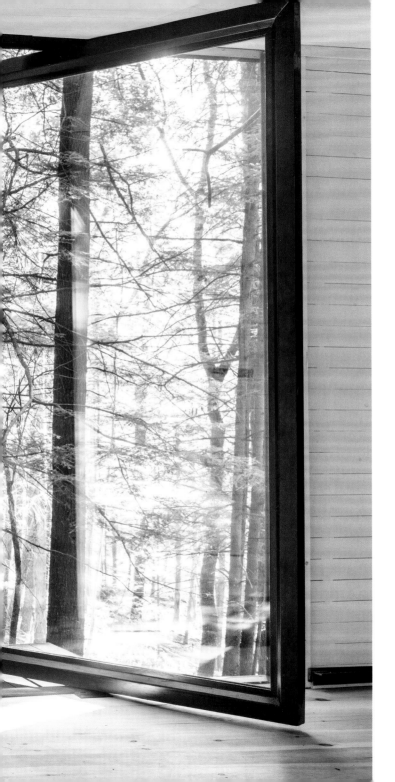
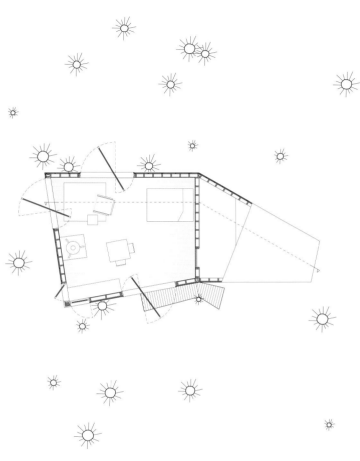

HIGH HORSE RANCH WILLITS, CALIFORNIA

Kieran Timberlake / 2016

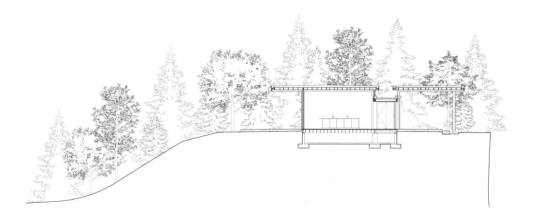

Built on a large sixty-four-acre property 150 miles north of San Francisco, High Horse Ranch is a secondary residence. The site has some steeply sloped areas and an open meadow, as well as forest zones with oak, Douglas fir, and ponderosa pines. Working with the indications of the client, the architects privileged a location on a cliff at an altitude of 2,300 feet above sea level with a view of a forested valley. The kitchen, living, and dining space, with eleven-foot ceilings and intended as the "social center" of the residence, faces this southern valley view and has full-height glazing and pivoting doors that can open to the exterior. Off-site construction techniques were used that allowed the main building to be divided into a total of thirteen modules; two more modules for the guesthouses were put in place by a crane without damaging any of the nearby trees. The rectangular, flat-roofed volumes have sides covered in expanded Corten steel screens. This method allows the structures to be built with a minimum amount of material waste and damage to the site, which can only be reached via a long and winding gravel road. The main house has an area of 2,580 square feet (240 square meters), and the two guest cabins, set on concrete piers and sloped sites, measure 290 square feet (27 square meters) each. The guesthouses each have a different orientation and offer a covered porch and fire pit as well as sleeping quarters and bathrooms. This house succeeds in combining a certain feeling of luxury with enough roughness to bring the residents into real proximity with the natural setting, which has been left largely undisturbed.

Opposite: Light, full-height glass doors allow the living area to extend in a natural way to the exterior terrace, which has the same flooring as the interior. **Following spread:** Designed in a decidedly modernist vein, the house is made warmer by the use of wooden ceilings, which extend to the lower face of the overhanging roof.

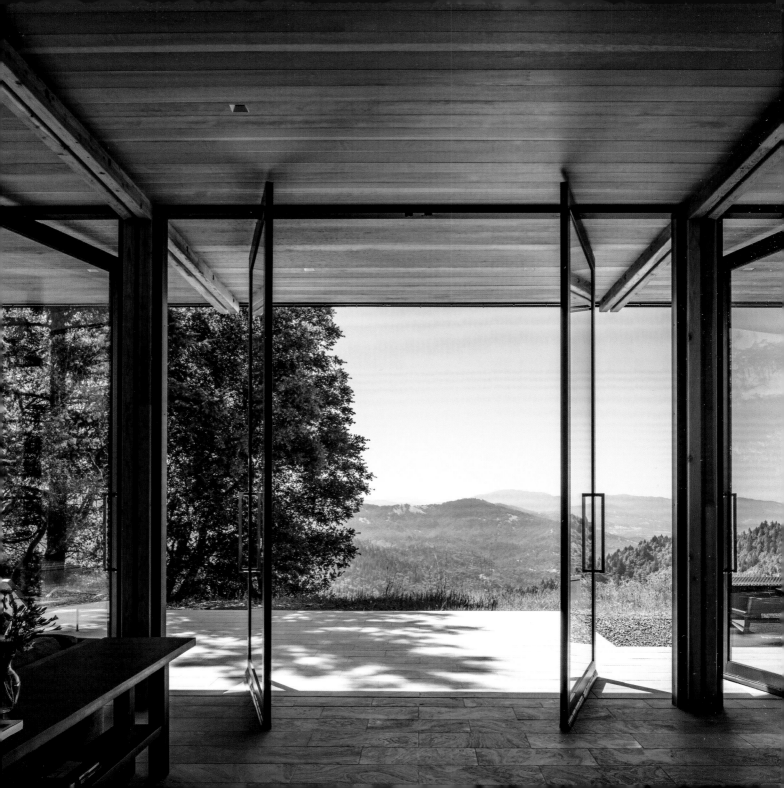

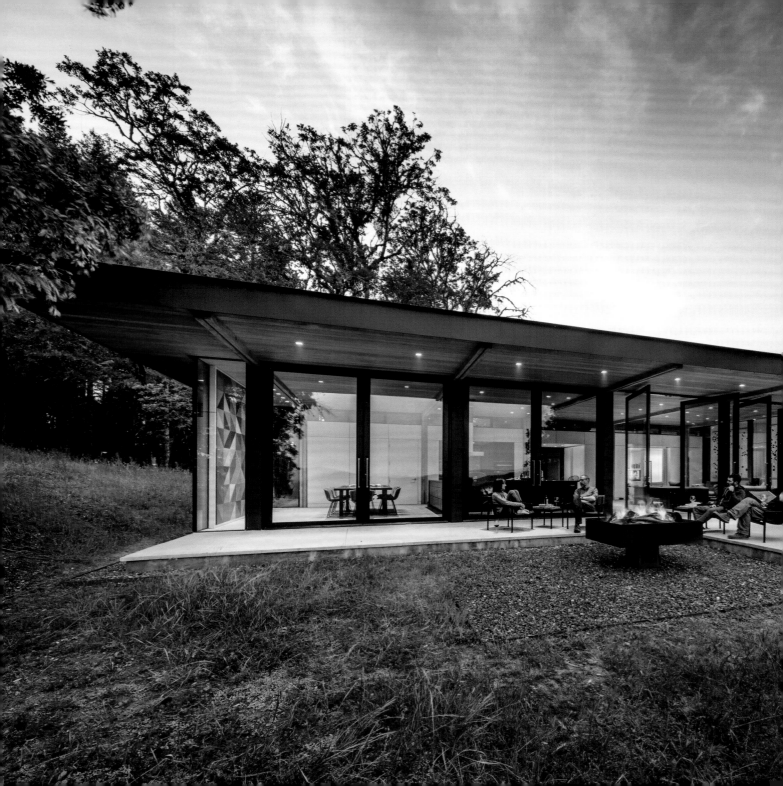

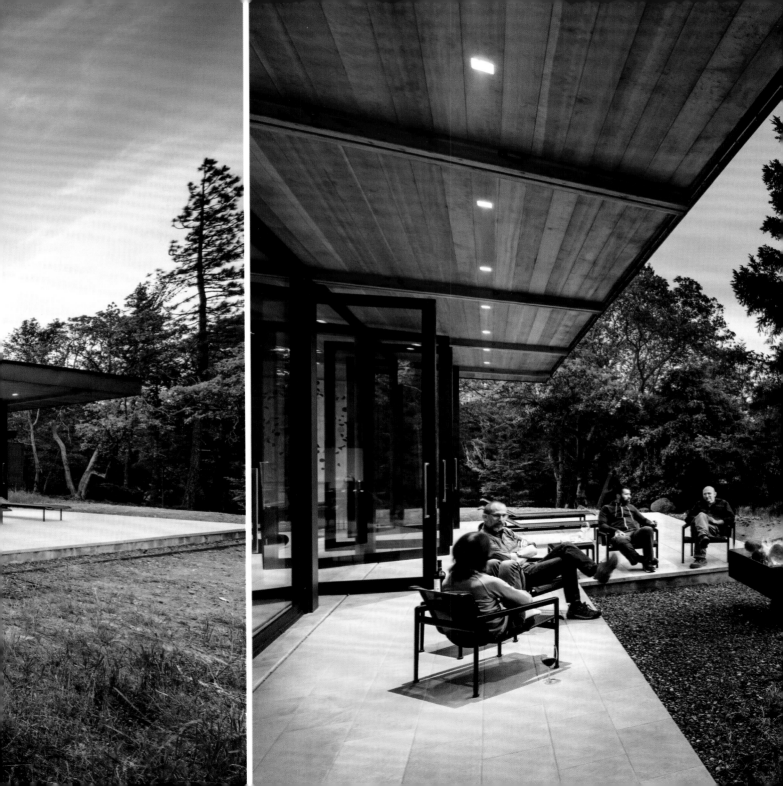

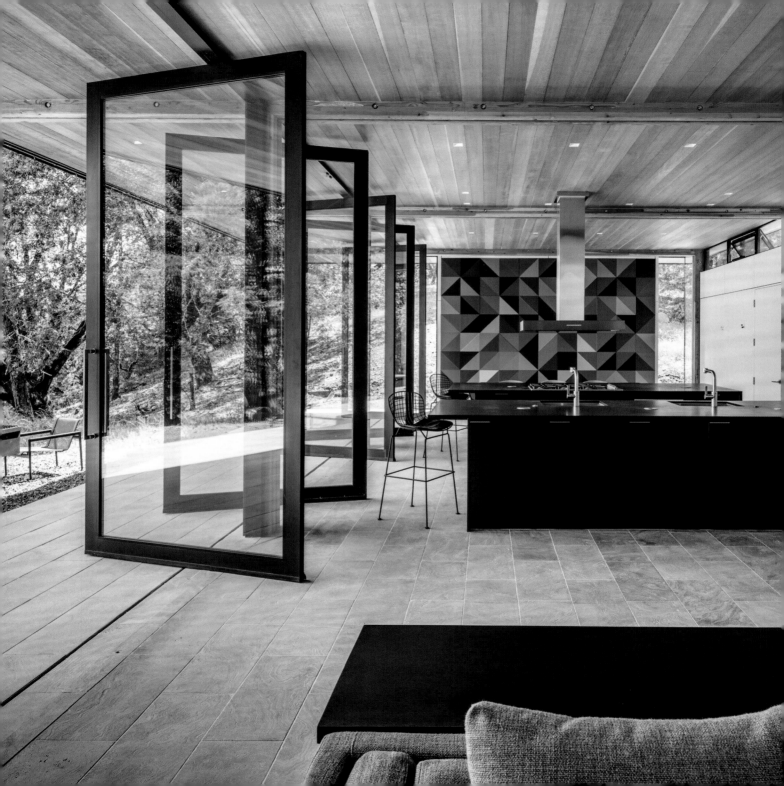

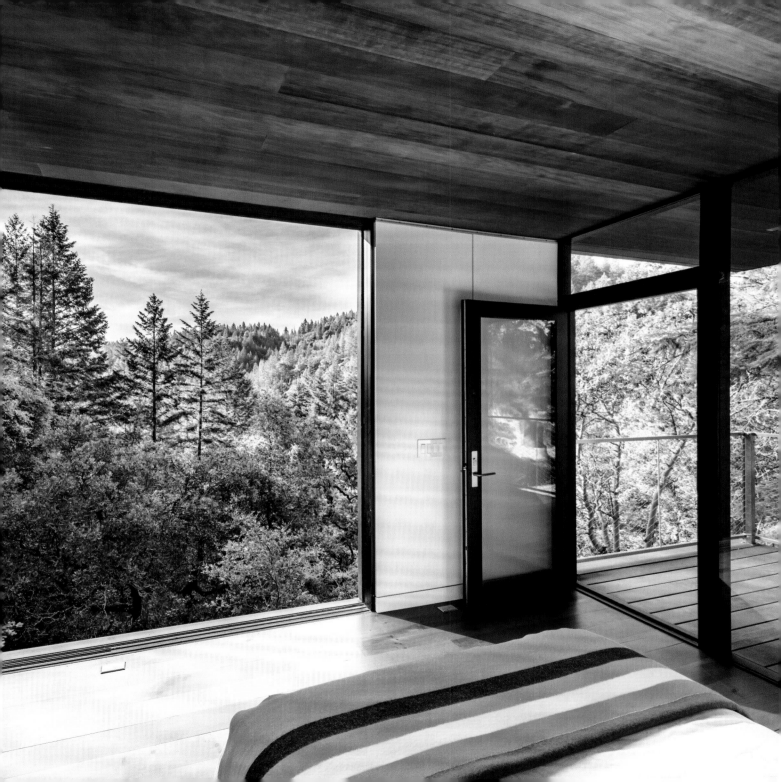

GLASS/WOOD HOUSE
NEW CANAAN, CONNECTICUT

Kengo Kuma & Associates / 2010

Kengo Kuma references Philip Johnson's Glass House (1949) as well a number of houses by Marcel Breuer, all built in New Canaan, for the design of his Glass/Wood House. Built on a 2.5-acre site and with a floor area of 8,934 square feet (830 square meters), this project involves the renovation and extension of the Lee Residence (1956) designed by local architect John Black Lee in the form of a "symmetric glass box." Kuma explains, "We built a new house to make this glass box orthogonal and formed an L-shaped terrain in an attempt to create a kind of 'intimacy' in the forest." The addition has a wooden joisted roof partially set up on three-by-six-inch steel pillars where the site slopes down into the forest. The older house received an exterior cladding of wooden louvers—also to increase the sensation of intimacy. Kuma concludes, "Thus, we worked to realize an 'intimate transparency' or 'mild transparency' to overtake the isolated transparency of the 1950s."

Opposite: The extreme lightness of the structural design makes the house seem like a nearly unsupported glass box hovering in the forest. **Following spread, left:** A glazed wall opens to the forest in an image that speaks of Japan as well as modern Connecticut. **Following spread, right:** Starting with the original "glass box" design of John Black Lee, Kengo Kuma renovated and lightened further, creating an example of pure modernism.

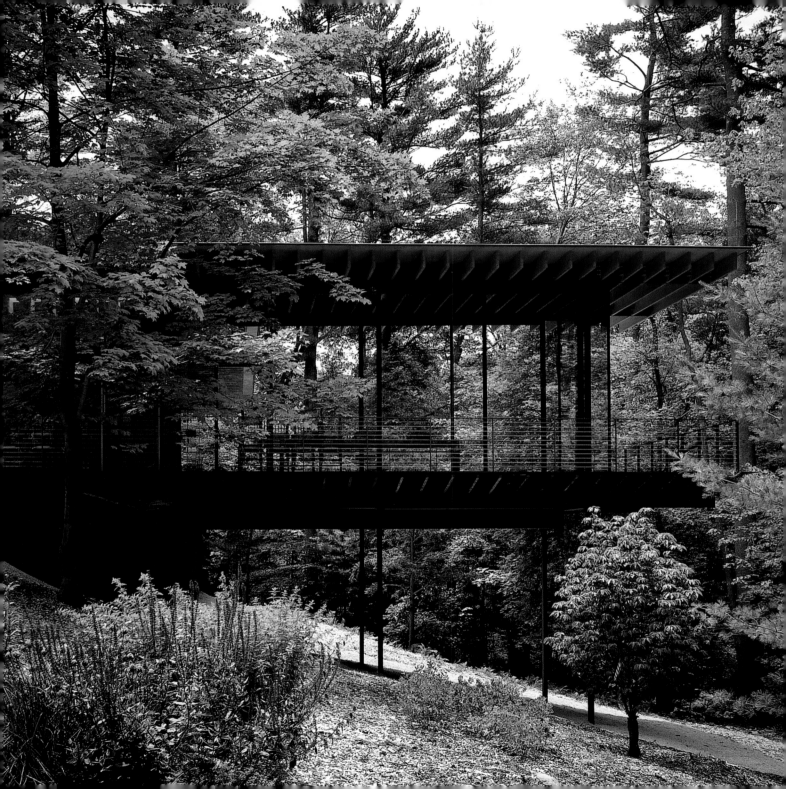

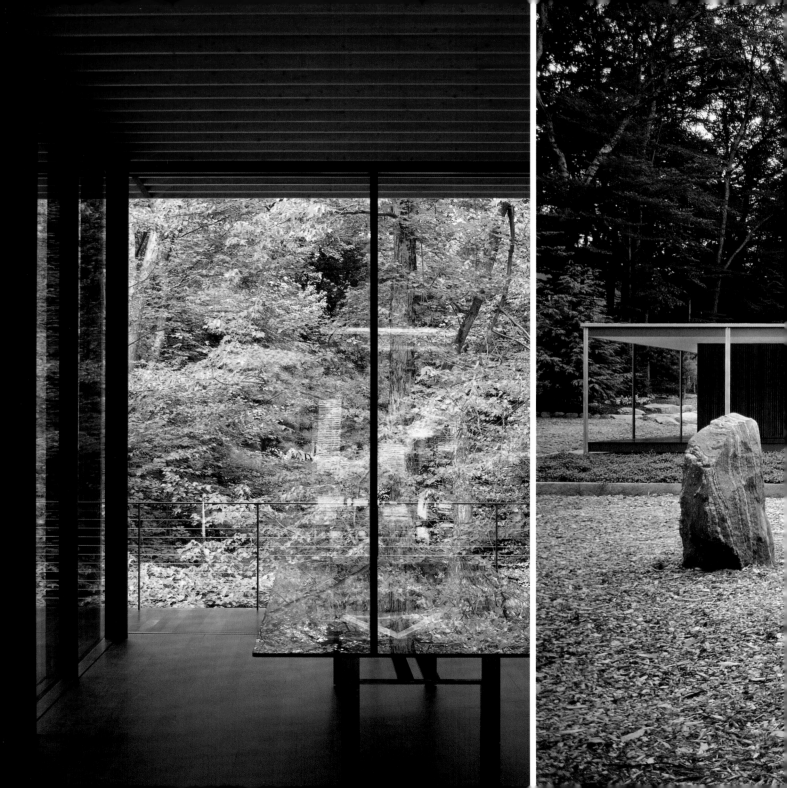

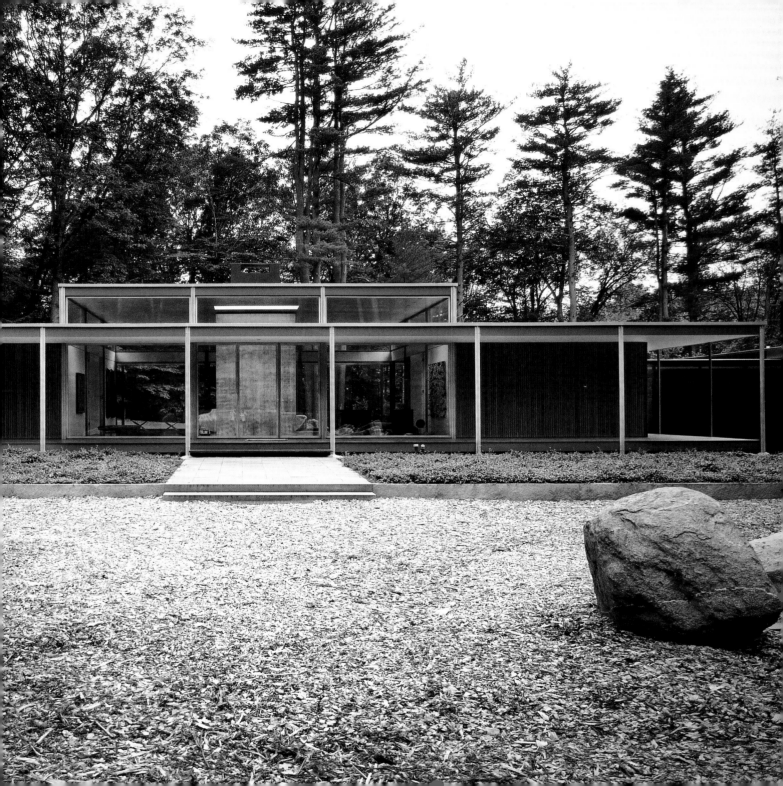

WEEK'NDER
MADELINE ISLAND, WISCONSIN

Lazor/Office / 2011

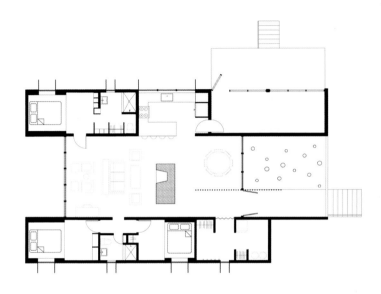

Madeline Island is located in Lake Superior. Construction access to the site dictated the use of two prefabricated modules that were brought by ferry and truck. The assembly was carried out with bottle jacks instead of a crane, utilizing posts to minimize the use of concrete for the foundation. The house has a kitchen, three bedrooms, two bathrooms, and a laundry space. Corrugated metal, plywood, and pine give a "rustic feeling" to the design. Full-height glazing in the main living space and a screened porch make the feeling of proximity to the natural setting more palpable. A "cathedral ceiling" with clerestory windows brings ample light to the interior living space. Wooden floors and bunks made with plywood modules participate in a warm palette of colors and materials inside that contrasts with the black-and-white exterior and the black metal windows and stove pipe. Two steps lead up from the ground to the partially enclosed entrance sequence, which becomes more solid as visitors approach.

Above and opposite: The plan shows a composition made up of rectangular volumes. **Following spread, left:** A wood-burning stove with a long black pipe emphasizes the height of the living space. Light and views come from several different angles. A refined and light screen made of wood partially shields the entrance area of the house. **Following spread, center and right:** Simple black or white furnishings fit in well with the black window frames and light ceilings and walls.

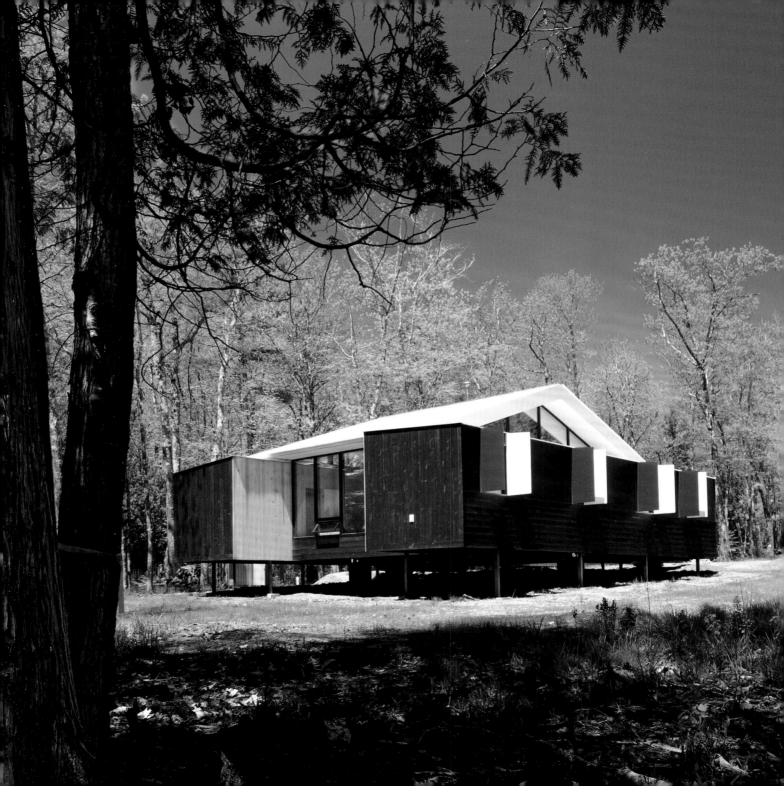

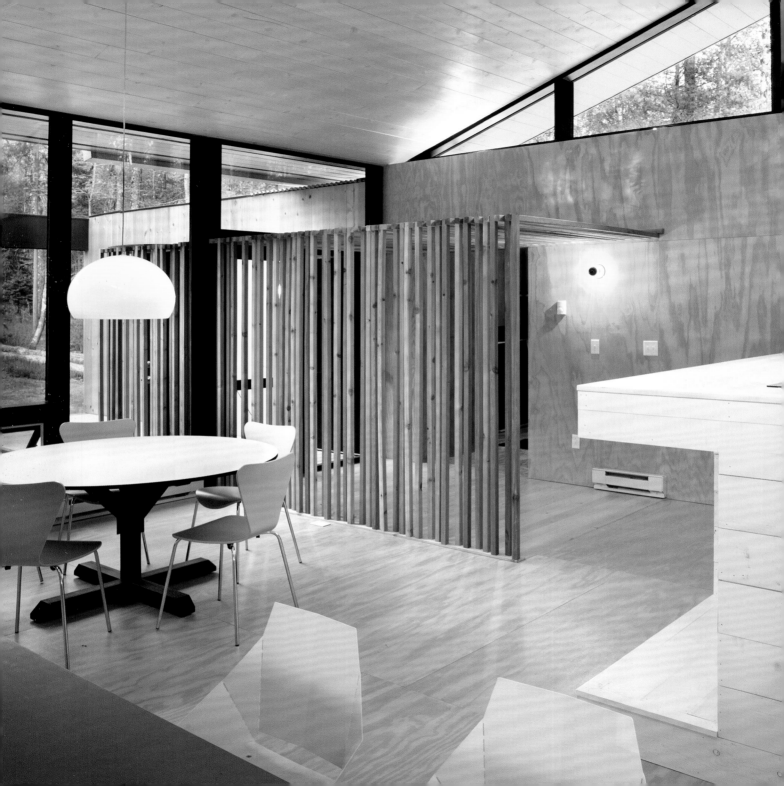

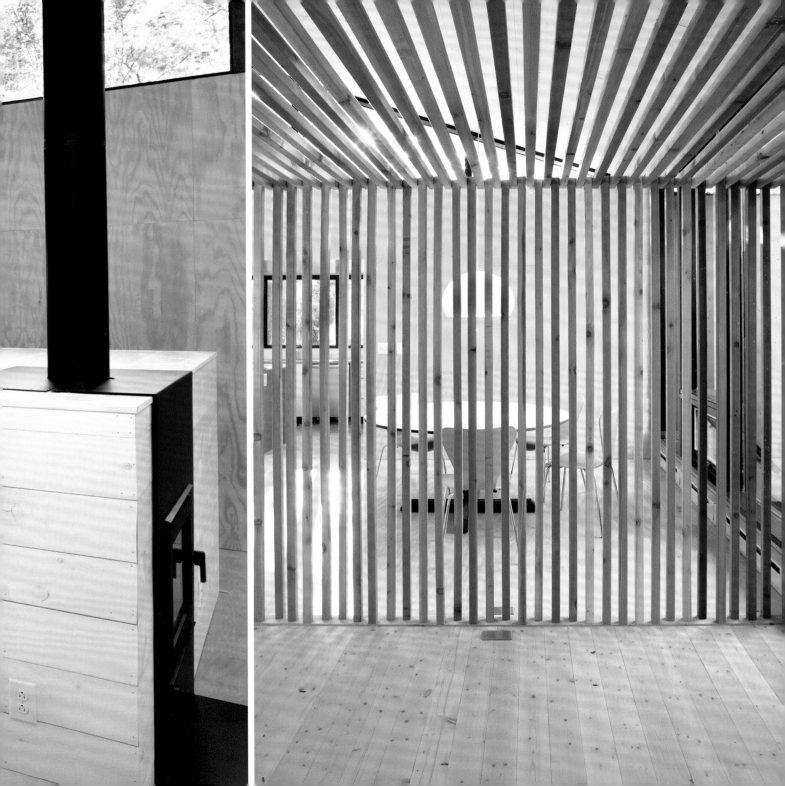

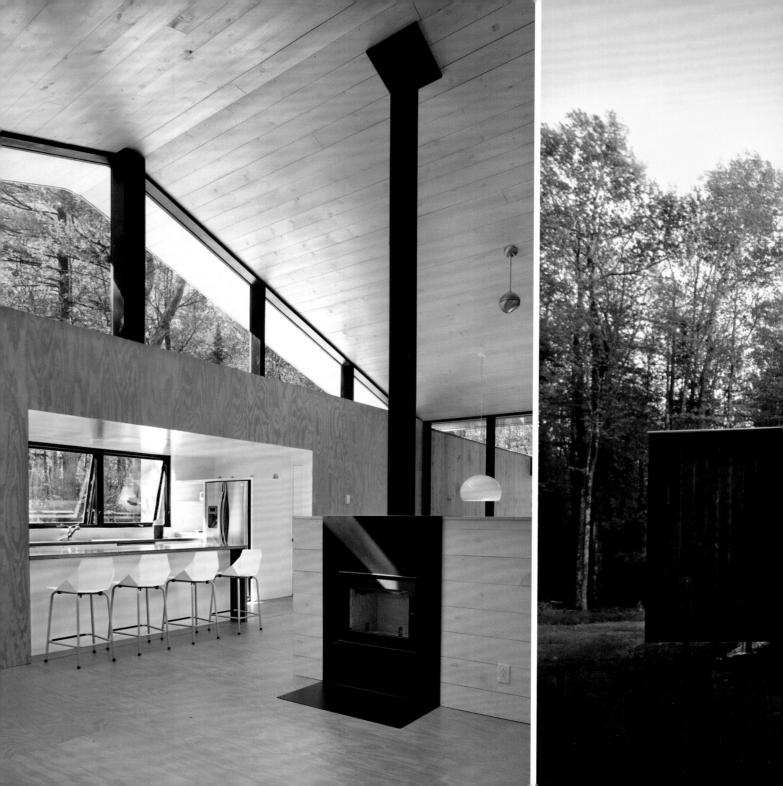

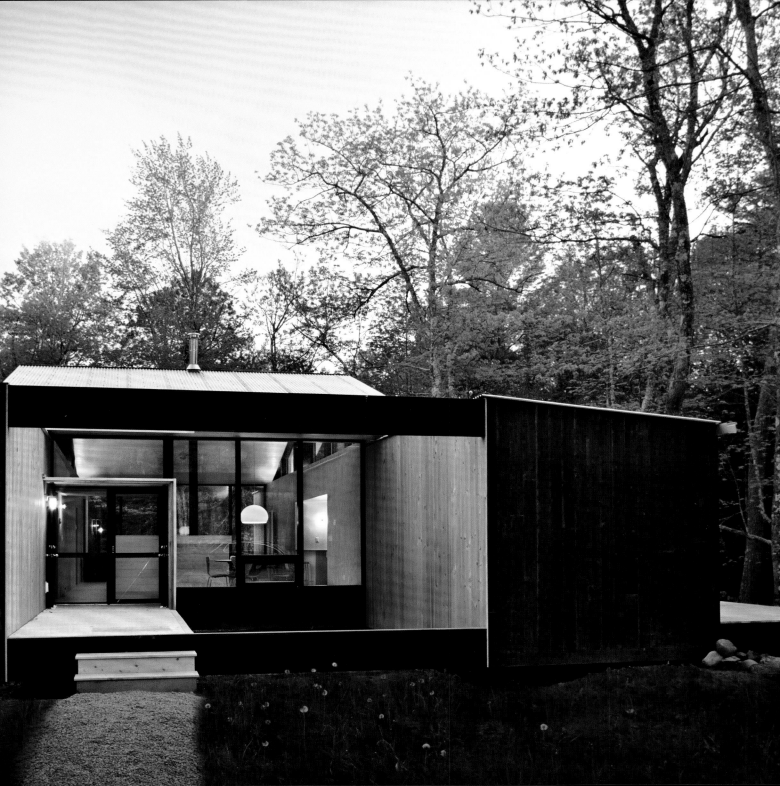

LUNDBERG BREUER CABIN
SONOMA COUNTY, CALIFORNIA

Lundberg Design / ongoing

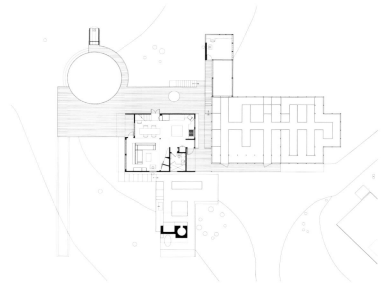

This rather exemplary cabin has been published quite frequently as an example of the use of reclaimed materials and an increasing awareness of ecological issues posed by houses in forest environments. The single-slope roof of the main part of the structure rises up into an almost fully glazed facade, allowing residents not only to view the environment, but also to benefit from ample natural light. Built by Lundberg Design principal Olle Lundberg for himself, this cabin in the redwoods makes extensive use of reclaimed materials from other projects. A large pool, twenty-five feet in diameter and fourteen feet deep, was made with a former water tank for livestock. The exteriors of the cabin are in reclaimed redwood. The floors inside are in multicolored slate, and walls are covered in Montana white pine. A number of the objects in the house, such as the coffee table, are flawed rejects from other firm projects, and the firewood holder was custom designed for the cabin. Construction, which has been ongoing for years, was carried out by Lundberg and his office team. The architect states that recent additions include an outdoor kitchen with a pizza oven, a biological wetlands filter for the pool, and a photovoltaic system, "which we hope will make the project a net-zero energy consumer."

Opposite: With a decidedly "handmade" feeling, this house has continued to evolve over more than a decade. **Following spread, left:** An outdoor bath or swimming pool nearly flush with the wooden terrace was made with a reclaimed water tank. **Following spread, right:** Though the rectangular window panes and furnishings do not necessarily evoke the most recent designs, a spare elegance in the house is evident.

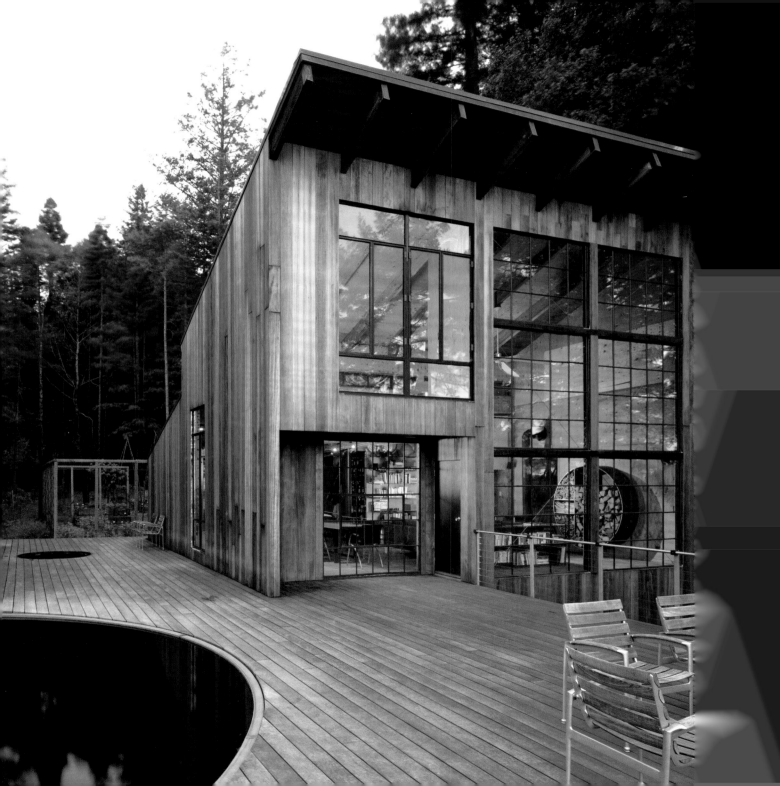

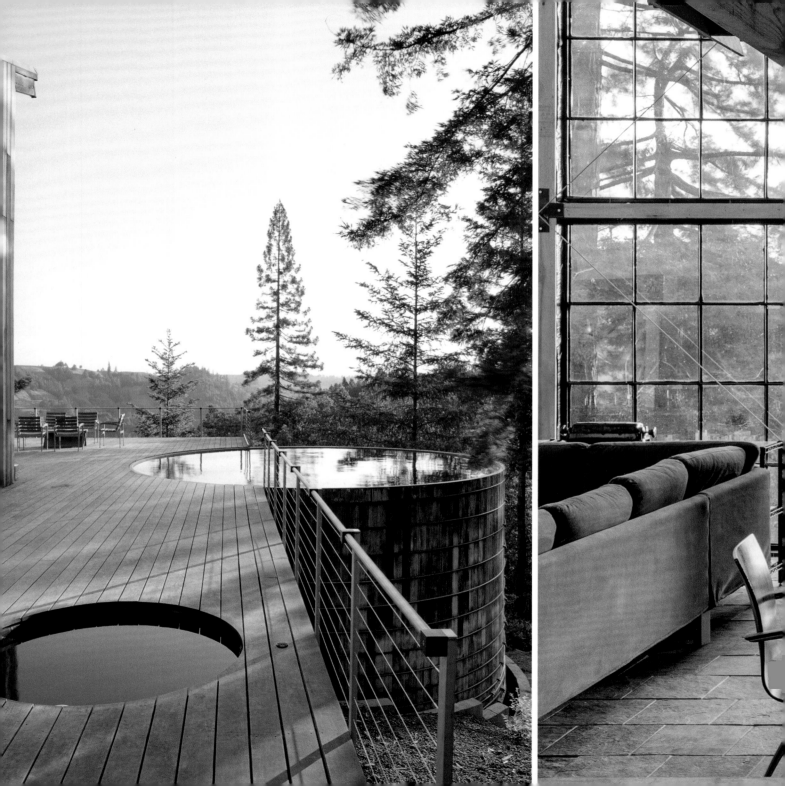

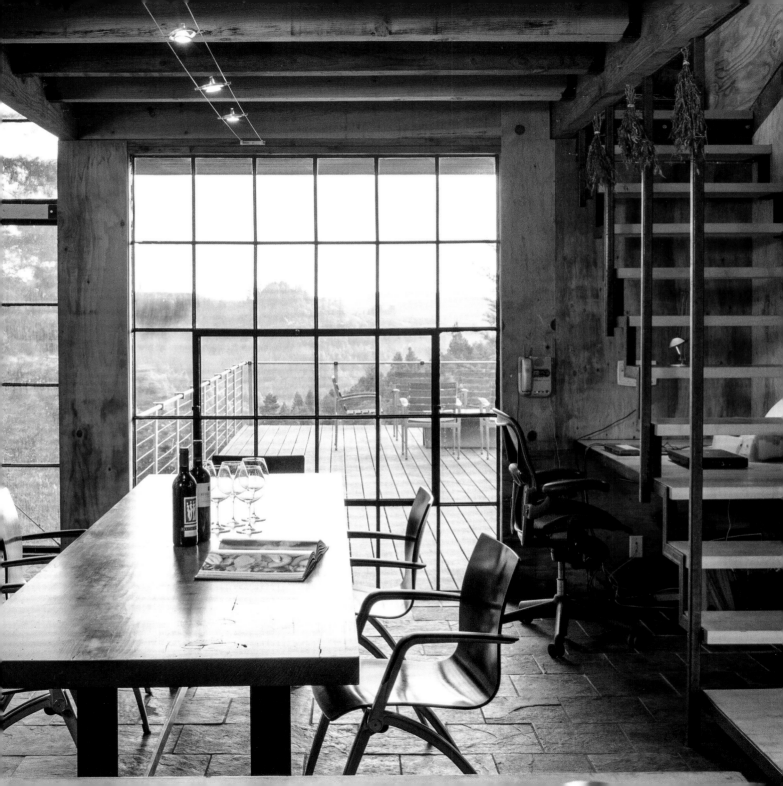

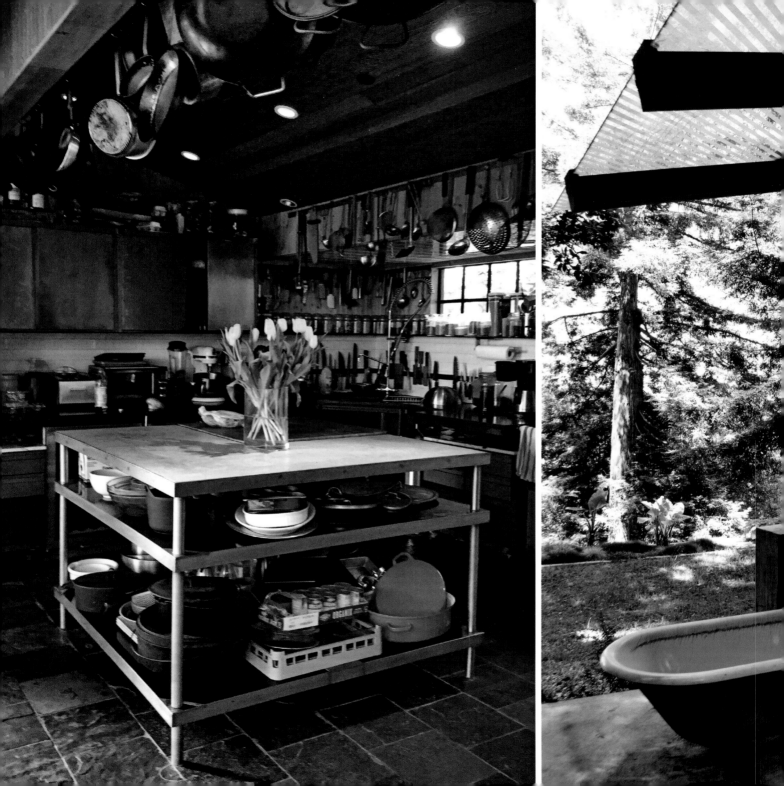

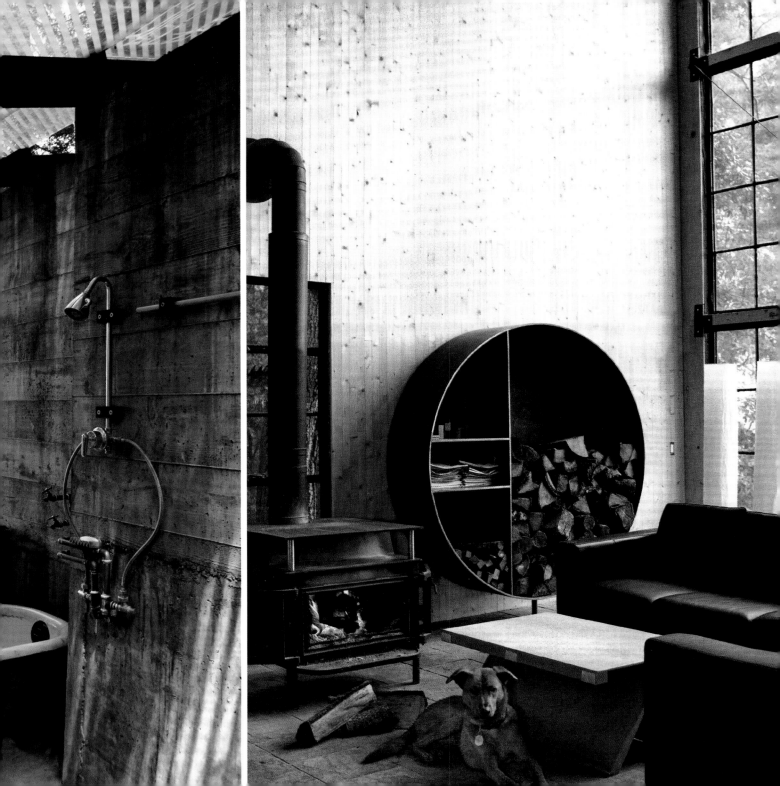

LAKE MANITOUWABING RESIDENCE
MCKELLAR, PARRY SOUND, ONTARIO, CANADA

MJMA / 2018

A new 2,746-square-foot (255-square-meter) all-year residence was commissioned to replace a 1930s building on this same site. A central courtyard outdoor living area is part of a plan to create a space for entertaining while taking in the natural environment and includes a lake deck and screened porch. Three volumes aligned on an east–west axis contain the public living area, the outdoor living space, and finally a private section. Designed to take advantage of passive heating and cooling, the house has overhangs and glazed areas intended to avoid significant solar gain in summer while allowing natural heat gain in winter. The northern and eastern facades are, as the architect states, "heavily opaque, minimally articulated, and highly insulated to protect from winds and heat loss." Cross-ventilation through the use of operable windows is possible. Concrete floors with radiant heating,

low-emissivity glazing, an efficient boiler, and a convection wood stove are part of an overall energy-saving scheme. The precise location of the structure and its design were intended to minimize the loss of existing trees on the site. "It provides clean lines, abundant light, and connection with nature while achieving a humble and contextual form that harmonizes with its context," the architect states.

Opposite: Thin, full-height window frames give the house an airy lightness. A large boulder sits in gravel, justifying comparison to Japanese designs. **Following spread, left:** The living room and fire place allow residents to take in the lake in the comfort of their own private space. **Following spread, right:** A wall clad in vertical wood strips and a wooden dining room table accentuate the relationship of the modern house to its forested location.

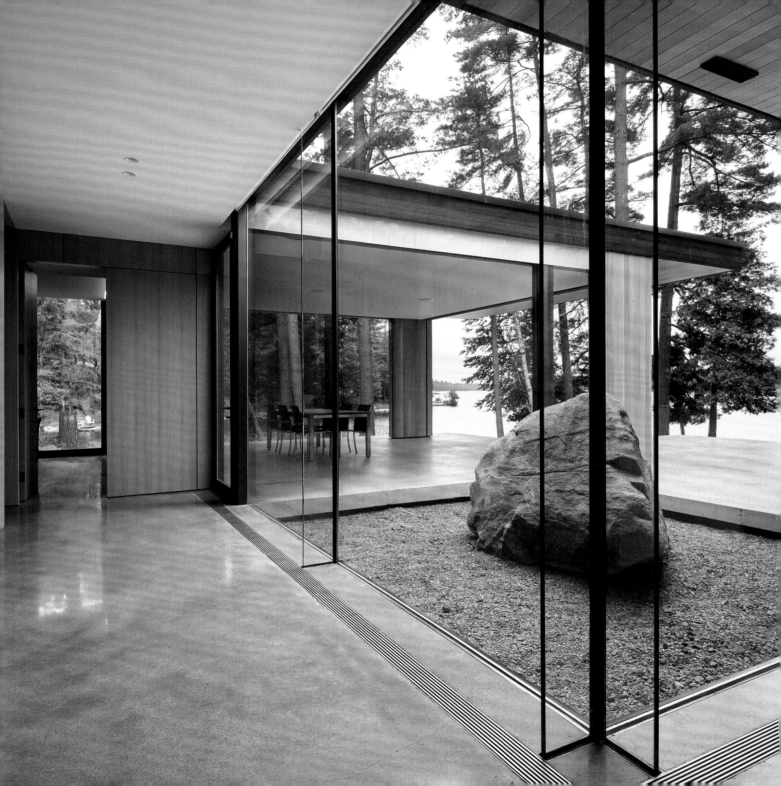

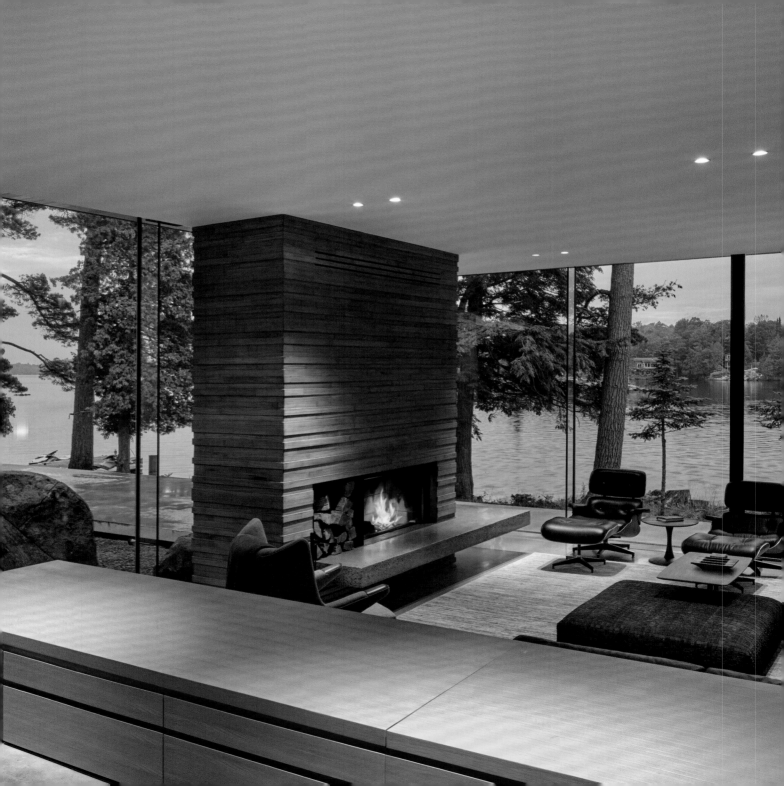

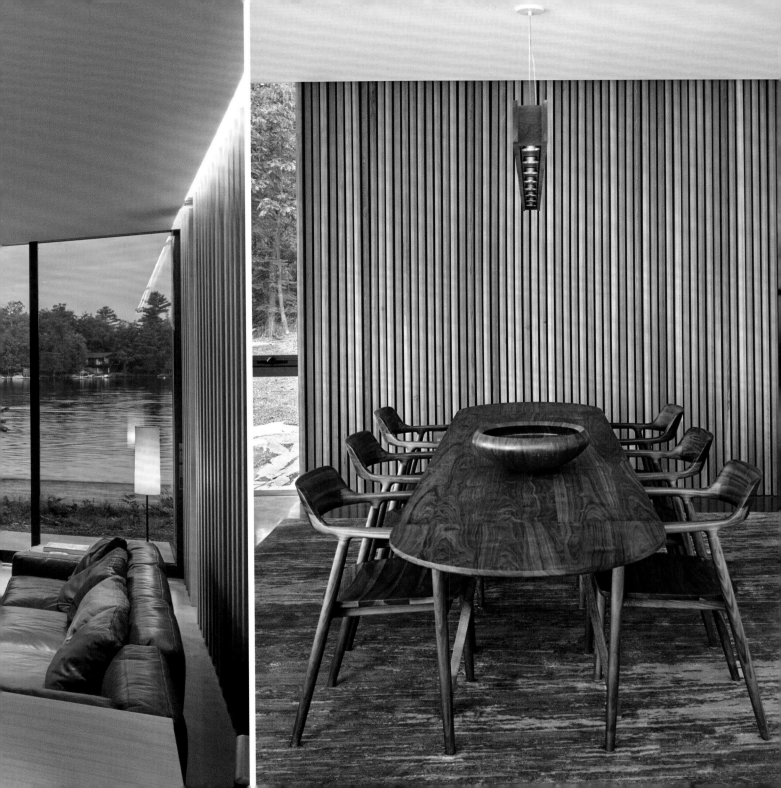

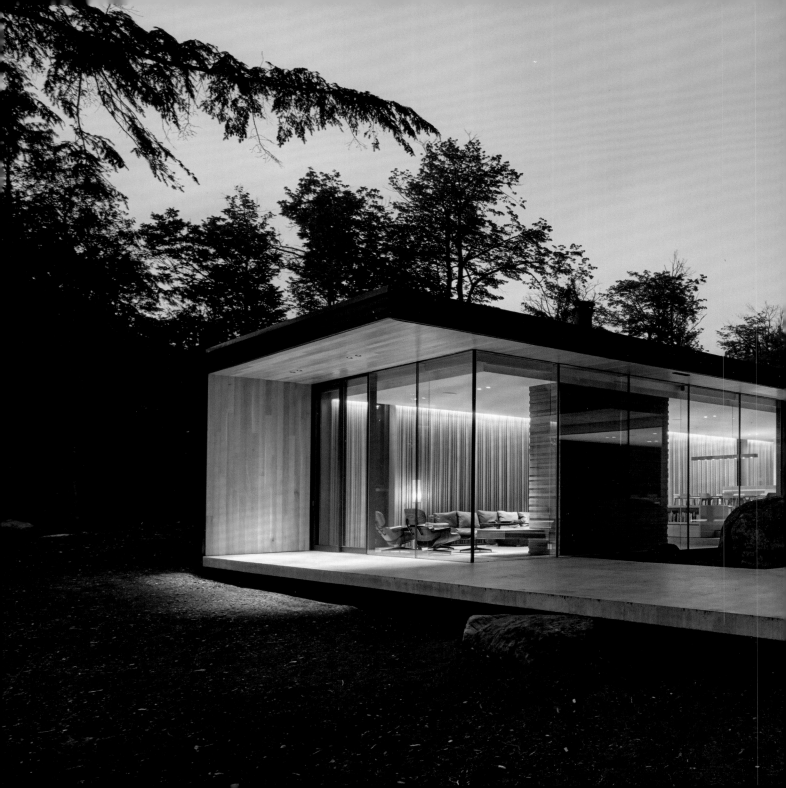

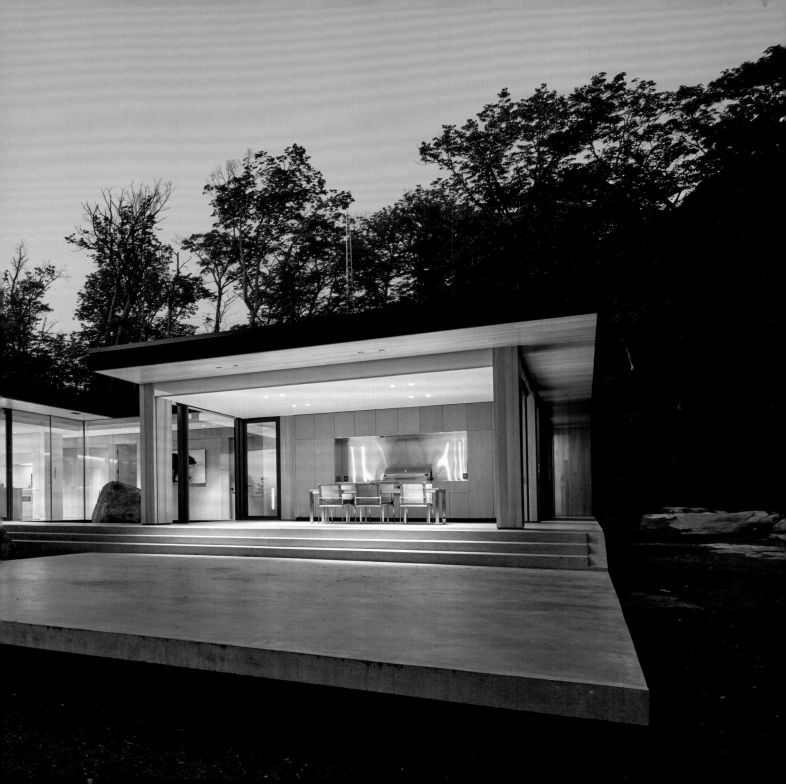

GAMBIER HOUSE
GAMBIER ISLAND, BRITISH COLUMBIA, CANADA

Office of McFarlane Biggar Architects + Designers / 2014

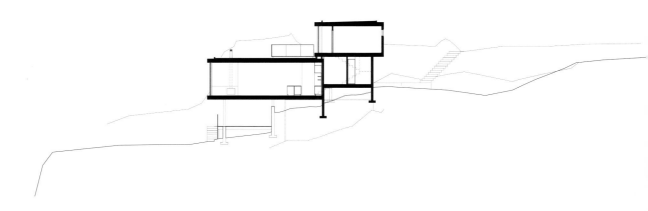

Gambier Island, considered rugged and sparsely populated, is located in Howe Sound near Vancouver. This house was built on a 7.3-acre site and intended for a young Vancouver couple and their two children. It is located at the top of a steep cliff on the northeast coast of the island. The design for this off-grid house "touches lightly on the ground" to lessen its impact on the natural setting. The residence is accessible only from the water, which necessitated minimal amounts of construction material. The three-bedroom house includes an open-plan kitchen, dining, and living space. It is made up of two stacked boxes clad in insulated glass, cement board, and wood. The interior ceilings and floors of the 1,700-square-foot (158-square-meter) house are in Douglas fir. Large wooden decks allow the setting to be enjoyed in a comfortable way without unduly perturbing the island.

Opposite: The house sits on a steep, rocky site, and although it appears to be thoroughly modern, it is entirely respectful of the natural setting. **Following spread, left:** The kitchen, dining, and living volume has a nearly uninterrupted view of the water. Wooden ceilings and floors emphasize the rapport with the exterior. **Following spread, center:** The kitchen and the stairs leading to the bedroom area are entirely modern in design, using wooden surfaces and windows to engage with the island location.

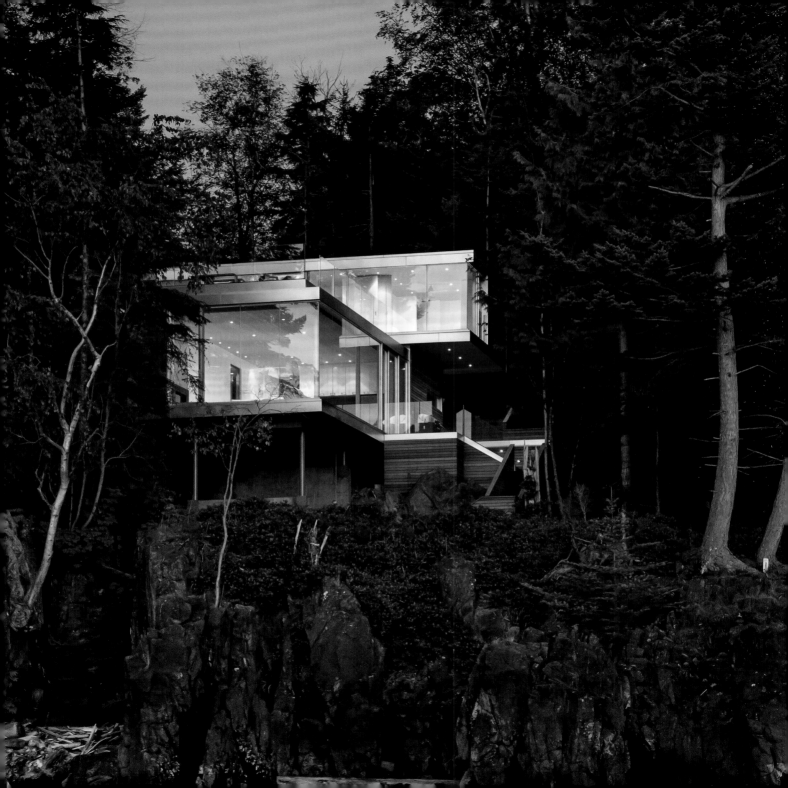

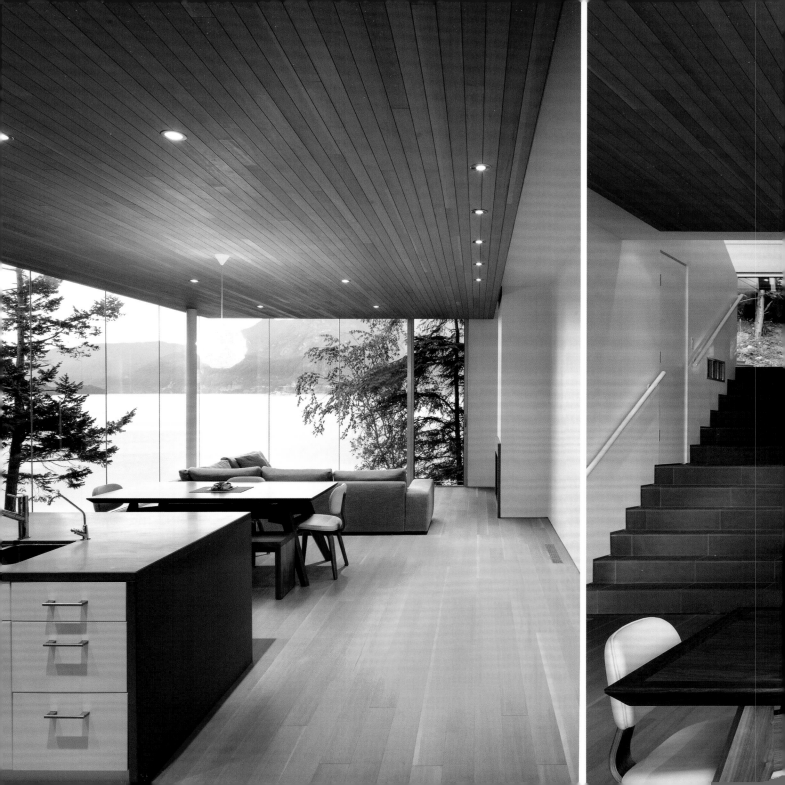

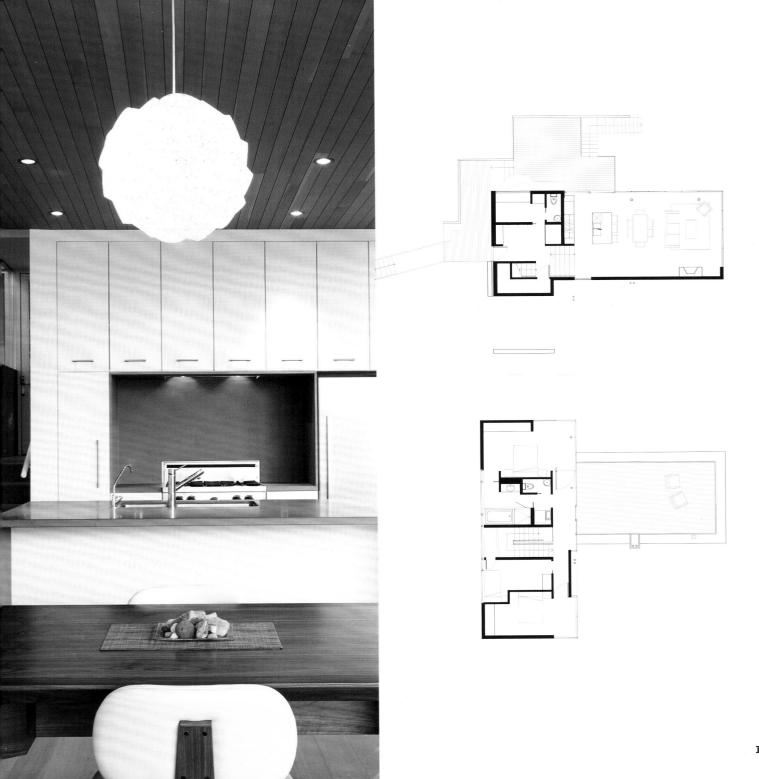

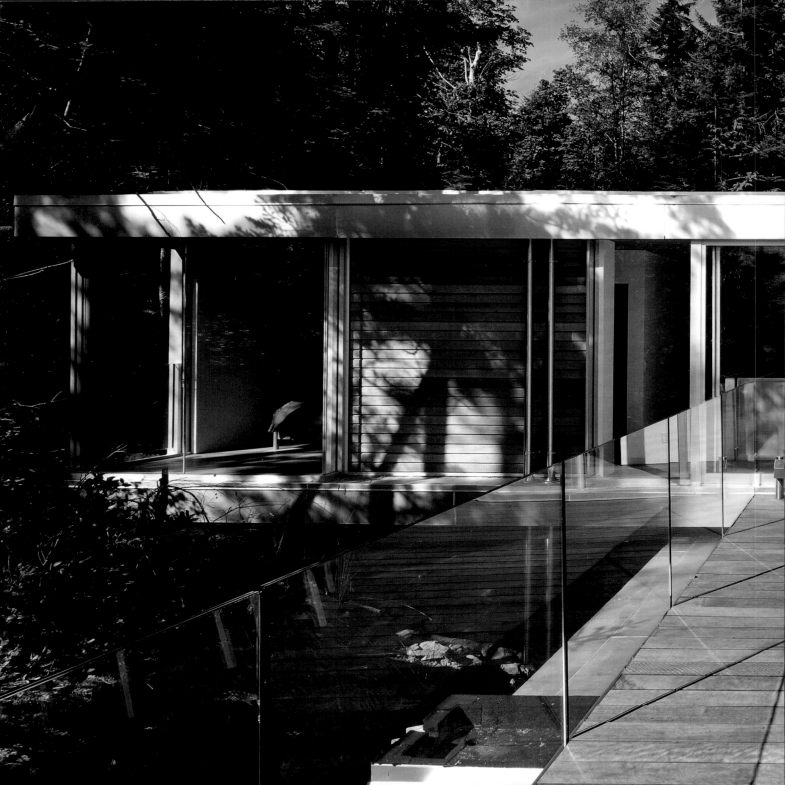

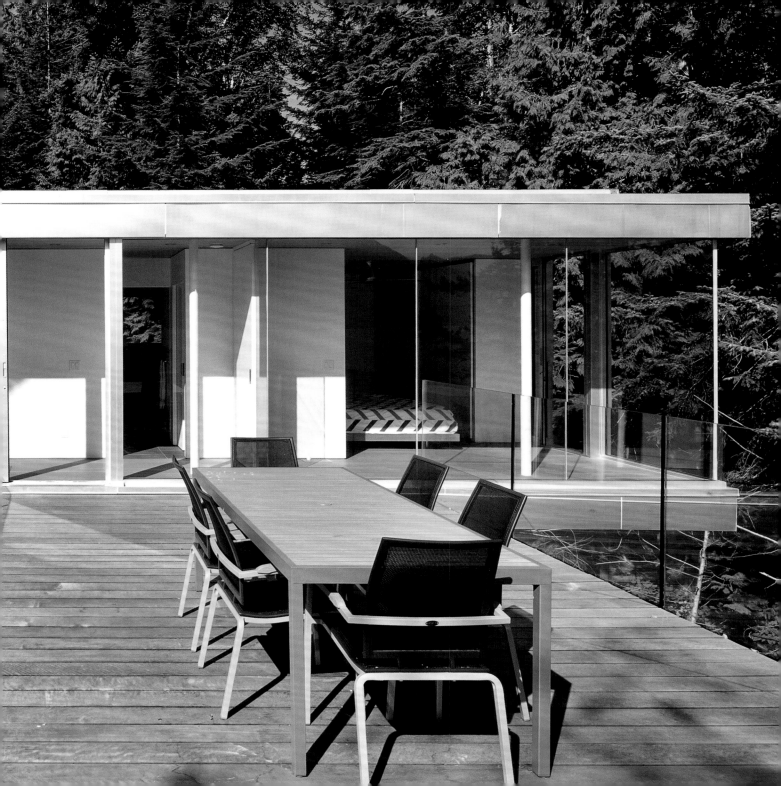

CHECHAQUO LOT 6 CABIN
METHOW VALLEY, WASHINGTON

Prentiss + Balance + Wickline Architects / 2016

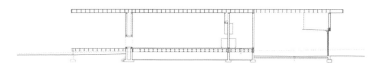
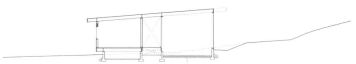

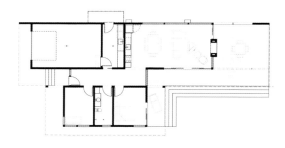

This small cabin is in a meadow surrounded by ponderosa pines in Methow Valley near Mazama, Washington, close to North Cascades National Park. A winner of a 2018 Merit Award from the American Institute of Architects Spokane chapter, the house has a kitchen, living, and dining space and a covered outdoor area with an "indoor/outdoor" hot-rolled steel plate fireplace. A smaller section of the house contains a bedroom, a bathroom, and a flexible space. The house has a black standing-seam metal roof and siding on the rear side, with shiplap Douglas fir siding finished with a dark navy stain facing the meadow. The interiors and outdoor living space of the cabin, which was built with a limited budget, are clad in plywood, and the deck is in ipe wood. The deck is low enough that no guard rails are necessary. Interior concrete floors have a radiant heating system. Lifted slightly off the ground, the cabin appears to hover above the meadow grasses in the summer.

Above and opposite: As visible in the drawings and the photo, the cabin is extremely simple and sits lightly on its forest site. **Following spread, left:** The living space of the cabin makes a very different impression of luxury and taste—elements not often associated with cabins in the woods. **Following spread, right:** The kitchen and dining space is modest but modern, efficient, and attractive.

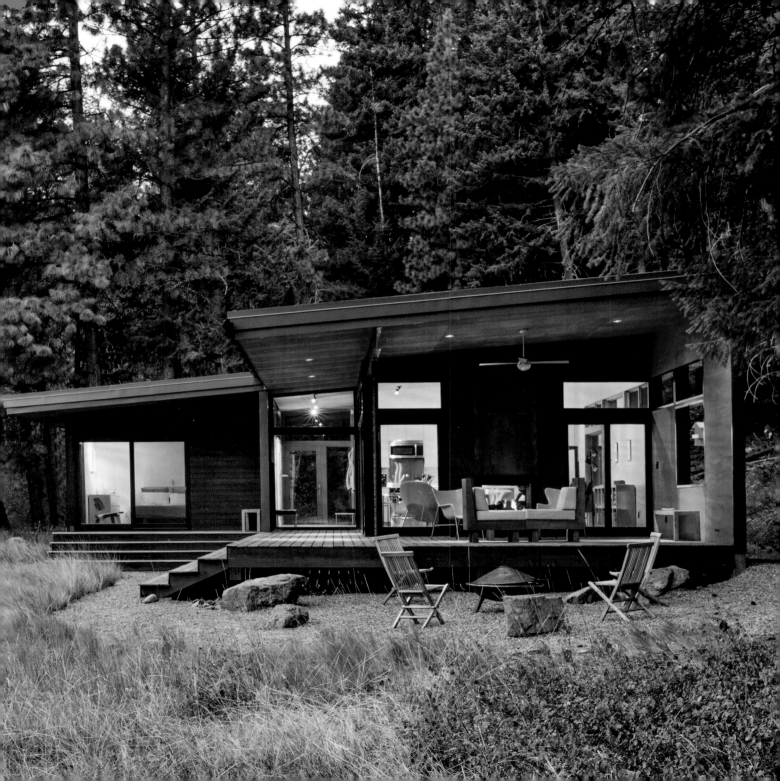

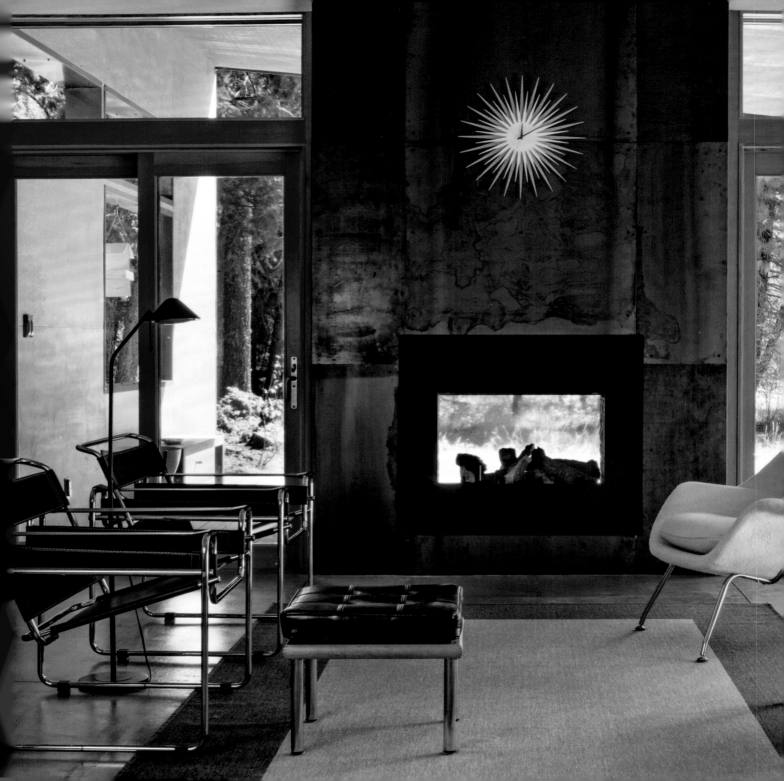

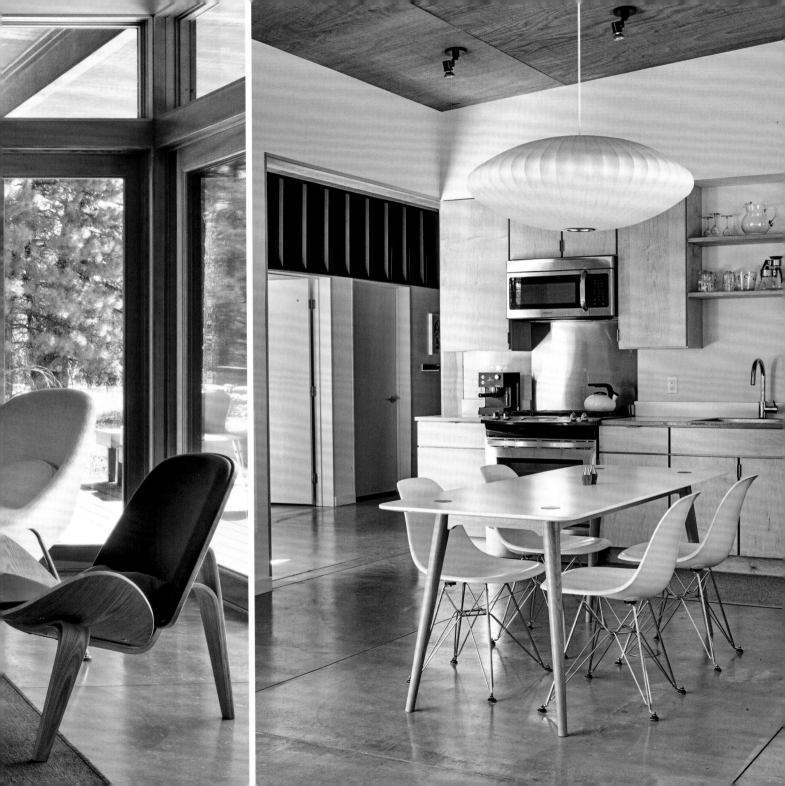

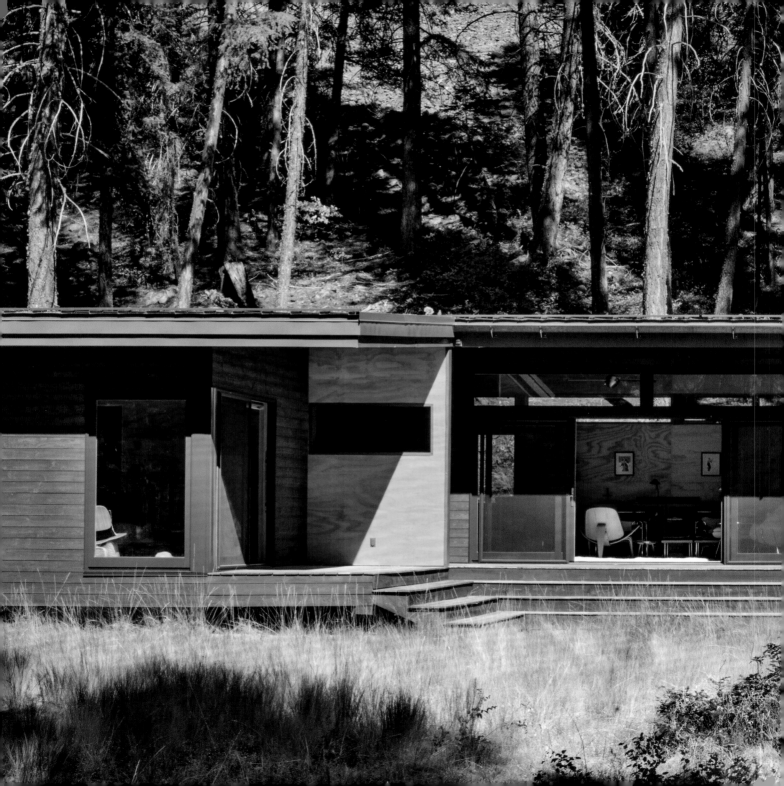

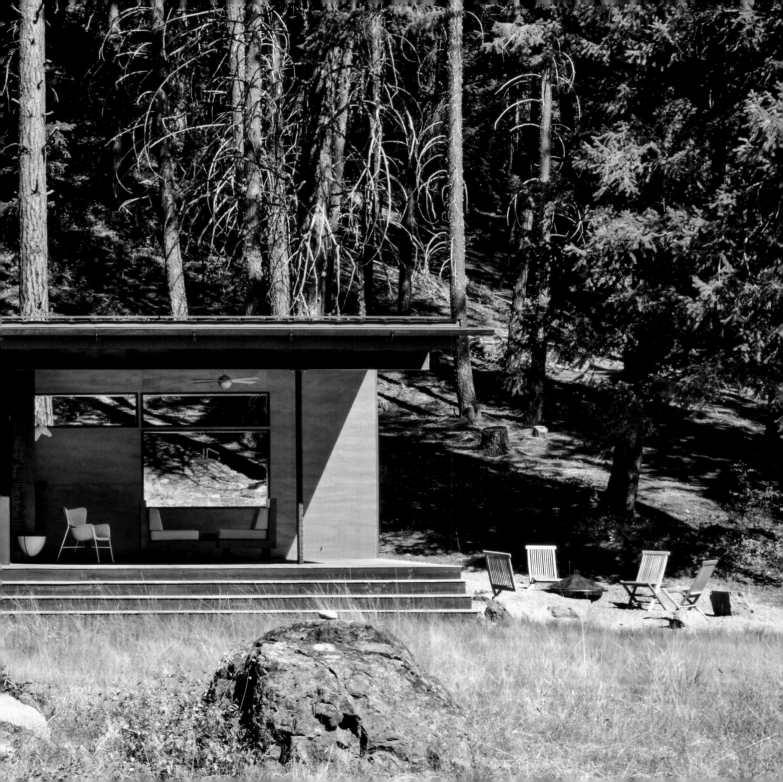

HAYES RESIDENCE
BERKELEY SPRINGS, WEST VIRGINIA

Travis Price Architects / 2013

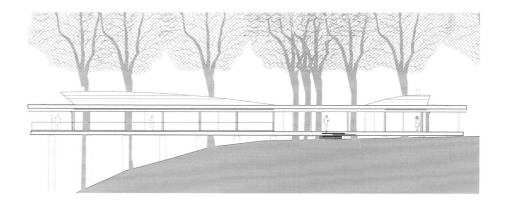

The 2,000-square-foot (186-square-meter) Hayes Residence was built on a five-acre site near the Potomac River. The main section of the house contains a bedroom and a kitchen, dining, and living area. The plan also includes a guesthouse, connected by the deck, with a bedroom and bathroom. Existing trees on the steep site were preserved, some of them growing up through openings in the outdoor terrace and some through the house itself. The structure of the residence is based on a wood truss, with steel beams and columns. Main materials are patinated copper for the roof, maple plywood ceilings, and Brazilian slate floors. "Super-insulated" storefront glazing is part of a sustainability scheme that also emphasizes natural cross-ventilation and shading from the trees, as well as materials that "require the least environmental degradation for their life," according to the architect. Slightly lifted off the ground, the Hayes Residence, with its integrated trees, is a modern yet nonintrusive presence in the dense forest environment.

Above and opposite: The residence is formed essentially from two slabs and is held up on the lower end of the sloped site by thin columns. **Following spread:** The interior of the house is fully glazed. Existing trees on the site were preserved and integrated directly into the architecture, heightening the impression of a direct connection with the woodlands outside.

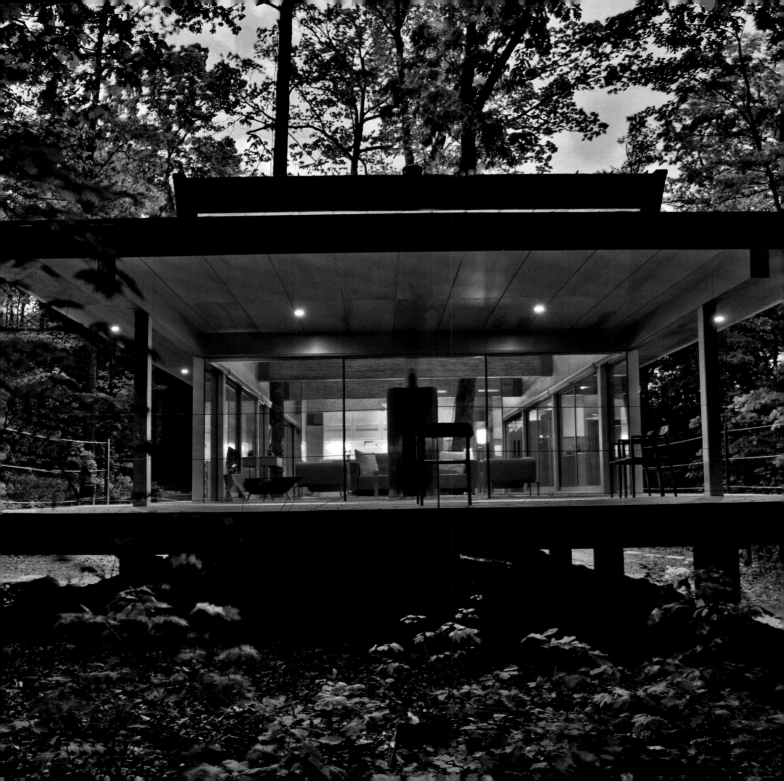

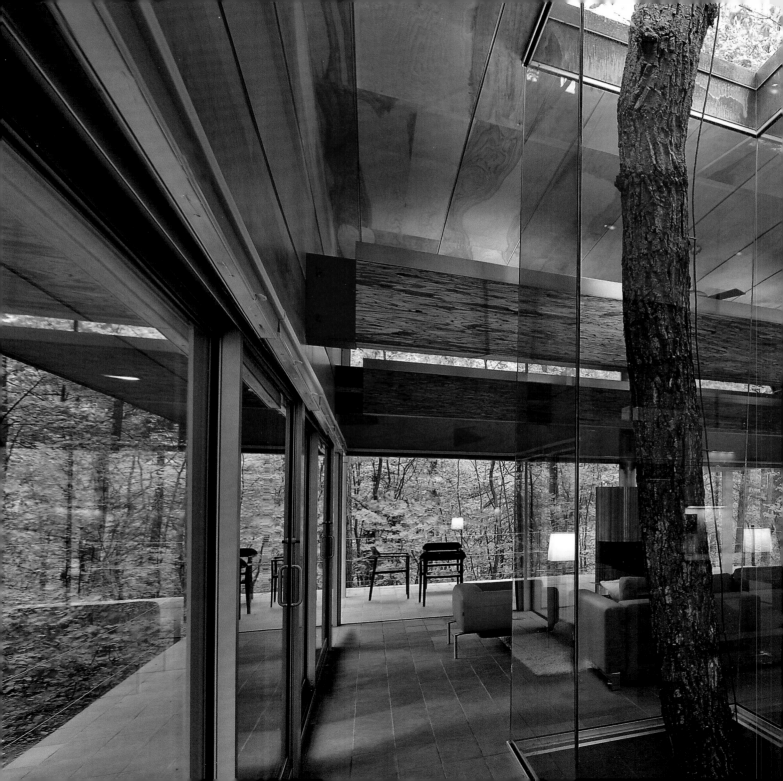

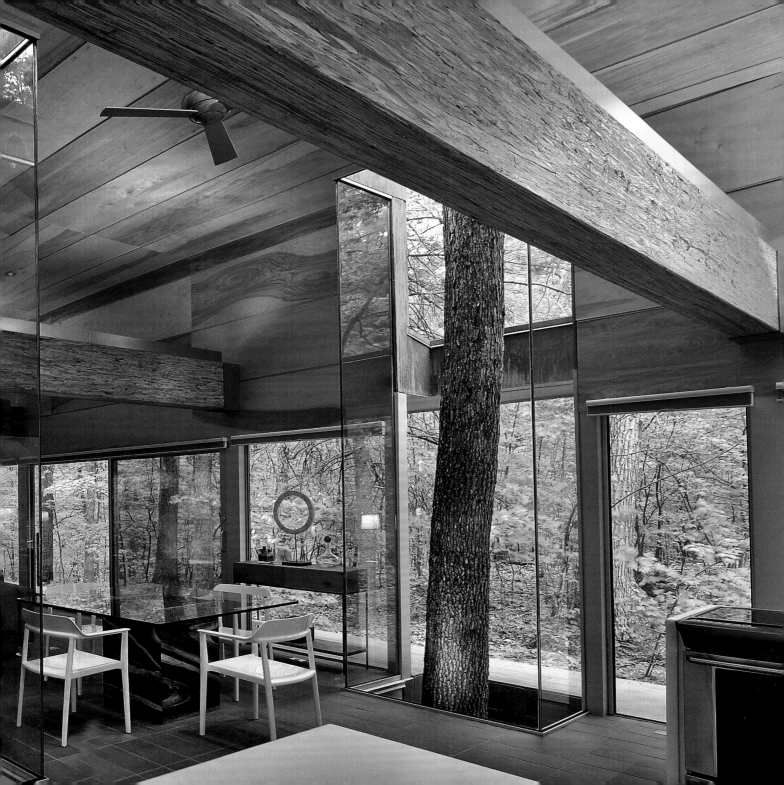

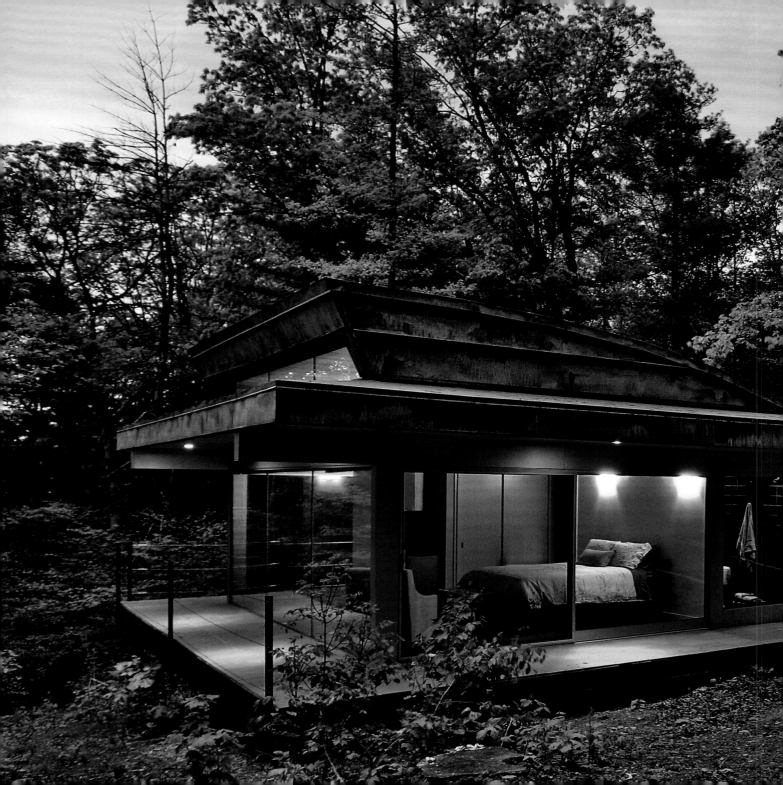

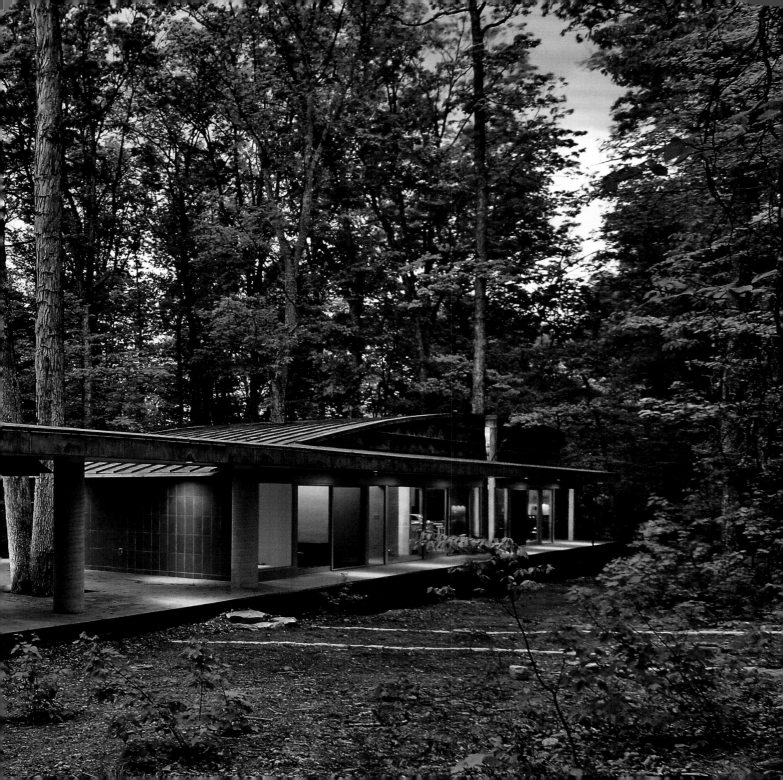

OAK PASS MAIN HOUSE
BEVERLY HILLS, CALIFORNIA

Walker Workshop / 2015

Walker Workshop served as both architect and general contractor for this large 8,000-square-foot (743-square-meter) house. The public areas are situated above the bedrooms, which are below grade but still open because of the sloped site. Courtyards bring natural light into the lower area, and the upper section is broadly glazed. The house has a green roof that is planted with edible herbs. Despite being in Beverly Hills, above Los Angeles, the site has over 130 native coast live oaks (*Quercus agrifolia*) that were preserved during construction. The house has a long infinity swimming pool that cuts the house in two. Cast-in-place concrete is visible on numerous interior and exterior surfaces, contrasting with the dark wood floors and cabinetry. Gently stepped terraces create generous outdoor living spaces. Despite the obviously luxurious nature of the house, it is understated in its colors and forms, allowing the presence of the trees to gently harmonize it with the natural setting.

Opposite: Sitting between a pond and an elevated forest viewpoint, this part of the house is almost entirely clad in glass. Its modern lines contrast with the trees even as it emphasizes views of nature. **Following spread, left:** Dark floors, wooden walls, and cladding—but above all, full-height glazing—characterize the dining and living space of the house. **Following spread, right:** A plan of the house shows the topographic lines that indicate slopes, revealing the complexity of the design.

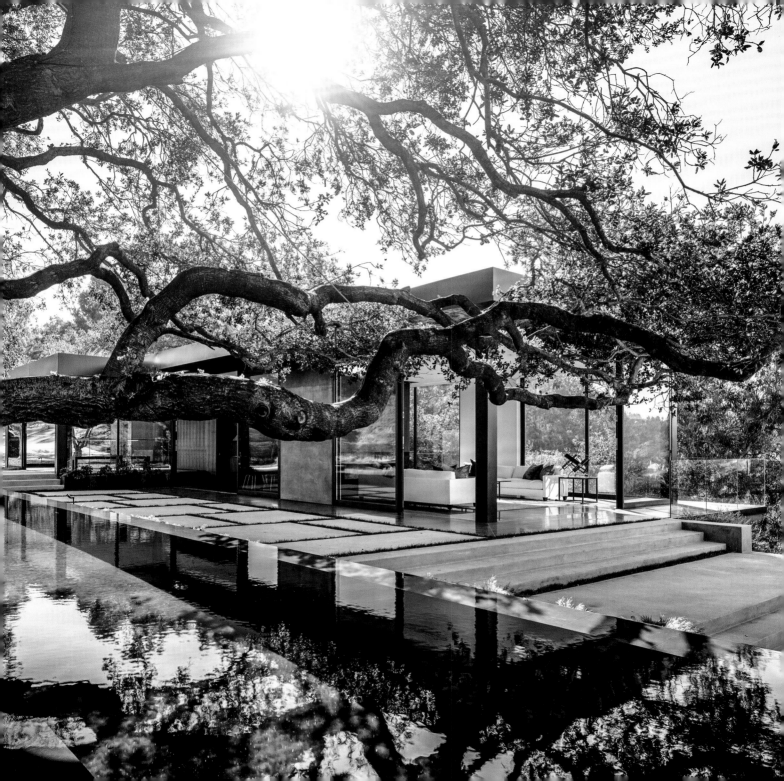

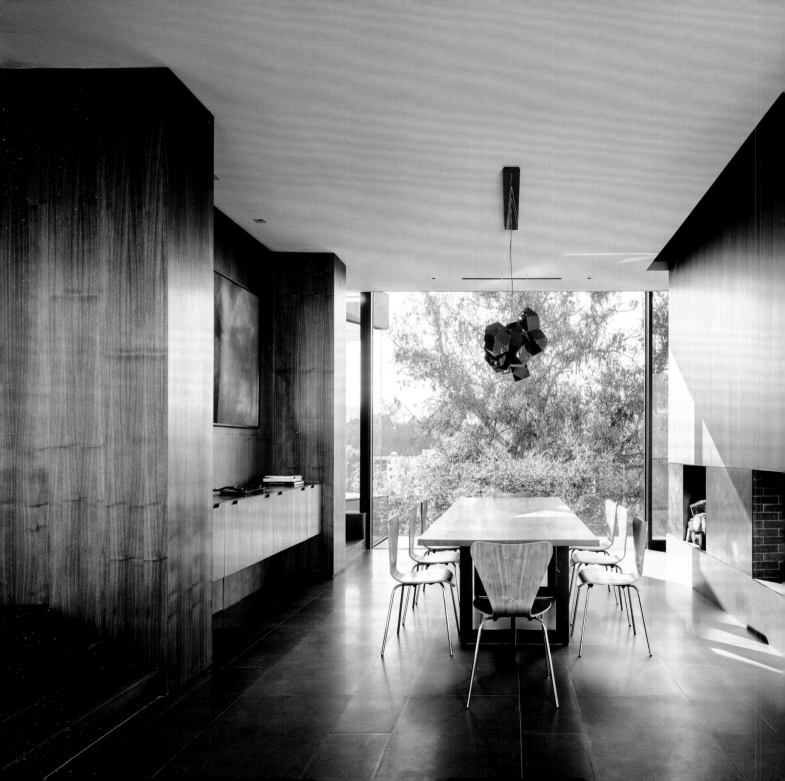

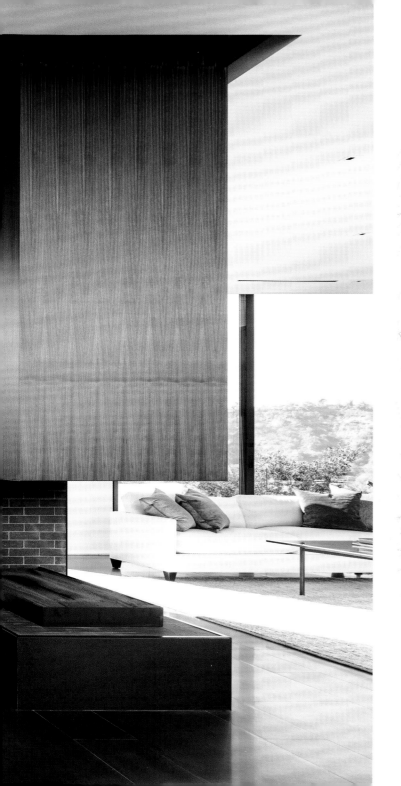

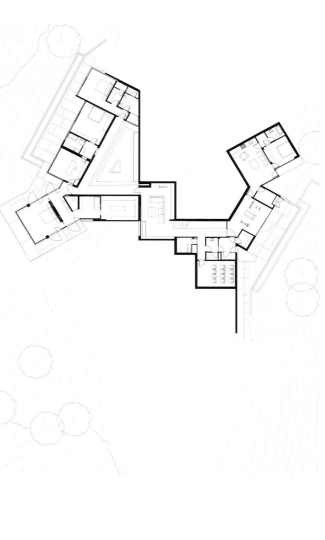

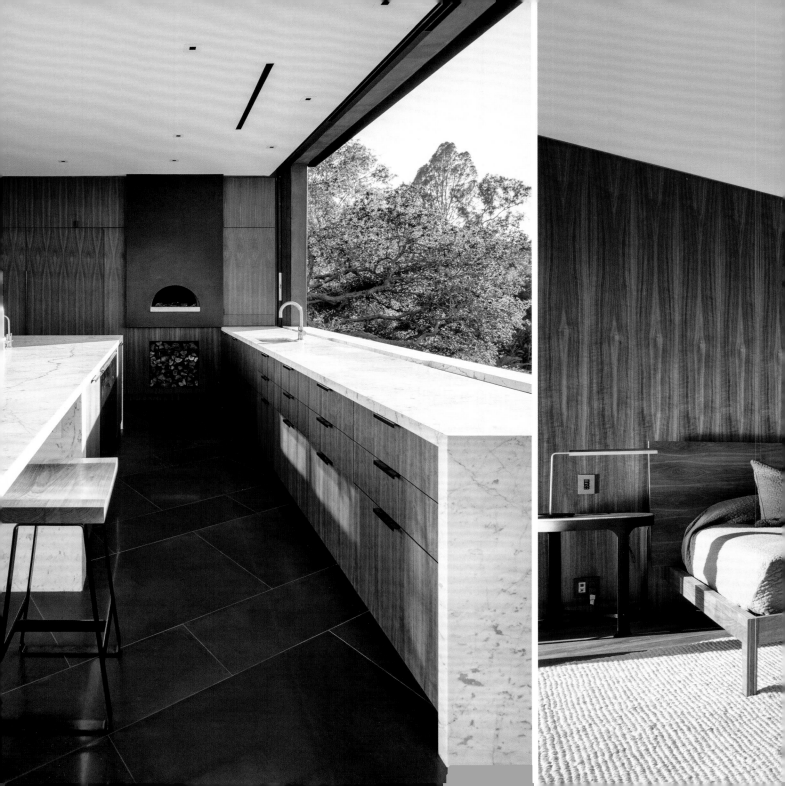

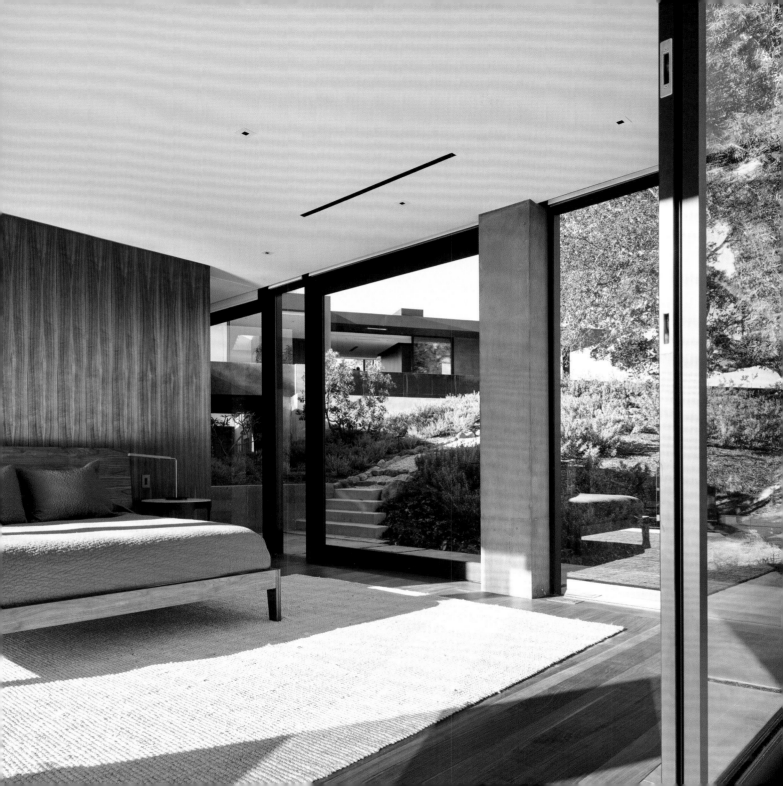

LA COLOMBIÈRE
SUTTON, QUEBEC, CANADA

YH2 Architecture / 2015

This 1,300-square-foot (120-square-meter) cabin has an unusual history: it was originally built as a one-story storage space for a lumberman and then was made into a forest refuge. The architects, YH2, further converted it into a three-story residence without increasing the footprint in 2015. The main reason for this was to avoid cutting trees near the house, which is clad in dark cedar shingles. The interior is entirely painted in white. A living space with a black wood stove marks the ground level. A light stairwell connects to the upper levels and creates a vertiginous vertical shaft through the building. An exterior covered terrace was placed on the uppermost level. The architects say that the structure reminds them of a birdhouse perched in the forest, hence the name La Colombière, which means "a house for doves" in French. The project won a 2015 Prize of Excellence in Architecture from the Ordre des Architectes du Québec.

Opposite: The high narrow form of the house reveals something of its origins. Its dark cedar cladding implies a certain unity with the forest setting. Broad windows allow residents to take in the environment. **Following spread, left:** Aside from black window frames and the wood-burning stove, the interiors emphasize light colors. A full-height sliding glass door is the threshold between inside and out. **Following spread, right:** Plans reveal the orthogonal nature of the overall design and show the broad openings that allow the house, which appears rather closed from the exterior, to open out.

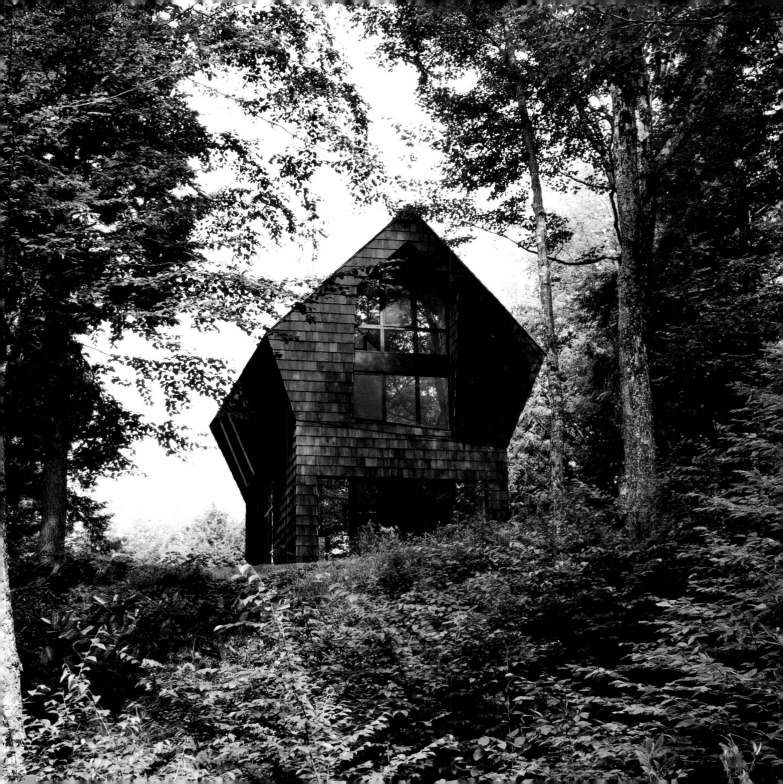

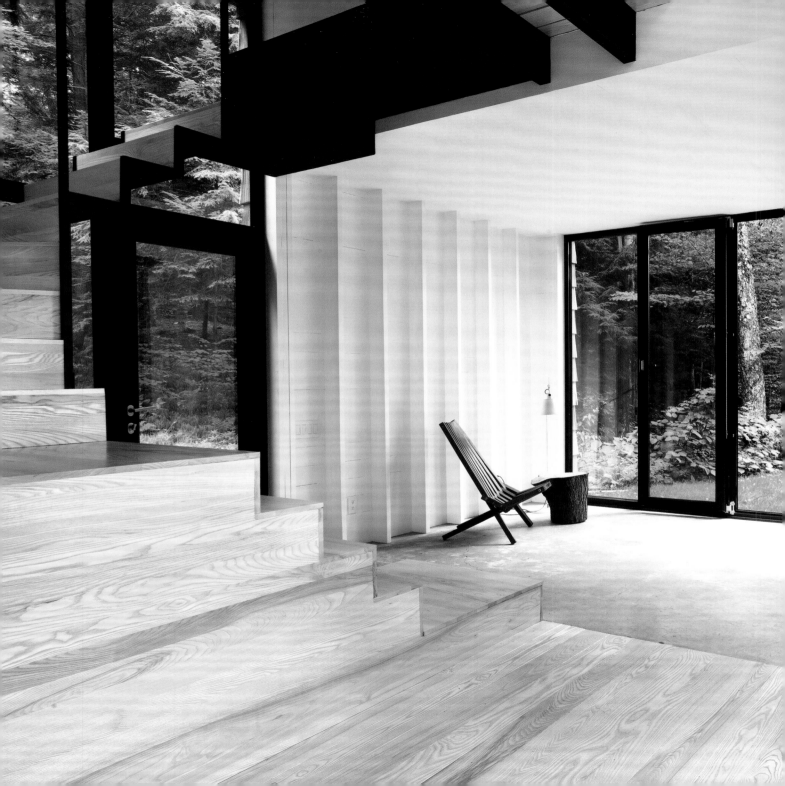

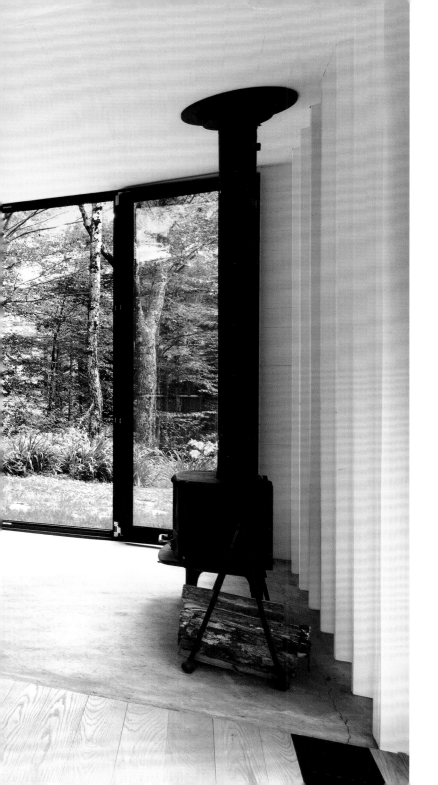

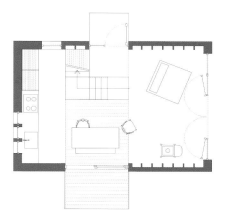

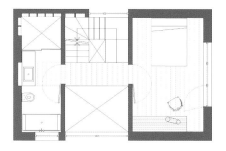

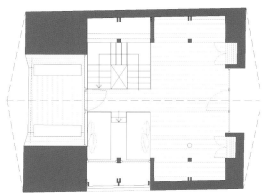

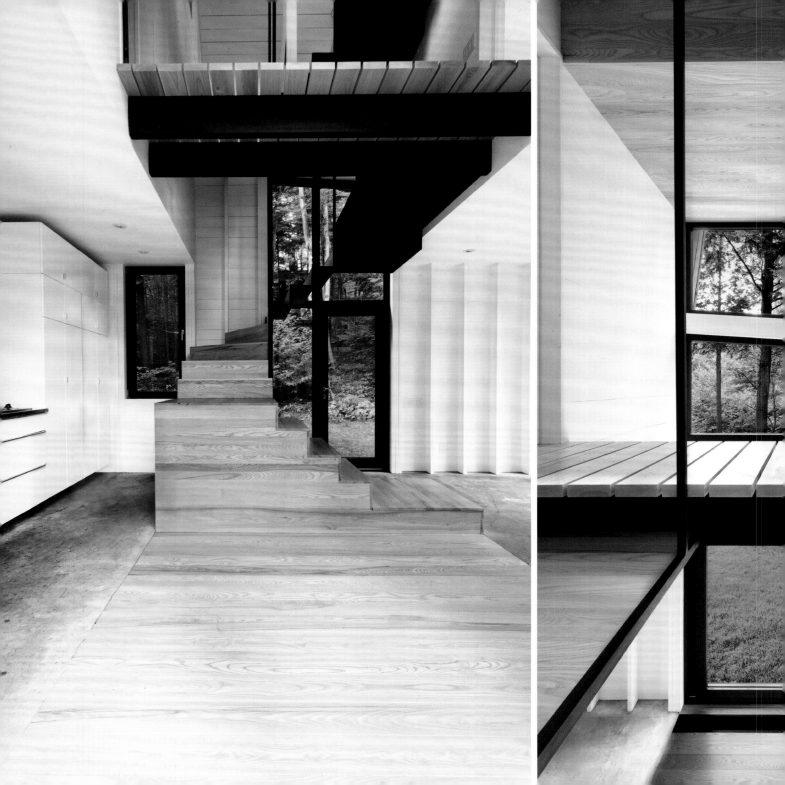

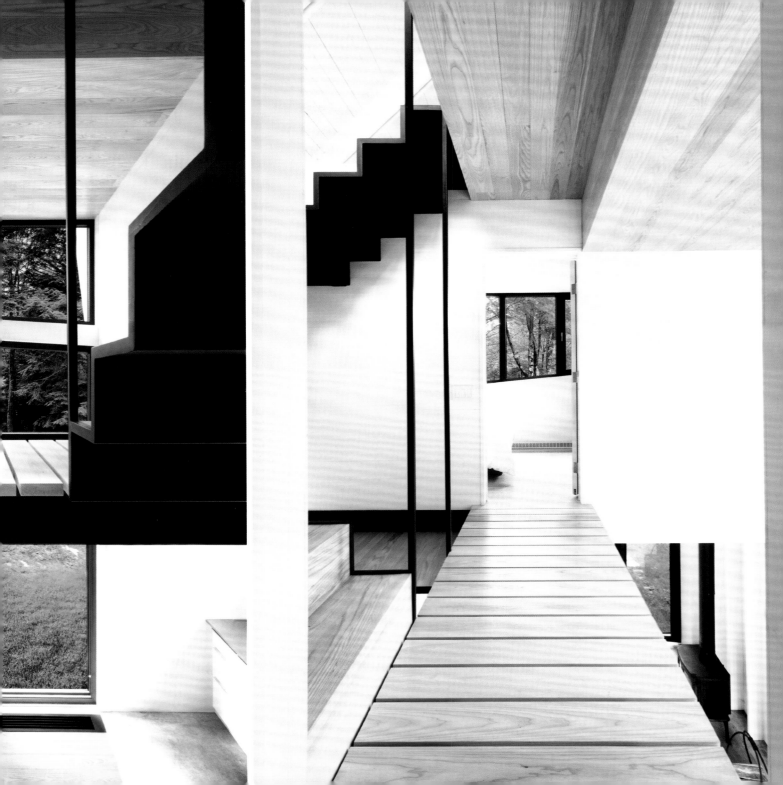

VILLA IN THE PALMS
SANGOLDA, GOA, INDIA

Abraham John Architects / 2018

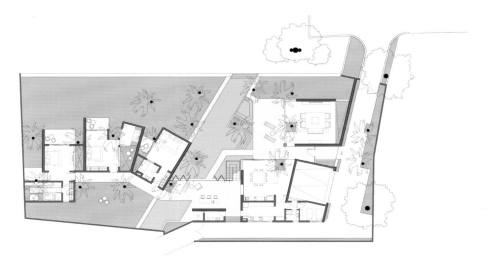

This four-bedroom, 6,566-square-foot (610-square-meter) house was built on a 14,000-square-foot (1,300-square-meter) site. The design appears to be "almost village-like," as it was built around a grove of eighty-year-old coconut palm trees. The studio's design approach "is to reconnect architecture with nature," and no trees were cut to accommodate construction. The bedrooms are intended to "feel like separate homes," and each one has a bathroom, gardens, and an internal courtyard. These volumes are connected by decks, passages, and bridges that meander through the trees and over pools and gardens. Local architectural features and materials were employed, including screens made from hundred-year-old recycled teak wood. The landscape design makes use of local tropical species—mostly palms—that maintain their lush greenery throughout the year. The roofs are pitched at different angles and are designed to harvest rainwater, in particular during monsoon season. The walls are made with laterite, a type of hardened clay topsoil material. The northern facades and open internal courtyards allow for natural ventilation and privacy. An "infinity" swimming pool divides private areas of the house from more public ones. A family room, garden, and the master suite are located on the upper level.

Above and opposite: The plan and the photo make visible the pavilion-type design arrayed around a central pool. **Following spread, left:** Built in close proximity to existing trees, the house opens onto a central pool. **Following spread, right:** Existing trees were left in place, even in the pool, which separates the elements of the house.

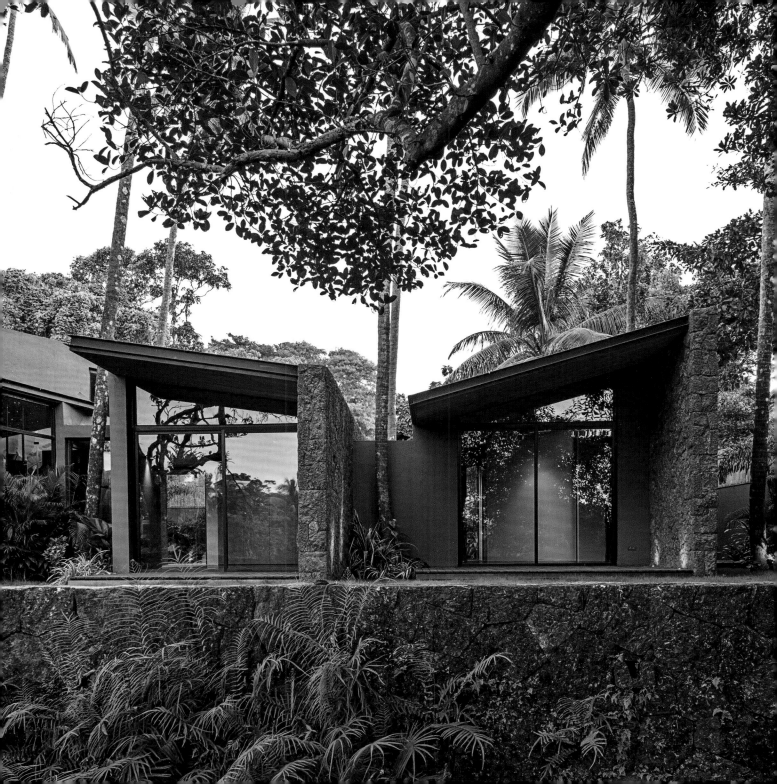

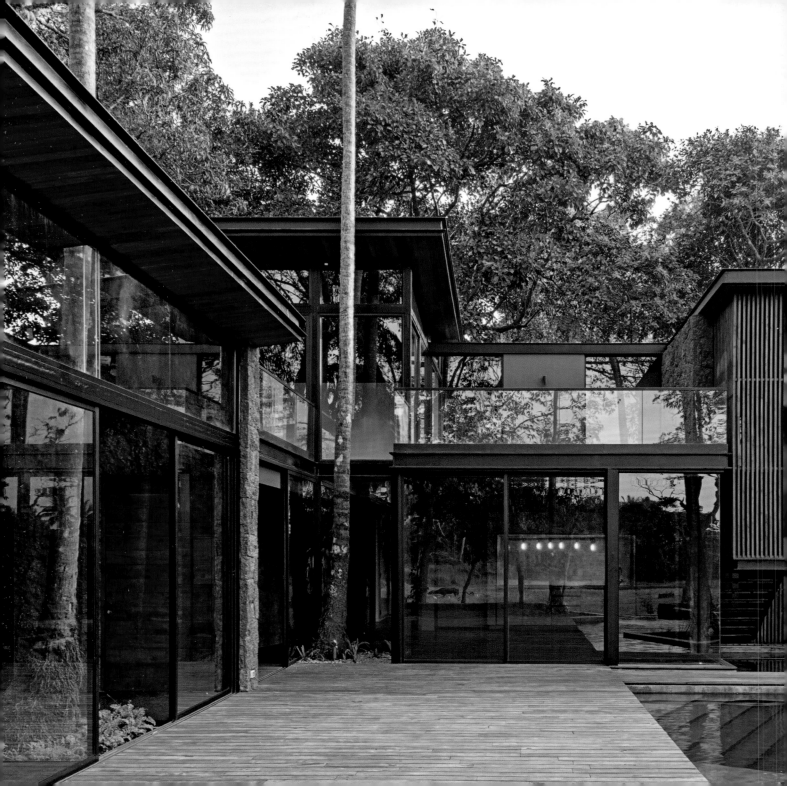

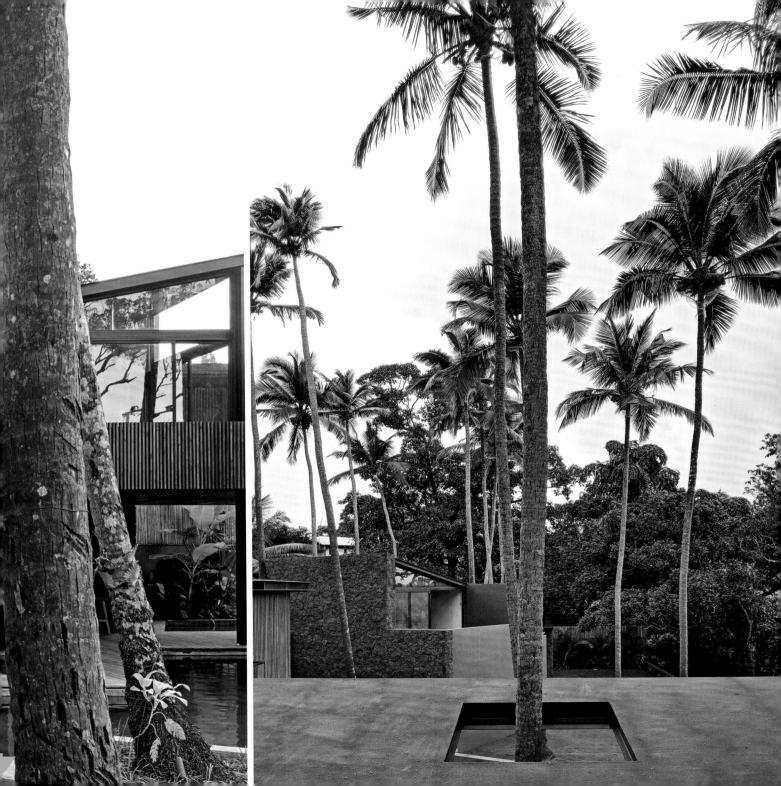

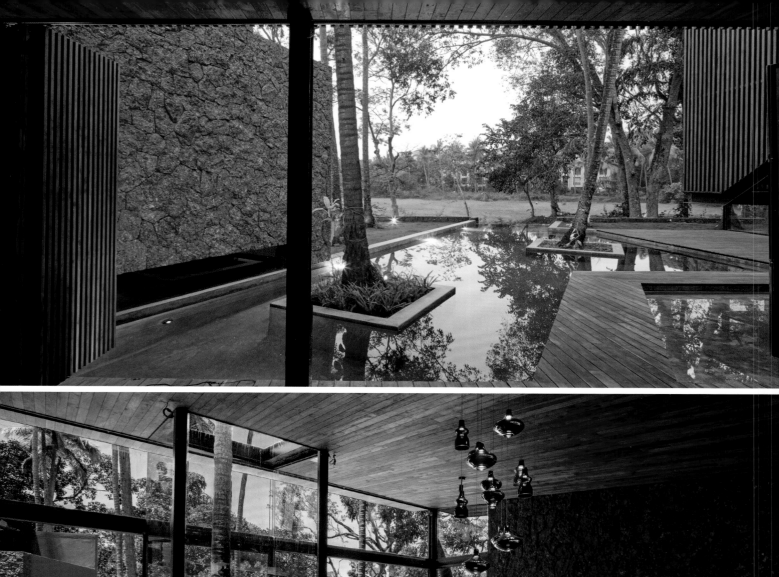
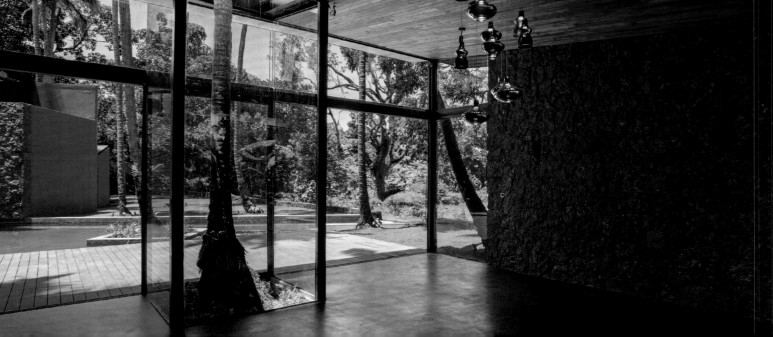

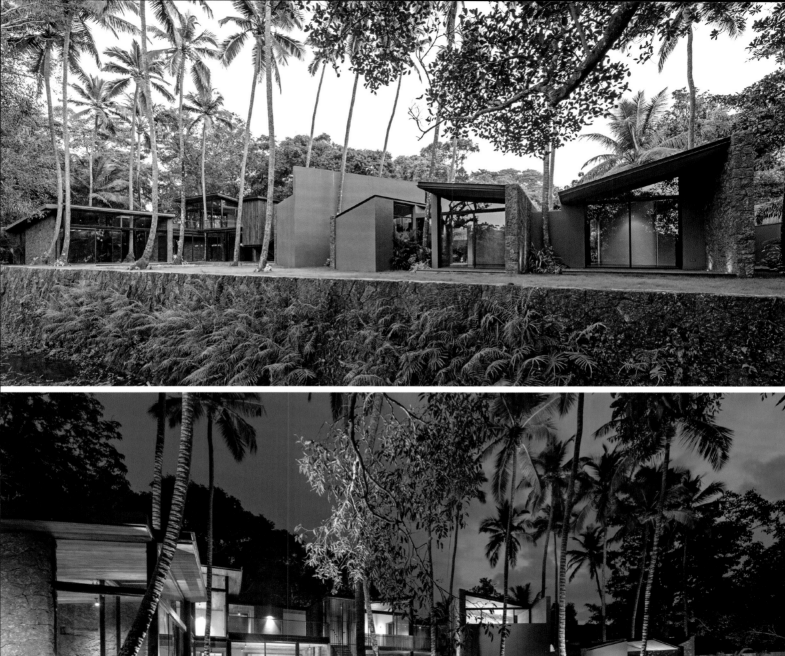

FOREST QUINTET
YANGGU-EUP, SOUTH KOREA

Chiasmus Partners / 2010

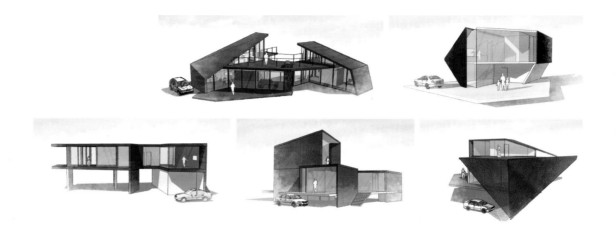

The Forest Quintet is a group of five houses built on a fifteen-acre site in the Yanggu mountains, which straddle the demilitarized zone in northern South Korea. Designed for a group of relatives and close friends, the residences share an "architectural language and the main materials," and yet each structure is unique. The architects explain that they were inspired by Korean garden pavilions, which are oriented to specific views of nature and are sometimes close together but do not give the impression of being crowed into a site. They say, "These houses are not objects inserted into nature, but rather they are enclosures that allow nature to pass through." The houses all have gaps that allow light, wind, and views "to literally pass through them." One of the main materials used was redwood, which gradually turns gray with exposure to rain and sunlight. The interiors are described as being "simple in materials and color palette." The architects explain, "During the design process, each family had many design inputs and endless conversations. These are their dream homes. We are so proud that at the end of the process, when they all moved in, rather than envying their neighbor's home, each family stubbornly insisted on their own home being the best of the bunch." The architectural office Chiasmus Partners was founded in New York in 2005 and is now based in Seoul and Beijing.

Opposite: Varied in their forms, the houses make up a group of carefully designed structures on the same site in the mountains near the Korean Demilitarized Zone. **Following spread:** Although their language is similar, as are the materials employed, the houses have an individuality that is limited only by their responsiveness to their immediate neighbors. **Pages 178, 179:** Angled forms, broad windows, and vertical bands of wood are elements of similarity between these houses.

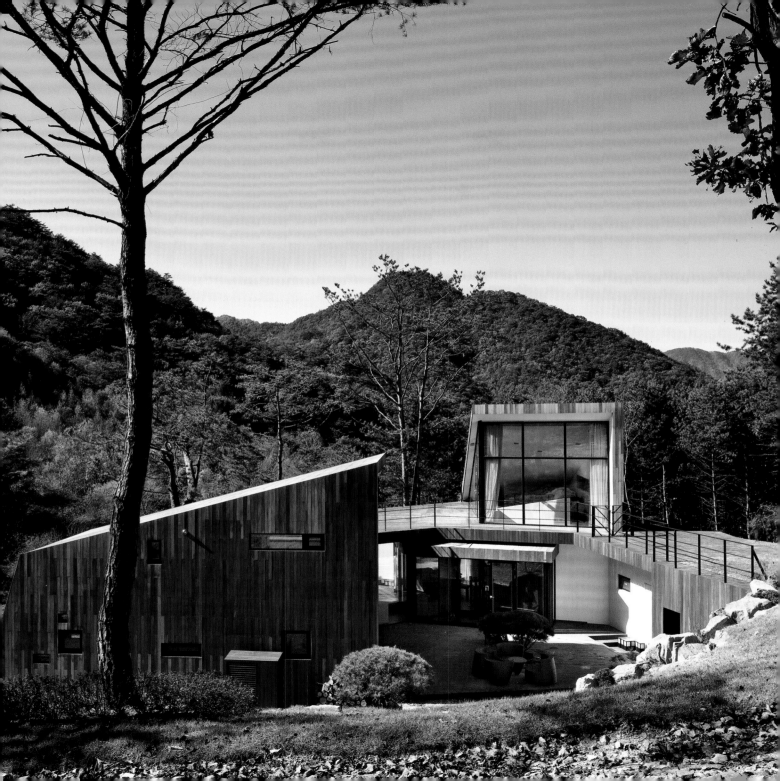

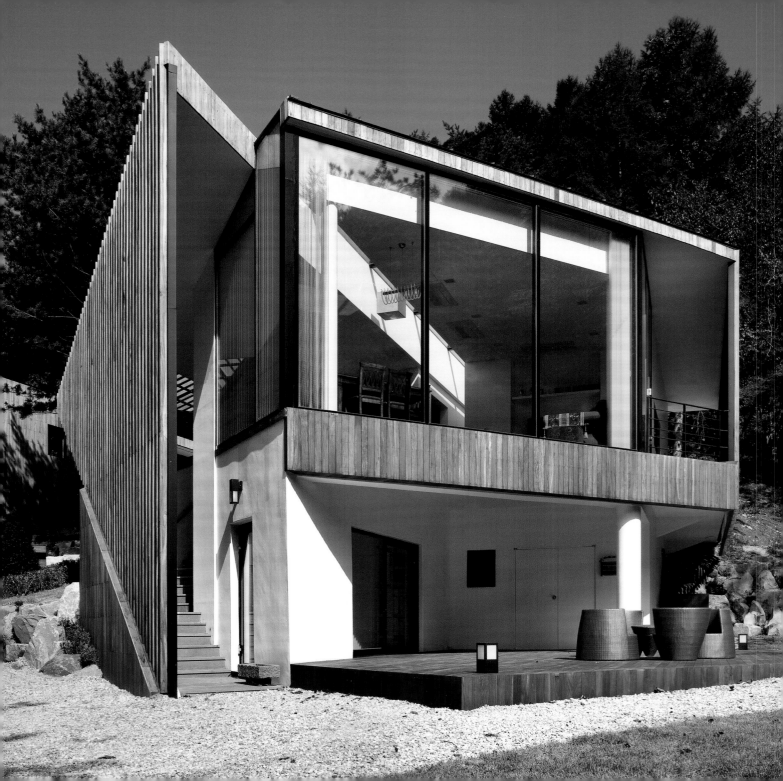

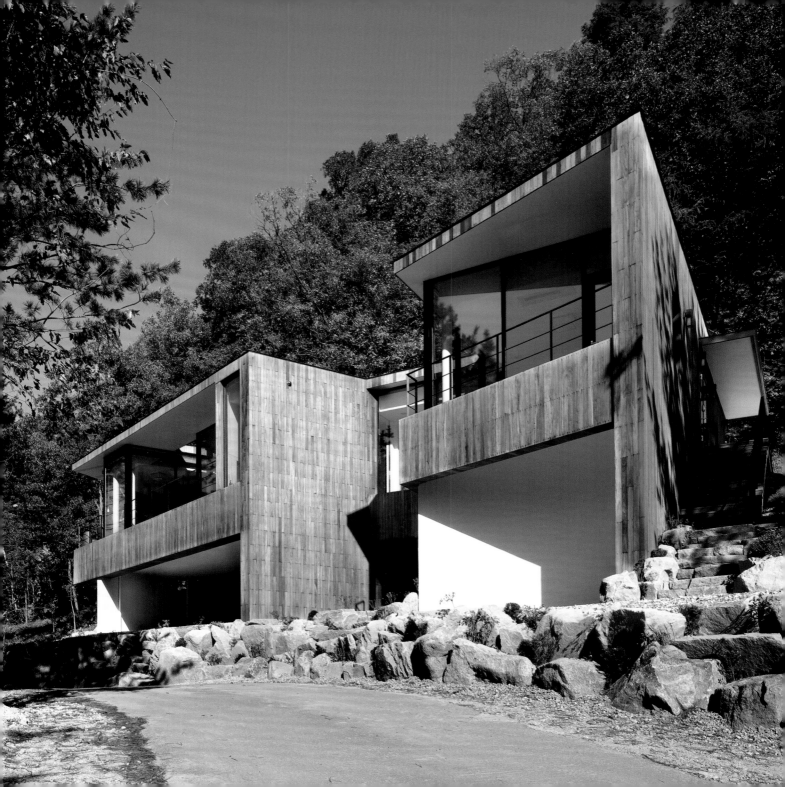

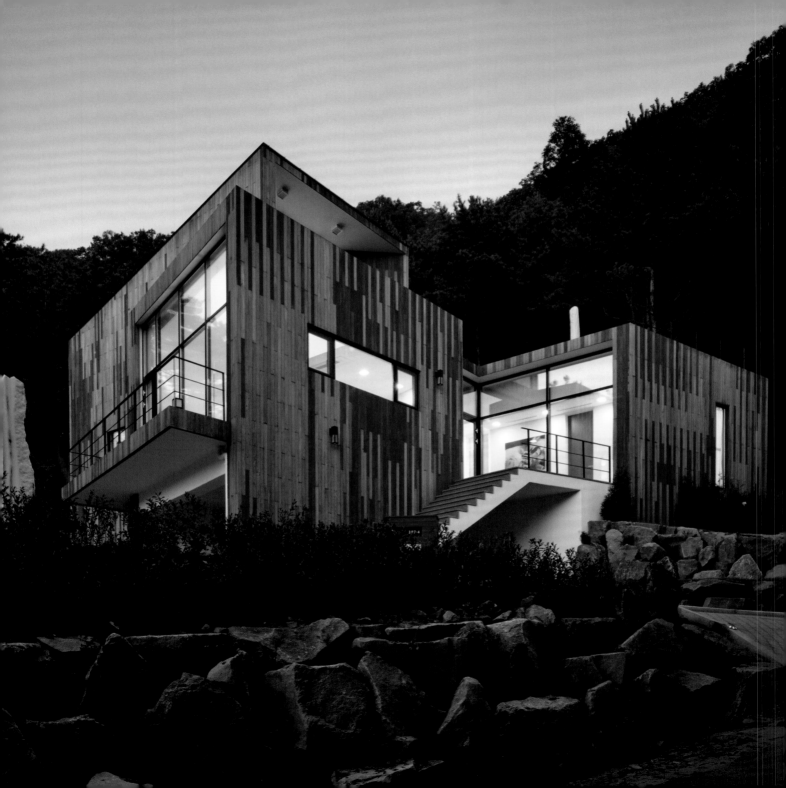

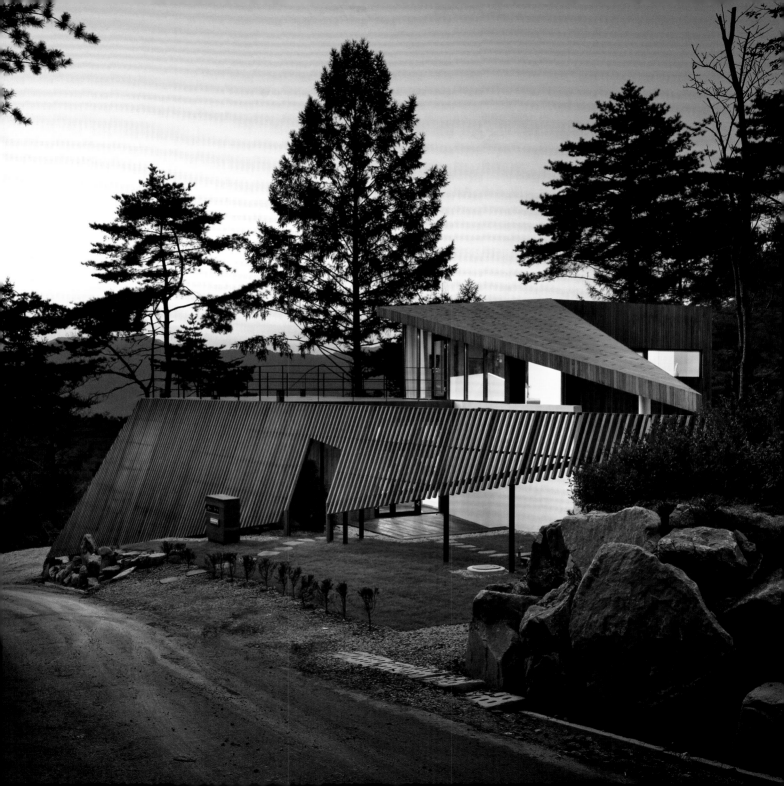

DECK HOUSE
JANDA BAIK, PAHANG, MALAYSIA

Choo Gim Wah Architect / 2012

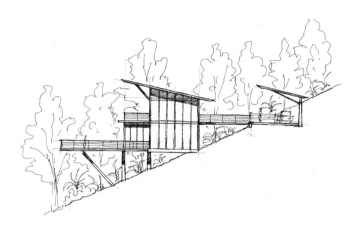

Janda Baik is about twenty miles from Kuala Lumpur. The client asked the architect to design a "simple, unassuming, and modern looking house" on a sloped site set at an altitude of nearly two thousand feet above sea level. The 3,907-square-foot (363-square-meter) house has a small lower ground level with a 441-square-foot (41-square-meter) covered terrace. The ground and first floor have roughly equivalent floor areas. The three-bedroom house was integrated into the slope with as little disturbance to the natural terrain as possible. A reinforced concrete foundation supports the steel and glass structure. The architect states that "despite its steel and glass look, the house functions like a traditional Malay house with tall ceilings, well-lit interiors, and sufficient ventilation with windows on most walls and aluminum louvers at the highest portion of the building for the hot air to escape." The extensive use of glass, with features such as wide sliding glass

doors, give residents a clear view of the forest surroundings. A double-volume void houses the staircase that connects the foyer and the living area. The open kitchen and living/dining area are directly connected to a partially cantilevered 34-by-22-foot timber deck. Timber is also used for the interior flooring. "A simple, cozy, and comfortable house with extensive outdoor areas is designed and built with minimum interference to the terrain for the occupants to embrace the best of everything the forest has to offer," the architect states.

Opposite: Set on a steep forest site, the house's roof is angled upward. The structure opens fully onto its forest environment. **Following spread:** The house offers a surprisingly glazed volume that is surrounded by the forest, creating a modern, airy loft in the trees. Wood, metal, and glass are combined in a subtle, sophisticated way. The plan (right) shows a simple rectilinear composition with the entrance to the rear.

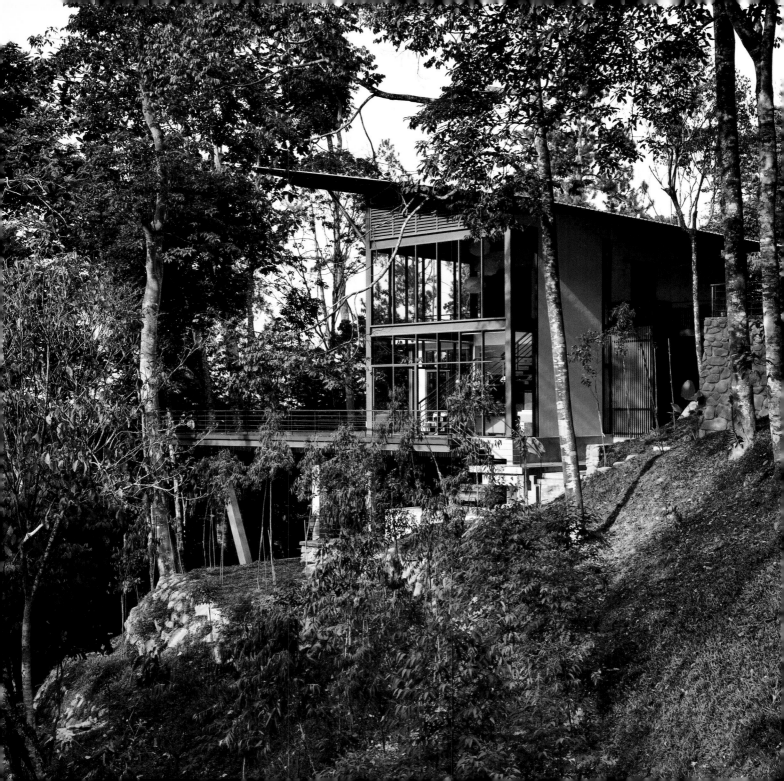

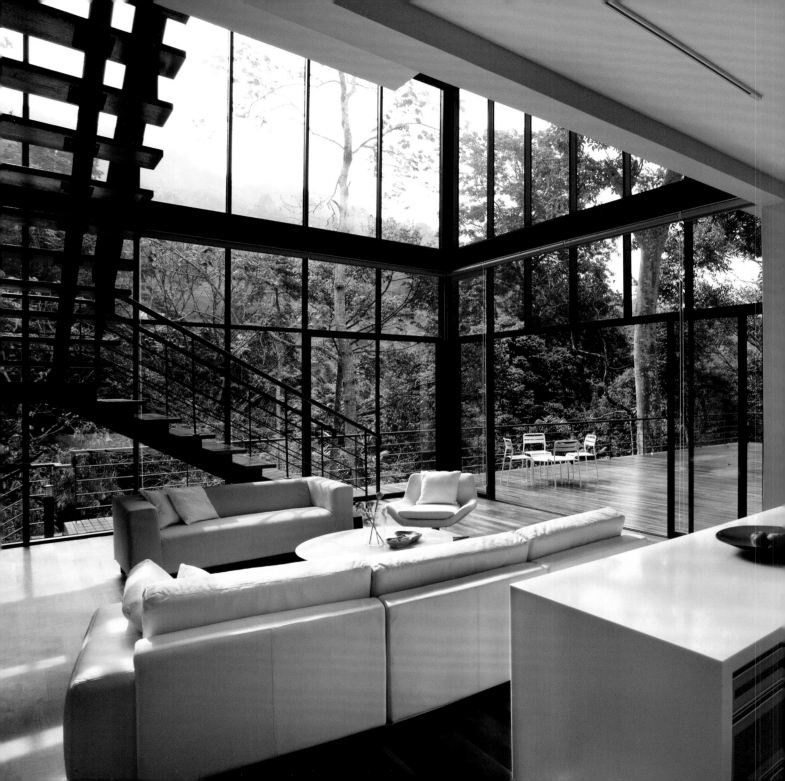

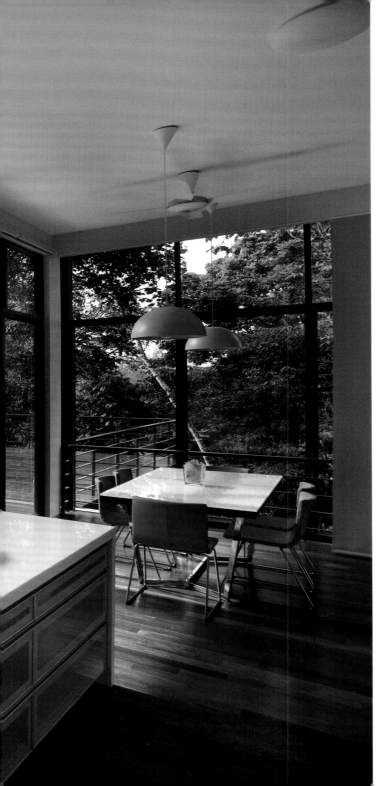

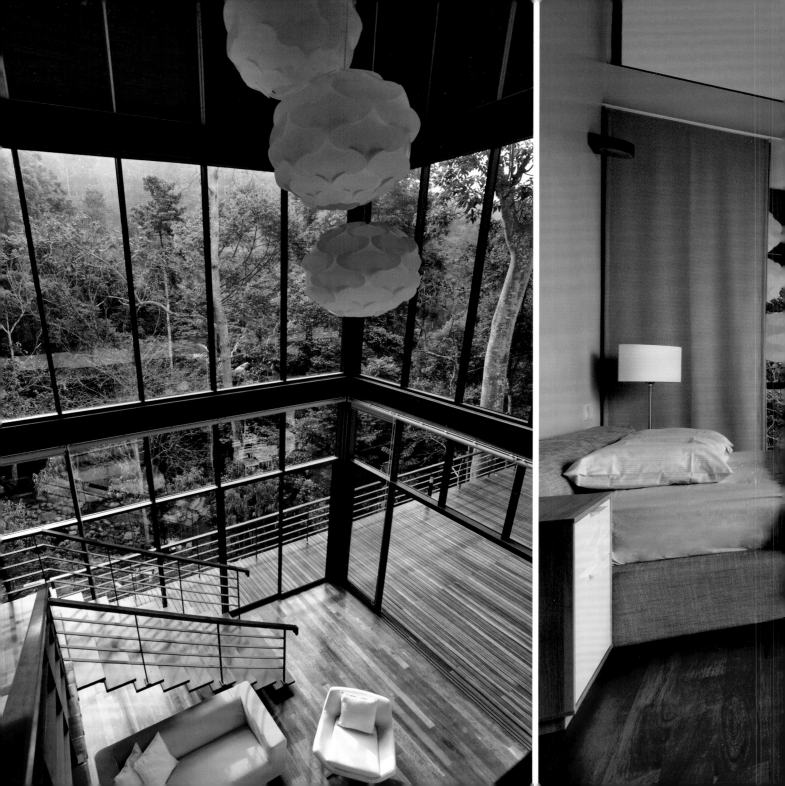

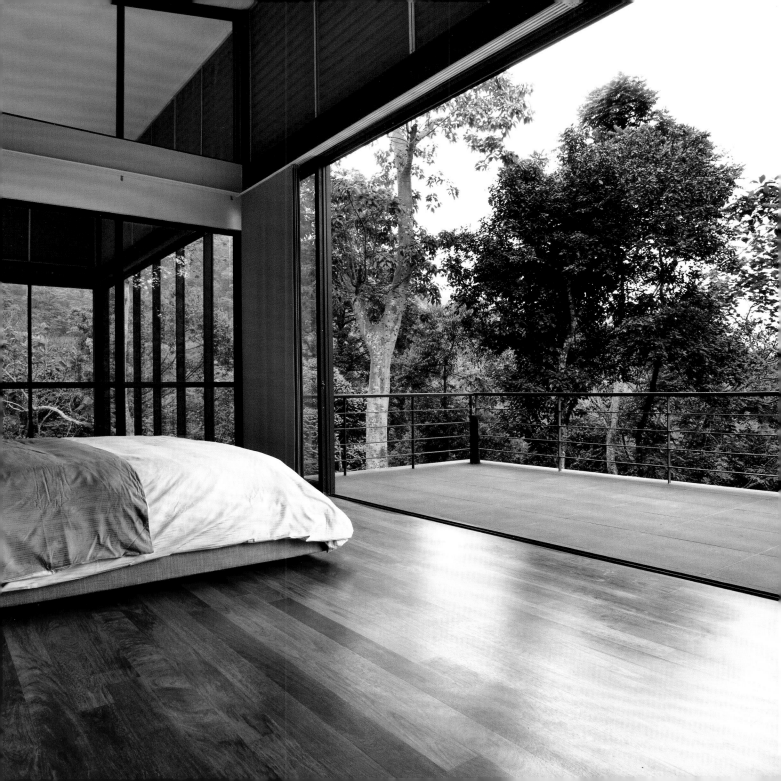

FOREST HOUSE 02
SÓC SO'N, HANOI, VIETNAM

D12 Design / 2018

With a very small floor area of 430 square feet (40 square meters), this holiday house in the mountains of North Vietnam about twelve miles north of central Hanoi is intended for two to four people. In order to reduce the foundation structure and the impact on the site as much as possible, materials such as a steel box, wood, glass, and lightweight concrete were used. The house is built on a slope and anchored to the rear, supported in the front by two thin columns. It has ample glazing. Existing trees on the site were integrated into the design and a rope grid was created for outdoor play. The house includes a living, dining, and kitchen area, a bedroom, a bathroom, and a jacuzzi. The architect Chu Van Dong states, "Views from the house are almost completely liberated, the interaction between the inside and outside the home is maximized, creating the feeling close to nature." He further expresses the hope that this design will inspire the construction of similar small houses.

Opposite: The house is summary in its forms and borrows from the vocabulary of tree houses, making it very much at ease in its forest environment. **Following spread, left:** A high wooden ceiling and high windows place the main living space in direct contact with the forest scenery. **Following spread, right:** In keeping with the tree house style, an outdoor terrace takes the form of netting suspended from the platform of the structure.

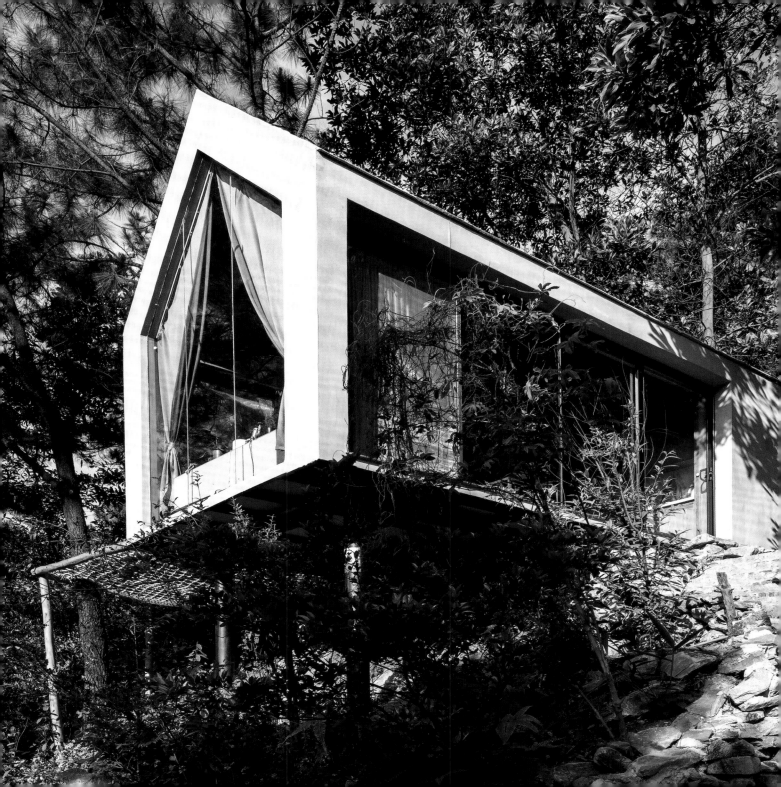

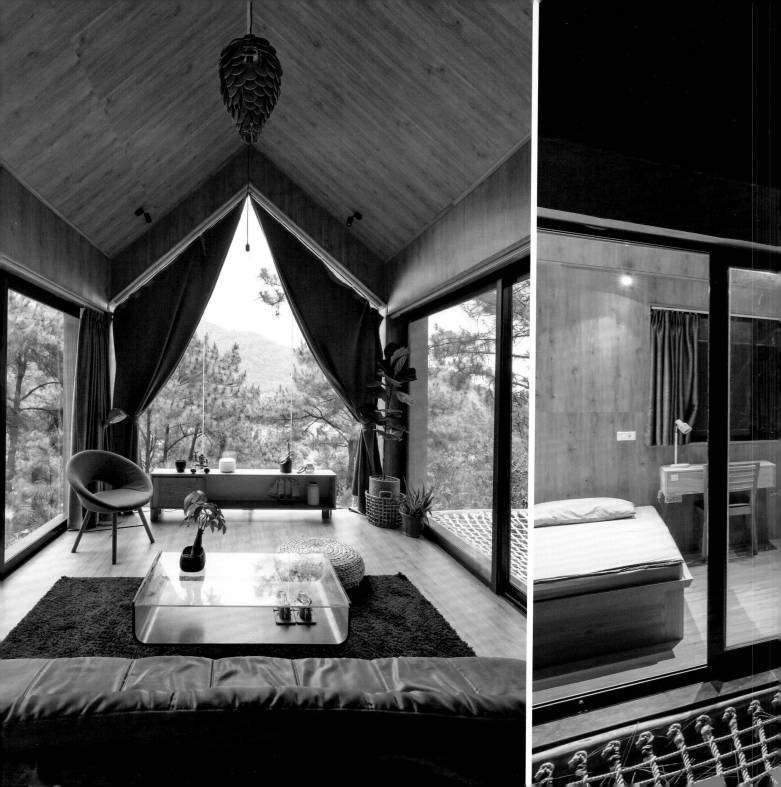

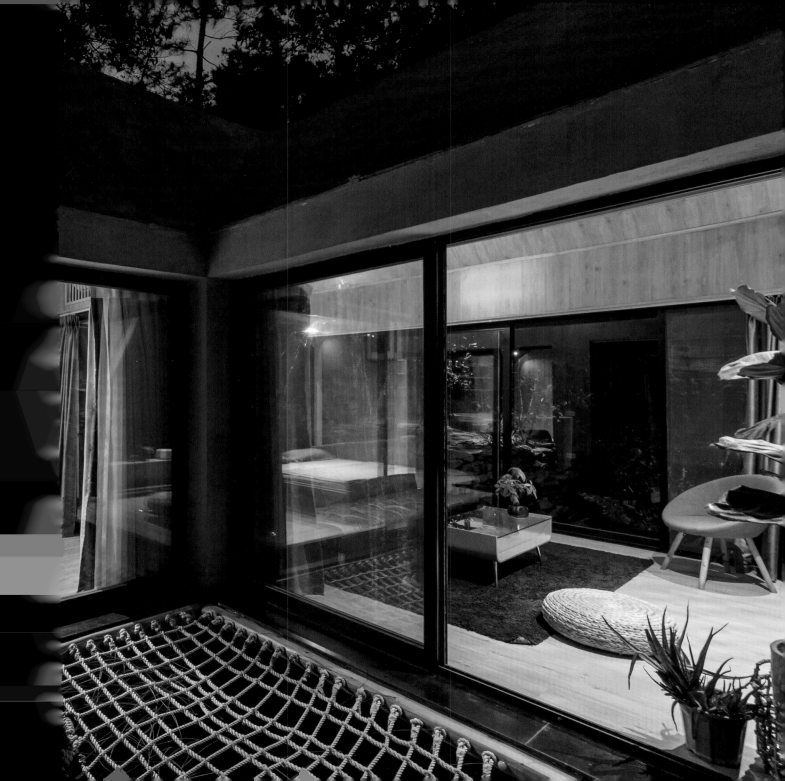

LEAVES VILLA
KARUIZAWA, NAGANO, JAPAN

KIAS / 2018

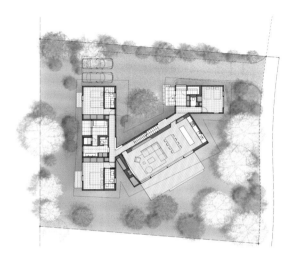

Located in Karuizawa, ninety-three miles from Tokyo, this house was designed to take advantage of the surrounding forest environment, where it was built on a 12,131-square-foot (1,127-square-meter) site. The living and dining space faces southeast for maximum light, and the master bedroom and bathroom face west, offering views of the forest. The three connected volumes that form the 2,422-square-foot (225-square-meter) residence were placed between existing trees on the site. With the goal of obtaining varying cross sections, the architect Kentaro Ishida designed the roofs with "curved surfaces like gently twisted leaves," he explains. The roofs were designed with straight laminated veneer lumber joists "arranged continuously to form an organic geometry." A number of wooden joists are exposed on the ceiling, underlining the "dynamic spatial character of each living space." Ishida further explains, "The design process that responds to its environmental context has produced multiple organic roofs and established architecture as an aggregate of diverse living spaces. The appearance of the villa blends in harmoniously with the natural surroundings and is perfectly integrated to the local landscape." Ishida studied at the Architectural Association in London. He worked for Herzog & de Meuron from 2004 to 2012 and established his Tokyo-based architectural studio, KIAS (Kentaro Ishida Architects Studio), in 2012.

Opposite: The lightly curved roof of the house and its generous glazing allow it to take a harmonious place in the forest environment. **Following spread, left:** A large door and generous glazing characterize the entrance to the house. **Following spread, right:** The living and dining space is marked by the angled wooden beam ceiling descending to a glass wall and sliding door that open the house to the exterior.

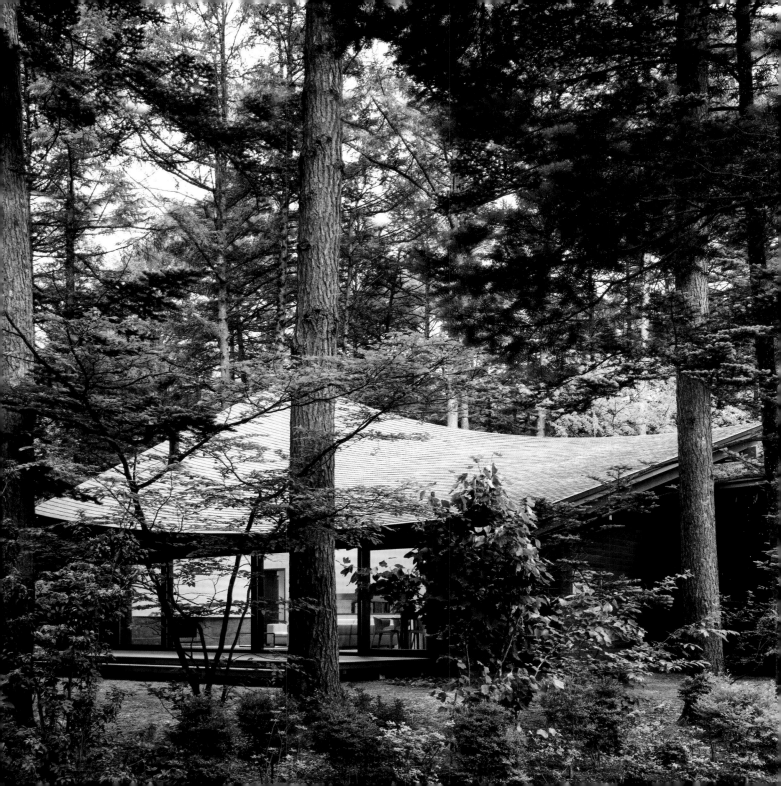

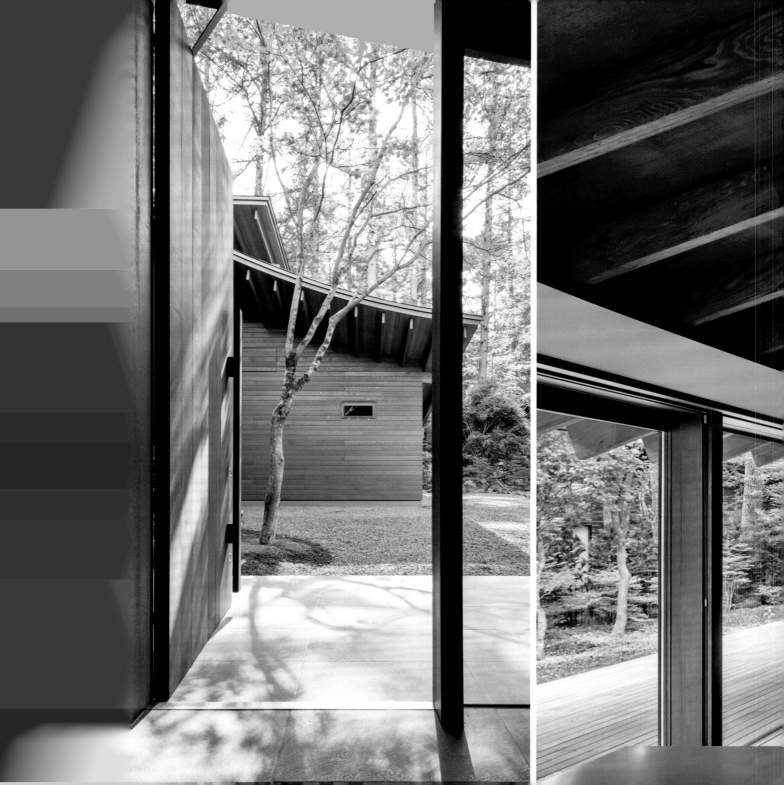

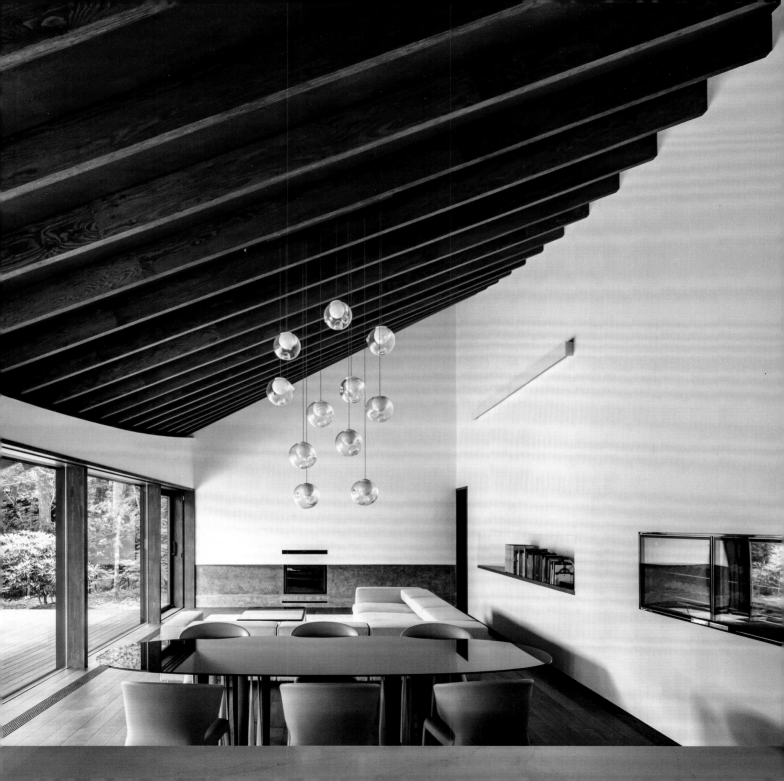

MOUNT DAISEN COTTAGE
HOKI-CHO, SAIHAKU, TOTTORI, JAPAN

Keisuke Kawaguchi, K2-Design / 2011

Built on a 13,982-square-foot (1,299-square-meter) site and with a total floor area of 3,369 square feet (313 square meters), this residence was built in a pine forest near a national park in Tottori Prefecture, which faces the Sea of Japan. The structure is raised off the ground on reinforced concrete pillars in order to preserve the living spaces from humidity in an area where there is a considerable amount of snow in winter. A pitched roof and a steel-and-wood-frame structure were chosen to bear snow loads. Many of the existing trees on the site were preserved; their precise locations and sizes were plotted and taken into consideration before the cottage was designed. The position and size of windows were calculated according to their distance from the trees and the views. The architect explains that this method "resulted in an intimate relationship between the indoor and outdoor spaces. The complexity of the seven buildings and the irregularity of their zigzag axis lines cause them to melt into the existing woods and approach a more natural form."

Opposite: The cottage takes the form of a series of interconnected pavilions in the forest. Their placement and form take the preexisting trees on the site into account. **Following spread:** Large windows connect the interior spaces to the forest environment throughout the structure. Wooden floors and ceilings together with generous glazing make the relationship between the house and its environment symbiotic throughout.

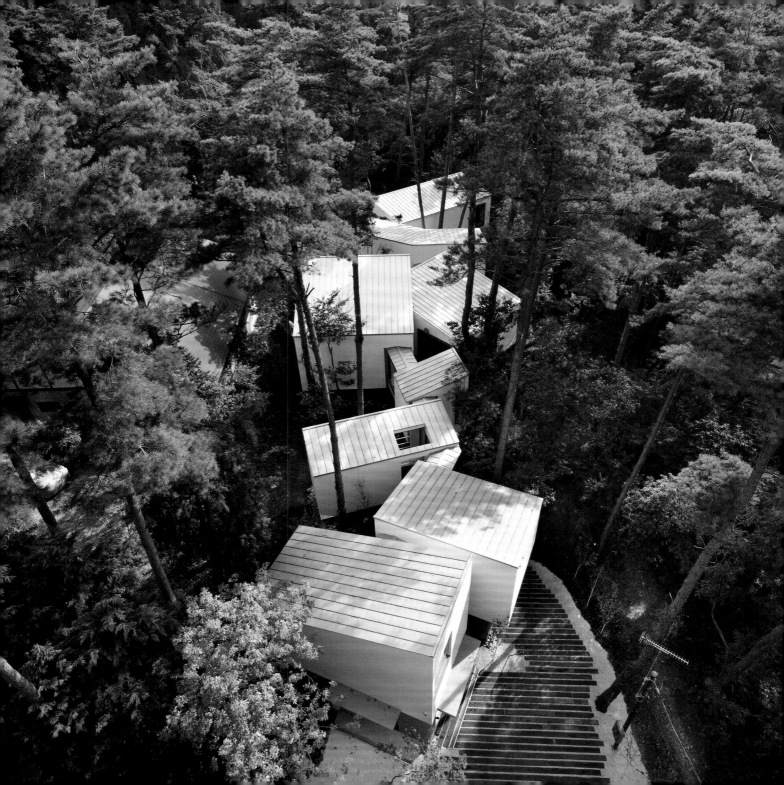

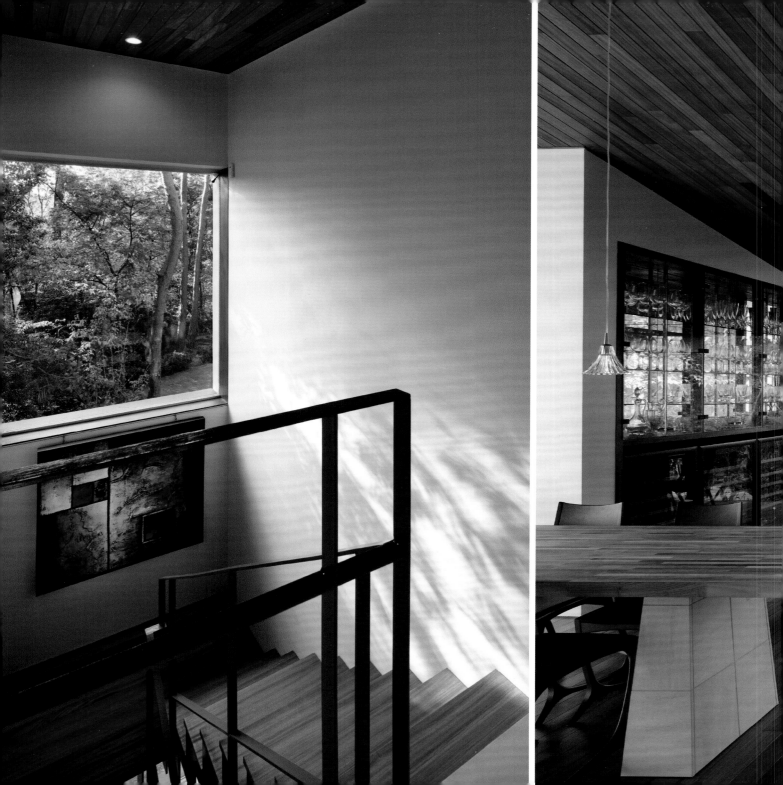

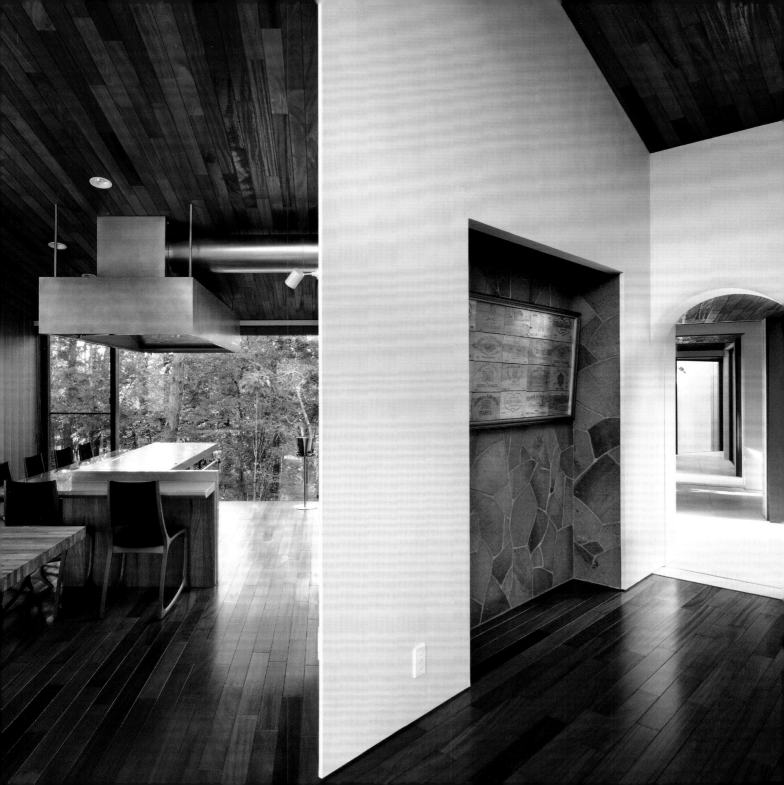

K-LAGOON
SASAVNE, ALIBAUG, INDIA

Malik Architecture / 2014

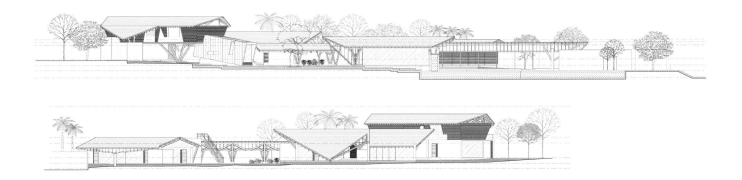

This large 22,380-square-foot (2,079-square meter) house was built on a 2.15-acre site with the intention of disturbing the heavily forested plot as little as possible. The client requested an integrated network of water bodies and channels, as well as "a hierarchy of traditional Indian spaces from the formal to the private, through a series of courts." The house was built with four main materials: stone, wood, clay tile, and fly-ash blocks that were produced locally. The first three of these materials are typically used in the architecture of the region. "Our real challenge in as far as the structure was concerned," state the architects, "was to use the traditional materials [and] techniques and yet evolve an exhilarating and contemporary syntax." Thin steel plates sandwiched with wood planks were used to carry the roof loads while reducing the amount of wood required. Natural light and ventilation were privileged,

and low-consumption LED artificial lights further reduce electricity use. The relatively complex house includes a gym, spa, hamam, and home theater. Wells and rain run-off are used to collect as much as 34,500 liters of water per day. The landscaping puts an emphasis on local plants, ensuring minimum water consumption. Indoor flooring is in local natural stone. The architects explain that "deeply shaded verandas and semi-outdoor spaces, repeated throughout the design, balance indoor and outdoor spaces."

Opposite: Bodies of water and a strict respect for the existing trees on the site serve to entirely integrate the house into its environment. **Following spread:** A covered walkway and generous outdoor spaces characterize the design, which benefits from an exceptional scale and clear respect for the surrounding natural environment.

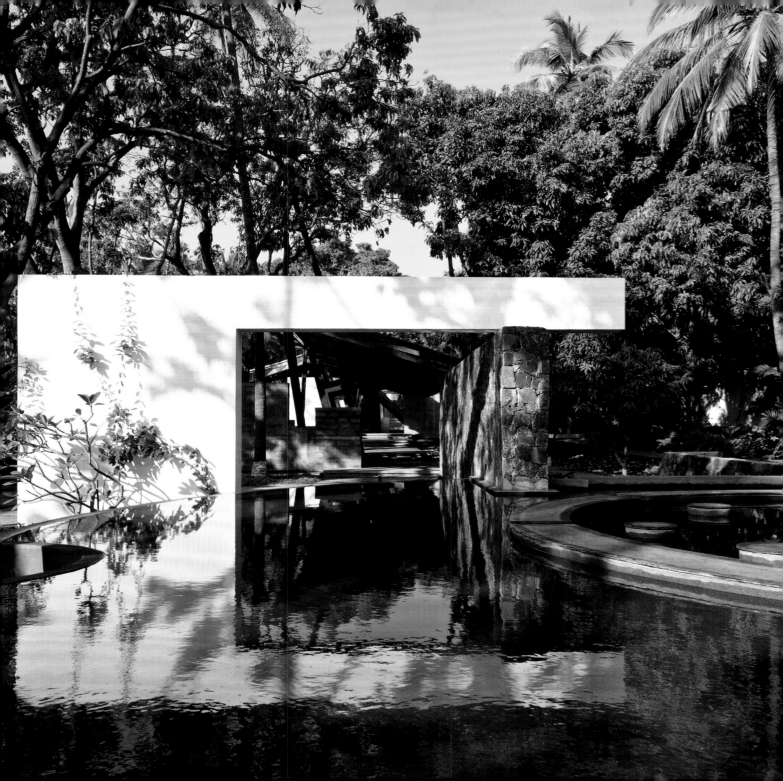

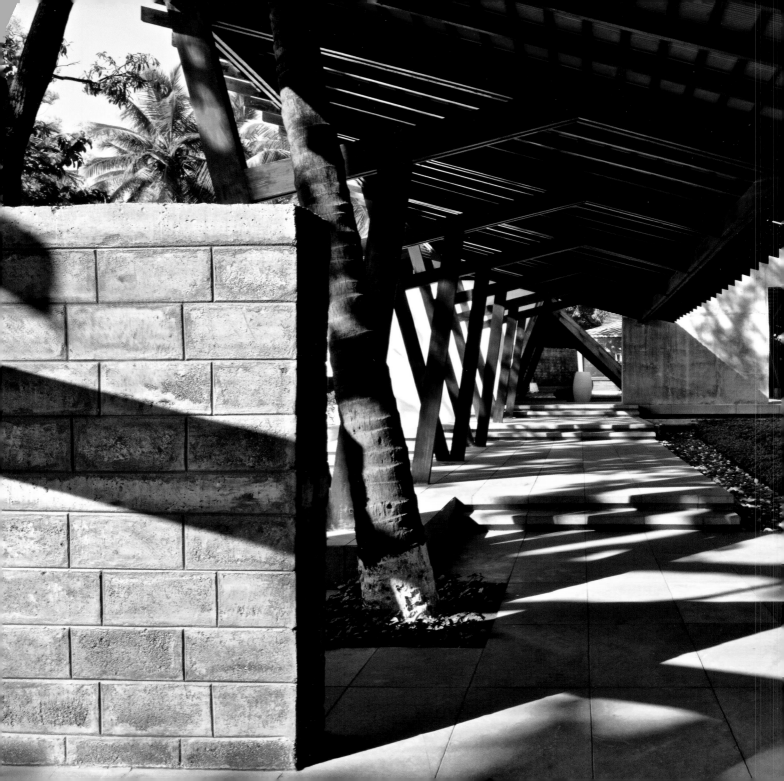

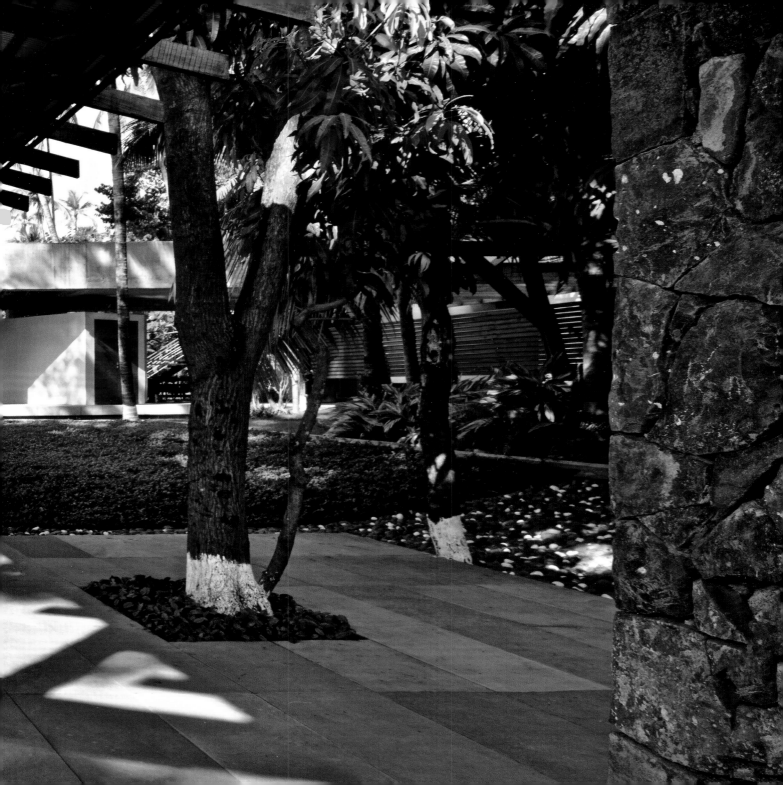

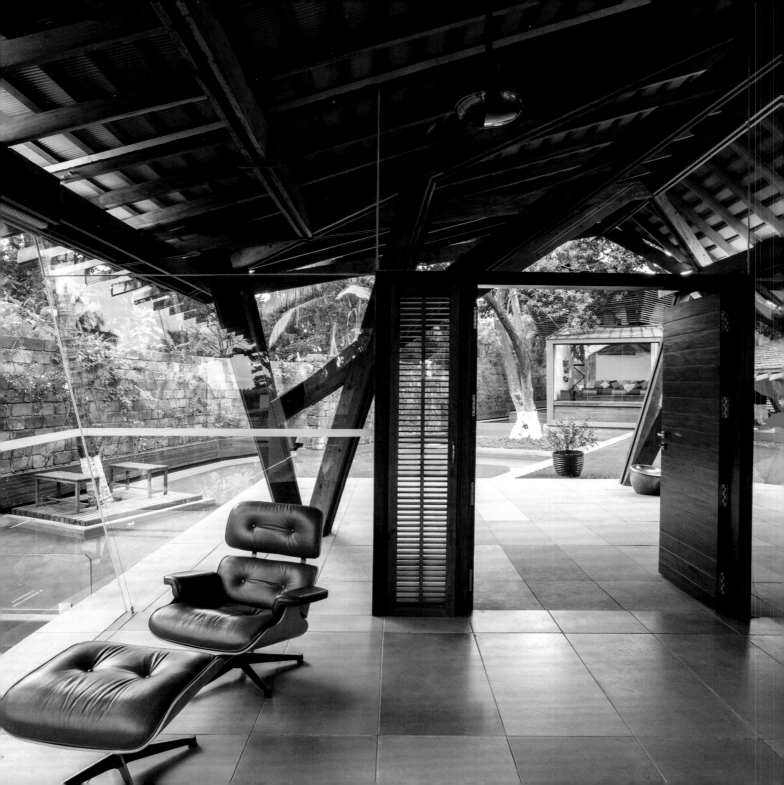

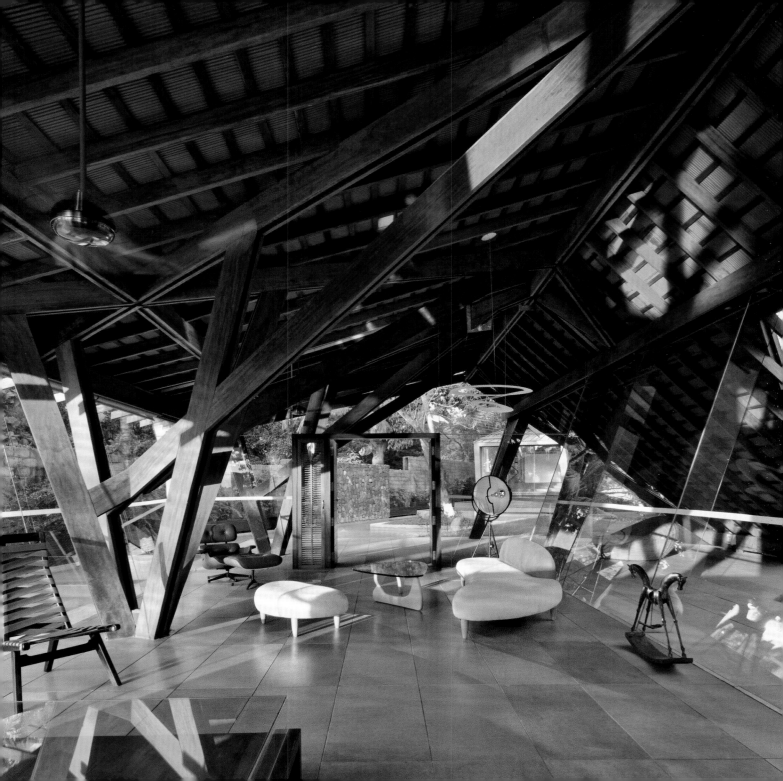

GUAVA HOUSE
HEMMATHAGAMA, KEGALLE DISTRICT, SRI LANKA

RA Designs / 2008

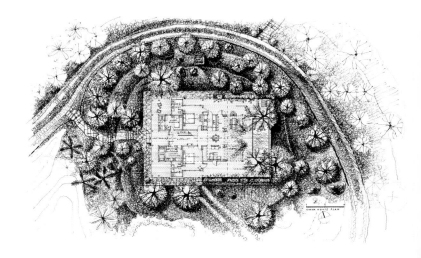

Built essentially with locally sourced "natural" materials, the Guava House has teak columns, beams, and floor boards and a grass thatched roof. The columns are elevated on stone bases or concrete to avoid direct contact with the humid environment. Mango wood was used for the exterior walls. Load-bearing brick walls and some steel constitute the main structure. There are also two separate "chalet" buildings, each with two bedrooms. According to the architect, the project "demonstrates how very old environment friendly technologies with enhanced sustainability using a proper marriage of modern technologies can meet the aspirations of a sophisticated lifestyle." Located in the central province of Sri Lanka, the site is on a former rubber plantation and has views of surrounding mountains. Trees on the site were retained. The main house, which opens to a timber deck and

an infinity pool, is "a place of peace and tranquility." The architect further explains that "the approach and challenge to the design was to find creative ways to develop a harmonious architectural language. It was important to engage with the stunning views, to be open, yet intimate at the same time." Built between May 2006 and March 2008, the Guava House occupies a generous 3.6-acre site. The building has a floor area of 6,383 square feet (593 square meters).

Opposite: With its light timber frame and wooden floors, the house opens broadly into the forested environment, creating a real synergy between exterior and interior. **Following spread:** Placed near a pool and almost entirely glazed or open, the structure can bring to mind the idea of a luxurious tree house, where modernity, tradition, and the presence of the forest have simultaneously guided the architects.

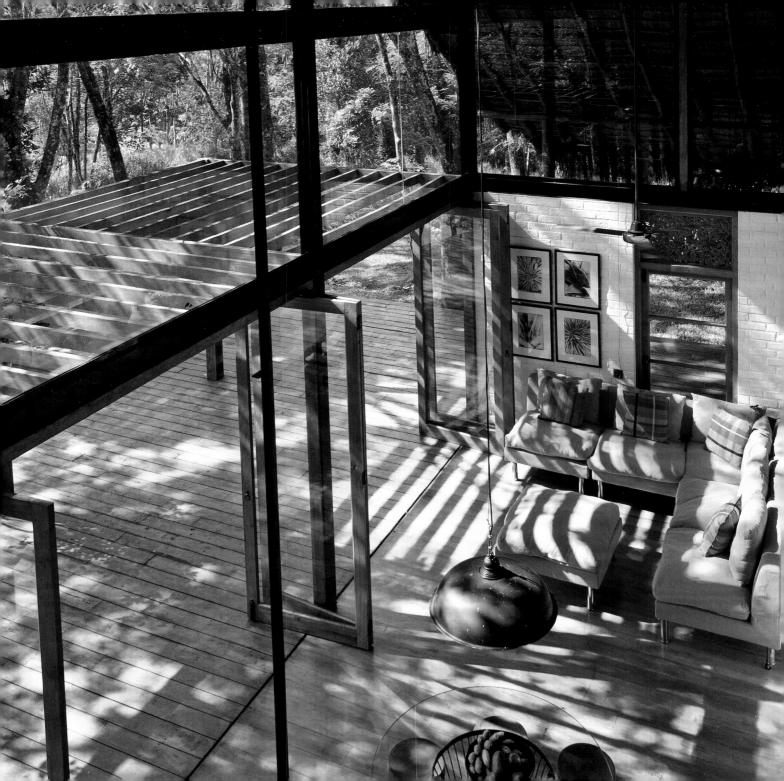

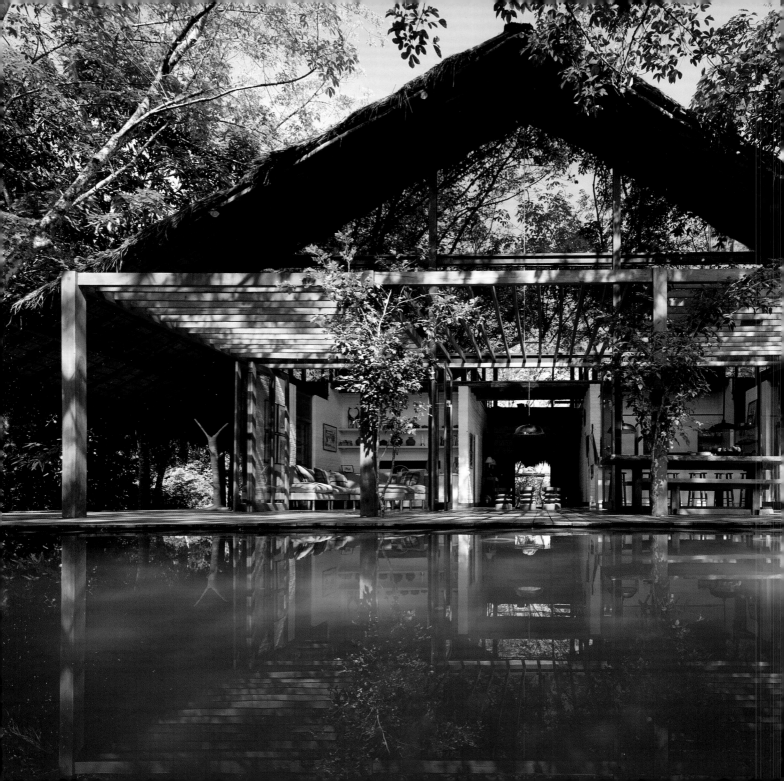

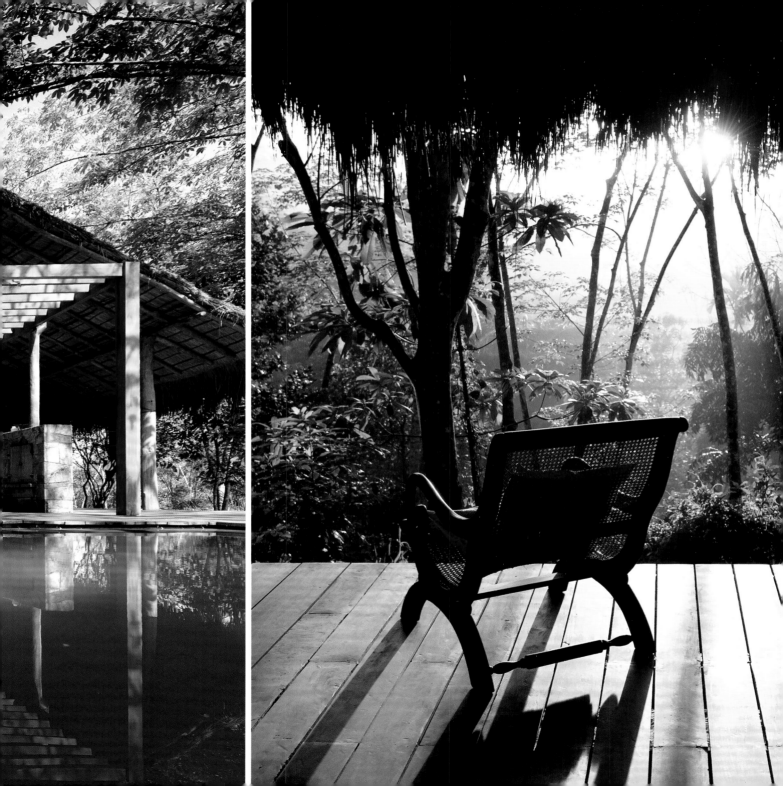

BRICK KILN HOUSE
MUNAVALI, ALIBAUG, MAHARASHTRA, INDIA

SPASM Design / 2011

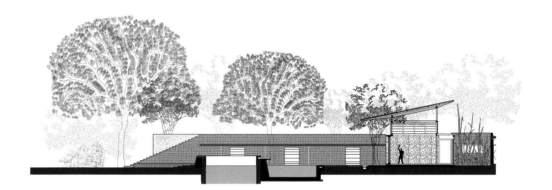

Located near Alibaug, where country homes of wealthy Mumbai residents are often located, the Brick Kiln House is located on a three-acre plot with a grove of tamarind and mango trees. Inspired by the large stacks of unused bricks often seen in the area, the architects "wondered what it would be like to hollow out and inhabit these almost primitive mastaba-like forms." The layout of the 8,934-square-foot (830-square-meter) house was informed by the locations of the largest trees and by the likely direction of wind and rain. Two main wings are set at a near–right angle to each other. Intentionally dark interiors and windows placed to allow cross-ventilation mark the house, as does a certain sense of "frugality," meaning that it is necessary to step outdoors to go from one room to another. According to the architects, "The living space has a curious shed-like volume, where the materials of the house come together rather loosely, insinuating incompleteness and creating a sense of being immersed" in the surrounding vegetation. The bricks of the house are thickly laid, creating a thermal mass that keeps the interiors cool. A pool that "takes form from the shadow of the trees" provides a further opportunity for residents to cool off. This was the first "design-build" project carried out by the architects, who worked with one brick mason, six carpenters, and a stone cutter.

Opposite: The brick walls and open terraces of the house give it an agreeable proximity to the natural environment that is at once modern and in keeping with local traditions. **Following spread:** The rear of the house opens entirely to a patio and pool, allowing the interior and exterior of the house to be in complete symbiosis.

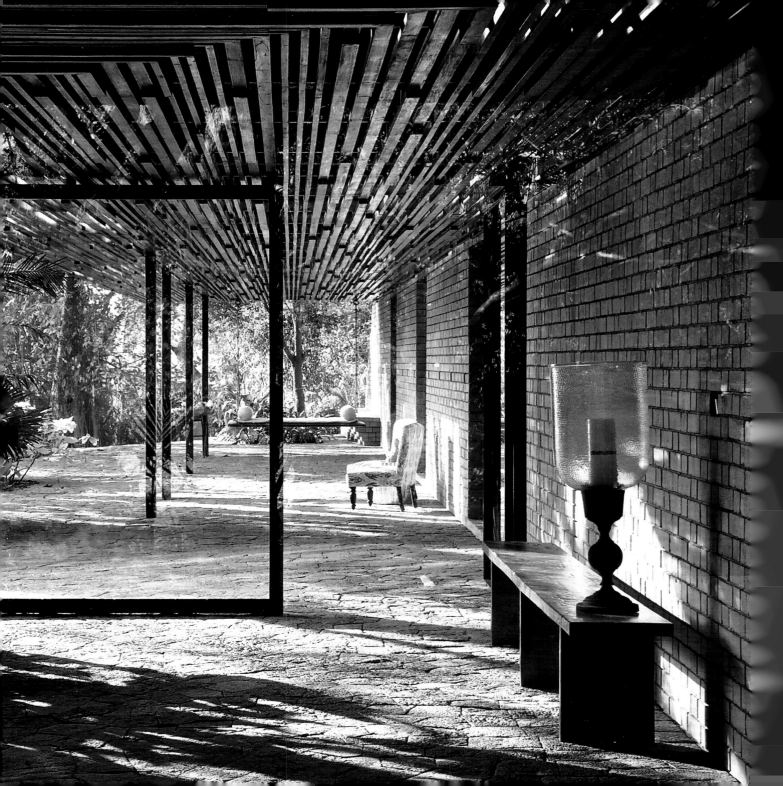

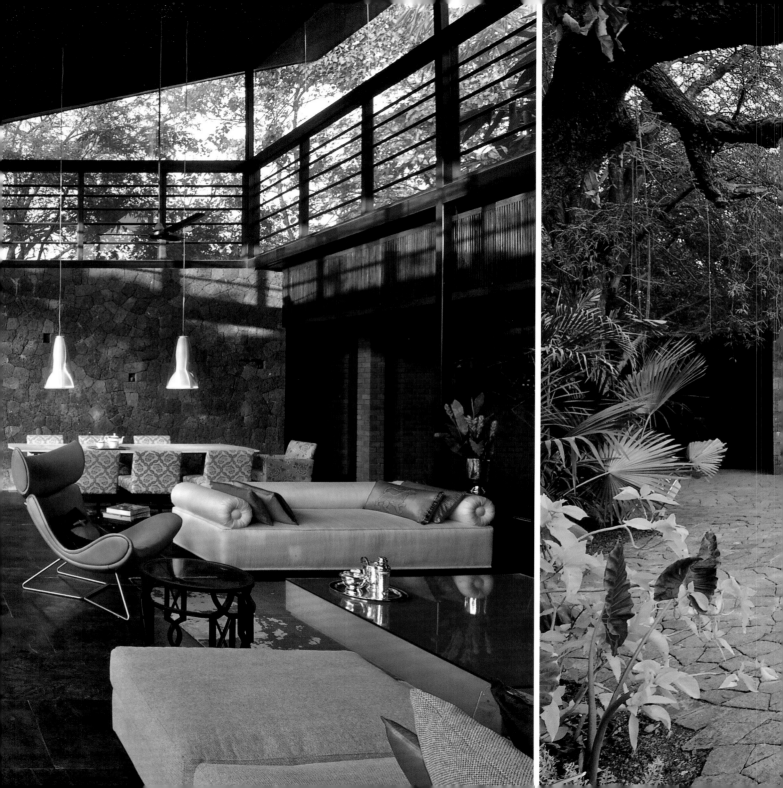

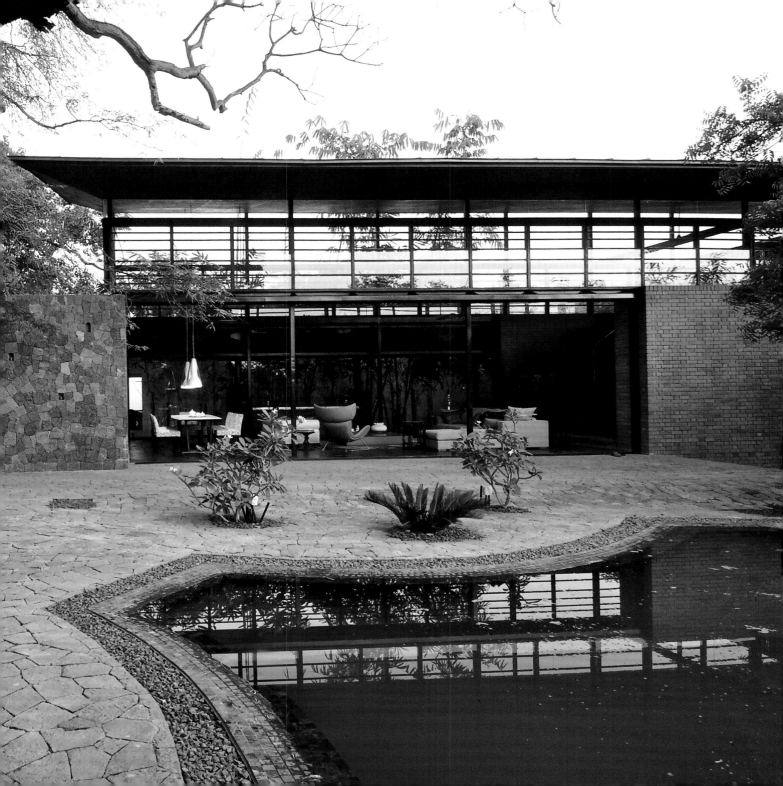

FOREST PAVILION
TITIRANGI, AUCKLAND, NEW ZEALAND

Chris Tate Architecture / 2016

Built on a sloped and heavily wooded 4.5-acre site in a West Auckland suburb, the Forest Pavilion is intended by its architect, Chris Tate, as an homage to the Austrian architect Richard Neutra, known as a pioneer of California modernism. Tate worked directly with the owner's construction firm; it was the sixth time the two worked together. The overhanging roof protects the terraces of the house, which are to the rear. The entrance side of the structure is more closed. The Forest Pavilion has three bedrooms along a central corridor that serves to connect all the spaces in the house. A media and music room occupies the center of the structure. A kitchen and dining area faces a fireplace that opens from the opposite side to the living space. Located about eight miles from the center of Auckland, Titirangi is a Māori name that means either "long streaks of clouds in the sky" or, more poetically,

"fringe of heaven." The only structure visible from the Forest Pavilion is in fact an earlier residence also designed by Tate (Forest House, 2006). Tate states: "Green glass and black joinery mirror the palette of the native bush. The cladding of natural timber contrasts with the machined structure of the building, highlighting the organic/engineered dichotomy of the Forest Pavilion."

Opposite: The house has been inserted into dense vegetation and contrasts in its rectilinear modernity with the trees that surround it. **Following spread, left:** The interior design and surrounding deck are as simple as possible, contrasting with the environment and creating a haven of modernity in the forest. **Following spread, right:** Existing trees on the site were preserved to the greatest extent possible, including one in the midst of the wooden exterior terrace of the house.

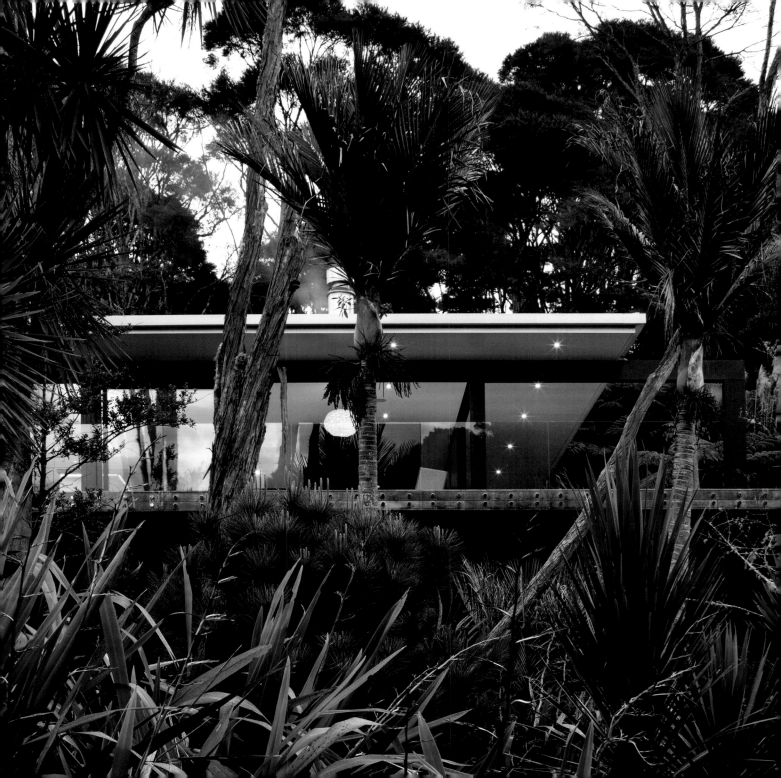

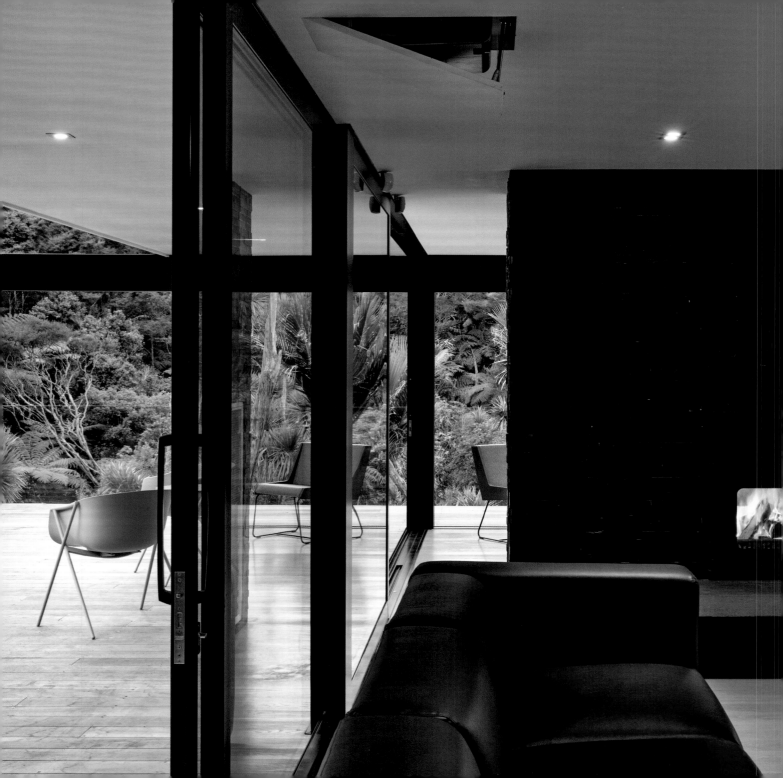

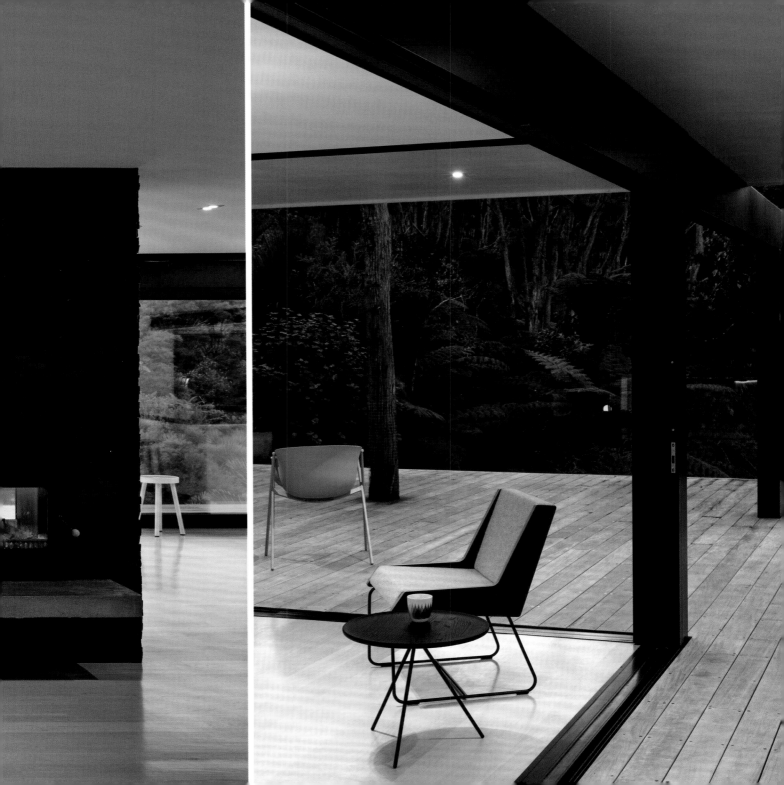

SPREAD HOUSE NAGANO, JAPAN

Makoto Takei + Chie Nabeshima/TNA / 2012

The Spread House is a weekend residence located three hours from Tokyo in Nagano Prefecture. It was built on a sloped site in what the architects call a "quasi–national park setting." The single-story structure is held up on the lower side of the slope by cedar-clad steel columns. This construction allows for minimal earthworks and disturbance to the wooded site. The plan forms a 35.6-foot (10.85-meter) square but is unusual in that its entire center, in the shape of a 14.4-foot (4.4-meter) square, is empty. The outside of the house is covered in burnt cedar panels (yakisugi), a technique often used in Japan in the past to preserve the wood from infestation or decay. Inside the house, the spaces are loosely divided by diagonally placed partitions, in contrast with what appears to be a strict square plan from the outside. The partitions are clad in cedar, which has a very light-colored stain applied. The floors are in a darker wood. The house is almost fully glazed, allowing for generous views of the forest. In keeping with Japanese custom, the furnishings are sparse, so the surrounding view of the forest fills the house. A small metal stairway descends into the central aperture from the main level, allowing residents to easily access the forest. According to the architects, "The place where the natural world comes into contact with artifacts is the origin of architecture."

Opposite: Transparent and lifted partially off the ground on the downward slope, the house appears to blend almost entirely into the natural setting. **Following spread, left:** The open core of the house permits a greater union with the wooded environment than any closed form. **Following spread, right:** In conjunction with its essentially square forms, the house has an unusual radial layout of its interior walls, contributing to an impression of motion and irregularity where the basic plan is strictly geometric.

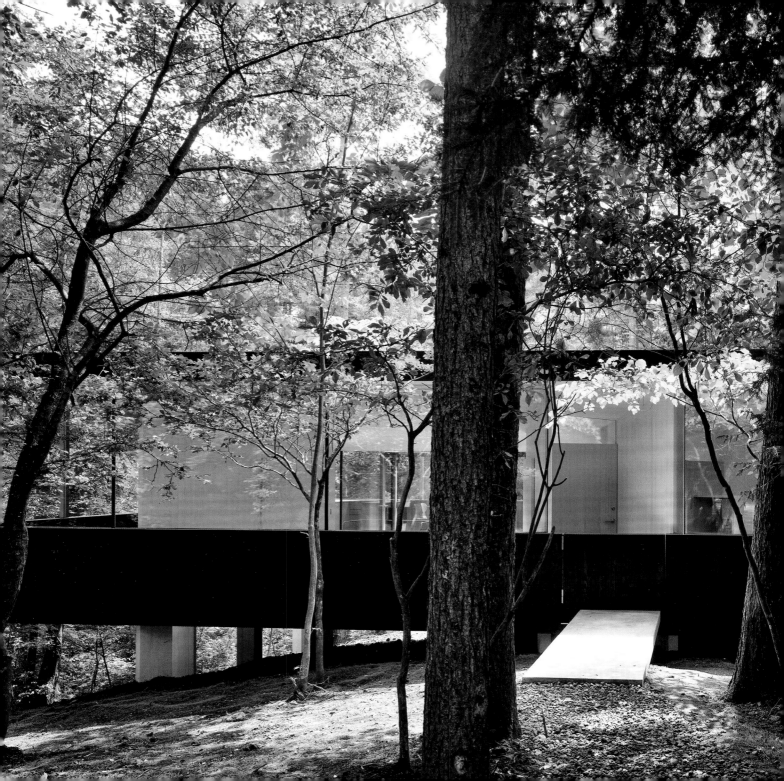

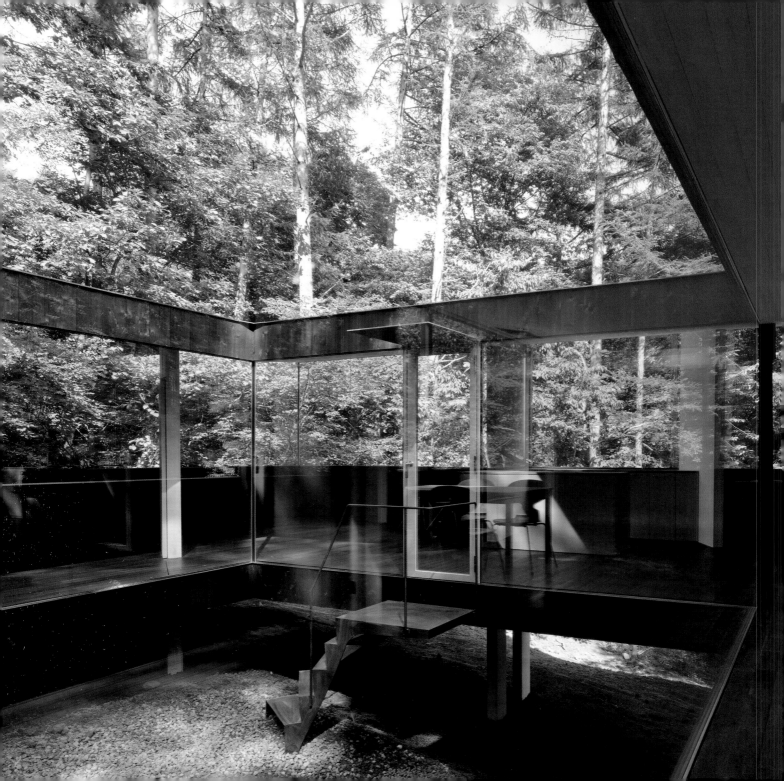

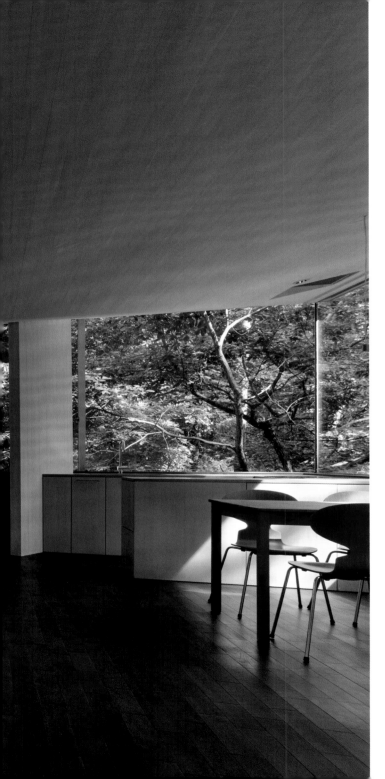

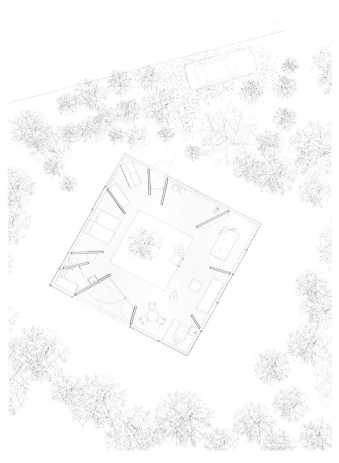

CHAMELEON VILLA
BUWIT, BALI, INDONESIA

Word of Mouth / 2017

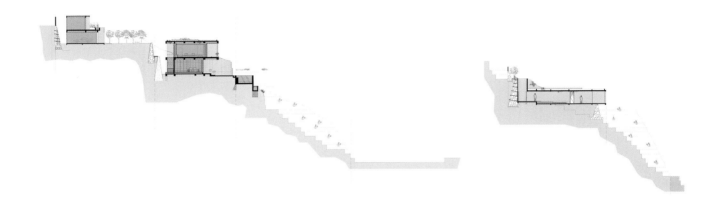

Buwit is a village in the southeastern coastal area of Bali. The forested 35,951-square-foot (3,340-square-meter) site has a challenging thirty-six-foot height difference from the arrival point to the bottom of the property. The architects state, "We worked on the idea of 'landscaped architecture' by blurring the boundaries between natural and built environments. As a result, the buildings appear to be a part of the land itself, sometimes disappearing within it and then at other times emerging from it." They placed the different elements of the 10,925-square-foot (1,015-square-meter) house at different levels to better take advantage of the views and surely also to minimize the earthworks necessary for construction. Green roofs emphasize the integration of the architecture into the natural setting and perhaps justify the name, Chamelon Villa. Each of the pavilions houses a different function, and all except the bedrooms, office, gym, and media room are open to the exterior. The main volume is formed by two stacked rectangular sections with one rotated slightly vis-à-vis the other. The concrete structures are complemented by the use teak, iron wood, polished concrete, natural stones, colored cement, and granite.

Opposite: Built on a steep slope, the house has a deck and projecting pool that serve to give an impression that the residence is actually part of the forest environment. **Following spread:** With wooden floors and ceilings, the living area opens entirely to an outdoor terrace limited by a glass barrier, offering views of the garden and forest beyond.

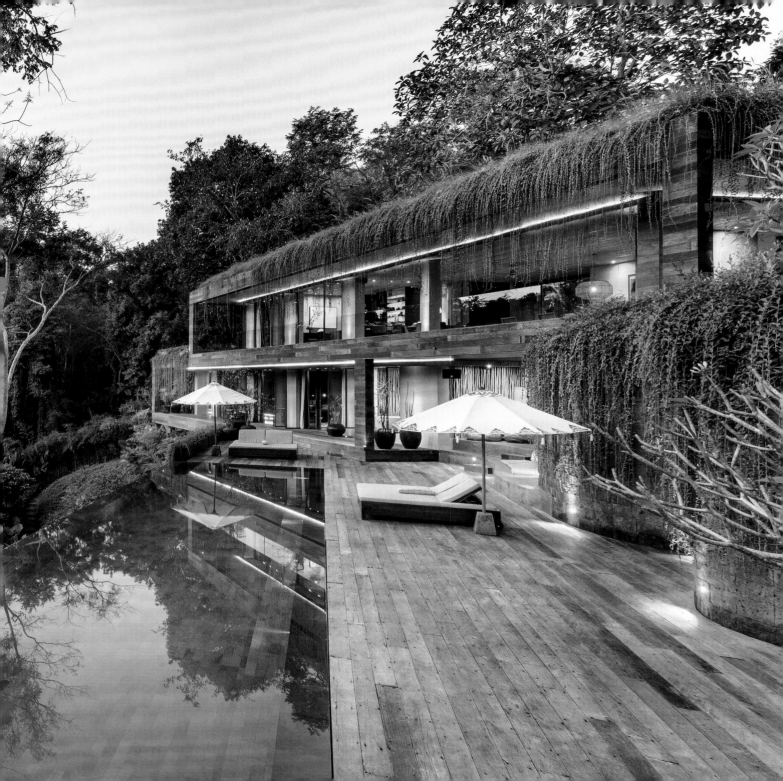

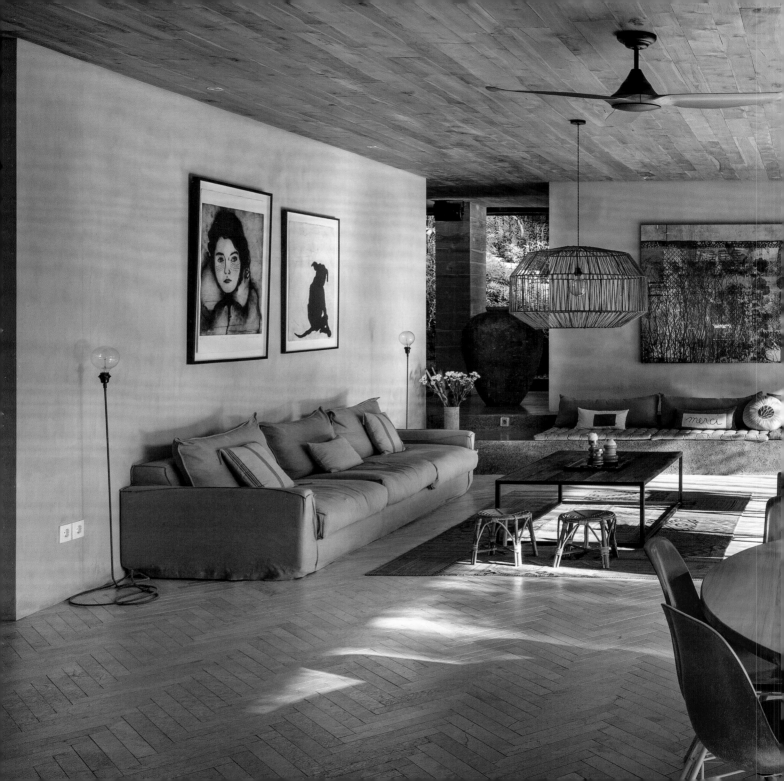

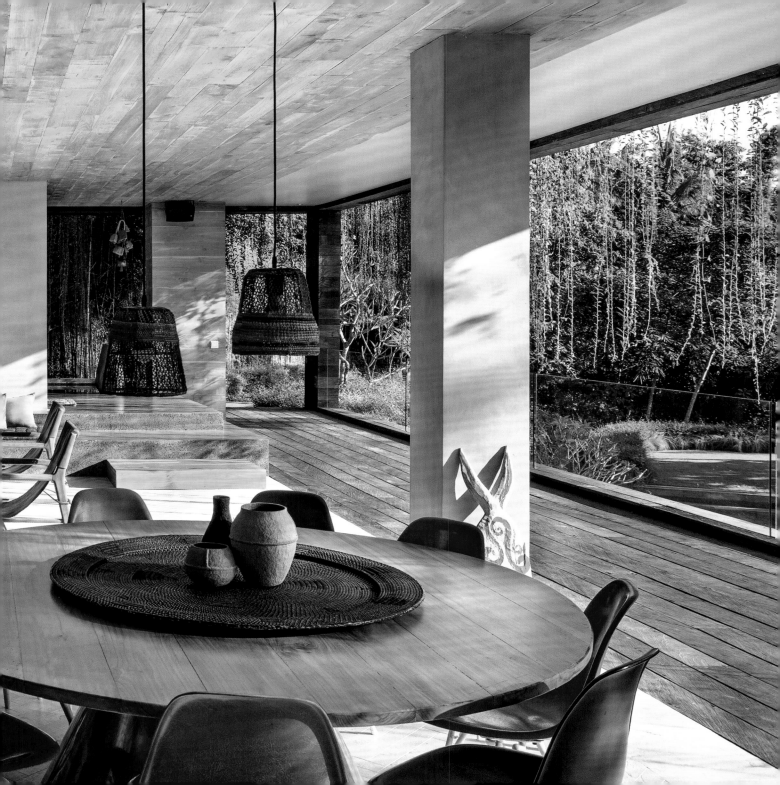

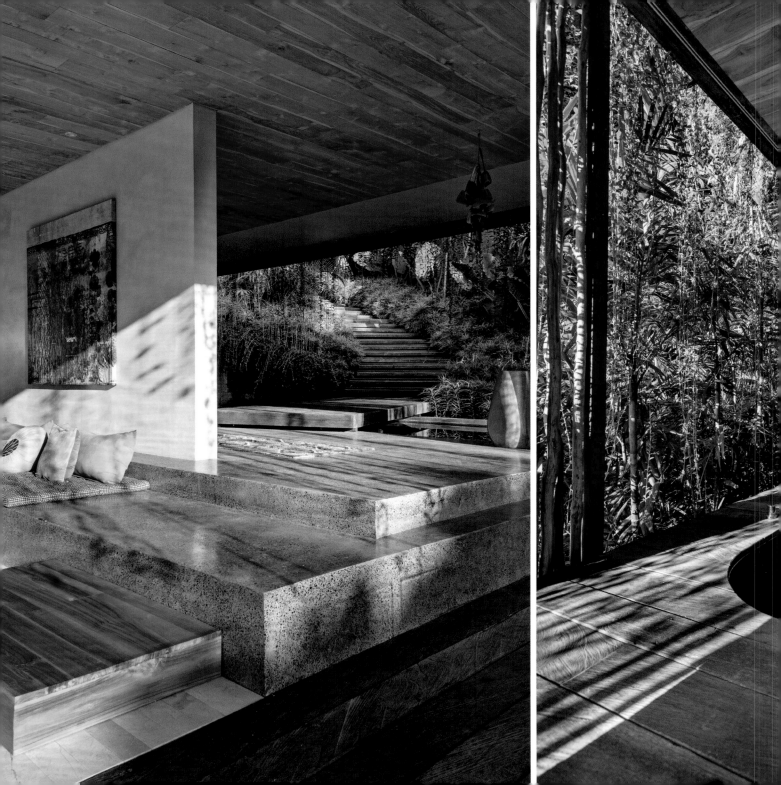

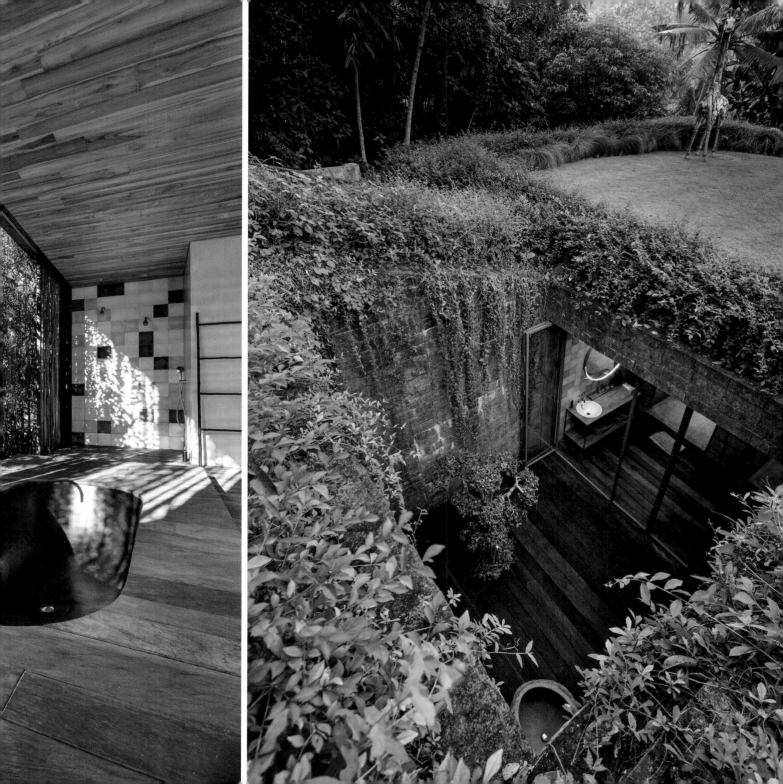

WOODHOUSE
ZUNYI, GUIZHOU, CHINA

ZJJZ / 2018

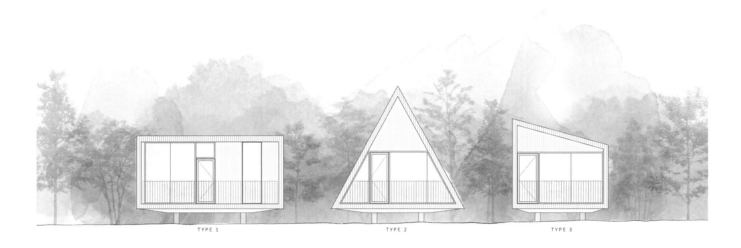

TYPE 1 TYPE 2 TYPE 3

The ten single-story pavilions that make up this hotel in a remote village in Guizhou provice, China, are each between 430 to 538 square feet (40 to 50 square meters) in size. The project is the result of a government policy to encourage agricultural tourism. "Our design goal was set to capture the beauty of nature with tranquil forms that harmonize with surrounding environment," the architects state. The pavilions were placed so as to disturb the natural site as little as possible. The difficult site required that all building materials be carried manually. Steel platforms with a carbonized wooden superstructure prepared on-site for reasons of cost were chosen for the structures. Three basic geometric forms were used for the houses, and windows were introduced according to the precise location of each structure. "The design of the wooden houses aims to harmonize with the landscape and the rustic atmosphere, while forming a contrast to existing village buildings," according to the architects.

Opposite: Forming a series of small hotel pavilions on a forested slope, the Woodhouse takes an unusual, modern approach to agricultural tourism in China. **Following spread, left:** Different roof angles and generous openings characterize the pavilions, which are at once close to the land and quite modern in their design. **Following spread, right:** The floor plans of the hotel pavilions are rectilinear and quite straightforward, differing essentially in the angles of the walls and roofs.

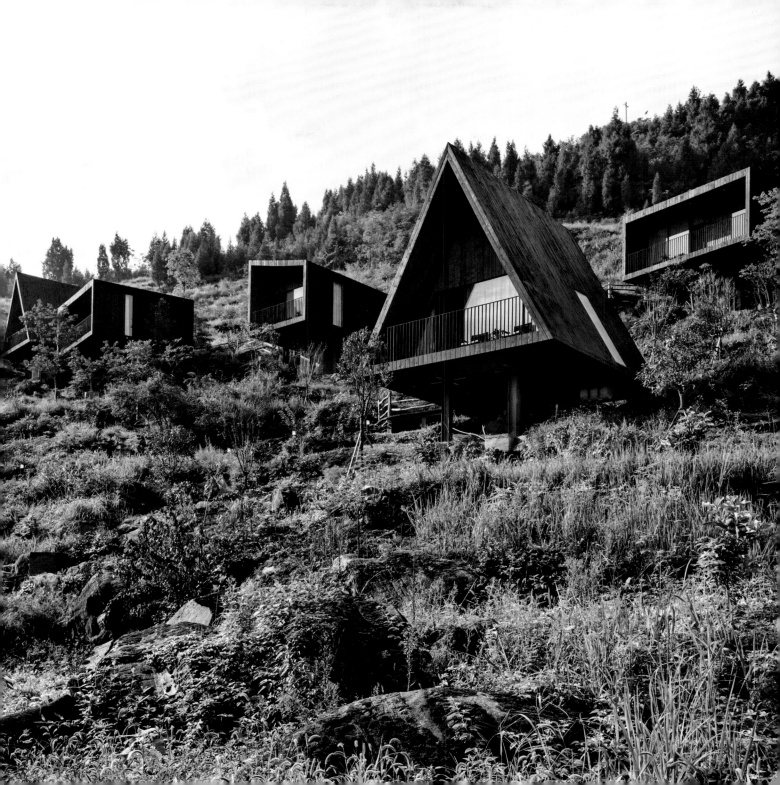

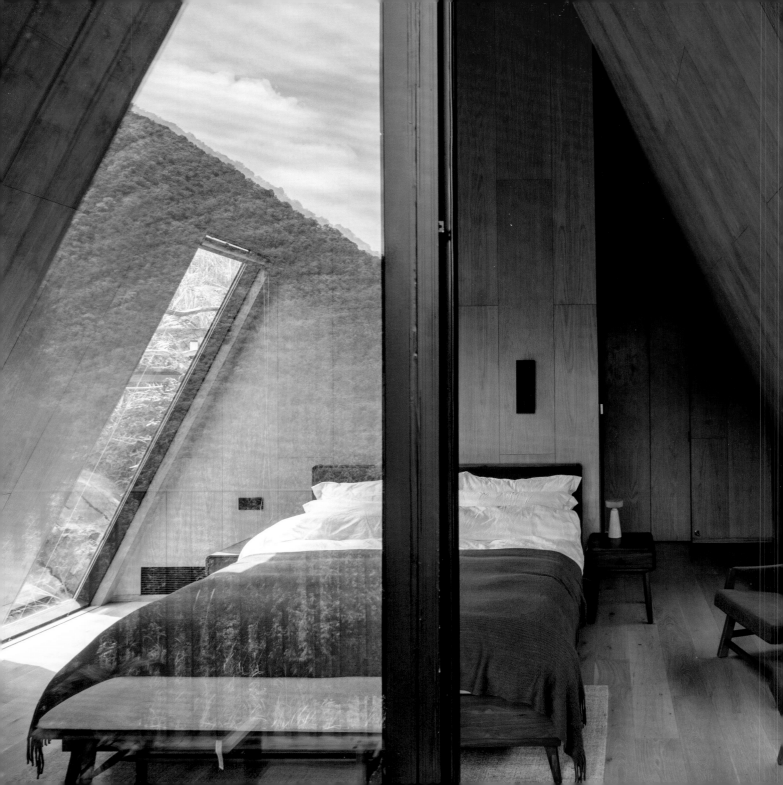

NO FOOTPRINT HOUSE
OJOCHAL, PUNTARENAS, COSTA RICA

A-01 / 2017

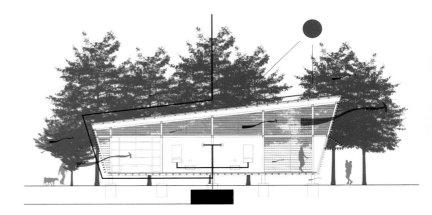

Built in a small village on the south Pacific coast of Costa Rica, the No Footprint House (NFH) uses natural ventilation and shading. Designed by the "think- and do-tank" A-01, it has a central core that includes the kitchen, laundry, bathrooms, closets, and machinery. The rest of the floor plan is open. The design uses vertical columns, a "floating" steel structure, and inclined outer facades, calculated to reduce the "direct impact of light and precipitation," explains architect Oliver Schütte of A-01. The outer facade has operable panels that can be opened and closed for airflow, for privacy, or for views. The house was prefabricated in Costa Rica and brought to its location on a truck. It was imagined as a prototype for three variations, measuring 387, 872, or 1,163 square feet (36, 81, or 108 square meters), and each can be made with different materials and finishes according to clients' wishes. The house is designed to be connected to local public water and energy systems, but

variations can be produced in an "off-grid" design. Hot water is produced by a solar energy system on the roof. The designers state, "The NFH is designed to blend with its natural surroundings and to minimize the impact of construction on the environment. The project seeks for integral sustainability in terms of its environmental, economic, social, and spatial performance." Schütte worked in the offices of Peter Eisenman and OMA/AMO in Rotterdam before founding A-01 with the aim of developing "innovative concepts and projects that are based on participatory design methodologies."

Opposite: Lifted slightly off the ground, the house disturbs its natural environment as little as possible and makes use of natural ventilation rather than mechanical systems. **Following spread:** With its angled roof and slat-covered exterior, the house has an unusual appearance that allows residents to take in the forest environment without creating undue damage to the site.

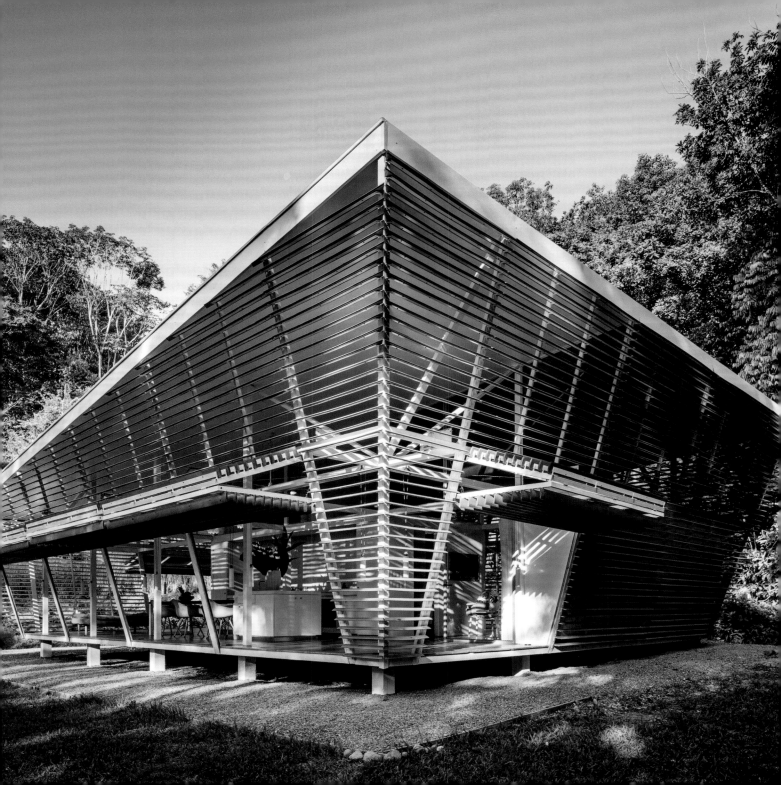

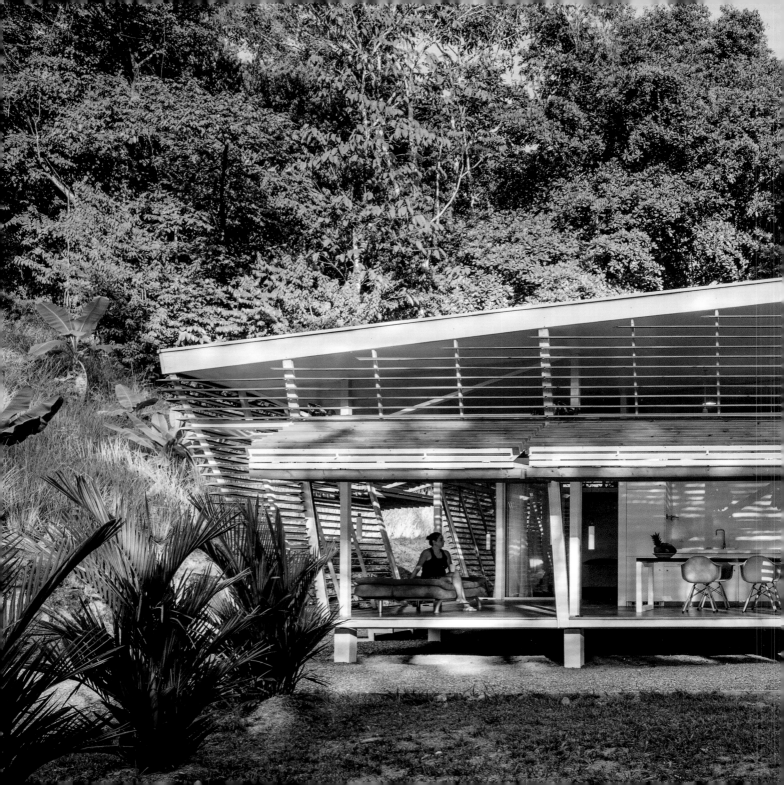

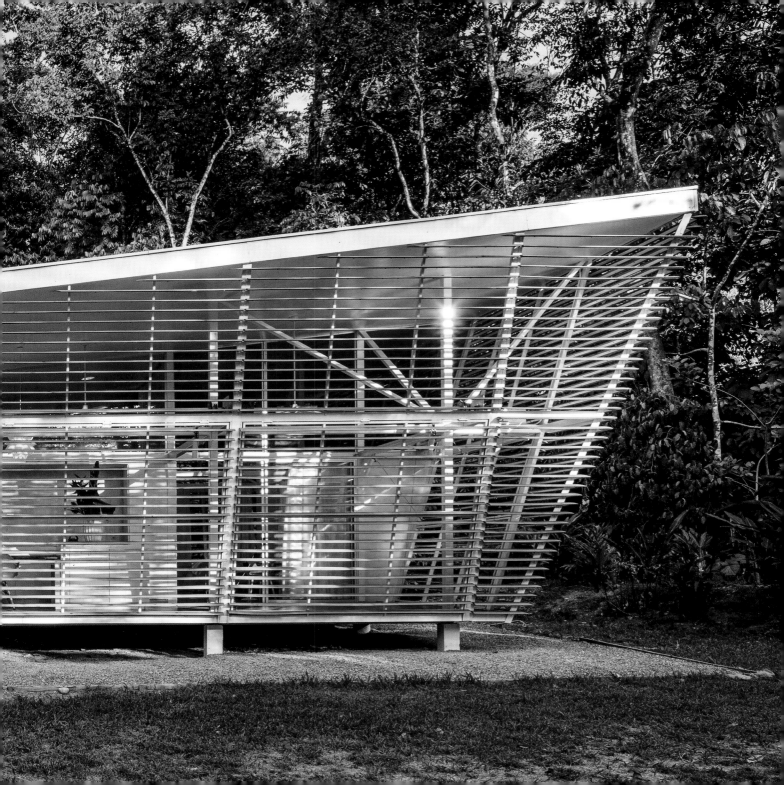

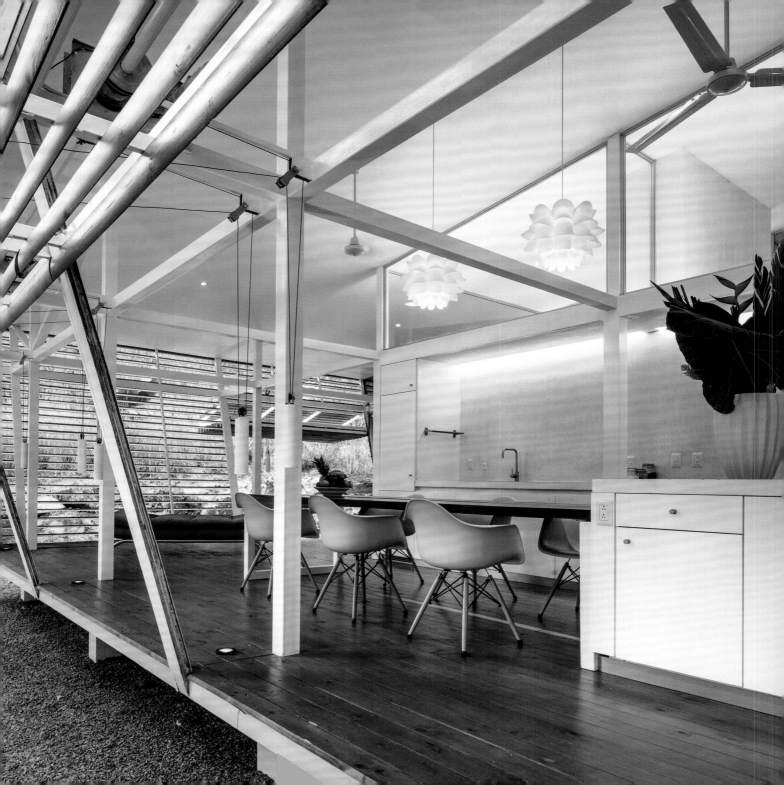

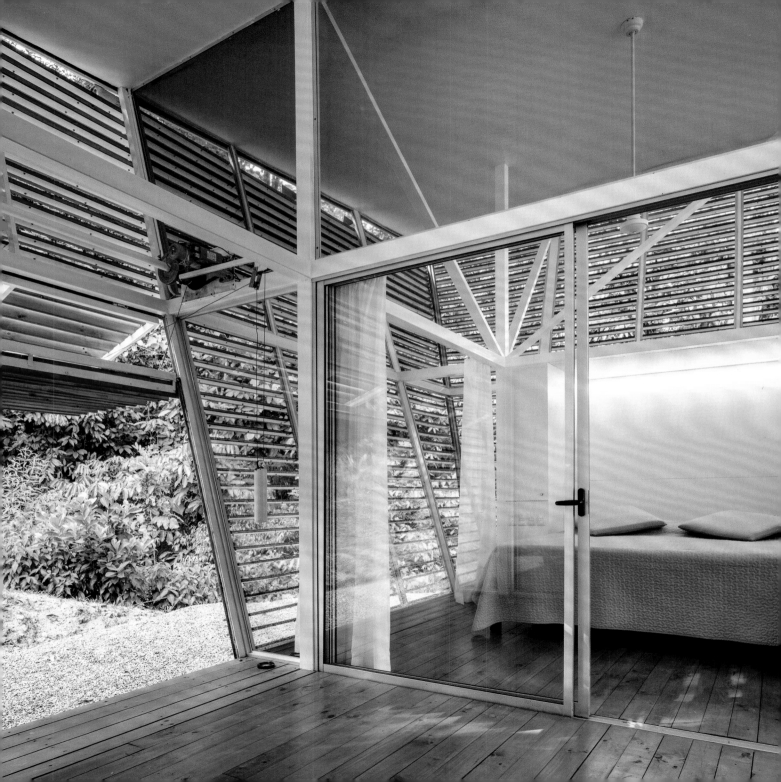

BRIDGE PAVILION
CALAMUCHITA VALLEY, CÓRDOBA, ARGENTINA

Alarcia Ferrer Arquitectos / 2014

Built near the shore of Lake Los Molinos in central Argentina, this 915-square-foot (85-square-meter) holiday pavilion was built in a eucalyptus forest over a ravine formed by an old road leading in the direction of Córdoba, which is to the south. The bridge-like house is supported on either bank by concrete walls that were pigmented to "achieve a texture and color in harmony with the place." The main structural element of the residence is formed by Vierendeel trusses that span the shallow ravine between the two concrete walls. The essentially open-plan house contains a kitchen, dining room, lounge, and bathroom and is conceived as a kind of passage over the existing channel. In this way, the passage toward the lake is kept free and the house does not touch the lake. The rectangular building has two glass facades that allow simultaneous views of the forest and the artificial lake, whose surface is about 2,500 feet (760 meters) above sea level. The firm that designed the house, Alarcia Ferrer Arquitectos, was formed in 2009 by Joaquin Alarcia and Federico Ferrer Deheza.

Opposite: Built over a natural ravine, the house is both transparent and light in its construction design, allowing residents to take in the setting without unduly disturbing the natural environment.

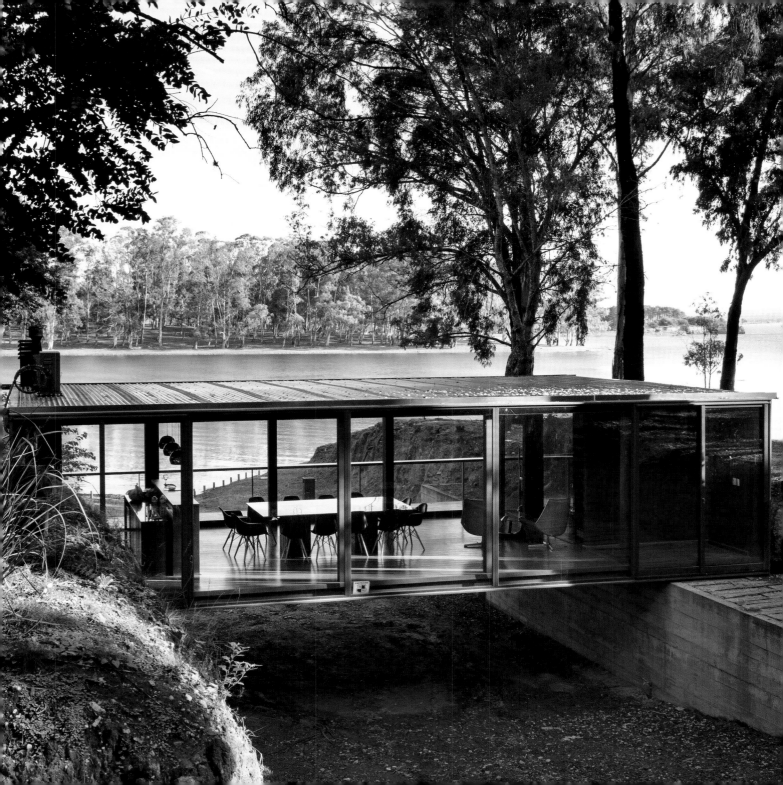

CASA LA ROJA
SAN JOSÉ DE MAIPO, CHILE

Felipe Assadi Arquitectos / 2017

San José de Maipo, Chile, is located thirty miles southeast of Santiago, close to the Andes and to Argentina. This small two-story house was built in an area with very low density. Houses typically have plots over one acre. The house has a double-height entrance terrace and was composed using a series of modular units that could be transported to the site and assembled using a crane—in this instance, the construction was carried out on-site. The design allows for expansion on the ground or upper floor. The bright red of the house is somewhat surprising in the context, but the architect, Felipe Assadi, explains that "the intense green of the surroundings suggests a complementary color, to activate the relationship between the landscape and the project through contrast. Hence the choice of pure red for the facades," which is fairly common in the houses in neighboring towns. The floor area of the house is 936 square feet (87 square meters). Since 2011, Felipe Assadi has been the dean of the architecture school at Universidad Finis Terrae in Santiago.

Opposite: This modular house stands out from its forested environment in a willful way, using the contrast with the surrounding green landscape to affirm the presence of the small structure. **Following spread, left:** The ground level is broadly glazed on three sides, giving an impression of lightness and proximity to the natural surroundings. **Following spread, center and right:** A suspended stairway connects the floors of the rectangular structure, which essentially forms a square with the outdoor terraces included.

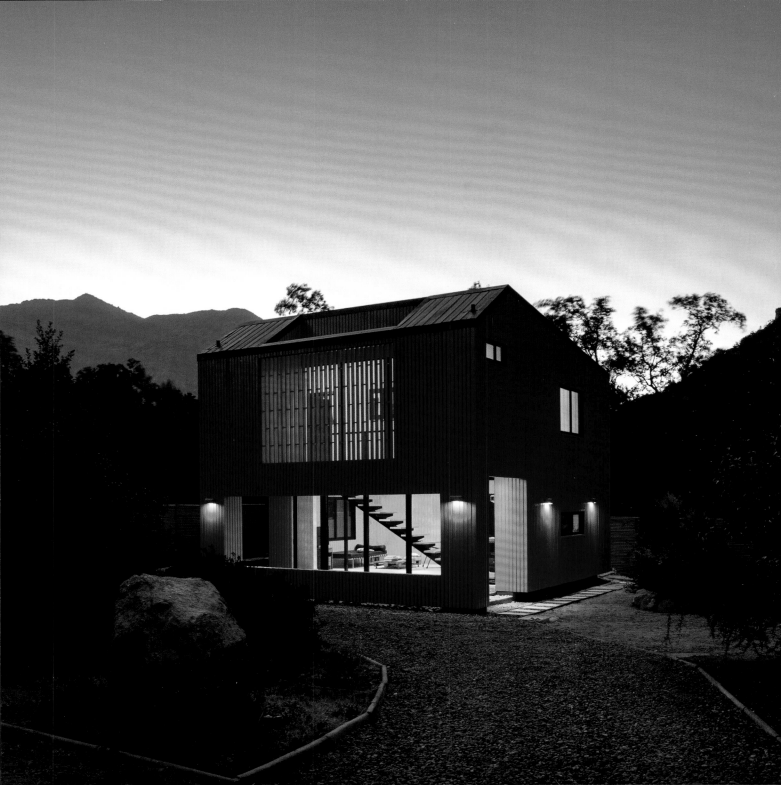

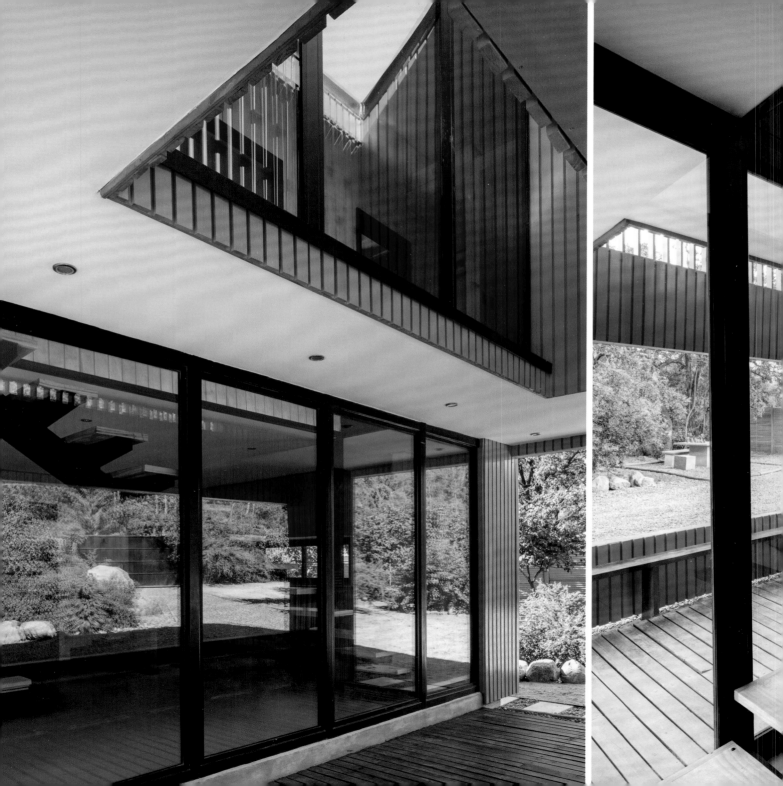

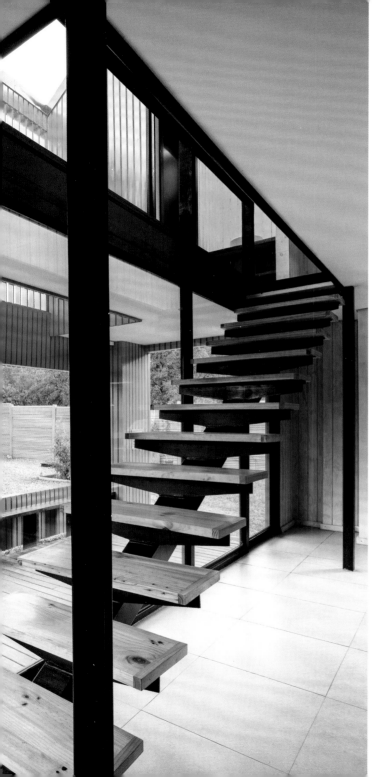

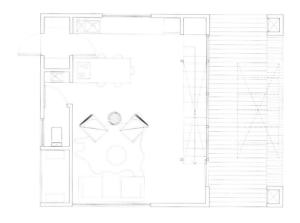

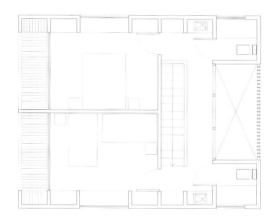

FOREST HOUSE
COSTA ESMERALDA, BUENOS AIRES, ARGENTINA

Besonias Almeida Arquitectos / 2018

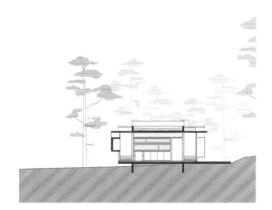
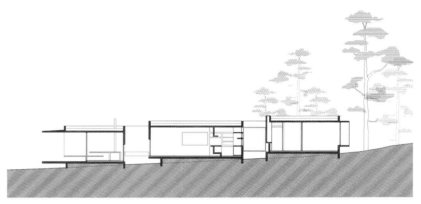

Costa Esmeralda is a private domain on the coast located 240 miles south of Buenos Aires. Set in dunes in a dense grove of trees, the site includes a seven-foot slope from front to back. The architects chose to create three connected volumes staggered by forty-five centimeters to deal with the slope and turned the house in the direction of the slope (north–south). The entrance is located at the center of the floor plan, at the same level as the outdoor spaces and the living, dining, and kitchen area. From here, small flights of steps lead up to the private areas and the bedrooms or descend to the living area. Interior courtyards bring light into the rooms. The house was built essentially with two materials, concrete and glass, with details in dark bronze anodized aluminum. The slabs that form the house rest on beams that allow for generous cantilevers. A green roof provides thermal insulation.

Hollow brick interior partitions were finished with painted plaster. An electric heating system was placed beneath the floors. Beds, sofas, and chairs are the only interior elements not made of concrete. The architects, Madrid-born Maria Victora Besonias and Buenos Aires–born Guillermo de Almeida, placed a premium on the modernity and ease of maintenance of this house.

Opposite: The poured-in-place concrete surfaces of the house bear the trace of their wooden forms, creating an intimate connection with the forest environment. **Following spread, left:** The density of the concrete structure is contrasted with numerous generally low windows that give a cave-like, protective atmosphere to the house. **Following spread, right:** The omnipresence of the pattern of the wooden forms used to pour the concrete gives a rough unity to all the surfaces of the house.

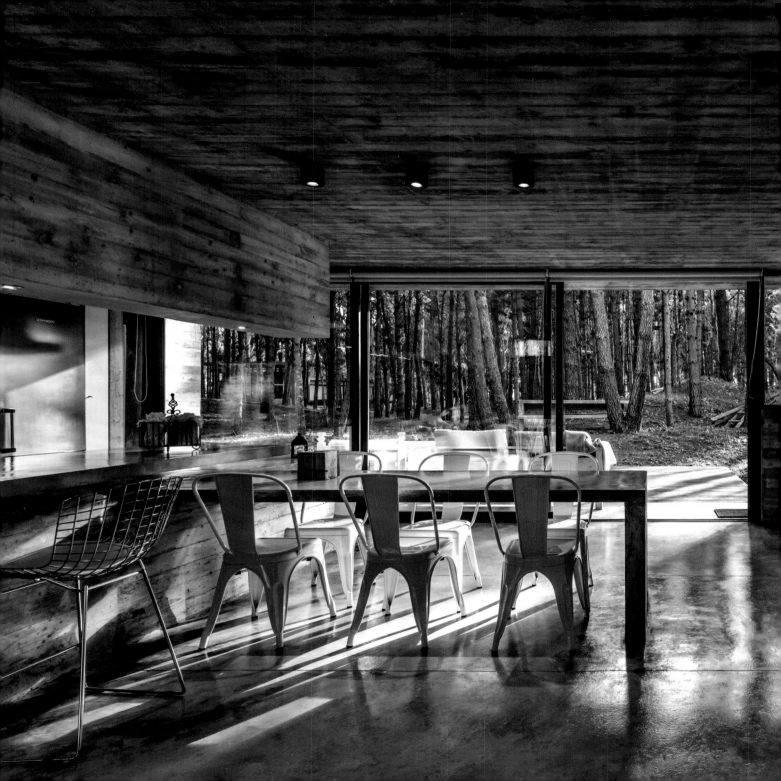

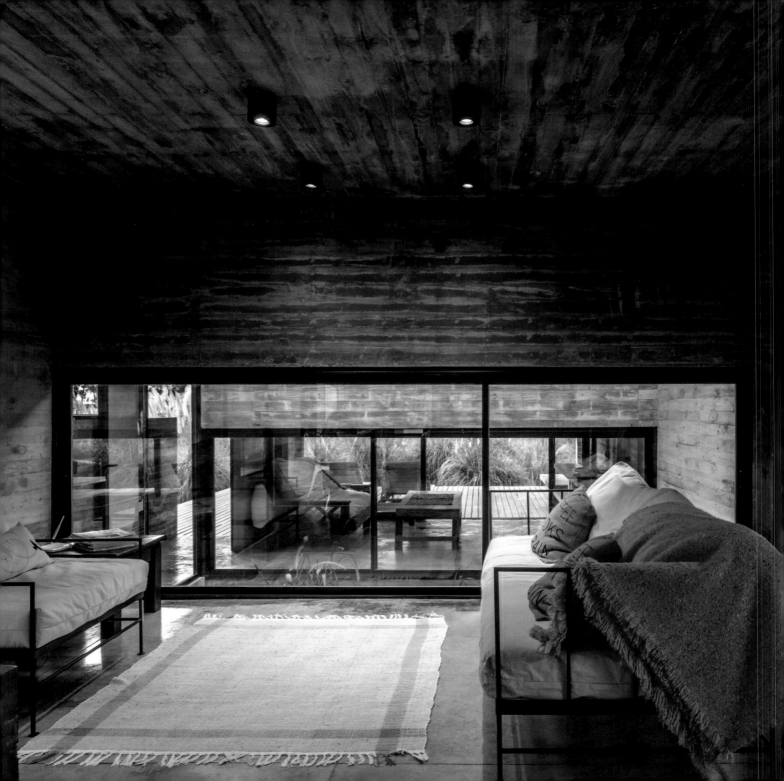

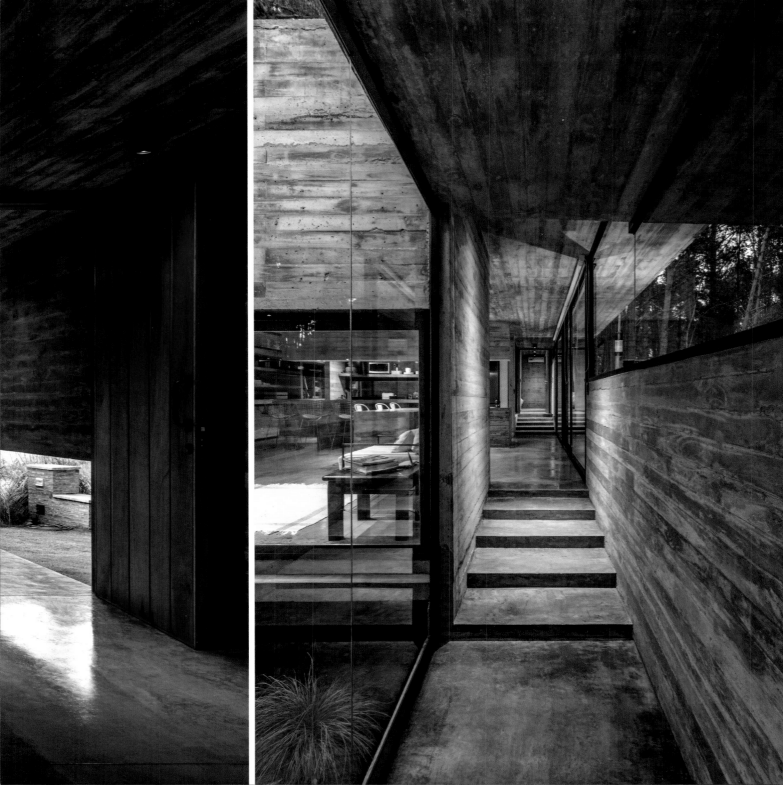

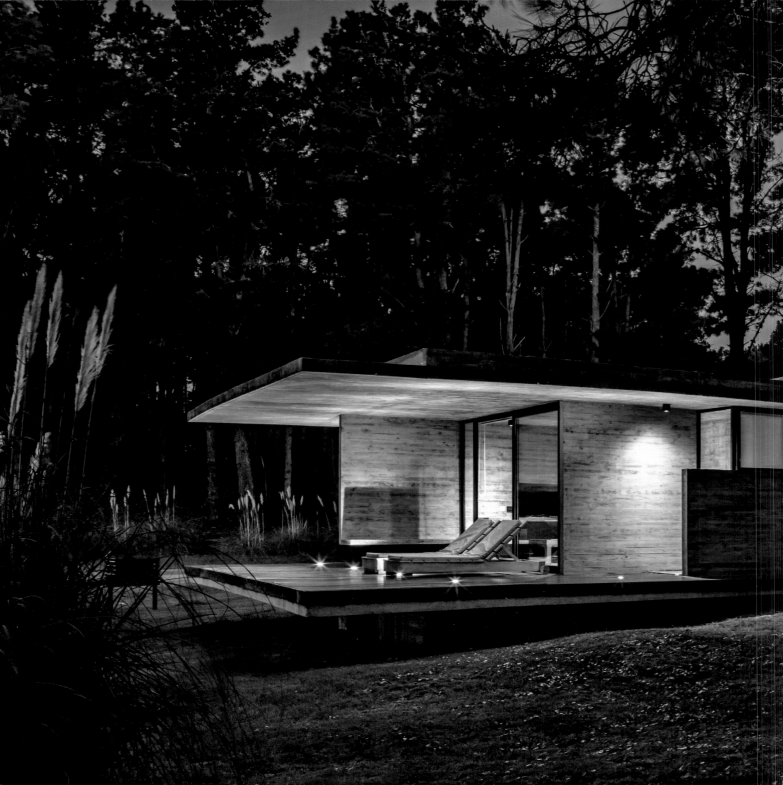

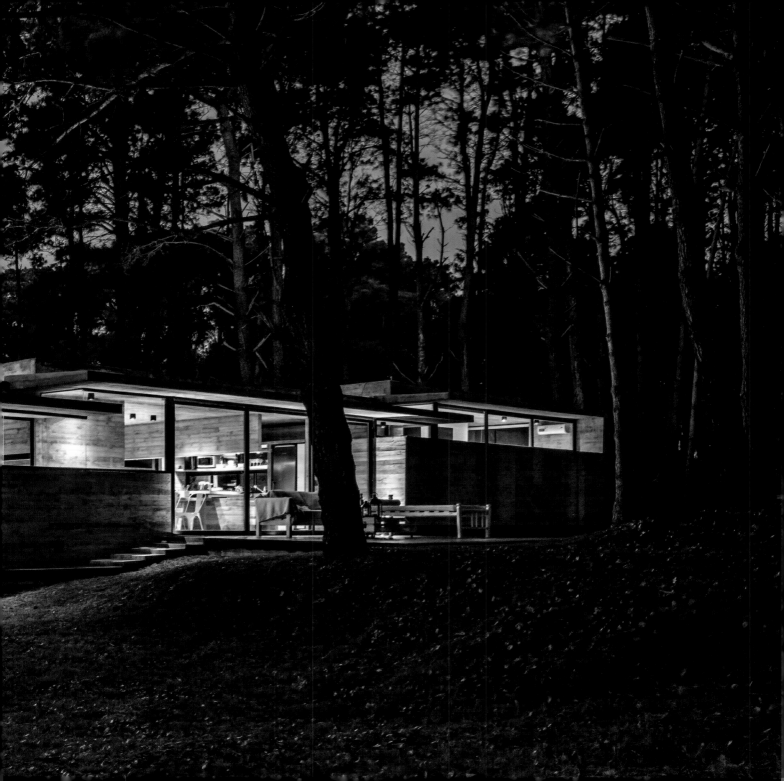

COCOBOLO HOUSE
MONTEZUMA, PUNTARENAS, COSTA RICA

Cañas Architects / 2016

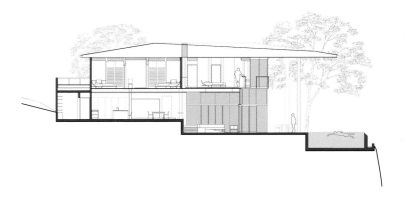

The Cocobolo House looks south over the Pacific Ocean from a cliff. It is cooled passively by ocean breezes and is named after a native hardwood tree on the site that grows through the large flat roof. Slightly uneven stone steps lead from the north side entrance down to the main door. A solid wood stairway hangs above a black river stone garden to the right of the entrance. A dining area and kitchen both open to the wooden terrace and mirror pool. The living area is stepped down toward the forest and the ocean. The main bedroom is above the living room. Two other bedrooms and a bathroom are located above the kitchen. Generous wood-and-stone outdoor terraces are partially covered by the overhanging concrete roof, which is held up by slender columns. The edge of the terrace is marked by a black infinity pool. One of the more dramatic features of the house is a three-foot-wide Corten steel volume that extends from the upper level master bedroom. The architect explains,

"This finger balcony is a wooden pirate plank–like walkway that visually starts at the entrance of the bedroom, extends outside over the terrace below, passes beside a Cocobolo tree (which penetrates both the handrail and the roof), juts out from below the eaves of the main roof, and ends in a small open space, large enough for two chairs, with a glass rail that points out toward the ocean horizon and is placed above the forty-meter-high [131-foot-high] void of granite cliff face and tropical green beach front."

Opposite: Placed at a cliff edge, the house projects an image of modernity that contrasts with the forested environment. **Following spread:** High columns offer generous space to an open living area near the dark pool that marks one side of the house. Both the plans and the photo show the close proximity of the house to the dense vegetation on the site, a design in harmony with the climate of Costa Rica.

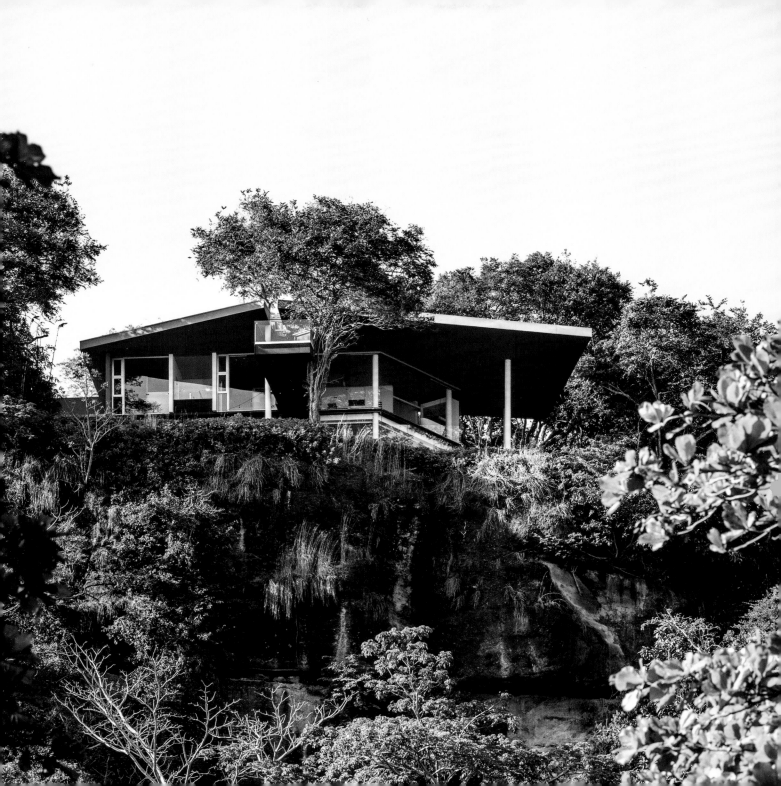

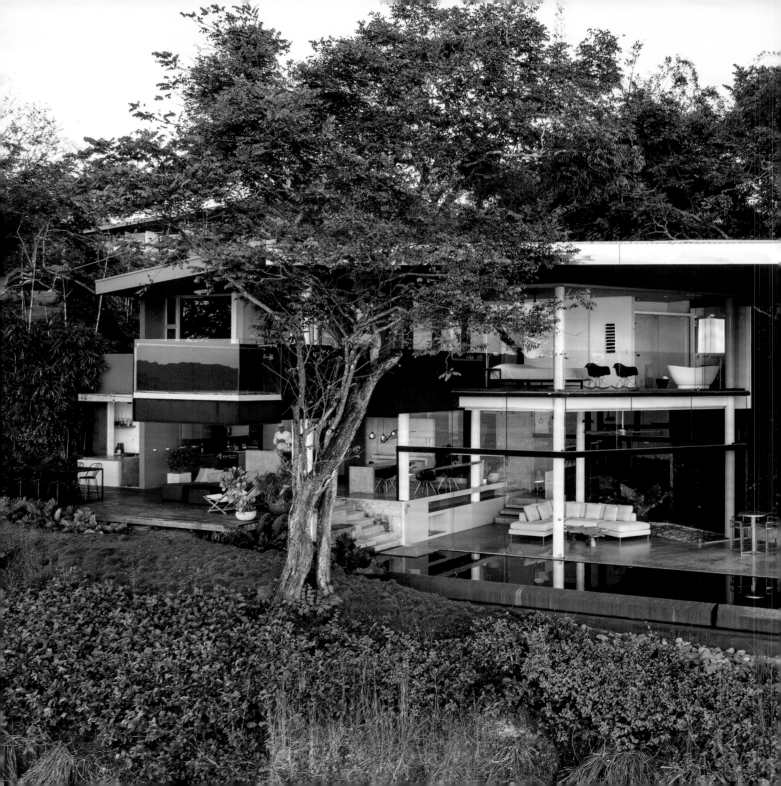

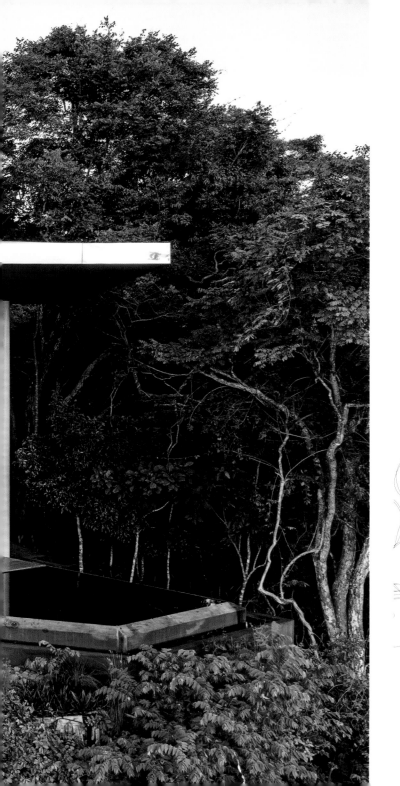

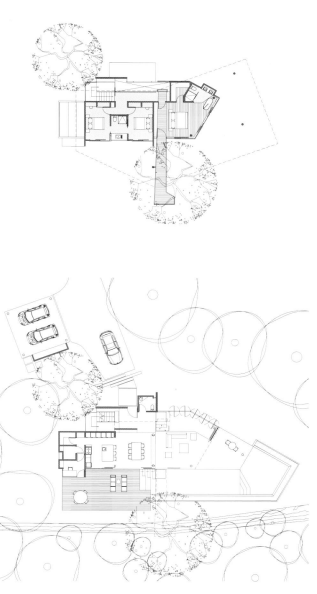

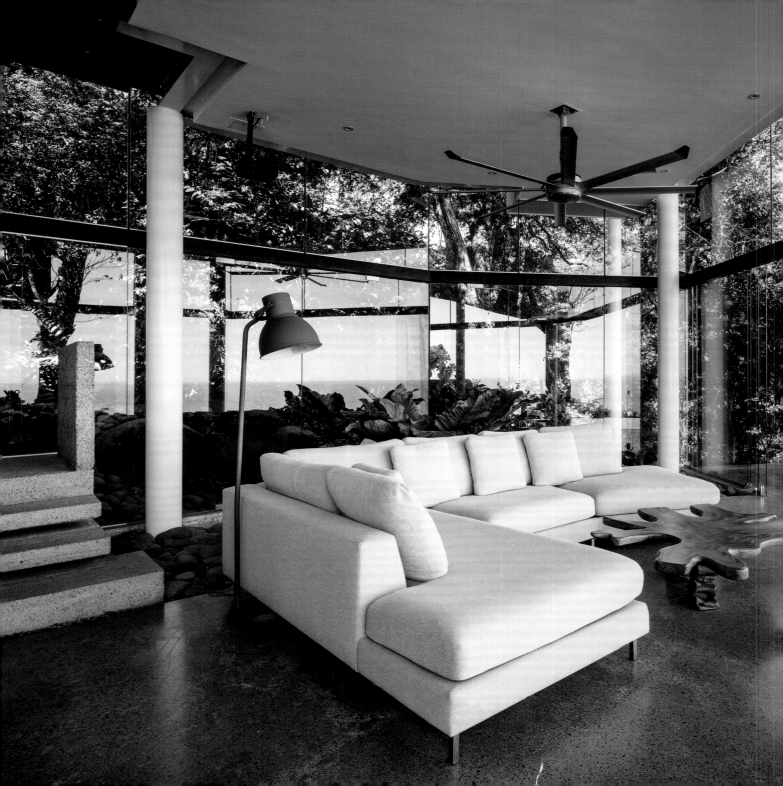

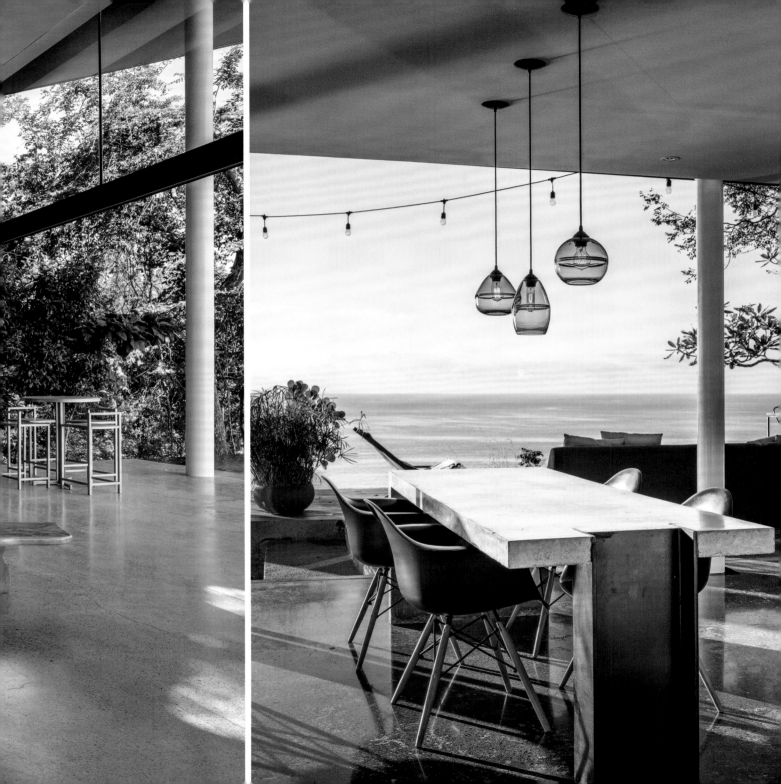

H3 HOUSE
MAR AZUL, BUENOS AIRES, ARGENTINA

Luciano Kruk / 2015

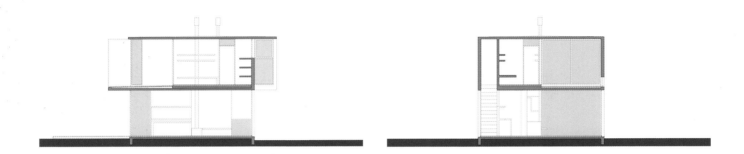

The small 2,777-square-foot (258-square-meter) site for the H3 House is located eight blocks from the South Atlantic in Mar Azul, which has a landscape formed of sand dunes and pine trees. Built for three sisters and their families, the 807-square-foot (75-square-meter) poured-in-place concrete house has a generous public area with a master bedroom and a smaller "cabin-like" room. Pine planks were used for the concrete formwork to create a link between the house and its natural setting. With a desire to keep maintenance to a minimum, even some of the furniture was part of the concrete volume. The pubic areas—kitchen and dining and living room—are on the ground floor. The upstairs bedrooms share a semicovered outdoor terrace space. The main windows are located to the rear of the house facing the outdoor deck and trees. Overhangs protect the concrete surfaces of the exterior

from water damage. The architect states: "The layout of the house is the result of an architectural synthesis of the sisters' intentions and desires. In its minimum scale, the house rises by its own will, but also integrates itself respectfully with its surroundings, both natural and human-built."

Opposite: Despite having been built with concrete, the house appears to sit lightly on its wooden terrace in this forest site. **Following spread, left:** Concrete is omnipresent and furnishings are kept relatively sparse, thus placing an emphasis on the natural setting seen through full-height glazing. **Following spread, right:** The plans of the house are a strict play on rectangular and square forms, albeit in a pattern that allows for unexpected openings.

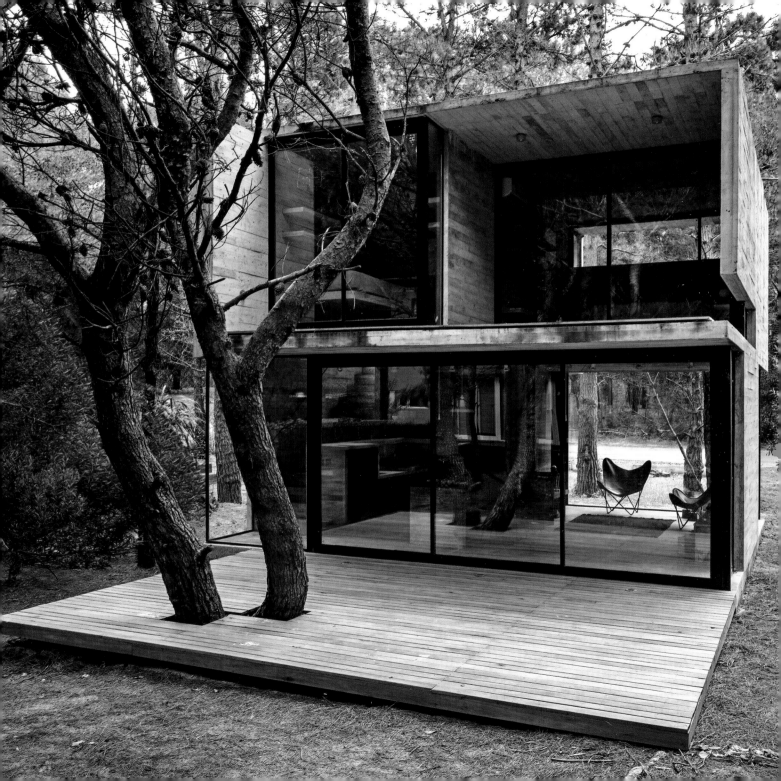

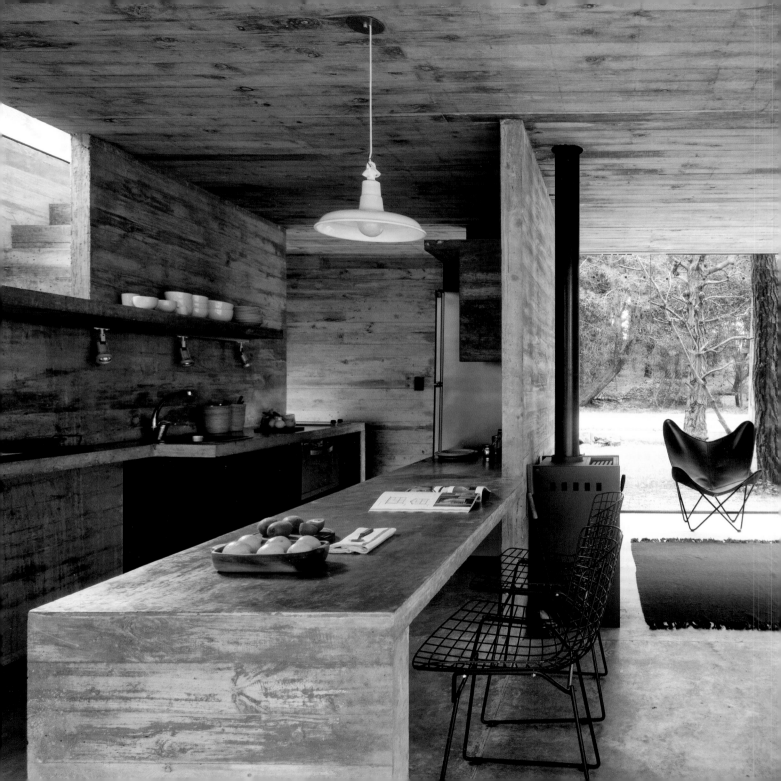

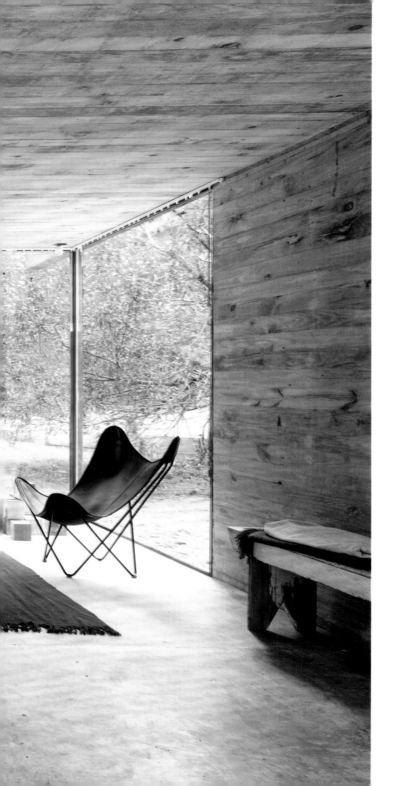

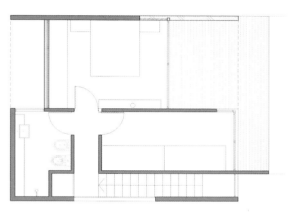

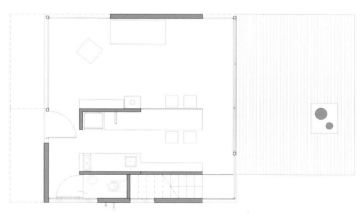

TREE HOUSE CONSTANTIA
CONSTANTIA, CAPE TOWN, SOUTH AFRICA

Malan Vorster / 2017

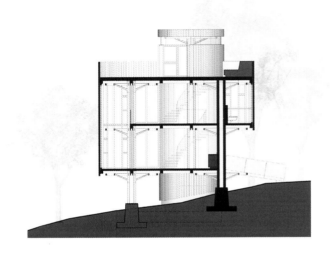

Built on a property with other structures also designed by Malan Vorster, this structure is a one-bedroom "hideaway" that is intended to resemble a tree house. The positioning of the building and its verticality maximize views from a high point on the property. According to the architects, "Inspiration was drawn from the timber cabins of Horace Gifford and Kengo Kuma's notions of working with the void or in-between space, while Louis Kahn's mastery of pure form and the detailing ethic of Carlo Scarpa informed a process of geometric restraint and handcrafted manufacturing." The pinwheel layout is based on the geometry of squares and circles. The architect emphasizes the directionality of the square as opposed to the organic relation of circles to the natural surroundings, with columns located at the center of each circular element. The bedroom is on the middle level, with living space below and a roof deck above. The semicircular bays formed by the circle contain a bathroom on the middle floor and a built-in seating area on the deck. A suspended Corten steel and timber ramp provides access, with Corten used for the columns and steel "trees" to support the timber floor beams. The untreated exterior is western red cedar.

Opposite: Not a tree house in the most traditional sense because it is anchored in the ground, the structure nonetheless gives an impression of bearing a close relationship to its forested site. **Following spread, left:** The vertical wooden slats and generous openings create a true connection between the modern interior and the surrounding forested land. **Following spread, right:** Rounded forms complement the square central area of the house, reconciling the natural environment and the more geometric realm of the architecture.

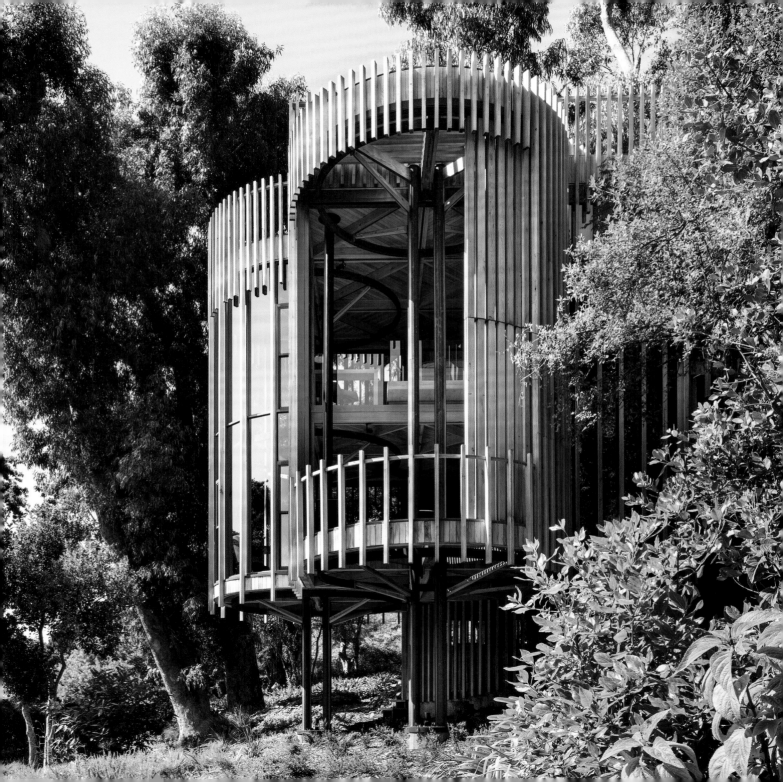

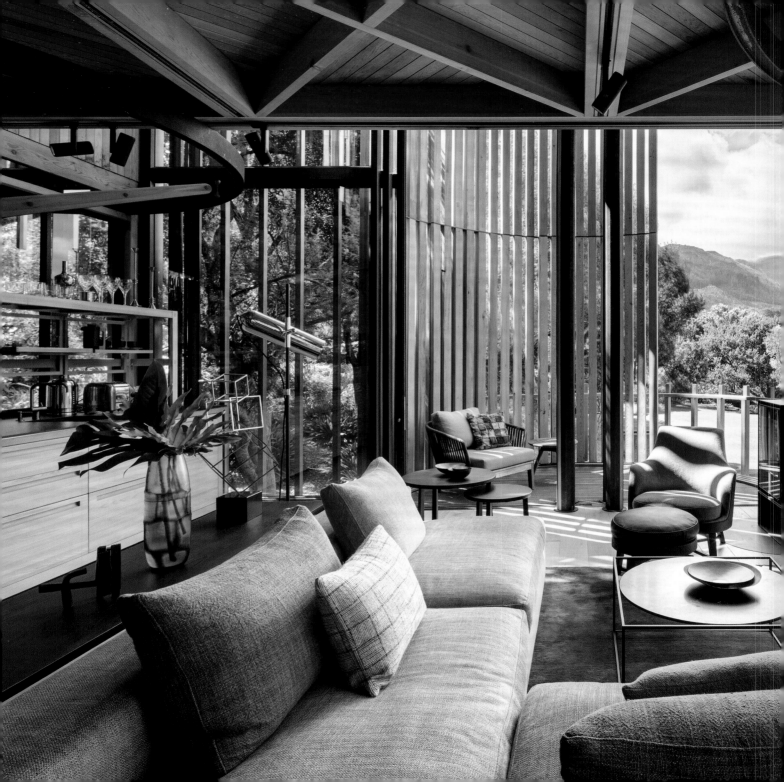

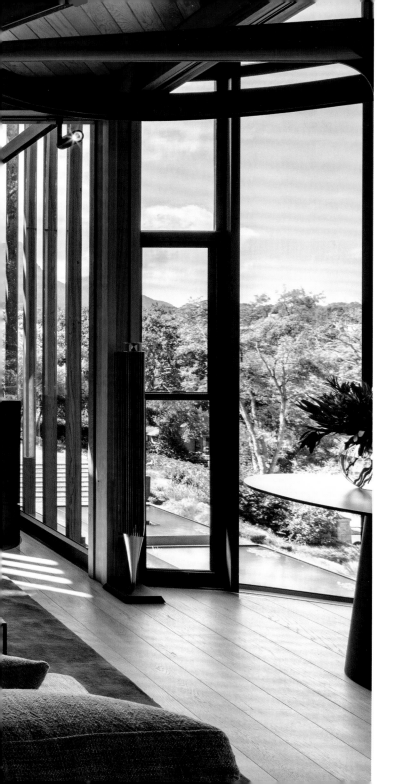
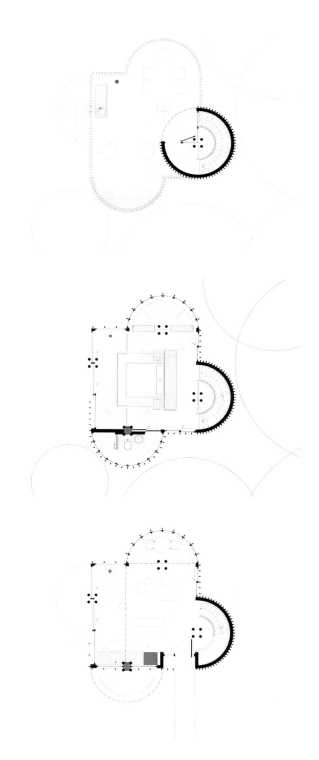

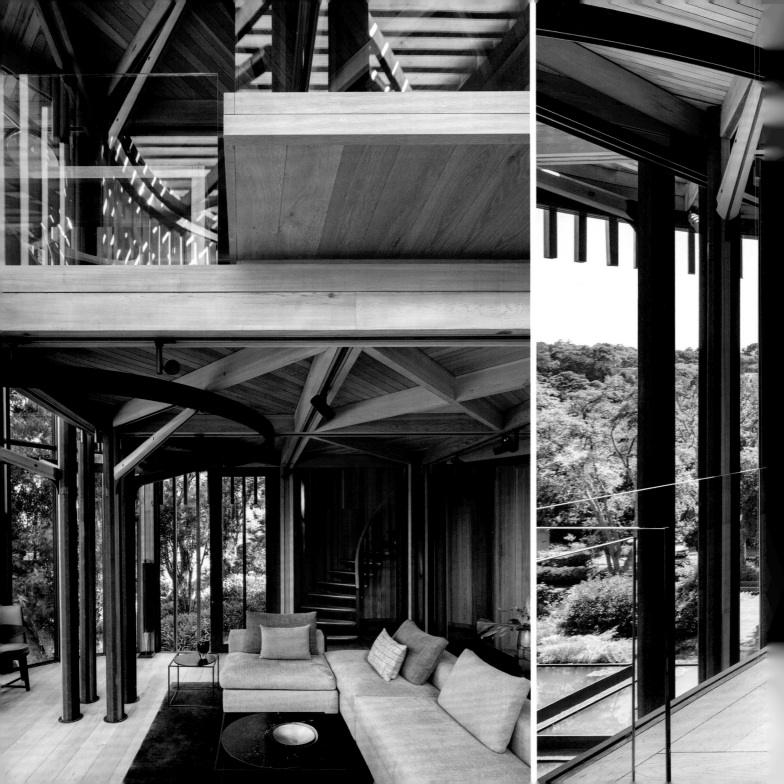

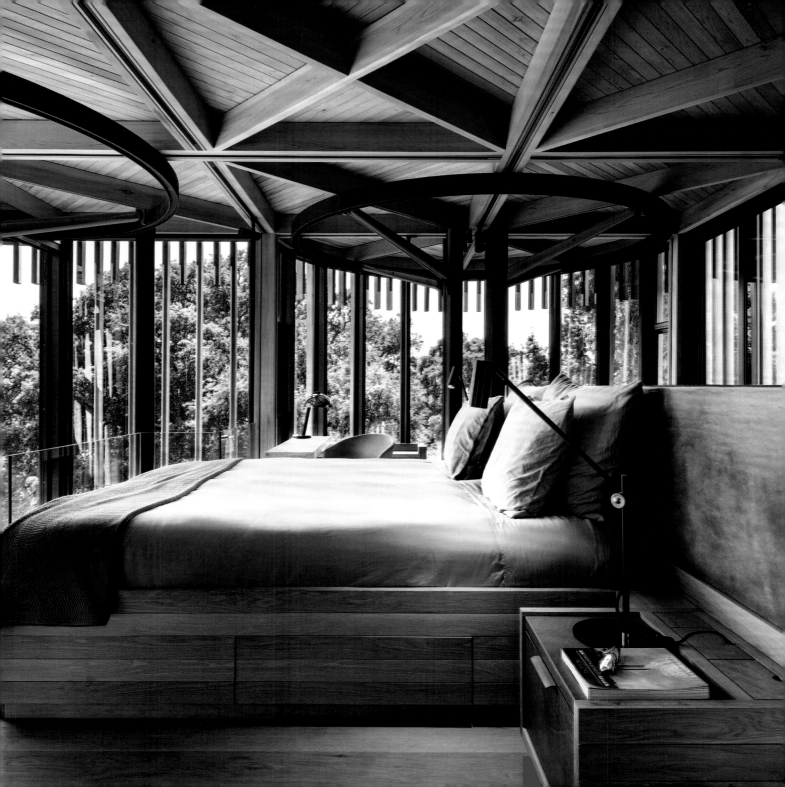

MORORÓ HOUSE
CAMPOS DE JORDÃO, SÃO PAULO, BRAZIL

Studio MK27 / 2015

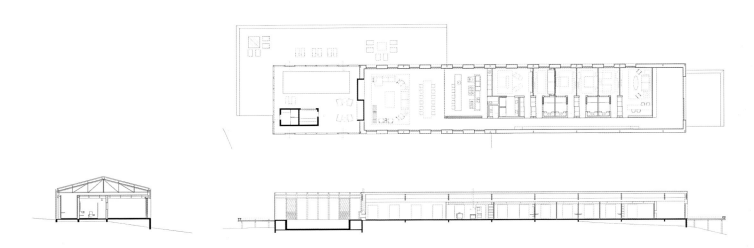

Located 112 miles from São Paulo, the 7,858-square-foot (730-square-meter) Mororó House was built on a generous 4.4-acre site. Because the region is known for relatively low temperatures, the design includes an enclosed bathhouse, pool, and sauna in a 46-foot-long glazed part of the residence. The living room and bedrooms are, by way of contrast, in an opaque area that is no less than 160 feet long. Sliding doors connect the interiors to an external wooden deck and the kitchen to the rest of the public areas. The architect explains, "This relation between empty and full in the facade allows for an excellent thermal performance, with a high degree of electric energy conservation." The clients wanted to place the house higher up on their rugged site, but the architect

persuaded them to use the lowest part of the land, in a pine forest, which is more interesting and more intentionally set into the topography. Although access to the location is difficult, the use of steel frame walls and other prefabricated elements allowed the construction to advance rapidly. Wood is used extensively inside the house.

Opposite: Although its rectangular form is strict, the house is unexpected in the relationship of the greenhouse-like public area and the more closed rear volume. **Following spread, left:** The living and dining area is placed next to the open kitchen. In this part of the house, the volume is almost entirely clad in horizontal strips of wood. **Following spread, right:** The living room has a stone floor and opens to a deck overlooking the forest.

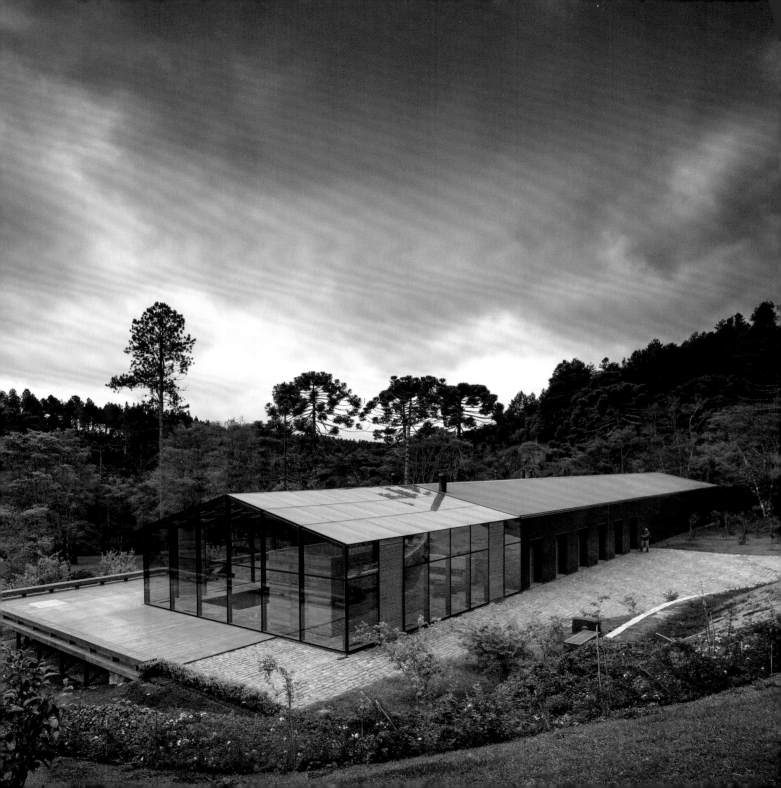

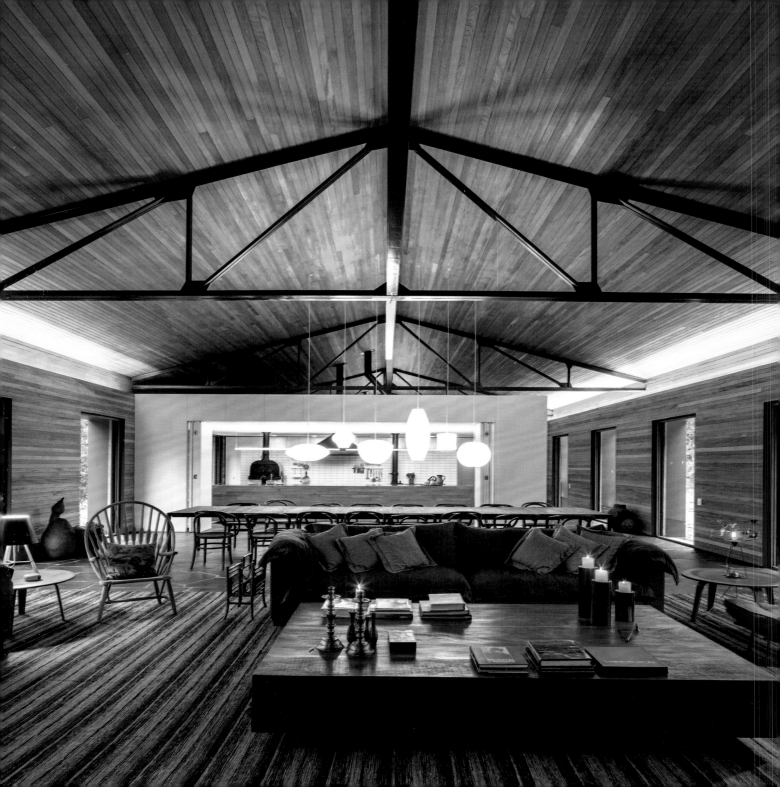

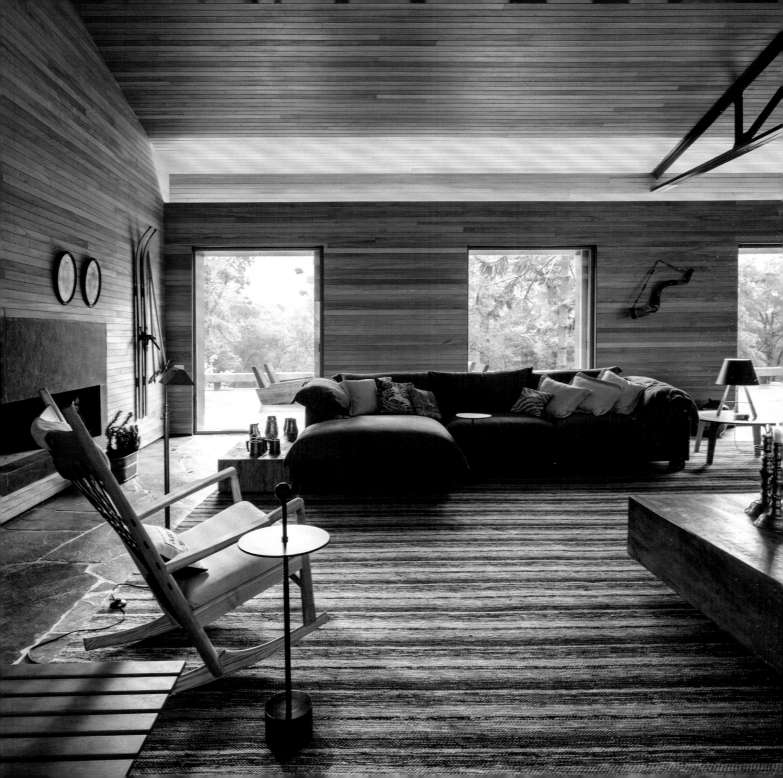

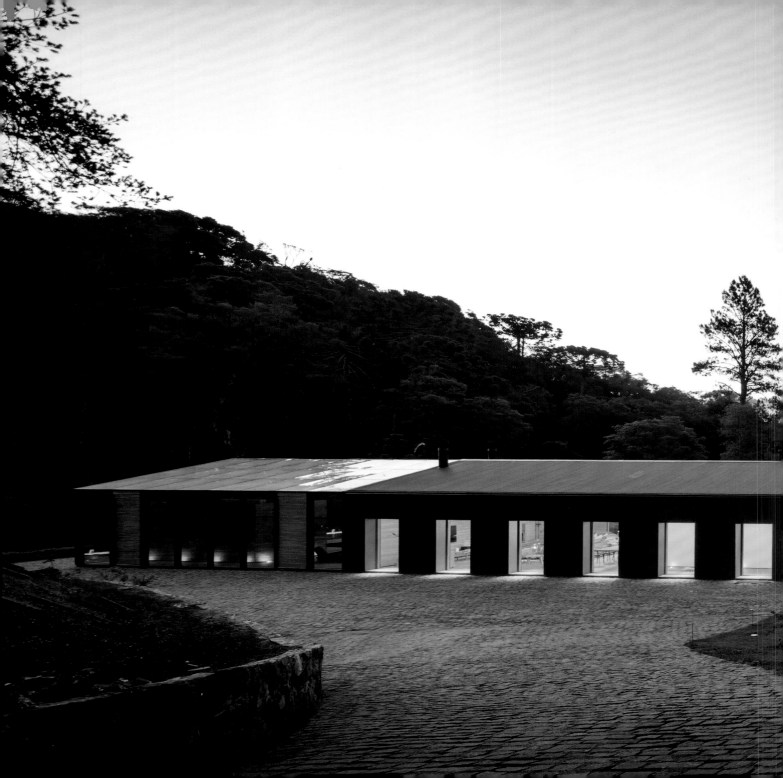

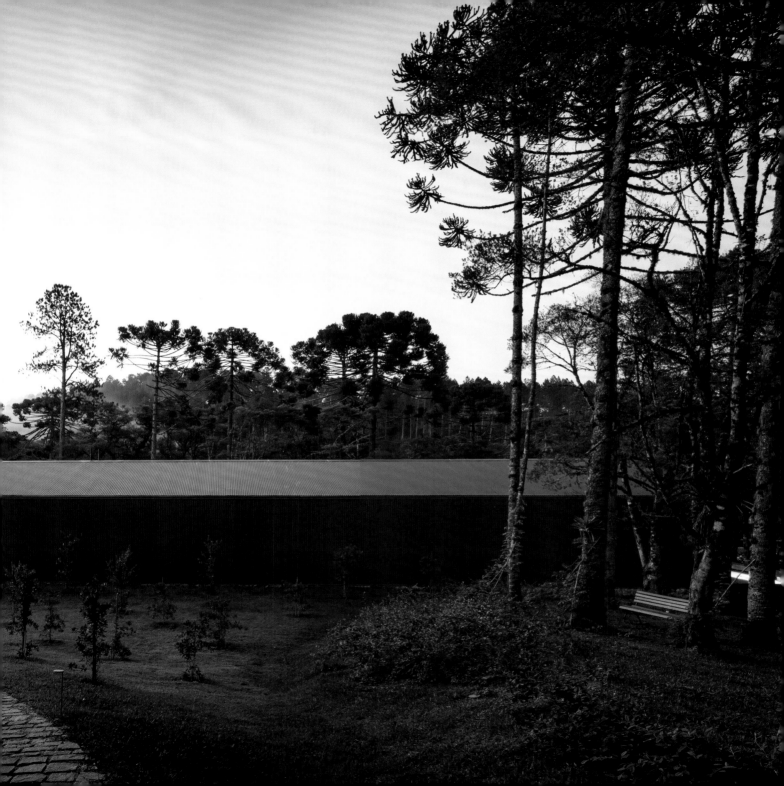

CHIPICAS TOWN HOUSES
VALLE DE BRAVO, MEXICO

Alejandro Sánchez García, Taller 6A / 2009

Four independent structures were designed on a wooded site with an intentionally small footprint in order to preserve most of the existing vegetation. Two facades of each structure are fully glazed, and the other two surfaces are covered in a dense horizontal wooden latticework to maintain privacy. The 20-foot (6-meter) square-plan houses are each thirty feet high. The houses each have three stories plus a roof garden with a view of the lake of Valle de Bravo. Inside, there are two bedrooms, bathrooms, a double-height kitchen, a living and dining area, a TV room, and laundry room. The bedrooms are on the top level. Architect Alejandro Sánchez García states, "Our philosophy is simple and logical design, architecture that is not pretentious, that is decisive in its use of local materials; timeless and transcendent. We believe in constant communication with the environment, with the setting, with the preexisting, as an honest dialogue that entails in situ awareness."

Opposite: The ground floor living and dining area is fully glazed on two sides with an open corner that permits interior and exterior to flow smoothly into a harmonious whole. **Following spread, left and center:** In its forest setting, the structure resembles a kind of tree house, tall and transparent on one side, and more closed on the other. **Following spread, right:** The open corner of the house has an outdoor deck that allows residents to be in even greater proximity to the forest environment.

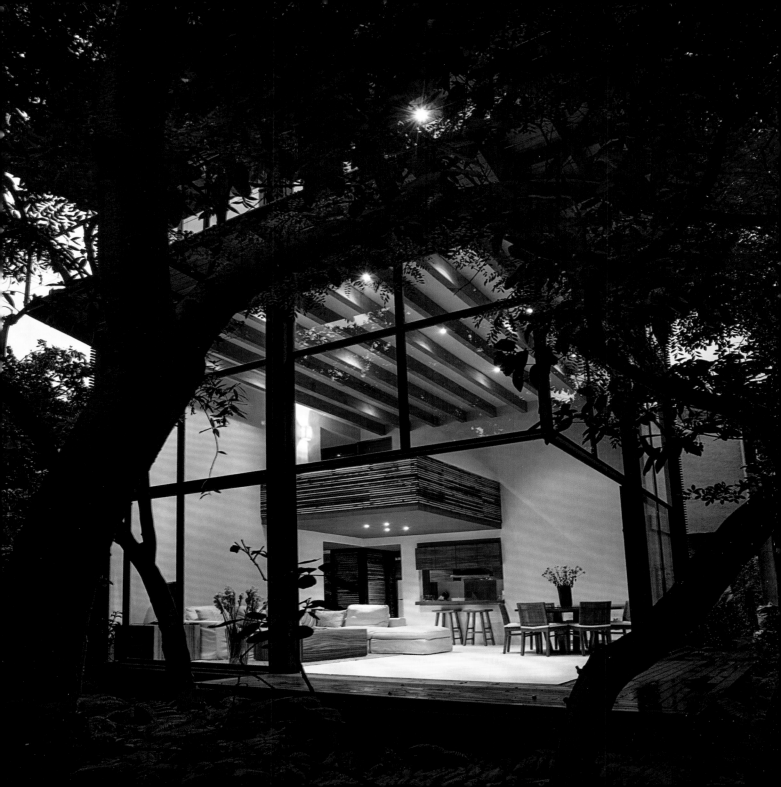

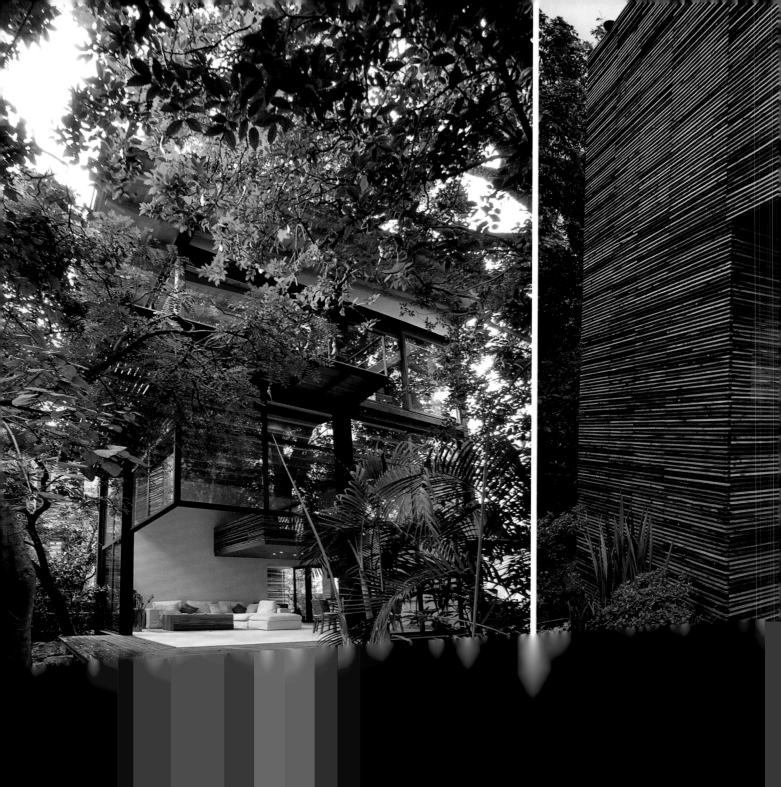

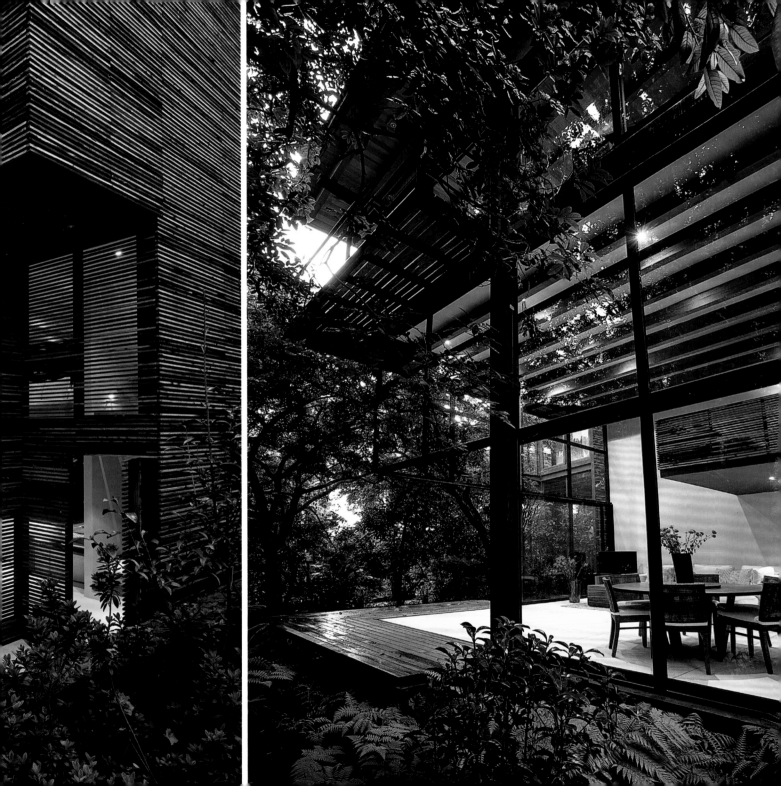

YELLOW HOUSE PUCON, CHILE

Alejandro Soffia Arquitecto / 2019

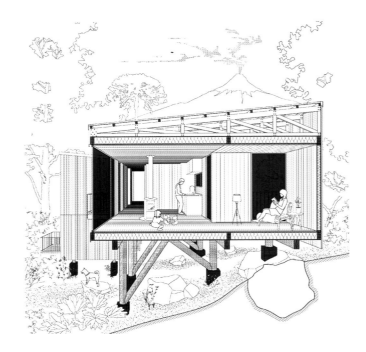

The architect Alejandro Soffia has a decided preference for prefabricated materials. He makes frequent use of lightweight structural panels—in particular, SIP or structural insulated panels—because of their ratio of structural resistance to thermal insulation. These were first developed by Alden Dow, an architect and Dow Chemical heir. The panels selected by Soffia come in three dimensions, beginning with four by eight feet. Using eight-foot-tall, 6.5-inch-thick wall panels, the architect devised a spatial module as the "dimensional unit" of the house. The panels are made with oriented strand board and a layer of expanded polystyrene insulation. The Yellow House is a 1,076-square-foot (100-square-meter) single-story house built on a 11,302-square-foot (1,050-square-meter) site. The relatively complex composition of rectangles that forms the plan clearly shows that the prefabricated components do not impose strict designs. Black stairs, terraces, and window frames, as well as an essentially dark wood interior, provide a strong contrast to the prevailing color of the residence. The house is located near Lake Villarrica, 485 miles south of Santiago.

Above and opposite: The yellow house and its black roof contrast with the forest environment. The section drawing shows how the house is set up on its sloped site. **Following spread, left:** The yellow panels of the house contrast with the surrounding forest environment. **Following spread, right:** The dark wood cladding of the interior spaces allows a focus to remain on the views of the forest as seen through the full-height glazing that runs along one side of this living and dining area.

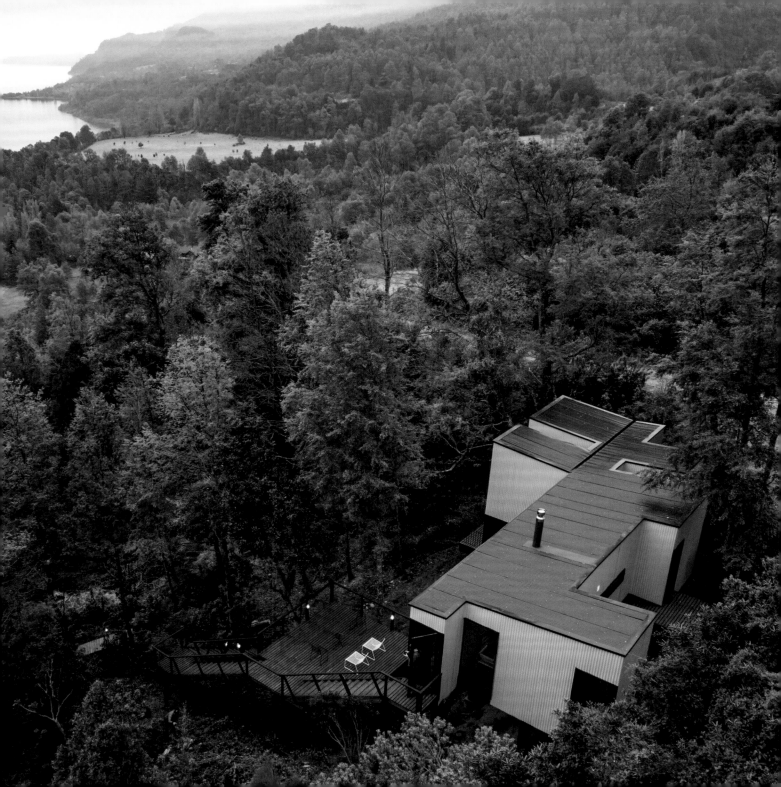

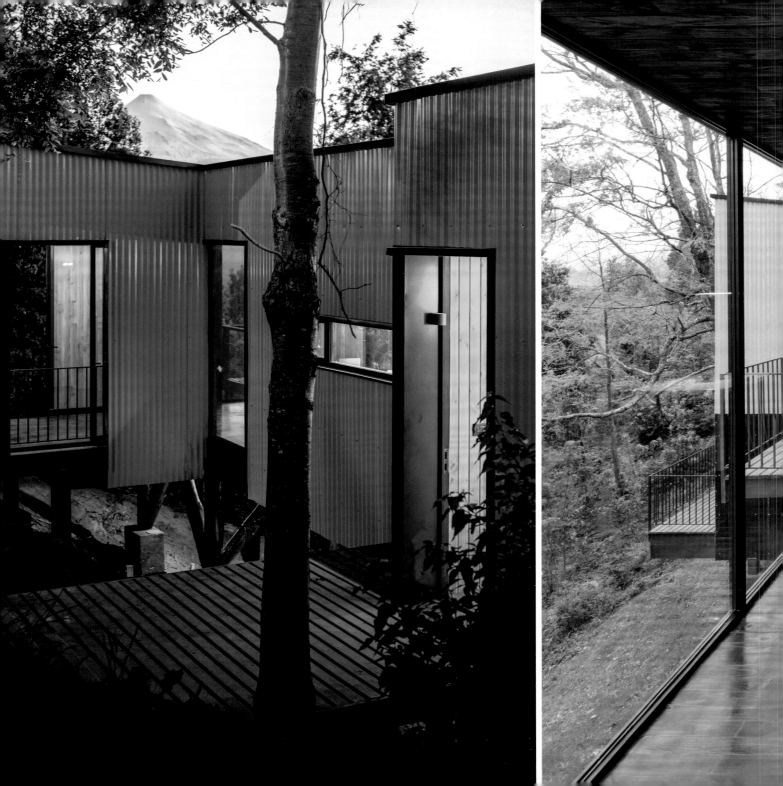

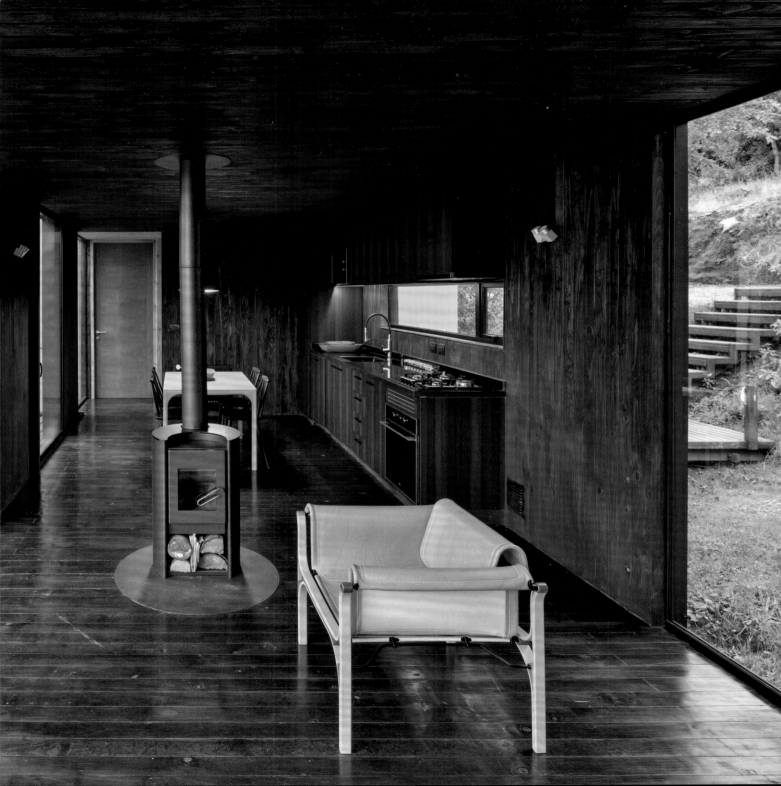

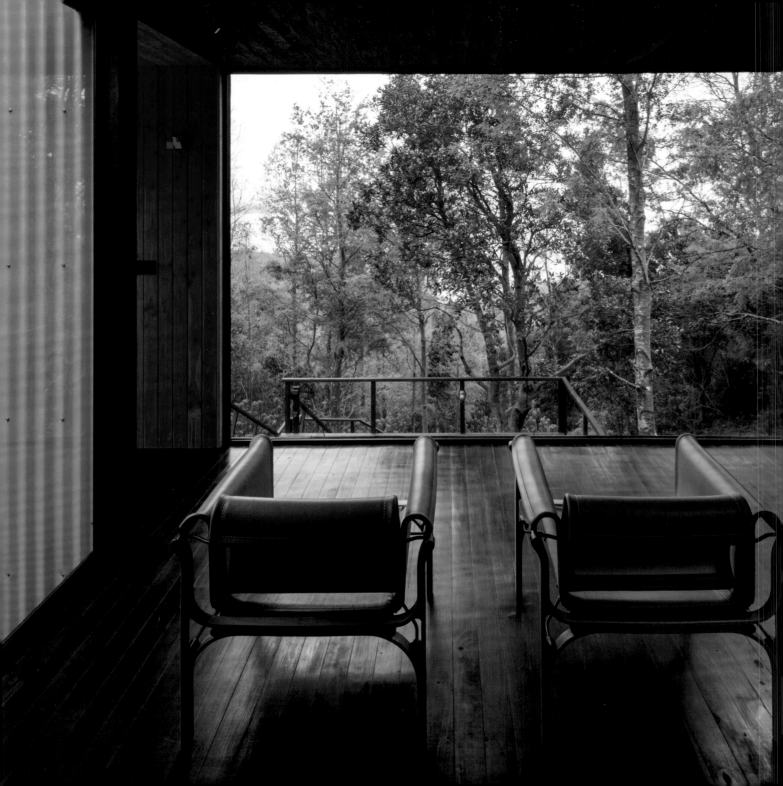

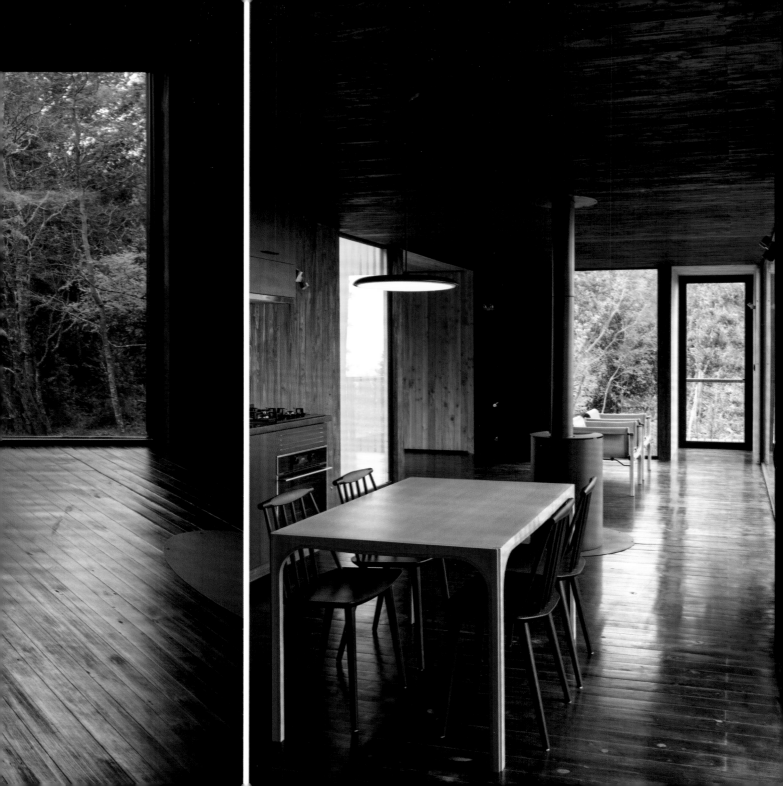

LLU HOUSE
CARRAN, MAIHUE LAKE, XIV REGION, CHILE

Cazú Zegers Arquitectura / 2018

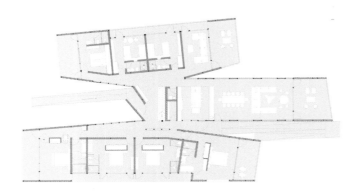

Intended as a family house where four generations could be lodged simultaneously, the LLU House has a floor area of 8,317 square feet (756 square meters). Built in the south of Chile on a 1.2-acre site, the house was conceived as a "protective mantle from the rain," precisely because the region is known for its frequent rains. The architect, Cazú Zegers, says that the design was conceived "in the manner of precarious tents, which are made by lumberjacks in the forest with nylon held by wire or ropes, sometimes with a central pillar to let the water run down." Built on one level on metal pillars, the house is lifted above a space with a barbecue and a hot tub. The center of the house is the public area with a kitchen, living, and dining space. The bedrooms are in the lateral elements of the design, which converge in this convivial center. Steel ramps clad in wood allow a handicapped member of the family to move about in a wheelchair. Oxidized vertically placed steel plates were used for the exterior, and the inside is almost uniformly clad in recycled oak, rauli (Nothofagus alpine), coihue (Nothofagus dombeyi) and laurel (Laurus nobilis). Details such as finials, benches, and coatracks were created by the artist Jessica Torres. Zegers states, "This is how, through a singular minimalist form, this work creates a contemporary dialogue with the landscape, highlighting and enhancing its enormous beauty and magnitude."

Above and opposite: The unusual plan and exposed timber surfaces of the house give it an unexpected liveliness in this densely forested setting. **Following spread, left:** The sophistication of the generous living space, with its suspended fireplace, contrasts with the rough wood ceiling. **Following spread, right:** Wood and glass combine to give a feeling of an intimate connection between the architecture and the forested site.

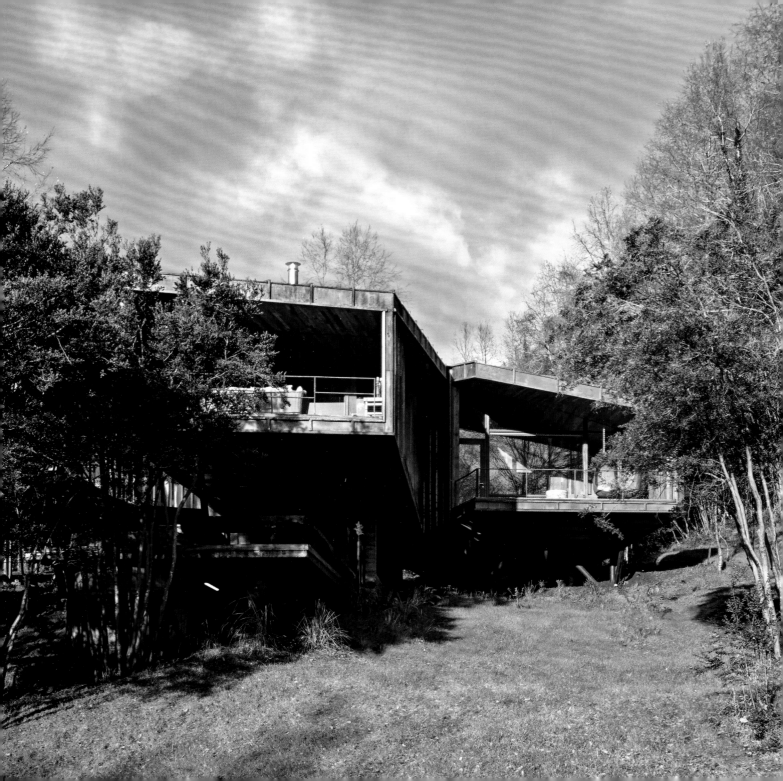

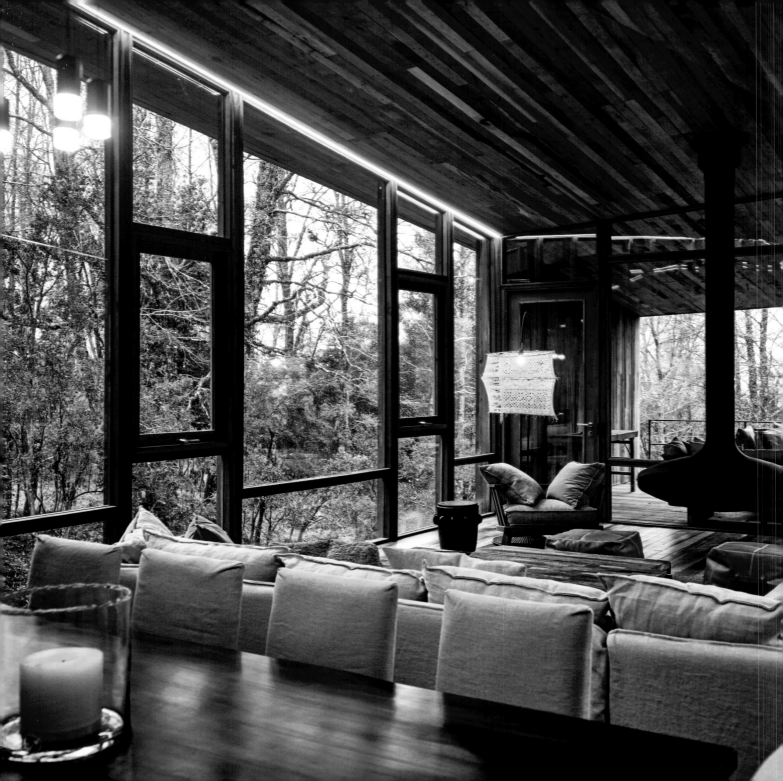

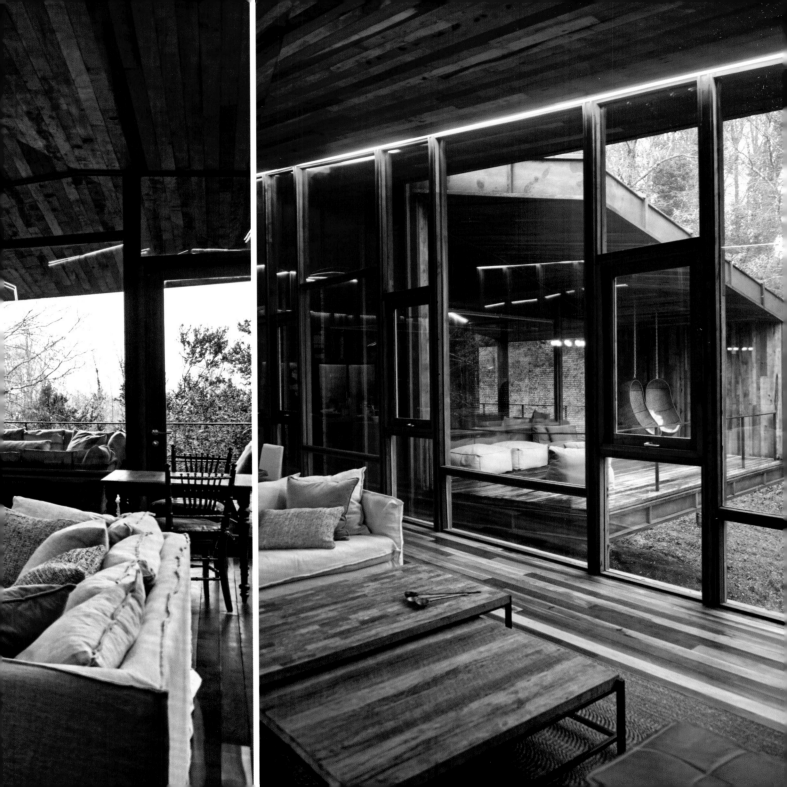

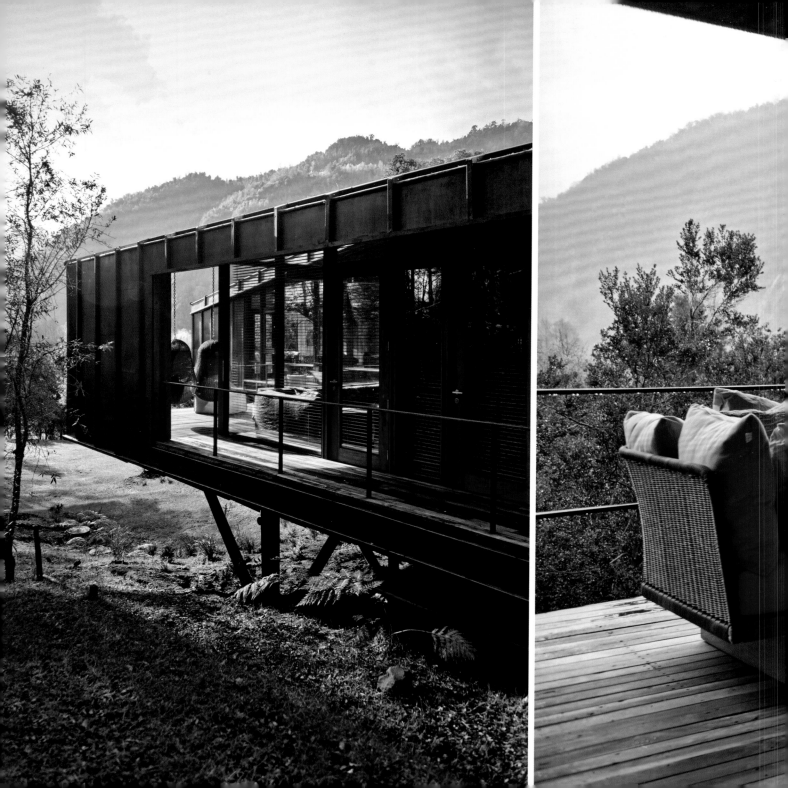

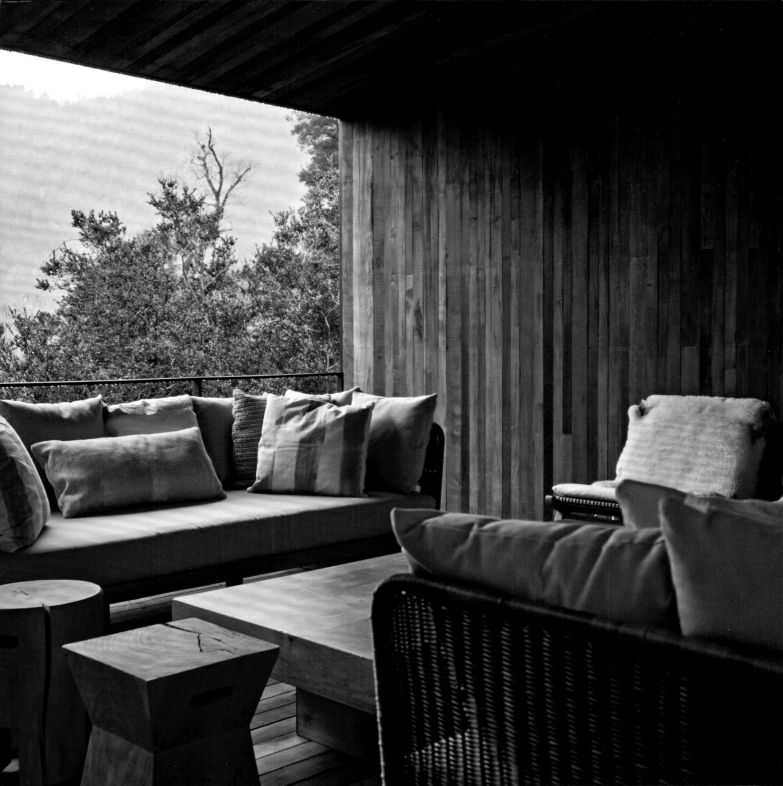

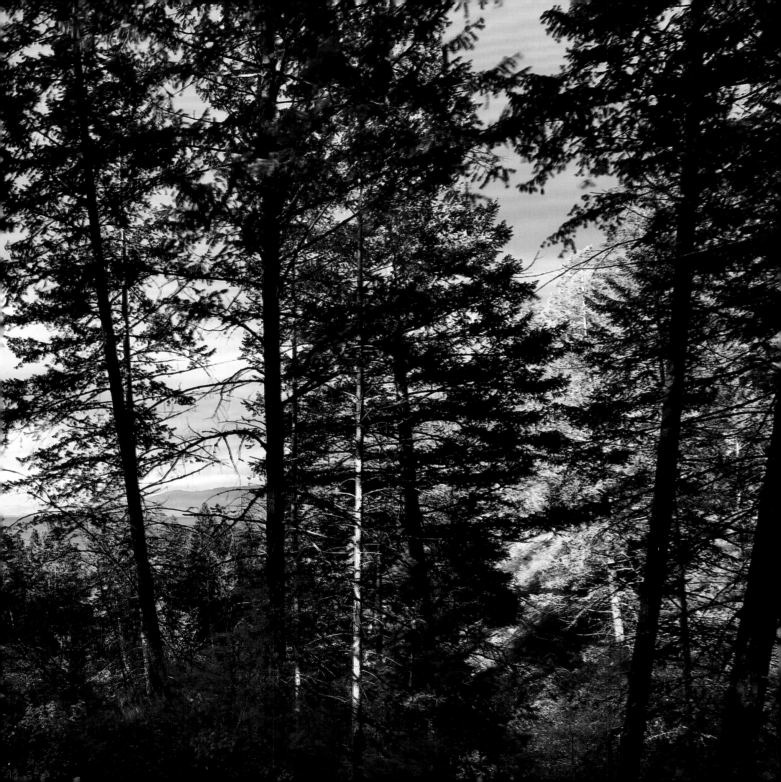

First published in the United States of America in 2020 by
Rizzoli International Publications, Inc.
300 Park Avenue South
New York, NY 10010
www.rizzoliusa.com

Publisher: Charles Miers
Editor: Ellen R. Cohen
Managing Editor: Lynn Scrabis
Production Manager: Alyn Evans

Design by Claudia Brandenburg

Printed in Italy

2021 2022 2023 2024 2025 / 10 9 8 7 6 5 4 3 2

ISBN: 978-0-8478-6607-6
Library of Congress Control Number: 2019914622

Visit us online:
Facebook.com/RizzoliNewYork
Twitter: @Rizzoli_Books
Instagram.com/RizzoliBooks
Pinterest.com/RizzoliBooks
Youtube.com/user/RizzoliNY
Issuu.com/Rizzoli

Photograph Credits

Abraham John Architects: 169–73 / Adam Letch: 259–63 / Alejandro Sánchez Garcia: 271–73 / Alejandro Soffia Arquitecto: 275–79 / Arches: 15, 16–19 / Art Gray: 59–63 / Ben Blossom: 51–53 / Bonte & Migozzi Architectes: 21–23 / Bourgeois/Lechasseur Architectes: 81–83 / Bruce Damonte: 31–35 / Carney Logan Burke: 85–89 / Chiasmus Partners: 175–79 / Chu Van Dong: 187–89 / Daniel Corvillon: 281–87 / Daniel Koh: 221–25 / Daniela Mac Adden: 255–57 / © David Sundberg/Esto: 91–95 / Eirick Johnson: 145–49 / Federico Cairoli: 237–41 / Federico Kuekdjian: 243–47 / Fernando Alda: 231–35, 249–53 / Fernando Guerra: 265–69 / Francis Pelletier: 163–67 / Gudmundur Jonsson Arkitektkontor: 25–29 / Ivar Kvaal Dyrseth: 37–39 / Jan Kudej: 55–57 / Jean Philippe Delage: 139–43 / Jim Westphalen: 69–73 / Joe Fletcher: 157–61 / Kengo Kuma & Associates: 117–19 / Kenneth Lim: 181–85 / KIAS/Norihito Yamauchi / Lauren Ghinitoiu: 227–29 / Lazor/Office: 121–25 / Lundberg Design: 127–31 / Malik Architecture: 199–203 / Martin Dimitrov: 97–99 / Matthew Carbone: 65–67 / Mina Bratina: 45–49 / Nacasa & Partners Inc./ Koji Fujii: 195–97 / Nic Lehoux: 75–79 / Noah Kalina: 107–109 / Paul Warchol: 101–105 / Photographix India-Sebastian Zachariah: 209–11 / Shai Gil: 133–37 / Simon Devitt: 213–15 / Studio Kamppari: 41–43 / Tim Griffith: 111–15 / Travis Price Architects: 151–55

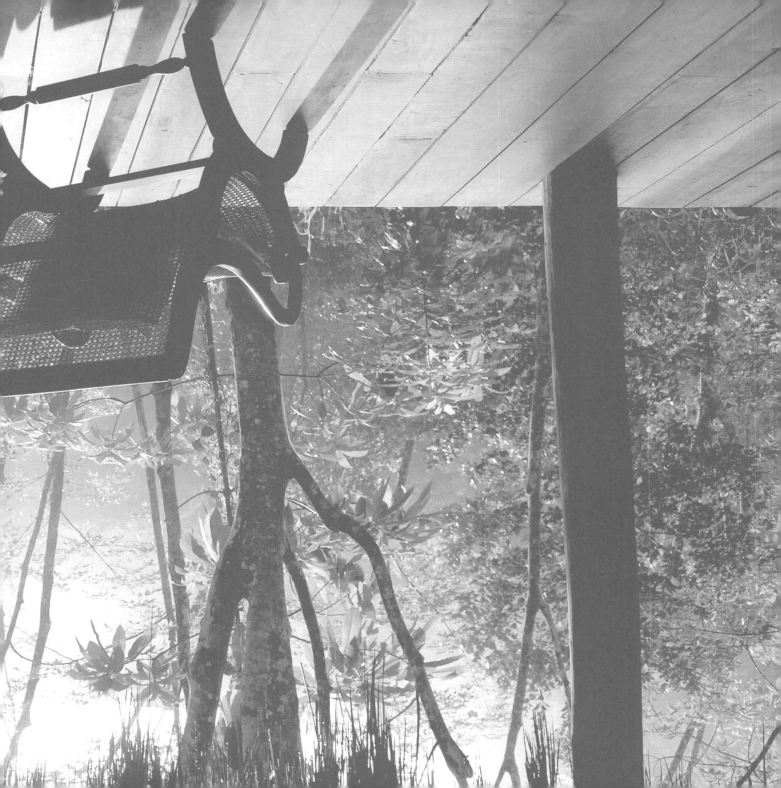